JUN 2 3 2015

W9-BWB-595

SPRINGDALE PUBLIC LIBRARY
405 S. Pleasant
Springdale, AR 72764

Abandoned America

The Age of Consequences

Matthew Christopher

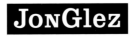

SPRINGDALE PUBLIC LIBRARY
405 S. Pleasant
Springdale, AR 72764

Foreword

Matthew Christopher's sojourn through the ruins of America has produced a document plangent with sadness and nostalgia that amounts to a beautifully composed farewell letter to Modernity. I prefer the capital M, by the way, to make the point that the condition we reflexively think of as being up-to-date or cutting-edge or in the vanguard of progress has been the chief sentimental delusion of our time, deserving emphasis to denote its true identity as just another passing phase of history.

Being immersed in Modernity for several generations, we have come to regard its institutions and usufructs as permanent achievements. Matthew Christopher's photographic record of decay depicts the tragic truth: that something extraordinary has ended and that nothing like it may ever come back. We're now going in the other direction despite a lot of wishful thinking: toward a loss of complexity, a reduction in the scale of activity, a loss of artistry, and probably the end of many comforts, conveniences, and amenities we have come to take for granted.

It is no accident that many of the ruined buildings pictured in these pages were built at a particular moment one might call the take-off point of Modernity: the turn of the 19th and 20th centuries. These were the decades when oil ignited the booster rocket of technological advancement. Over those few decades, most of the things we consider to be the hallmarks of Modernity made their first appearance: telephones, radio, movies, automobiles, powered flight, ocean liners, home electricity, skyscrapers, anesthesia, and more. The diminishing returns of all this technology naturally lagged a bit, but blowback eventually arrived in the form of the First World War (1914–1918), a horrifying industrial slaughter featuring "innovative" new weapons such as tanks, machine guns, and aerial bombs. The war traumatized Europe and demoralized America, and the effects of all that shocking violence were later expressed across all the arts in the various Modern movements.

The decades around the turn of the 19th/20th centuries are also sometimes called the Beaux Arts era, especially in architecture. The name refers to the fact that the USA then had few schools of architecture, so the ambitious youth of that day desiring an education flocked to the École des Beaux-Arts in Paris, where they were trained in a rigorous neoclassicism. As they matured, they designed perhaps the greatest buildings America may ever produce, buildings with immense power to stir our admiration and affection. The most notable of these are our beloved institutional monuments: the big libraries and museums, state capitols, city halls, courthouses, banks, grand hotels, and so on, extending clear down to our local post offices, hospitals, schools, theaters, and even power stations. The ruins of these things are the subject of Mr Christopher's book.

It also happened that this tremendous efflorescence of architectural skill coincided with some technological leaps in building techniques. For instance, it was not until the early 1900s that "advanced" societies were able to equal the ancient Romans' skill in using reinforced concrete. Unfortunately, entropy never sleeps and the blowback from that is now under way. The Romans used stone rubble and ceramics to reinforce their concrete while we Moderns, with our advanced metallurgy, use iron reinforcement (rebar). These now act as built-in time bombs stealthily destroying much of our recent architectural heritage. When small cracks allow water to get in, the iron rusts and expands and breaks up the stuff it's embedded in. The process can be remarkably rapid. Hence, the depressing spectacle of so many 20th-century American structures already falling apart while 2,000-year-old Roman-built bridges still carry traffic in Italy and France.

That said, the everyday American architecture of the period 1890–1930 is of such stunning aesthetic quality that a certain wonder and nausea attend its comparison with the narcissistic stunts and cheapjack vernacular crapola of our own time. Beyond the sheer architecture of all these schools, theaters, hospitals, prisons, and churches is an equally impressive armature of institutional support that suggests the tremendous organizational and vocational competence of our grandparents' day. The big, gorgeous American high schools of 1905 were fabulously well-run enterprises that turned out graduates with more skill and intellectual range than the PhD programs of the elite universities do today, burdened as they are with feel-good social engineering and half-baked psychotherapy that have been embedded in the curriculum like enervating parasites. I dare say that even the old prisons were far superior to the corrupt, overcrowded hell-hole "facilities" of this century which are effectively ruled by gangs of the inmates themselves.

The movie palaces of those early Modern days, like the Lansdowne Theater captured by Mr Christopher, present displays of middle-class opulence that are nearly unimaginable now. Reflect on what that suggests about the psychology of yesterday's working people: they believed that they deserved to have beauty in their lives, and the builders agreed to furnish it. Note especially the elaborate ceiling decorations; today, our absurd building codes prescribe so much sprinkler infrastructure and other crap that a decorated ceiling in a grand room is completely out of the question. So we make do with bland acoustical tile and shower heads.

Mr Christopher's photos of the ruined workplaces, the knitting mills, menswear factories, motorcycle shop, steel furnace, coal-breaking works, the power stations, are ghostly reminders of the way the USA produced real goods representing immense real wealth, as opposed to the matrix of rackets that the financialized economy amounts to today, with its empty promises to pay future obligations in exchange for creaming off the last remnants of genuine capital. These rackets, by the way, led by the Too Big to Fail (or Jail) banks and their corrupt handmaidens in government, will lead the way in our journey out of Modernity to a new dark age.

That prospect is re-emphasized in the beautiful photos of America's ruined churches, in particular the shot of St Bonaventure in Philadelphia, where the ceiling and the empty sky have become one. These marvelous structures, barely a century old, now look like harbingers of a dreadful dark age to come where beauty, grace, faith, and hope are abandoned and memory itself dissolves away to nothing. This book is both a warning about the sad transience of things assumed to be permanent and testimony to the spectacular artistry of humankind, which abides in us even when it goes dormant for a while.

James Howard Kunstler

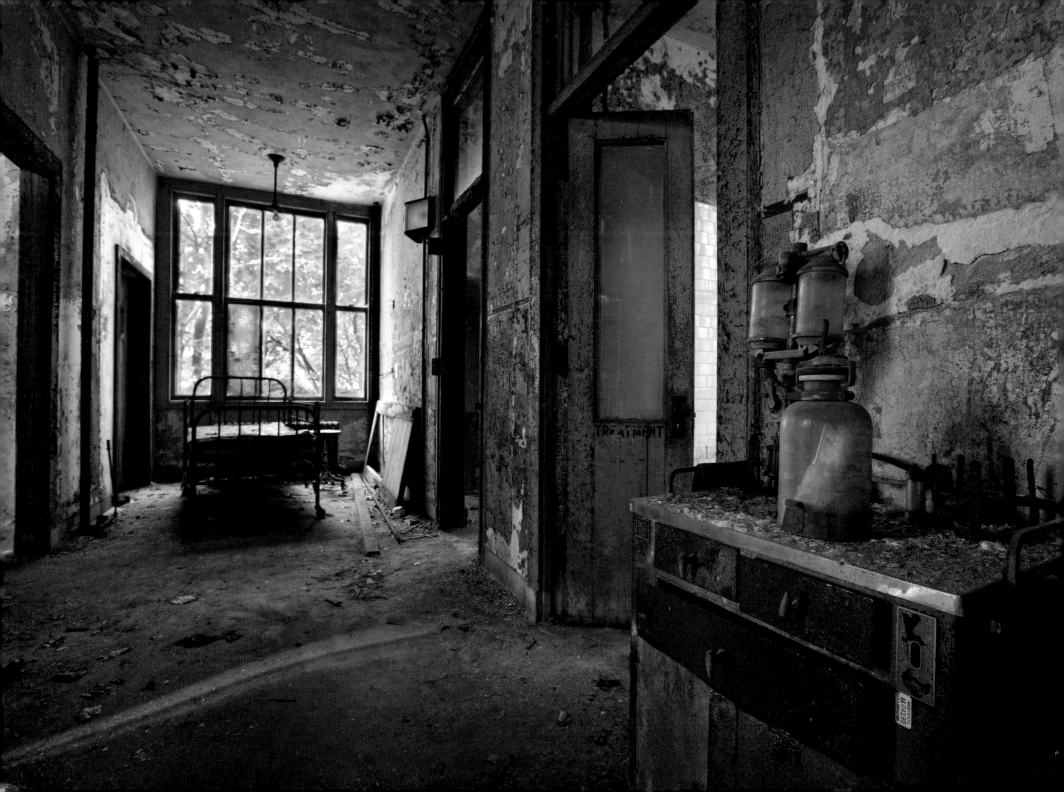

Introduction

At its core, the photography of ruins is fundamentally about death. Though the subject involves many elements, including art criticism, history, preservation advocacy, and sociology, the very basis for the entire genre is that the photographs are of abandoned—or functionally dead—spaces. It could be argued that such spaces still house life (in the form of the flora and fauna that reclaim them), and therefore are spaces in transition, but the key element is that what they were once created for is no longer. Much in the same way, a host of chemical and biological processes continue in a corpse but it is no longer considered living. It is this concept that frames many of the discussions and accusations about the genre; people living in Detroit, for example, chafe at their city being characterized as "dead" when it is still inhabited by living citizens and businesses. Nevertheless, this aspect of the work is what frames our response, and it is critical to decoding our reactions (and the reactions of others) to it.

The set of expectations and taboos surrounding the photography of death is firmly entrenched. We expect that the images will be presented with respect, and we expect that the photographer will not "take advantage" of the subject by exploiting it. Sally Mann's work photographing corpses at the University of Tennessee's anthropological facility, where decay is studied, provoked strong reactions from viewers (much to her delight) because she drew them uncomfortably close to this fine line. It does raise a host of uneasy questions about motive—such as whether Mann was using the photographs for shock value to promote her career. According to Grant Morrison, writing in *The Guardian*, Mann was "observed happily wandering from cadaver to cadaver, prodding this body part and stroking that one." Issues of privacy and the idea that someone could potentially treat our remains or those of a loved one in a similar manner are never far from the audience's mind. Conversely, there is Mann's own statement that "There's a new prudery around death. We've moved it into hospital, behind screens, and no longer wear black markers to acknowledge its presence. It's become unmentionable" (Morrison). Contemporary artists such as Andres Serrano, Enrique Metinides, and Maeve Berry also photograph the remains of the dead, and similar controversy surrounds their work. The photography of corpses is far from a new practice, however, and was in fact much more widespread in the past. Post-mortem photographs of deceased family members or criminals were common in the 19th century, yet flourished for different reasons. While an abandoned building can certainly be anthropomorphized, either intentionally or unintentionally, and while it is in many cases used as a metaphor for the human body or spirit, the simple fact is that it is not a corpse. Shattered windows may resemble eyes, open doors may remind us of mouths hanging agape, but an abandoned structure is a man-made object. Though life has inhabited it, it has never been a living entity. Does this mean that viewing it with the same set of standards and preconceptions is unfair? While a derelict building may in actuality not be a corpse, in some ways it may be just as significant. A human's body holds a connection to those who knew or loved the person, just as a dead factory may have had deep personal significance for hundreds if not thousands of workers. A church is not just an object; for many people, it is a symbol of union with the divine, a place where babies are baptized, couples are married, solace is sought, and the deceased are put to rest. While the meaning and use of these sites can be seen merely as projections of our own will and desires, these connections are very real and very deeply rooted in the emotions of those who harbor them.

To see a place you once called home destroyed by vandals may not physically injure you, but it is an erasure of your past, an attack on a part of your being. We expect a photographer who deals with these sites to tread lightly and with respect, and rightfully so; they are the bodies of hopes and ambitions, and in their link to our shared heritage and common past, they are in essence a part of our "extended family". Far from images of actual corpses that some may consider shocking and gruesome, these sites allow us to confront mortality on a much larger scale in a context that is perhaps less immediately horrific. However, while closure can be one intent/reaction, so too can the idea of "disclosure". In "Never Again and its Discontents," an examination of the purpose of creating museum exhibits that educate the public about atrocities, Laurie Beth Clark describes the possibility of disclosure as a form of activism or protest. While exhibits with the intention of closure are essentially there to fit "a conventional model of trauma therapy wherein a patient orchestrates a structured visit to the setting of a traumatic experience in

order to put the pain to rest" (Clark, p. 70), those with the purpose of disclosure favor "learning from the past and perpetual vigilance lest we repeat these crimes" (Clark, p. 73). This is the most common expectation of the photography of ruins: that the photographer will disclose the history of a site, the status of the community and the impact the loss had on it, while advocating for preservation and prevention of the future loss of historic structures. While this is certainly a legitimate endeavor and one that I have worked toward with my own photography, it can also be limiting. Rather than the photography of ruins existing for its own sake, it must justify itself by what it does or tries to do. It can't simply provide a locus for closure, or a eulogy—this is much derided as a shallow lament for a nostalgic past that never existed or as an act of wallowing in the loss of others.

Further complicating the subject of the representation of death through ruins, and directly connected to the closure/disclosure schism in their reading, is the separate set of expectations we have for artists representing their own impending demise versus the artist representing the demise of another. Thus far we have discussed the set of obligations that are inherent to representing the death of another. Sally Mann's work exemplifies this: her critics accuse her of exploiting the death of others. That she could merely celebrate the colors and forms of the decay of the bodies of others seems perverse and unpalatable.

Chekhov observed that what makes a great writer is that they "move you in a certain direction and they summon you there too, and you feel, not with your mind alone, but with your whole being, that they have a goal, like the ghost of Hamlet's father who does not come and trouble the imagination for nothing" (Boyd). When an artist examines the death of another, we expect that they are not troubling us with the ghost of another for nothing. We anticipate an almost narrative quality to their work, a certain dignity and gravitas, and a destination to which their work will take us where we can close the book on the subject and leave with a feeling of greater understanding—not only of the deceased, but of mortality and the meaning of life itself. Certainly this is evident in cinema and literature. For the death of another person to be displayed as an example of chaos and meaninglessness is almost unheard-of.

However, if an artist is representing their own death, many of the strictures on how the work is presented vanish. We don't expect someone like Jo Spence or David Wojnarowicz (who represented their own death through self-portraits) to provide us with some lofty understanding of the meaning of life or death. We understand and accept that their work may be frustrated, confused, angry, accusatory, or sad. Much as we try to allow those who are coping with their own death the freedom to process it in whatever way they need to, we allow the artist to represent the subject as best they see fit and try to view the work for what it is. In this case, impending death is the only context that is needed.

While the depiction of abandoned buildings is frequently seen as the artist's approach to the death of another, and while this is in some cases accurate, *it can also be read as their reaction to their own death*. If this is the case, then the reading may change entirely and the dialogue over whether closure/disclosure is critical to the merits of the work is rendered nearly irrelevant. What of a photographer who is diagnosed with a fatal illness and chooses to sublimate that into images of ruins? Would we call their work "ruin porn" or expect them to provide some outside context about the impact on the community? Would we ask that they present their work as activism or as a political statement about the destruction of the past, or could we simply allow it to exist as a manifestation of a meditation on their own mortality? If we are prepared to be more lenient with such photographs under these circumstances, we must ask ourselves if expecting a terminal illness to allow a work to speak for itself on mortality is justified. After all, we are all mortal, and when stripped of outside context, the presentation of ruins speaks of a death that awaits us all. Furthermore, if a body of work presents these places as the death of a way of life—or worse, the death of an empire—unless the person presenting them somehow manages to extricate themselves from the situation, their death may be implicit in the work.

Even if it is not the artist's intention to present their depictions of ruins as some sort of indicator of impending social collapse (as I do), the slow deterioration and eventual demolition of a location (or even its renovation, which would still erase the current state of disrepair) are analogous to the deletion of their existence and the qualities that make it up over time, and ultimately the frailty of the human condition. If the purpose of the artwork is an exploration of these things, is it not somewhat demeaning to the art and the artist to ask that they package their message for our consumption? If this is so, how does this translate to the artwork that is literally dealing with the dead?

These are questions without easy answers, but they merit serious thought before one enters into the critical dialogue about whether a work dealing with ruins is justified or not and whether or not we dismiss the artist and their intentions. Perhaps the one thing that we can be excused for is expecting the work to have some intentionality and thought, regardless of what that intentionality or thought may be. Dealing with the death of others, one's own death, or the subject of mortality as a whole is a heavy and difficult topic. However, I do not think it is unreasonable to expect, like Chekhov did of writers, that the artist does not trouble our imagination for nothing.

When I began seeking out abandoned buildings years ago as an exploration of the American asylum system and the history of mental health care, I had little idea how focused my entire life would become around it. Soon my interests had spread beyond state hospitals and I was visiting as many derelict structures as I could find. The sense of the sublime—the awe-inspiring and fearful—was just as present in a power plant's massive turbine hall as in the delicate way that ivy had worked its way through a broken window and across the wall of a forgotten bedroom. Over the years, I visited churches, homes, schools, factories, prisons, hotels, banks, hospitals, asylums, grain silos, oil refineries, steel mills, coal breakers, stockyards, shipyards, and so many others that I can barely recall them all. What had started as curiosity had become a preoccupation, which then turned into an obsession.

As time passed, however, a certain uneasiness set in. The places I was visiting were too big, too widespread; sites like Carrie Furnaces (once part of the Homestead Steel complex in Pittsburgh) and Bethlehem Steel were the first and second largest steel manufacturers in the nation respectively, and entire cities had been built around places like them. Now they were rusting away as the economies around them imploded. I started researching sites to photograph and was astonished at just how prevalent places like these were. For example, when I decided to seek out closed churches, I found dozens in one mid-sized town alone. When I turned my attention to the school system, the rates of building closures across America shocked me. I found entire towns that were like graveyards, places where I could easily visit a dozen different sizeable derelict locations in the space of a day. Everywhere I looked, communities were reeling from staggering losses that seemed to seep outward from the lack of industries to the vital infrastructure that supported the towns built around them.

Unlike the demise of the enormous ice-harvesting industry along the Hudson River, which had become extinct virtually overnight with the advent of the refrigerator, it was clear to me that these phenomena were not the result of progress. Often no comparable industries had come along to replace the ones I photographed, and often no new schools or hospitals had been built to replace the old ones. The jobs had been exported to other countries where labor and environmental laws could be easily skirted. American businesses were unable to compete with rivals who could easily beat their manufacturing costs because they could pay workers less than a dollar a day, ignore safety regulations, or dump industrial waste without fear of consequences. The resulting imbalance made for cheaper goods for American consumers, but came at the cost of the loss of more jobs—jobs that were replaced by low-wage service industry work, if at all. Churches found the donations that they operated on dwindling, schools and other civil services were cut back and then shuttered as local and state coffers ran dry. The arts were choked as patrons with disposable income became a rarity, and entire neighborhoods sat vacant, victims of foreclosures. I came to realize that the nexus of my photographic work, my website *Abandoned America*, was not only a literal descriptor (as in a showcase of abandoned buildings in America), but also referred to what I believed to be the abandonment of America itself—its ideals, its way of life, and its future.

Much of the work I have seen on the subject of abandoned sites specializes in one type of building, such as the asylum system, or one place—frequently that poster child for urban decay, Detroit. By presenting one area or one type of building, the content can be compartmentalized. In the case of the asylum system, many believe that the shift to community-based care is a triumph over the warehousing, abuse, and stigma that came to be synonymous with the state hospital system—and so we can view its collapse with a sort of idle detachment and comfort ourselves knowing that in the end it was probably for the best, even though we have gone back to many of the same problems that led Dorothea Dix to advocate for the system to be founded in the first place. In the case of Detroit, the demise of the automobile industry and the toll it took on what was once the nation's fourth-largest city are well known; in a sense, we almost expect to see the city in ruins.

My work, however, is intended to connect the dots, to show that it is not simply one type of structure or one geographic location that is affected. Major cities across the United States, from Buffalo to Cleveland to Baltimore and far beyond, and many smaller ones as well, are all grappling with how to redefine themselves as iconic architecture is lost and the industries that created the need for the cities in the first place wither and die. Interest and involvement in historic preservation has grown by leaps and bounds, but it would be much less prevalent and necessary if there weren't so many places endangered and destroyed every year. Much like a surgeon attempting to operate on a corpse, we try to figure out what to do with urban blight and abandonment without addressing its root causes.

While my photography may take cues from the Picturesque representations of ruins created several centuries ago by artists like Giovanni Battista Piranesi, Caspar David Friedrich, and Hubert Robert, and while I see many universal themes represented in the external depiction of our own mortality and transcendence through reclamation by nature, my work is very much rooted in the present day. It would be easy to create a body of work romanticizing some idyllic notion of Americana, but the sites I photograph are not just large museums full of *in situ* artifacts. They are indeed time capsules in a sense, but they represent not only the past but our present

day as well. They also offer a sobering glimpse of what our future might look like if we do not address the problems that have created this situation. It is not my place to suggest specific solutions to that dilemma. These sites are part of our shared heritage, and rather than present them as part of some politically motivated polemic, it must be left to the viewer to acknowledge them and interpret their significance.

That said, I feel strongly that we have been indoctrinated to point our finger at others rather than accepting that we all share ownership of this situation. All too often, I have seen stalemates between conflicting ideologies result in buildings left vacant and exposed to the elements rather than reused, until it is too late to save them. In this sense they are also symbols of the current American landscape. I believe we have entered an Age of Consequences, a point where our own actions over the past several decades are having catastrophic effects on our towns, our national economy, and our environment.

These sites are not anomalies, and they are far too important to be ignored. Buildings serve as a mirror in which the inhabitants see their own character reflected. They are built with meaning, used with purpose, and ultimately come to illustrate the spirit not only of their architects but of those who live, love, work, and suffer within them. Even in their disuse they are symbolic and show shifts in values, finances, and ambitions. By exploring the remains of these symbols of social infrastructure and presenting the photographs of their remains, *The Age of Consequences* is a eulogy, not just for the abandoned shells of past losses and failures, but for our current culture and the losses and failures that we are now sustaining.

Matthew Christopher

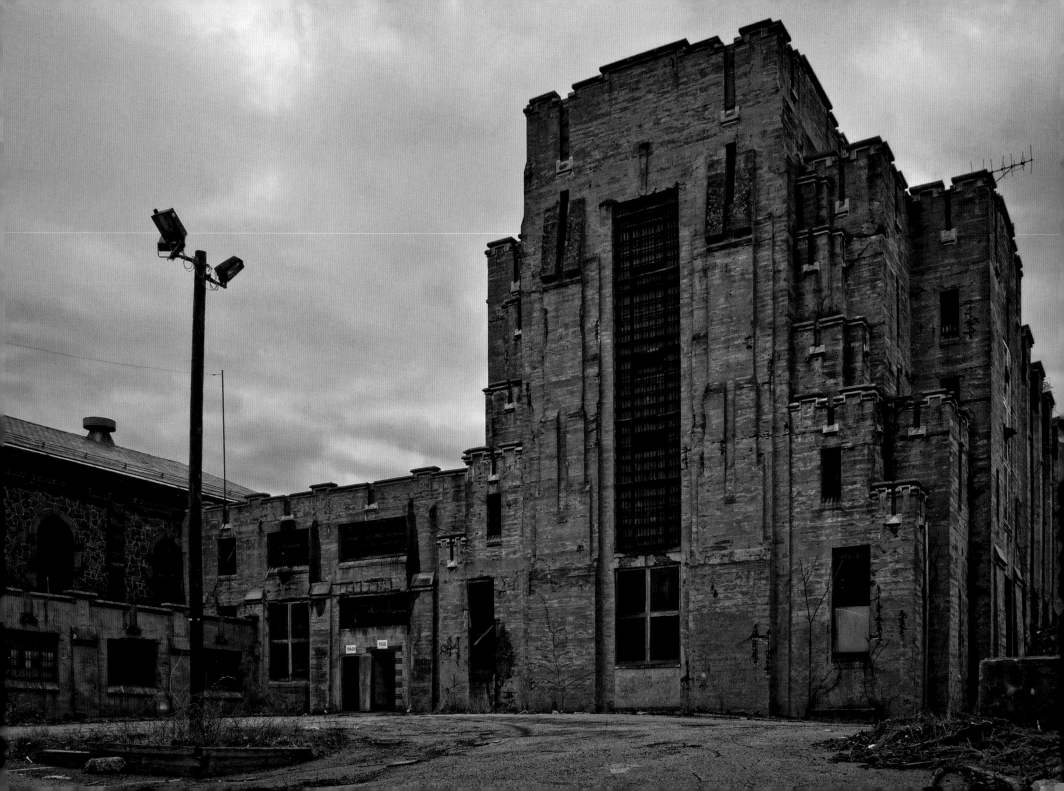

Contents

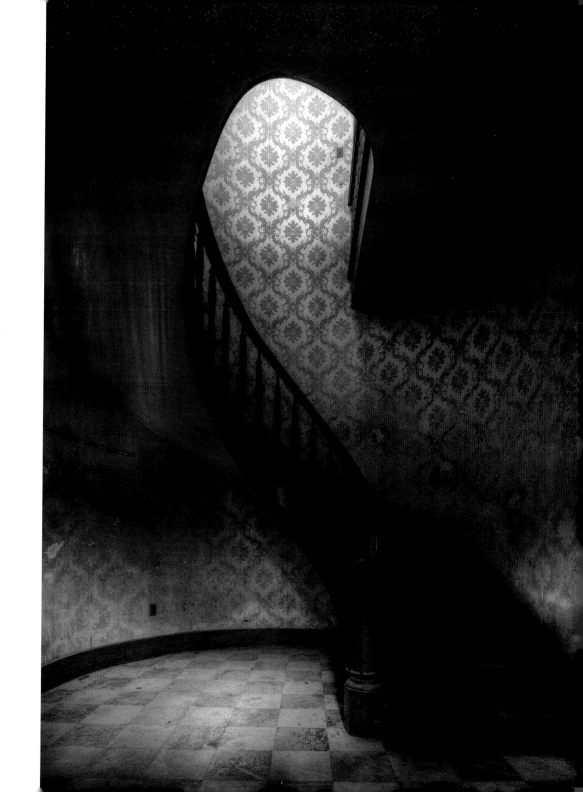

New Castle Elks Lodge

The original New Castle Elks Lodge (Benevolent and Protective Order of Elks 69) was built in 1887 and was one of the earliest Elks lodges in the country. By 1915 the Elks had outgrown their building and in 1916 a new lodge was built that was one of the most prominent and remarkable in town. The parade and the dedication were huge events that drew Elks members from across the region; the townspeople were offered tours of the new quarters. Elks Lodge members were primarily from vaudeville and theater groups, which may explain the theatrical character of the oval room on the third floor of the building. According to the Lawrence County Memoirs, "The new building had a large basement and three full stories, with a large meeting/dancing hall on the top floor, a billiards parlor, social rooms, a two-lane bowling alley, a kitchen and dining area, locker rooms and shower facilities, and a reading and writing room."

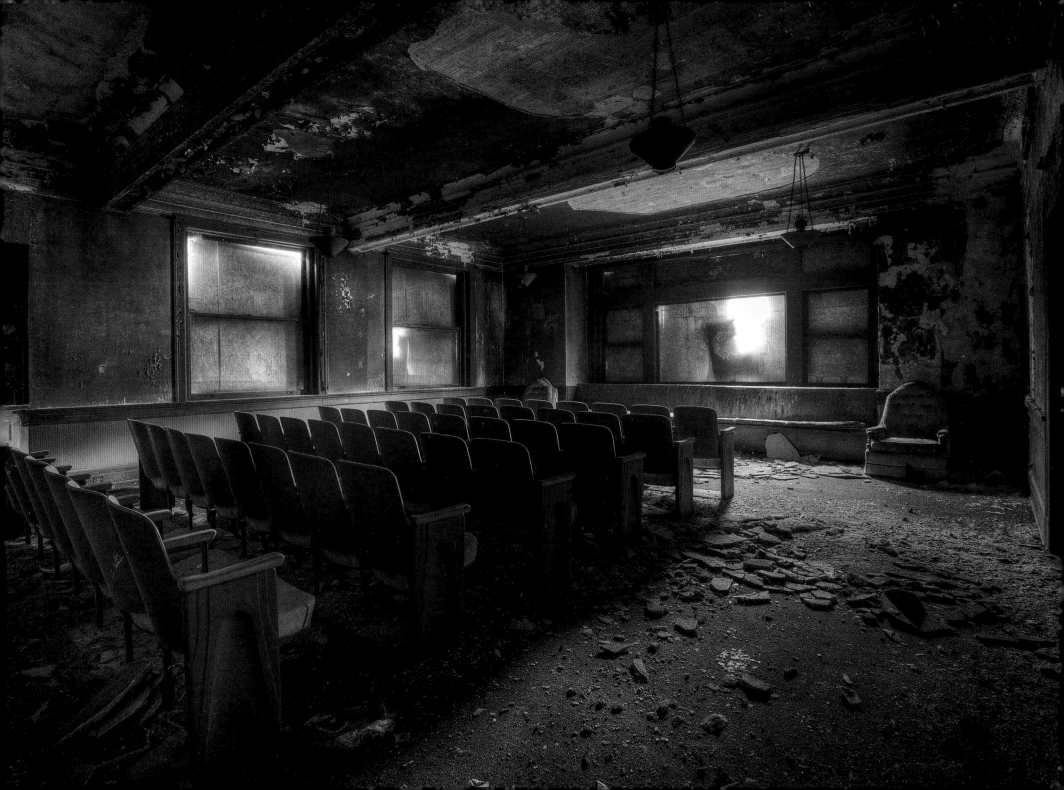

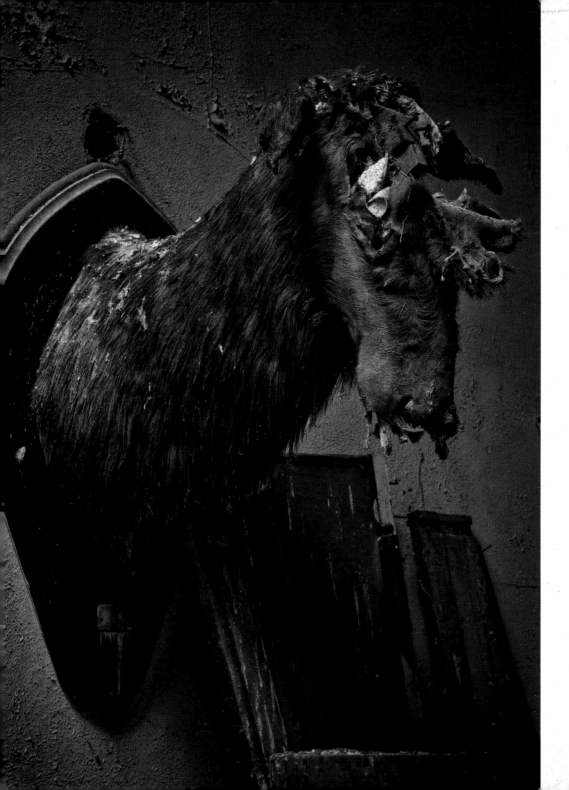

By the 1980s the membership had dwindled and the remaining Elks decided to relocate to a smaller building. In the 1990s ownership of the original lodge was given over to the city, which allowed the building to deteriorate with no apparent effort made to restore or reuse it. In 2011, the city decided to demolish it despite the state museum and the historical commission's interest in a potential rehabilitation. A little over a month after my first visit to the site, I went back to reshoot several pictures and found that two-thirds of the back half of the building had been torn off. The rest was in the process of coming down – a sad and wasteful end, as there appeared to have been no effort to salvage anything other than the seats in the theater.

Finding the New Castle Elks Lodge was essentially dumb luck, as I stumbled across it when going to visit family in that part of the state. I had no idea what to expect when I went inside, but the doors on the back were wide open and a dish of cat food lay on the back step. I quickly realized that a squatter was living there when I saw a roomful of water bottles and trash. This is always a little unsettling because there is no way of telling what kind of person you might encounter, whether they're violent, whether they'll ambush you, and so on. Considering that I was by myself and nobody really knew I was in the building, that could have been a problem.

The second issue that made photographing this building an uneasy experience was that the floors were in pretty bad condition and it was mostly very dark. When I reached the large, theater-like room on the top floor I noticed several holes and as I approached the raised area with the elk head, my foot went through the floor — something that is hard to get used to, no matter how many times it happens.

And then there was the elk head. After the initial rush of awe at seeing the huge oval room on the third floor, I took a closer look at the rotting head on the far wall. Every viewing angle seemed more horrific than the last, and the head was perfectly positioned in a dusty patch of sunlight in such a way that you couldn't *not* look at it. The wood boards and hay it had been stuffed with were exposed by the drooping skin, likely further damaged by mice who crawled in to get hay for their nests. It was one of those things that you know will make for interesting and distinctive pictures, but still makes you inwardly recoil when you look at it leering out from the shadows.

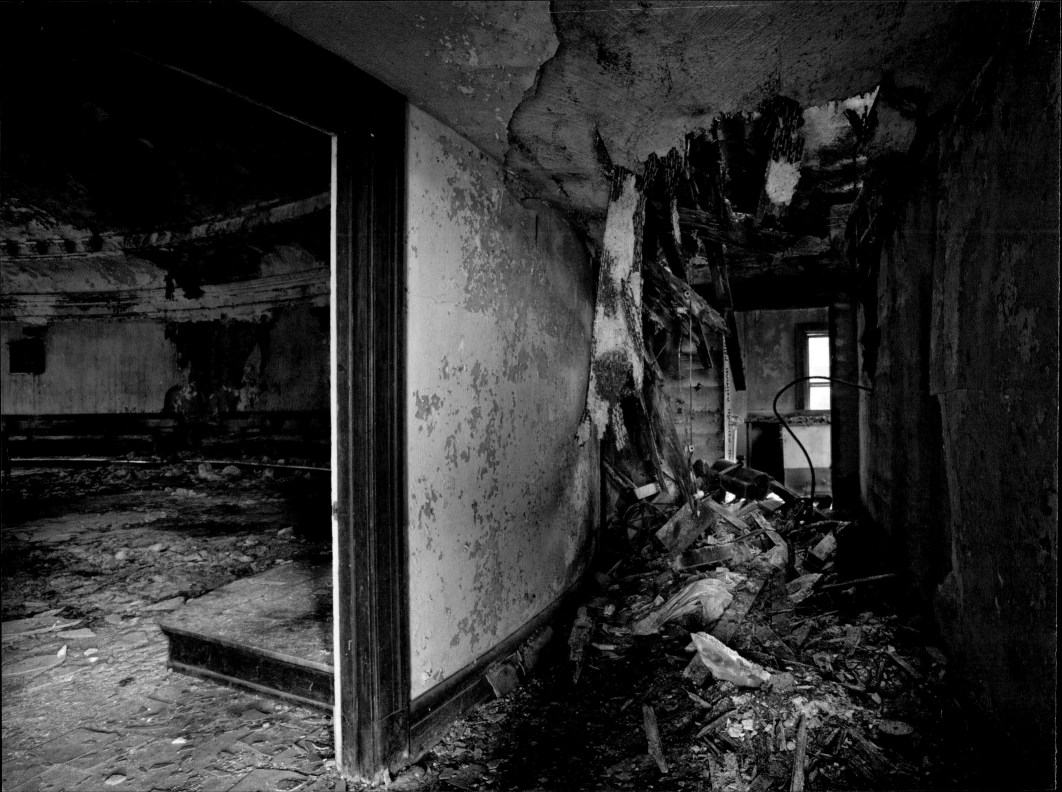

There were a number of really amazing spots in the lodge. The scorched theater-like room on the first floor really was interesting, and the oval room on the third floor, with its dangling ring of lights in the center and the old benches lining the walls, was very distinctive and showed the ravages of unmolested decay. When I went back a little over a month later, I was dismayed to see that the building was undergoing demolition. My first visit would also be my last.

There is little in the world as disappointing as making a trip out to take pictures of a location, only to find that you are unable to photograph it for some reason or another. It is even worse when you are confronted with the evidence that you will never have the chance to photograph it again. Seeing rooms I recognized and had walked through two months earlier hanging off the end of the building was surreal. I could make out a few of the benches still tenaciously clinging to the wall on the third floor, some of the enormous steel roof supports in the rubble, and bits of the chessboard tiled floor veering off at odd angles. It was tempting to try to go into what was left to get a few last pictures but I decided against it. The structural integrity of the building had been bad enough when it was still intact. There was little else I could do but work my way behind the fencing and take a few shots of the lodge before it was gone forever, taking most of the wood paneling, masonry, bricks, and interesting curios with it to the landfill.

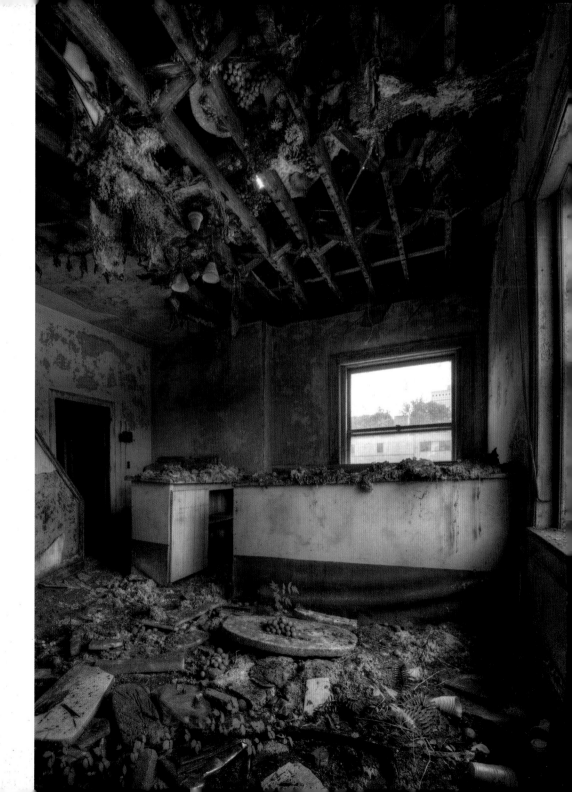

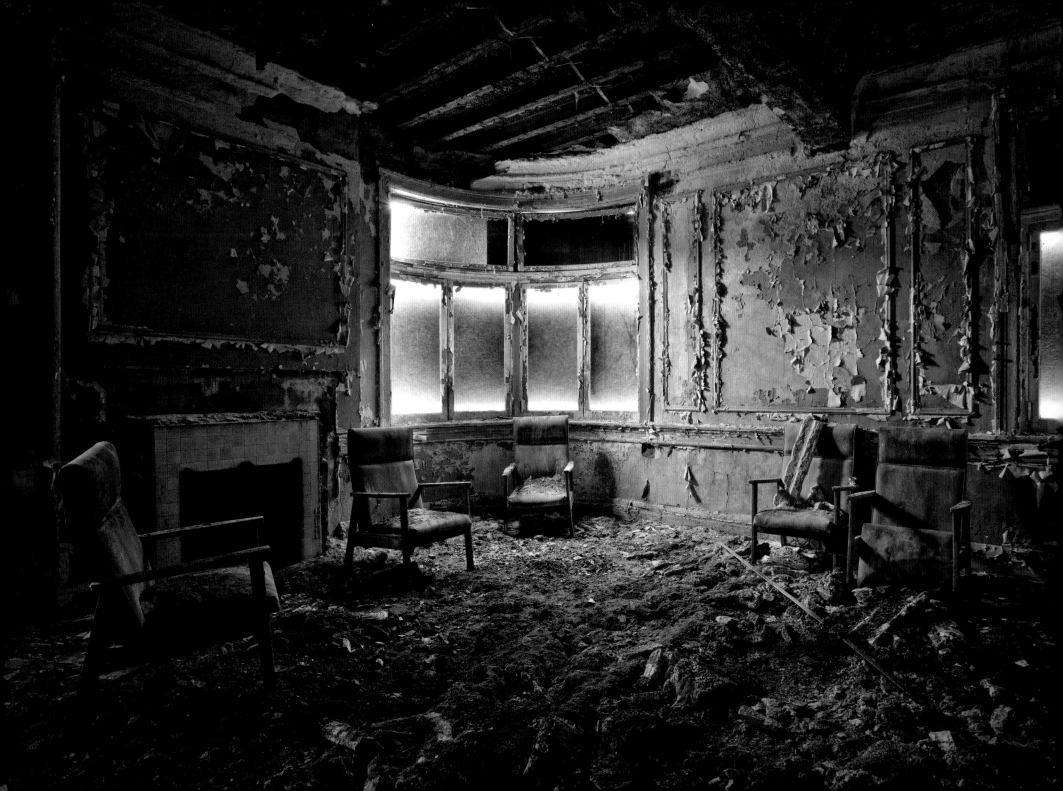

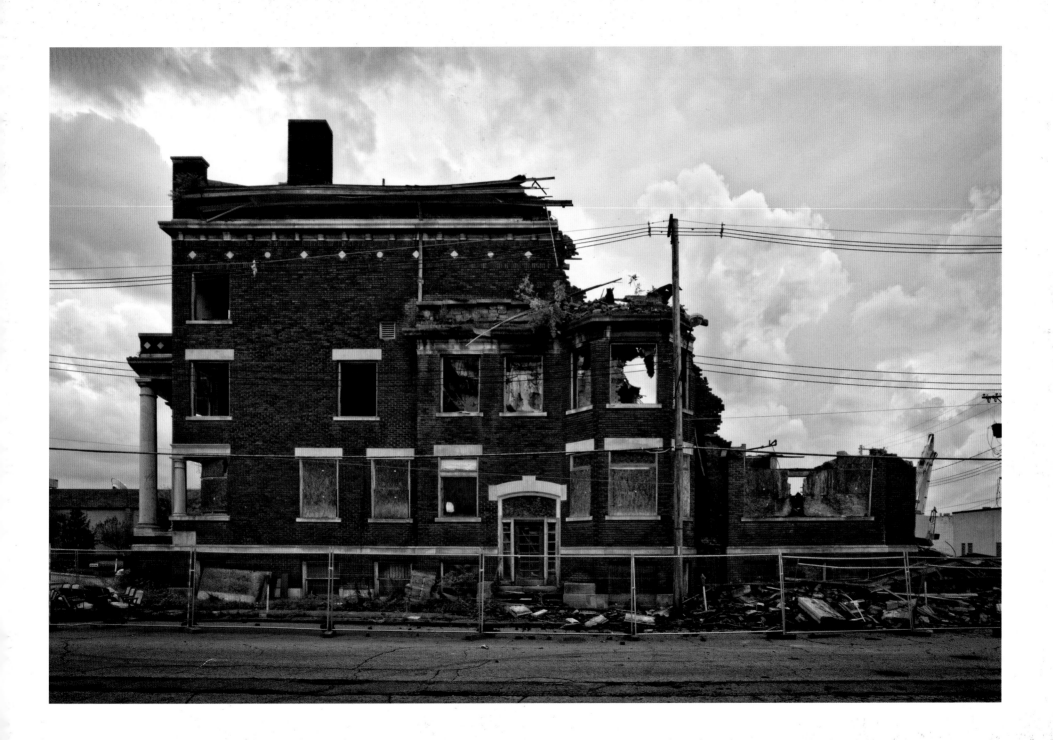

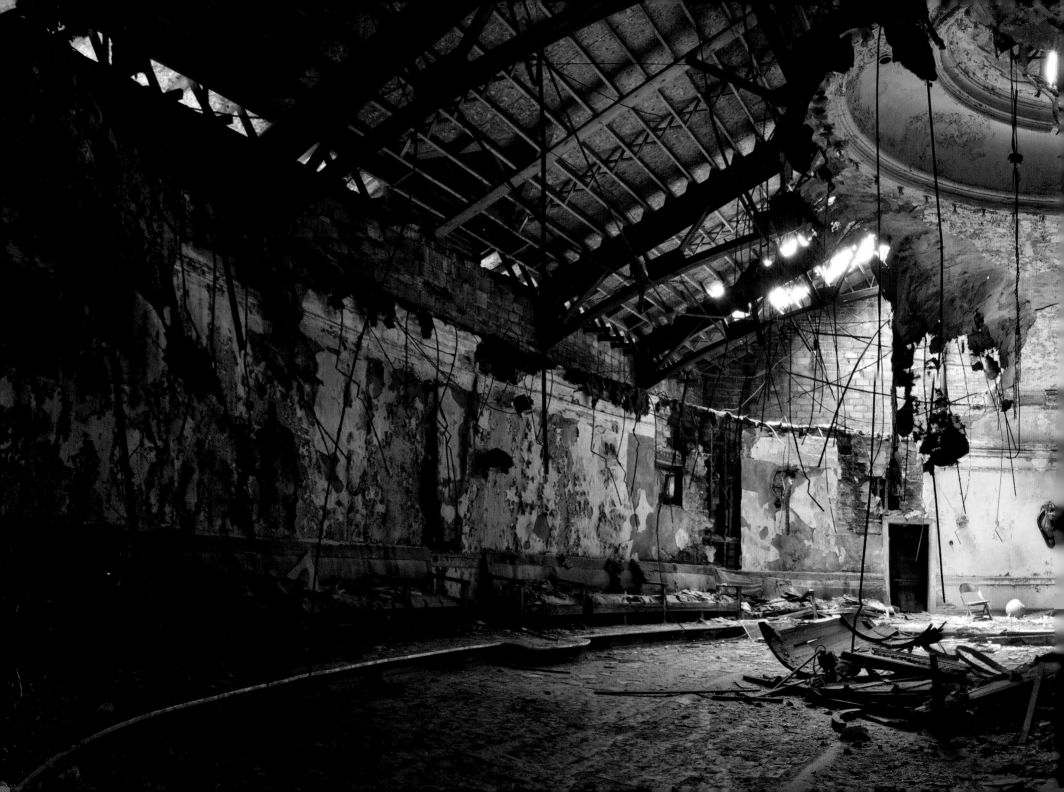

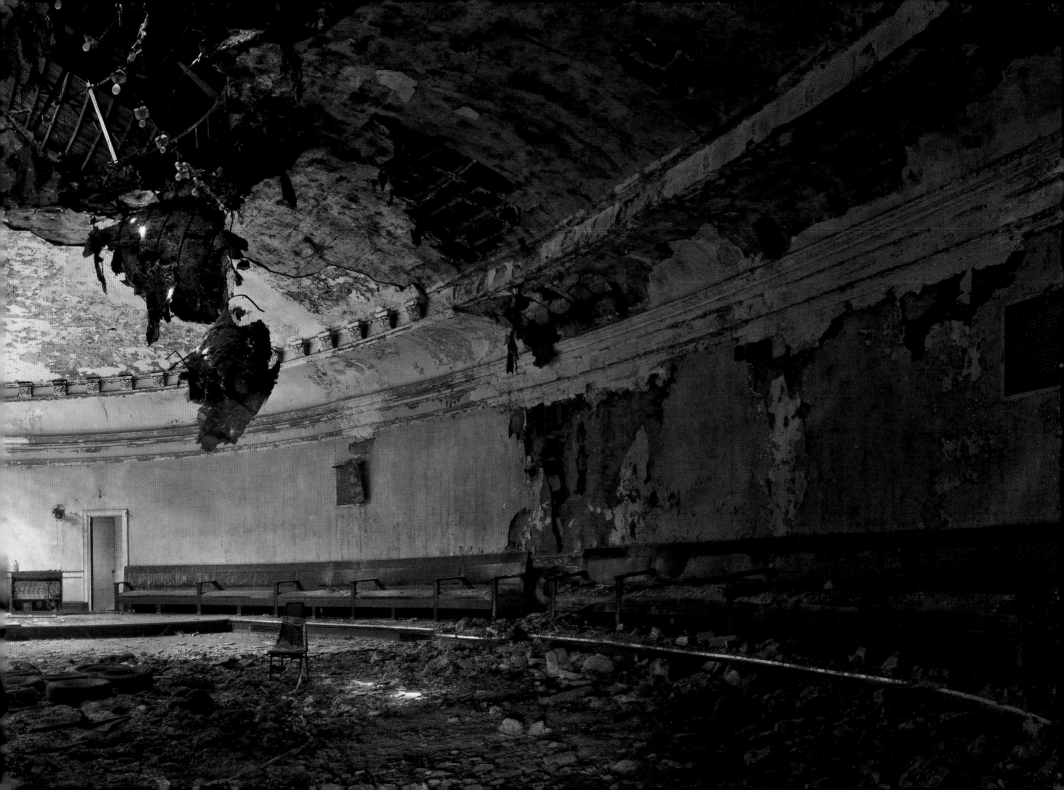

Henryton State Hospital

Henryton State Hospital was built between 1921 and 1923 as the Maryland Tuberculosis Sanatorium for African Americans. Originally the 530-acre complex comprised a utility plant and six main buildings with a capacity for eighty-eight patients. The buildings were in the Georgian Revival style popular in sanatoria construction at the time. The site had open porches and large windows and was on a south-facing hillside where it would receive "healthful air" from the westward wind while minimizing cold air from the north.

Higher tuberculosis rates among African Americans strained the budget and in 1938 several more buildings were erected to expand the capacity for care to 500 adults and children, but by the time they were completed in 1946 tuberculosis rates had dropped. According to an inventory of properties prepared for the state of Maryland, the facility now consisted of "an Administration building and two Hospitals, a Children's Hospital, four large brick residences or 'cottages' for physicians, nurses, and other staff, one small frame house for staff members, two water tanks, a heating plant, a garage, and a small storage building, all erected between 1923 and 1955." In 1962 it was converted into a state hospital, but the push towards deinstitutionalization and the rise of psychotropic medications rendered it obsolete little more than twenty years later. It was closed in 1985.

On my first trip to Henryton State Hospital in 2006, I hiked up the hill past the abandoned power plant and saw the relatively large main building in the distance. Even at this point, the vandalism on the site was bad, but nowhere near what it would become in later years. Someone had already thrown the theater seats out of the windows, but a year later the theater was burned to the ground in one of over seventy arson-related fires after Henryton's closure. Nevertheless, despite the holes that had been kicked in the walls or the windows that had been smashed, the walls were not entirely covered with graffiti of swastikas and penises. In the following years every architectural feature would be torn away, making Henryton one of the best examples of how publicizing a location ultimately destroys it.

It's strange to me, looking back through some of my photographs from this period in Henryton's past. It's odd to see walls not covered with spray paint, windows that aren't broken. It's strange to think back to a time when you could go to the campus and not see dozens of people walking around it, drinking beers or barbecuing on the rooftops, playing in the river down the hill from the site. On one hand, I think it's great that many people are able to enjoy exploring abandoned sites at their own discretion, albeit in this case with the risk of being caught/fined. On the other, it saddens me that respect and responsibility don't matter more to people. Abandoned sites have no real form of protection – from vandalism, from theft, from arson.

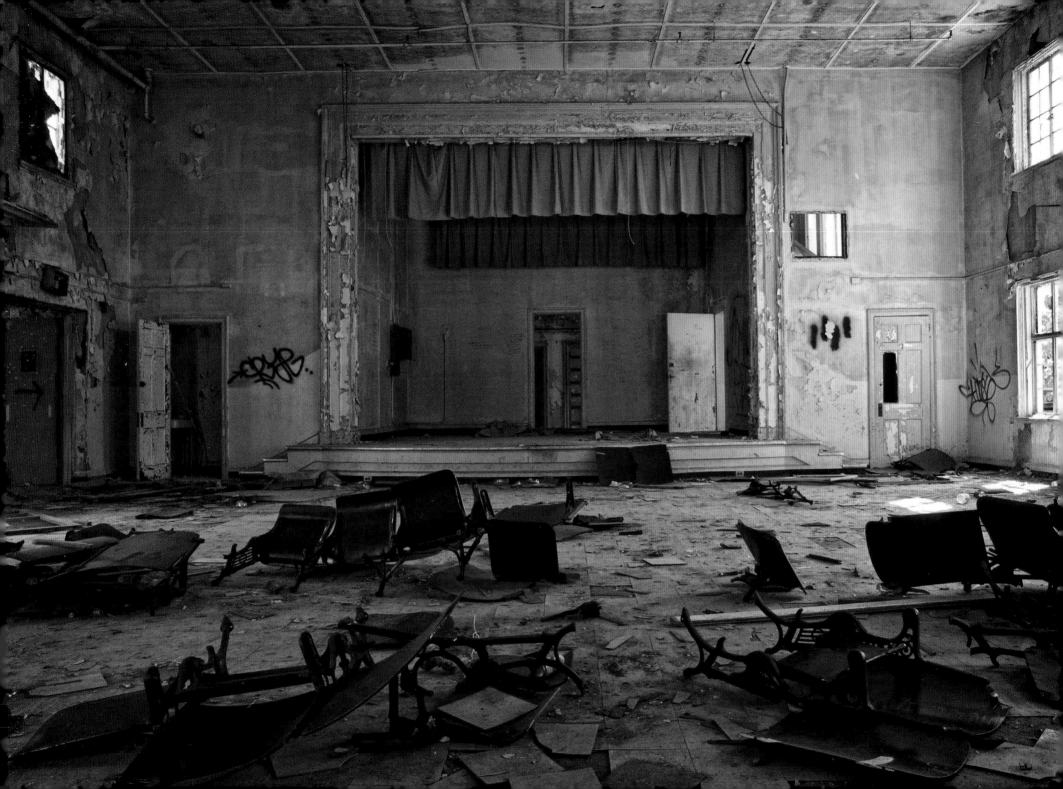

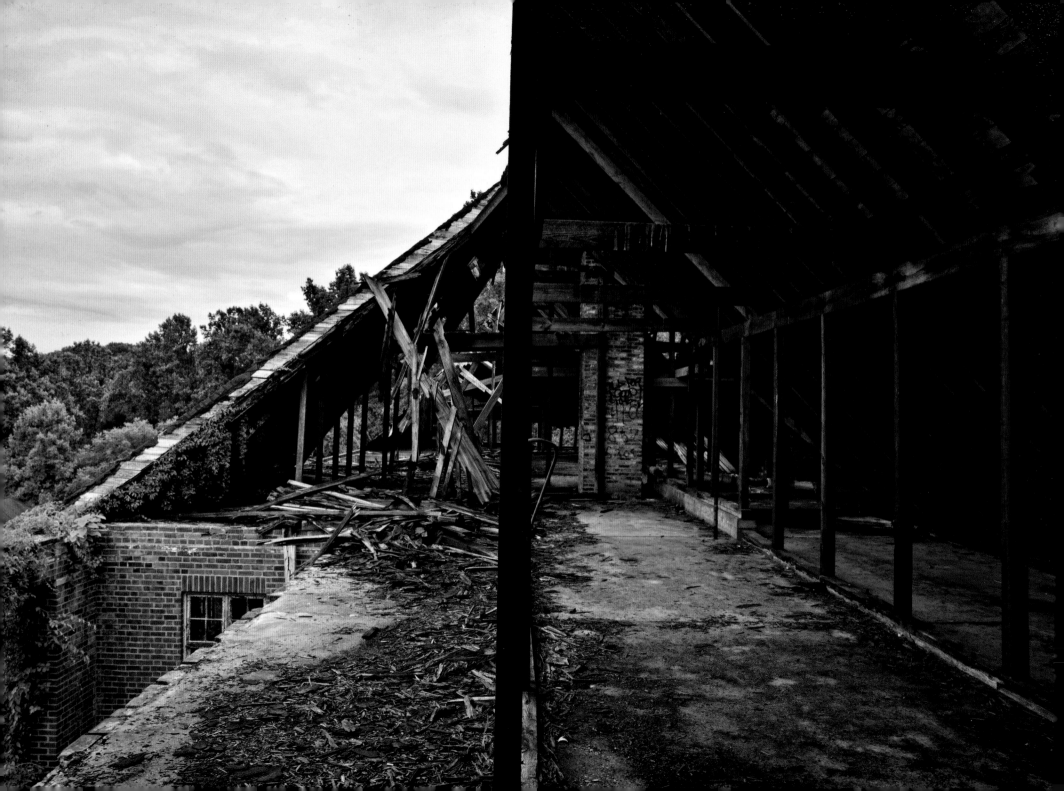

Visiting Henryton got harder every year. I look back now and think I should have taken more pictures. Like many places I've seen trashed over the years, I start to tell myself that the place I am visiting is too far gone, that with all the vandalism it's not worth it. The question then becomes whether what I'm looking for is a "pristine" ruin, whether there is merit in photographing an often-photographed place, and perhaps what the usefulness is of showing what really happens as time wears on.

A year after the demolition in 2013, I don't have answers. I feel uneasy knowing I could have and perhaps should have done more, but there is also a part of me that knows that if Henryton was still around I wouldn't go out of my way to return there. The subject of my work is the decline of a space, but on some level I dislike watching it. You always feel like you're losing something, every time you return.

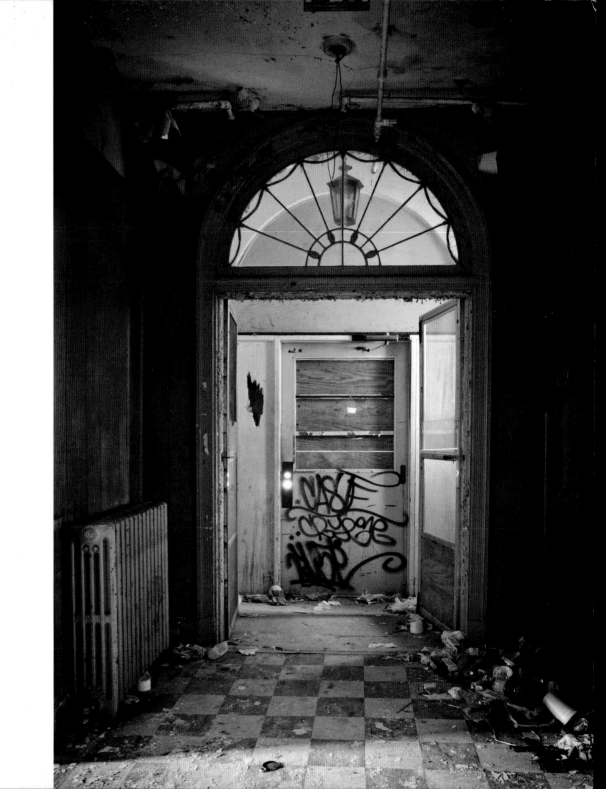

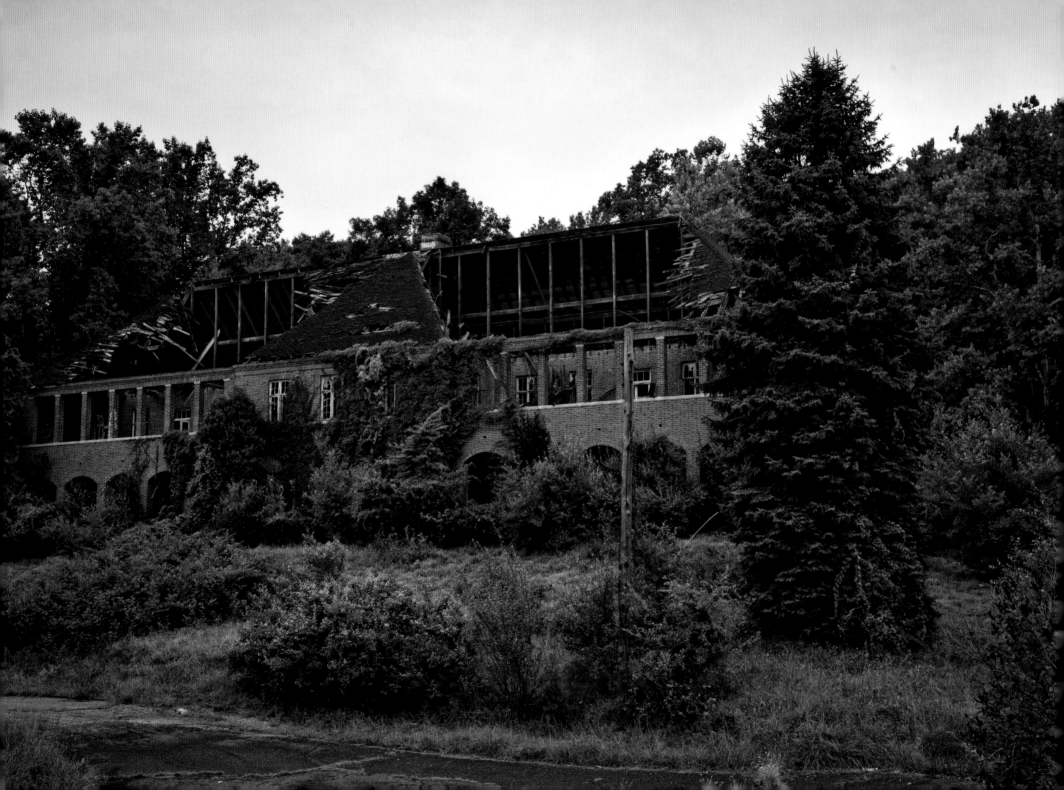

St. Peter's Episcopal Church

Saint Peter's Episcopal Church of Germantown was built between 1873 and 1883 for Henry Howard Houston, the Vice President of the Pennsylvania Railroad. Houston was interested in developing the surrounding area, and the church is believed to be part of his plan to attract a wealthy clientele to settle there. The church itself, the adjacent rectory, and the chapel/Sunday school were designed by noted Philadelphia architects Frank Furness and George Hewitt in a style that incorporated Gothic and high Victorian elements. The parish house was the final addition, designed by Theophilus P. Chandler Jr in 1898. It is rumored that Walt Whitman frequented the campus.

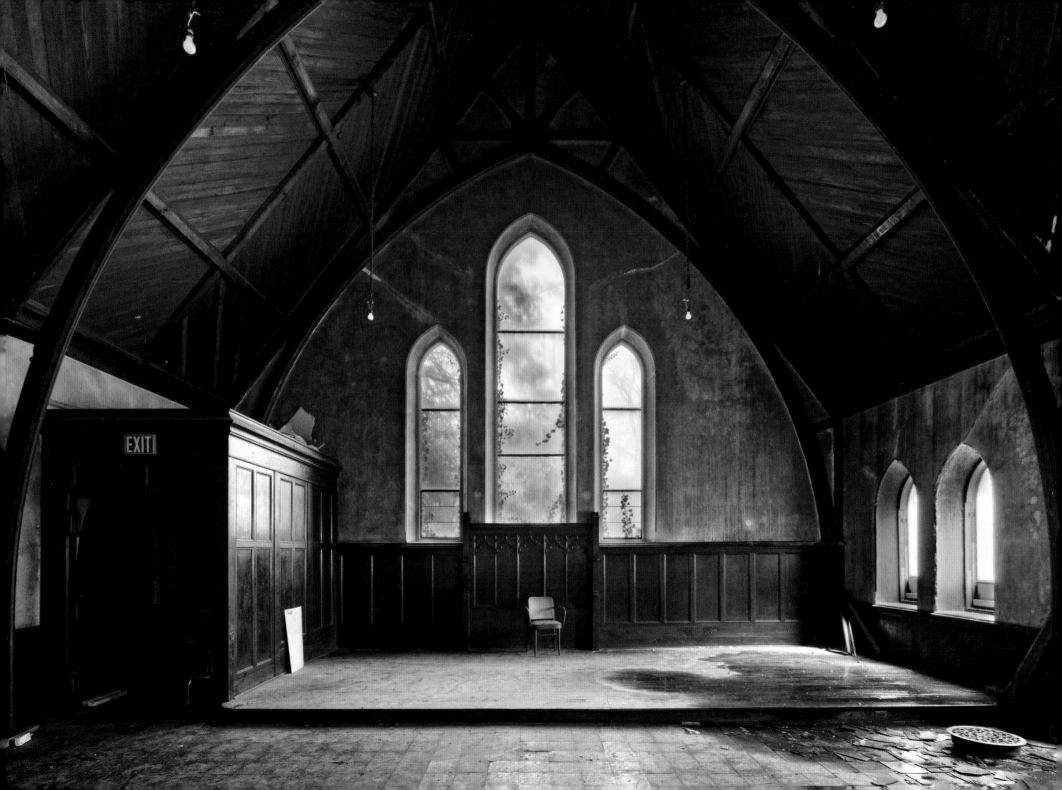

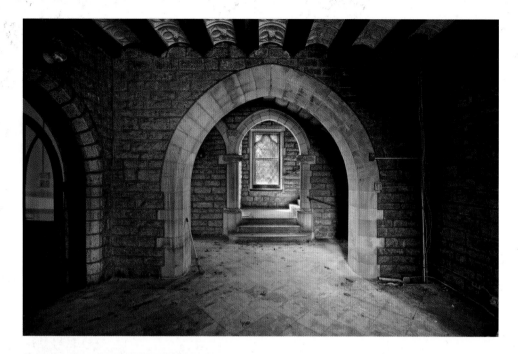

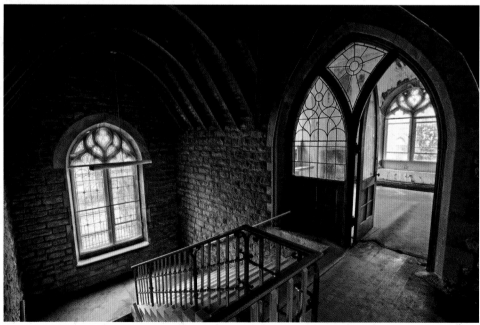

Dwindling membership and a consequent inability to fund the costs of operation led to Saint Peter's closure in 2005. The buildings had been on the National Register of Historic Places for forty years and contained a number of historical treasures, including two Tiffany stained glass windows and two created in 1909 by celebrated muralist Violet Oakley. Many people in the area were concerned that these would be lost. In a somewhat controversial move, after the closure the windows were taken to the Pennsylvania Academy of Fine Arts and the E. M. Skinner organ was removed and placed in another Philadelphia church.

When I first visited the church in 2010 its prospects seemed bleak; later that year it was placed on the Preservation Alliance for Greater Philadelphia's list of most endangered sites. Churches in the Philadelphia area had been closing at an alarming rate and many were torn down rather than repurposed. Restoration was expensive and the specialized architecture did not lend itself to other uses. Despite the beauty of the buildings and their exquisite wood and stonework, the realtor who led me through the site didn't seem terribly optimistic about their future.

In 2013, the Waldorf School chose to rehabilitate the buildings and move the school onto the property. While some modifications will be made to the structures to improve heating/cooling efficiency, they are committed to keeping the character of the site intact. The asbestos abatement has been completed and school is scheduled to start there in 2015. It is a rare but welcome ray of sunshine in the often gloomy landscape of Philadelphia church closures.

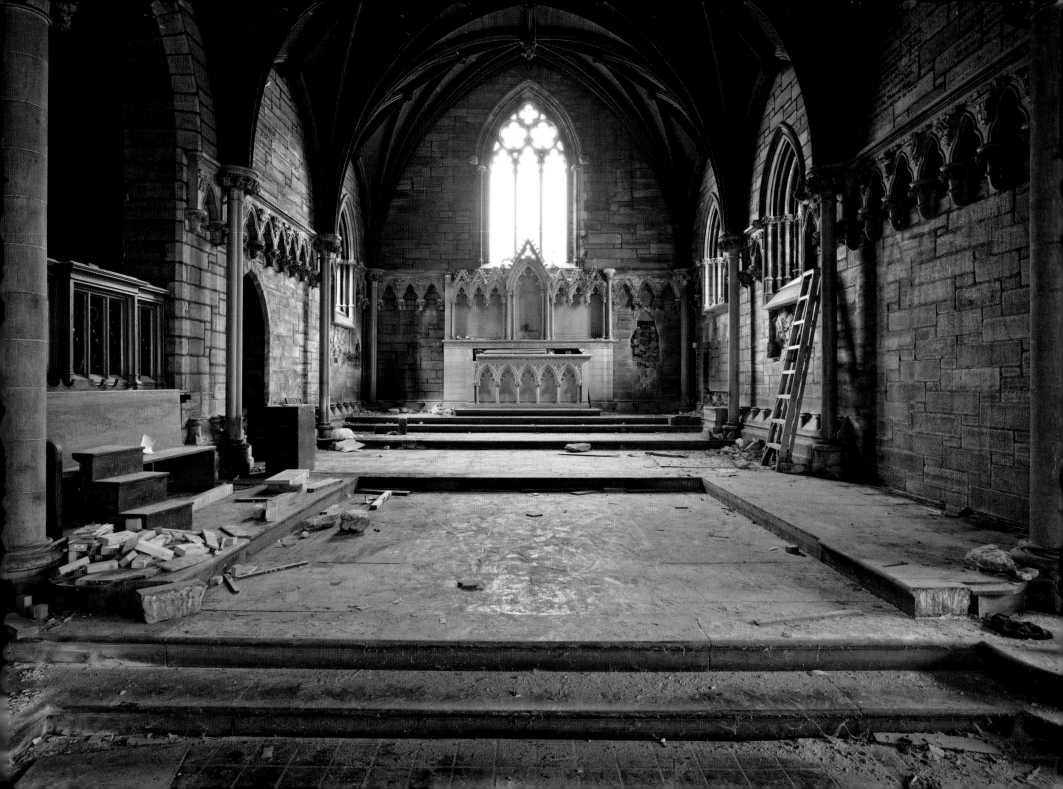

Lebow Brothers Clothing Company

Originally part of the Crown Cork & Seal Company, the factory at 1500 Barclay St in Baltimore that would later become Lebow was built by architect Herbert West in 1914 to serve as a machine shop. According to the Baltimore Heritage website, "between two and three hundred people worked at the machine shop and employees benefited from amenities including an outdoor rooftop recreation area for ladies and a separate area for men in the building's courtyard." In 1950 the building was leased to the Lebow Brothers Clothing Company, which manufactured high-end men's apparel including suits and coats, hundreds of which were still left in the factory when it closed in 1985. The closure was due to a variety of factors, including relaxed dress standards in the workplace, which led to an overall decline in men's clothing stores.

The factory building was redeveloped by Seawall Development Corporation as part of a $26.5 million project to repurpose the site for the Baltimore Design School. The groundbreaking for the school was slated to take place on May 7, 2013 and it opened for the 2013–2014 academic year.

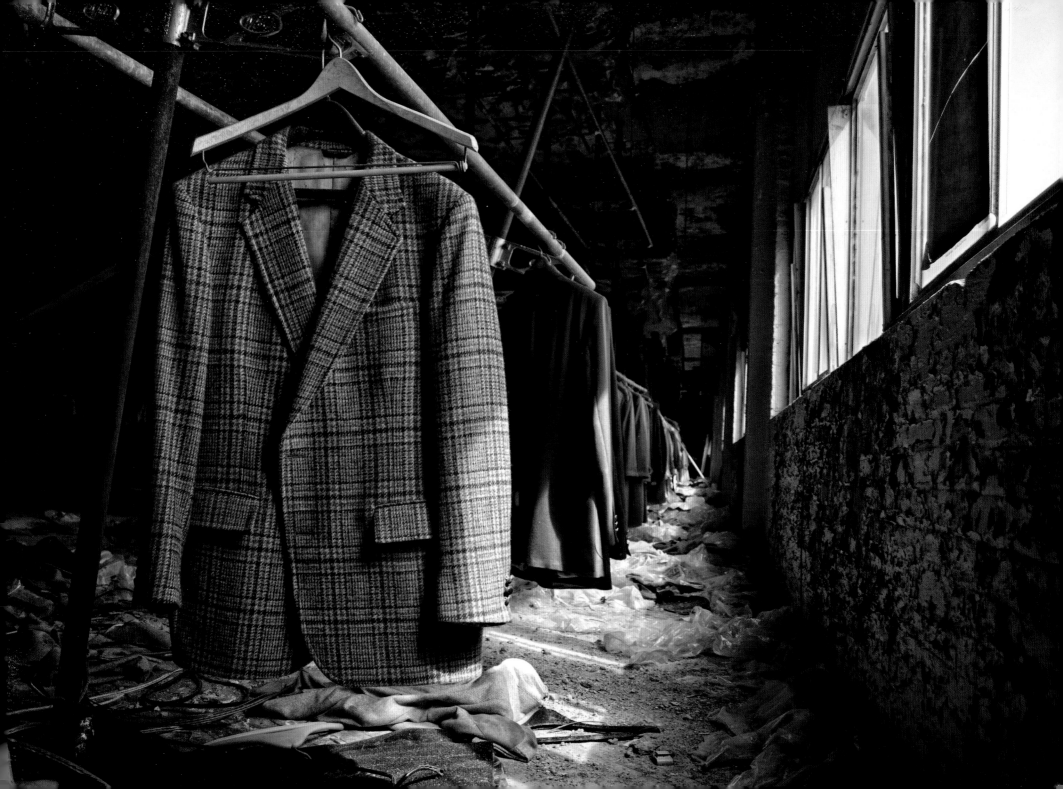

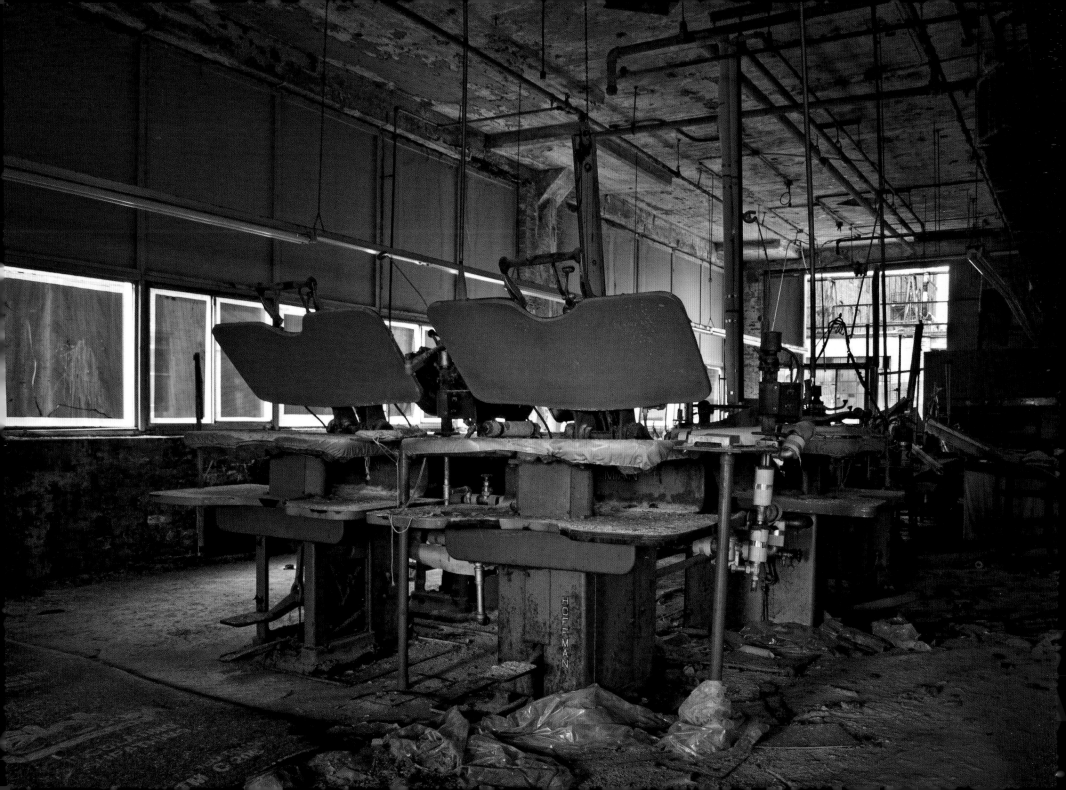

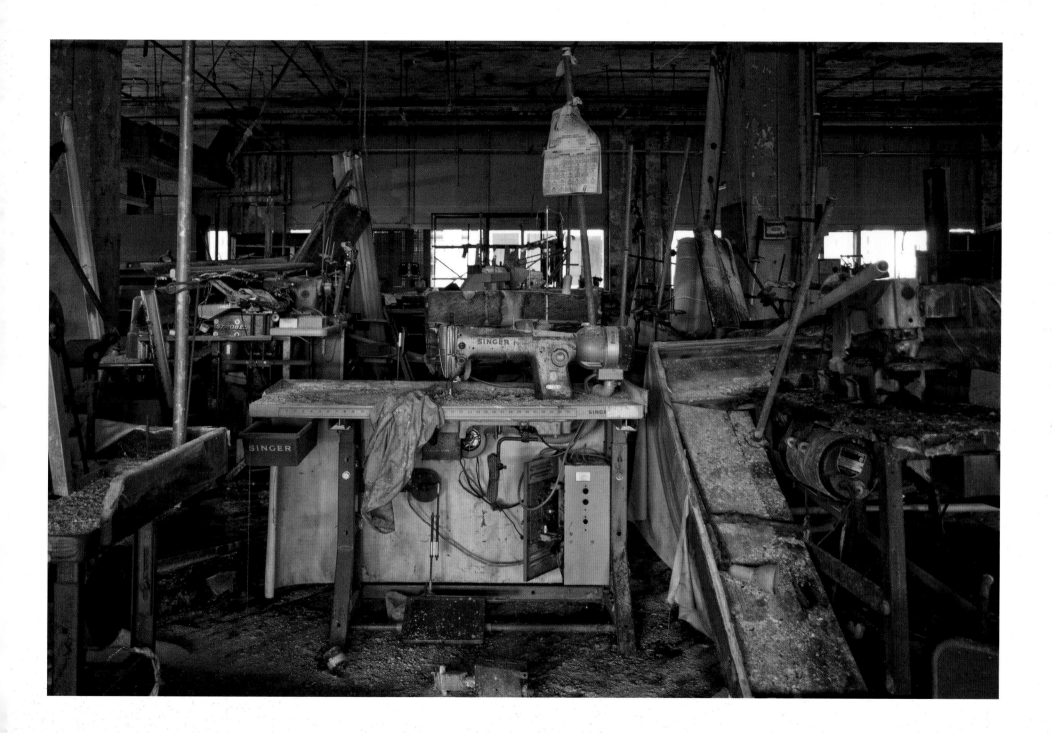

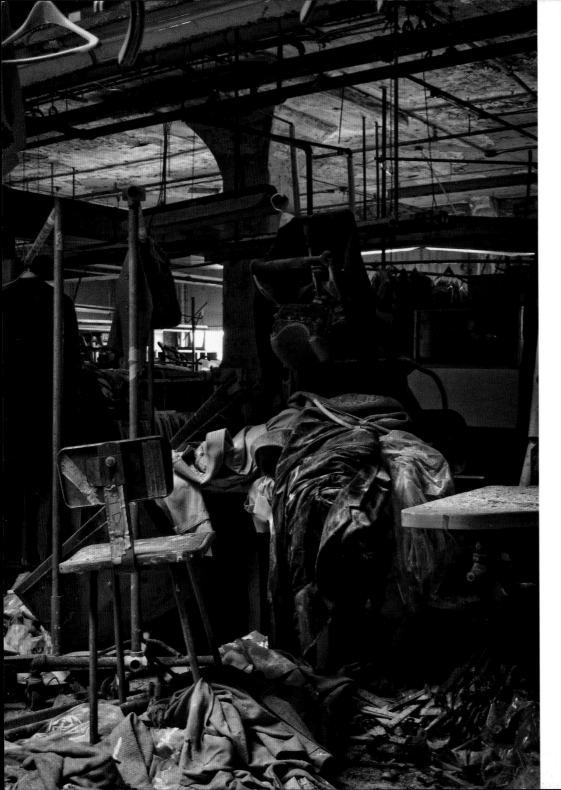

When I visited the factory in 2008, it was still full of hundreds upon hundreds of coats, many still in their plastic slip covers and in perfect condition. As we entered the main gate, a young man with soot on his face was leaving. He asked us what we were doing, and we replied, "What are YOU doing?" He looked sheepish for a second then replied, "Scrapping." Upon entering the factory I was struck by two things: the first was that any errant spark from cutting metal out would turn the place into a maze-like inferno. The second was that it would be infinitely easier to steal coats and sell them than it would be to cut out scrap.

The wastefulness of it is hard to convey in words or images. I thought of how many homeless people or impoverished families could have benefited from the coats. Often when companies go bankrupt all the assets are seized with hopes of selling them off to pay creditors, but sometimes rather than go to the effort to do so – particularly with smaller items that might not bring big returns – they are left to rot. Wading through an ocean of coats makes one very aware of how flawed this system can be, and what the practical cost is.

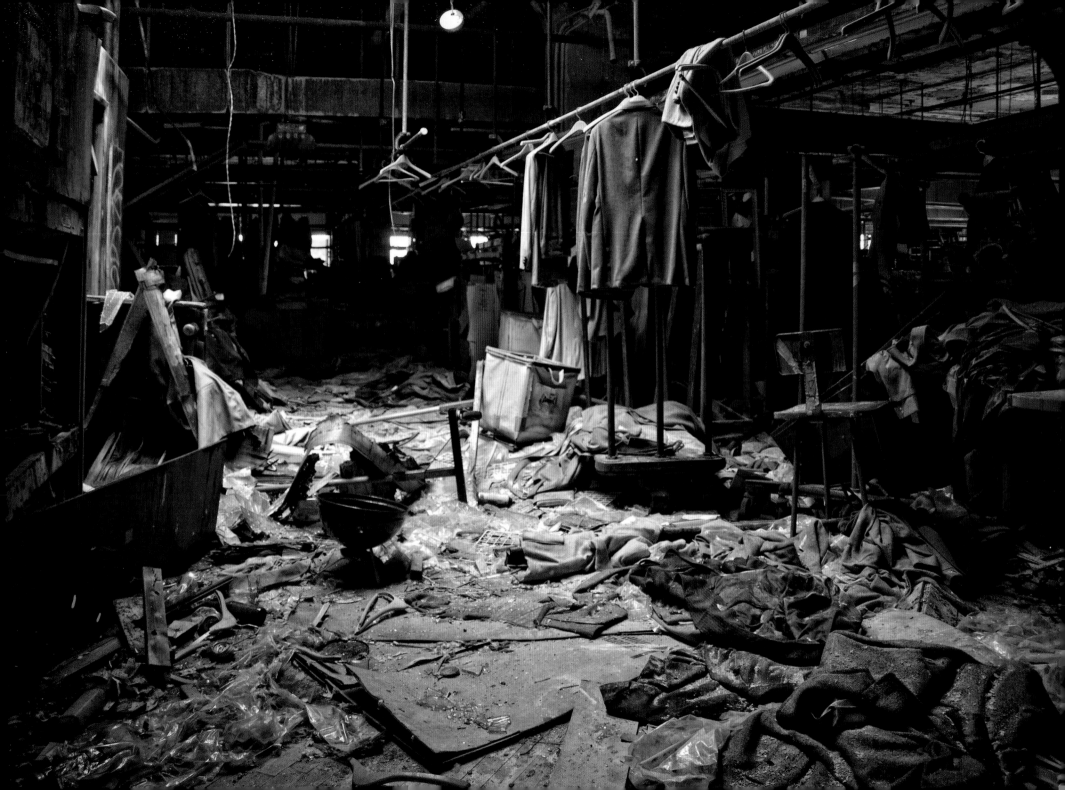

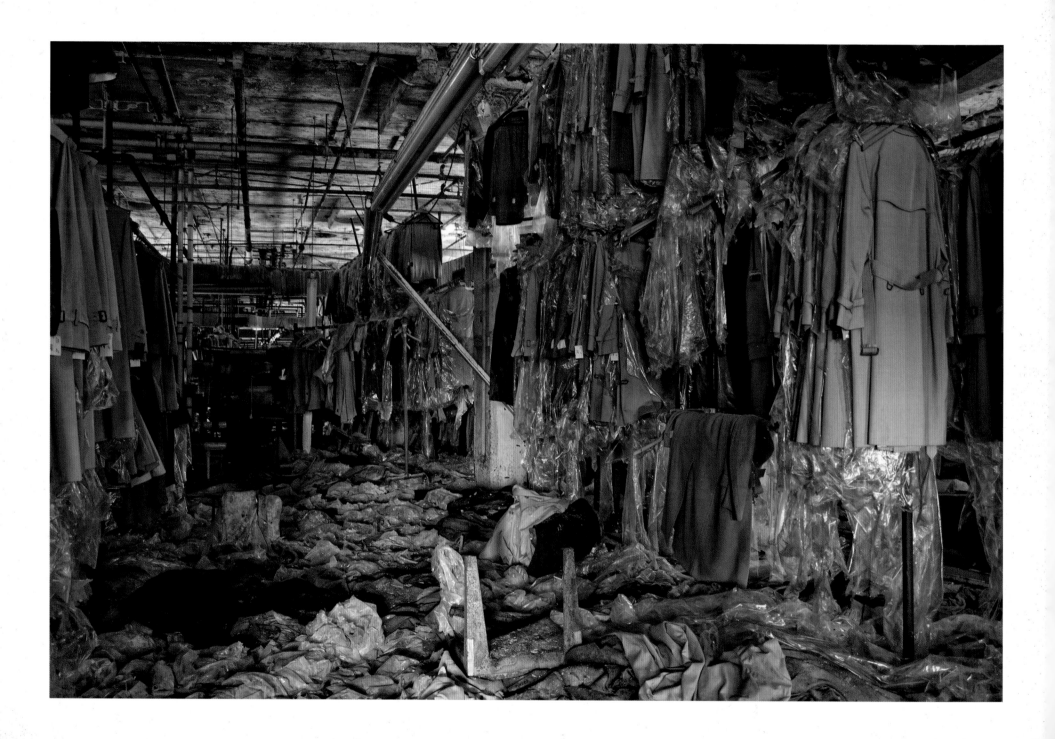

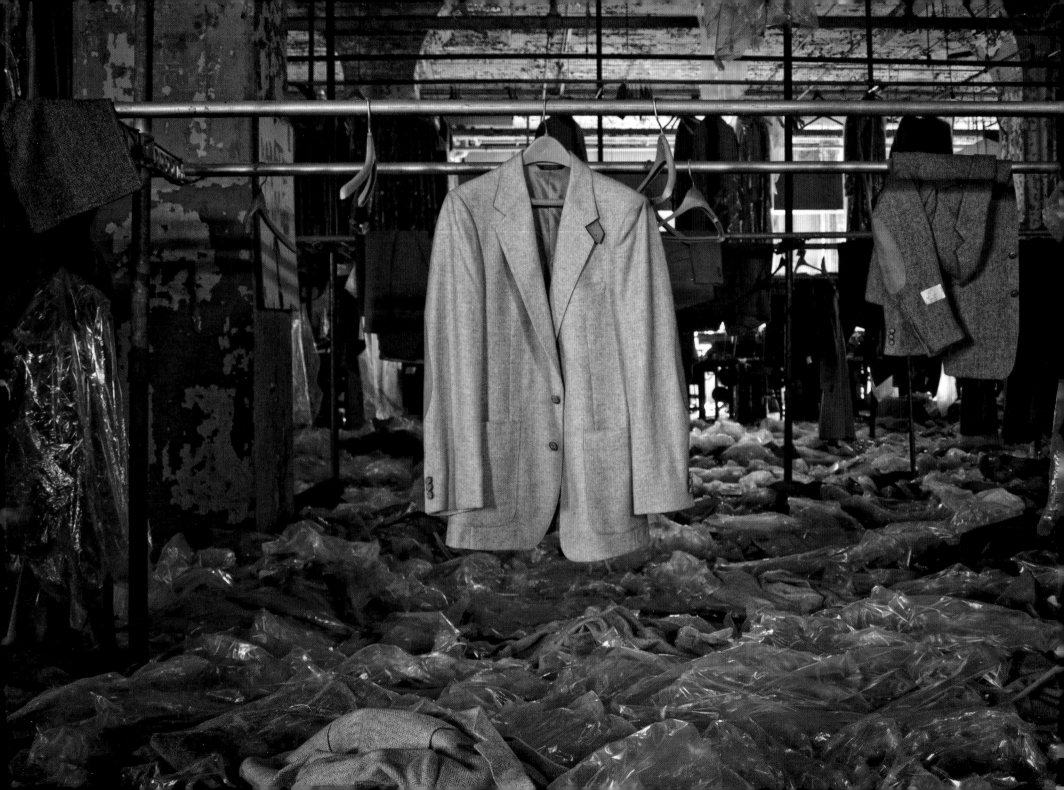

Old Essex Prison

The original Old Essex County Prison in Newark, NJ, was built in 1837 but closed in 1970 when a new jail was completed. As the oldest surviving government building in the county and one of architect John Haviland's finer works (he also designed Harrisburg State Hospital and Eastern State Penitentiary), the jail was added to the historic register in 1991 but by this point demolition by neglect had ruined much of its structure.

The prison was constructed for $30,000 when a fire destroyed the county courthouse. The design incorporated garden paths, a greenhouse, and courtyards for well-behaved inmates. Another feature of the grounds was the gallows in the yard used for hanging murderers. The original main building was a square, two-story structure with a cell block wing extending from it, but in 1890, 1895, 1904, and 1909 the prison was expanded. These expansions brought running water and toilets to the 300 cells now in the building.

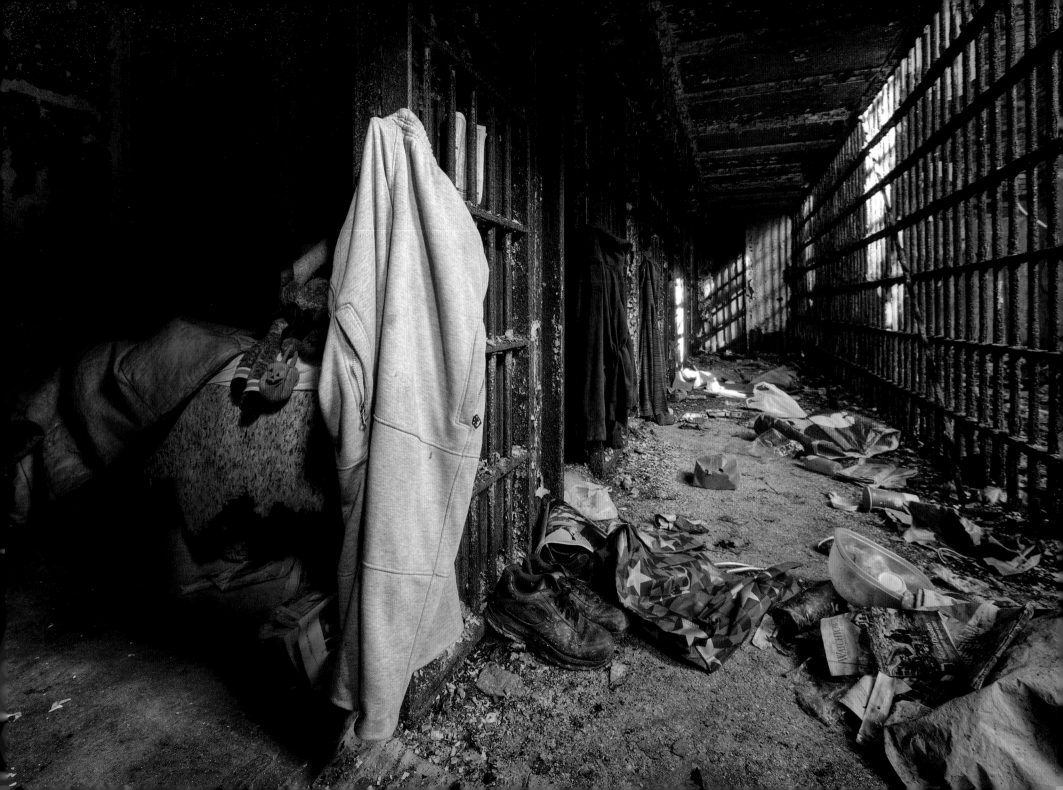

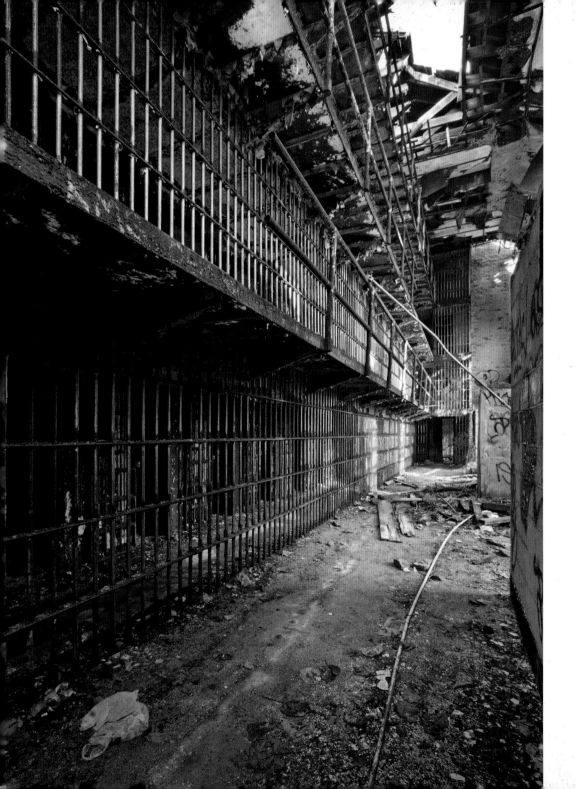

After the prison was closed in 1970, the Essex County Narcotics Bureau moved in and used the building until a bitter dispute about the bureau's location arose between the sheriff and the county executive. A judge ordered the evacuation of the building due to deteriorating structural conditions. During the move, hundreds of confidential documents were left behind from the DEA's (Drug Enforcement Administration) stay, including evidence, wiretapping transcripts, and case files. A *New York Times* article on the ensuing controversy reported that at one point the items left in the jail even included confiscated gambling machines, although no trace of them can be found today and several attempts have been made by law enforcement officials to reclaim and destroy the records. Shortly after its closure, scenes for Spike Lee's film *Malcolm X* were filmed there.

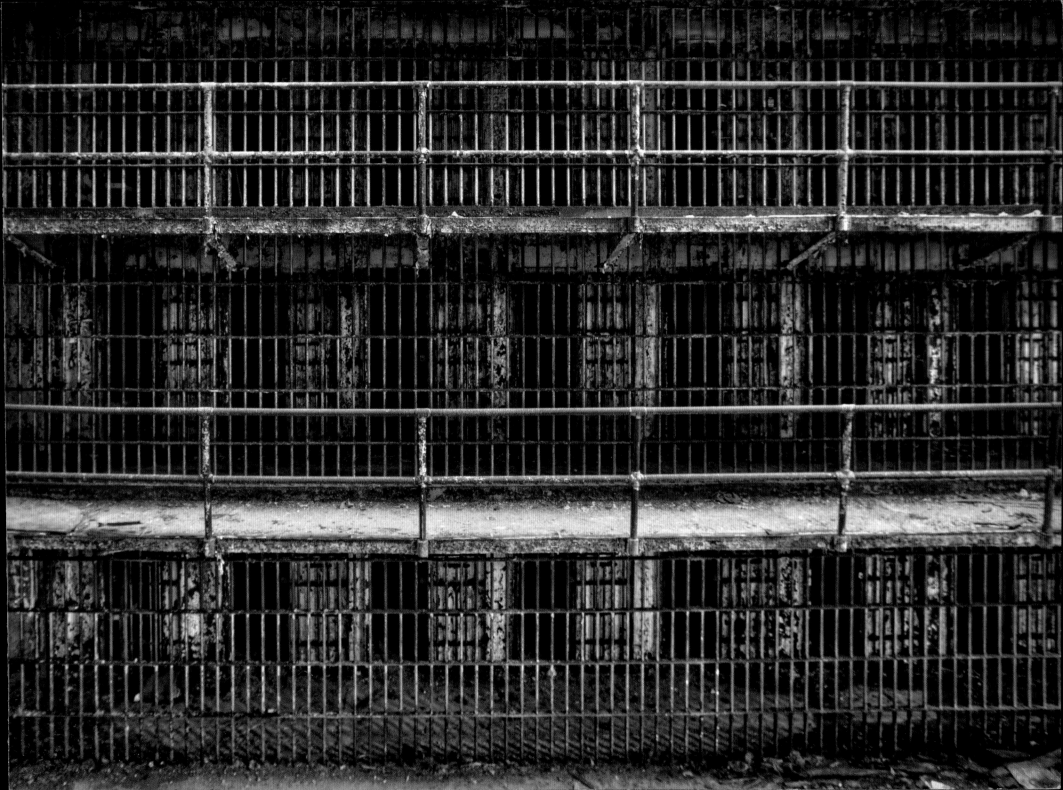

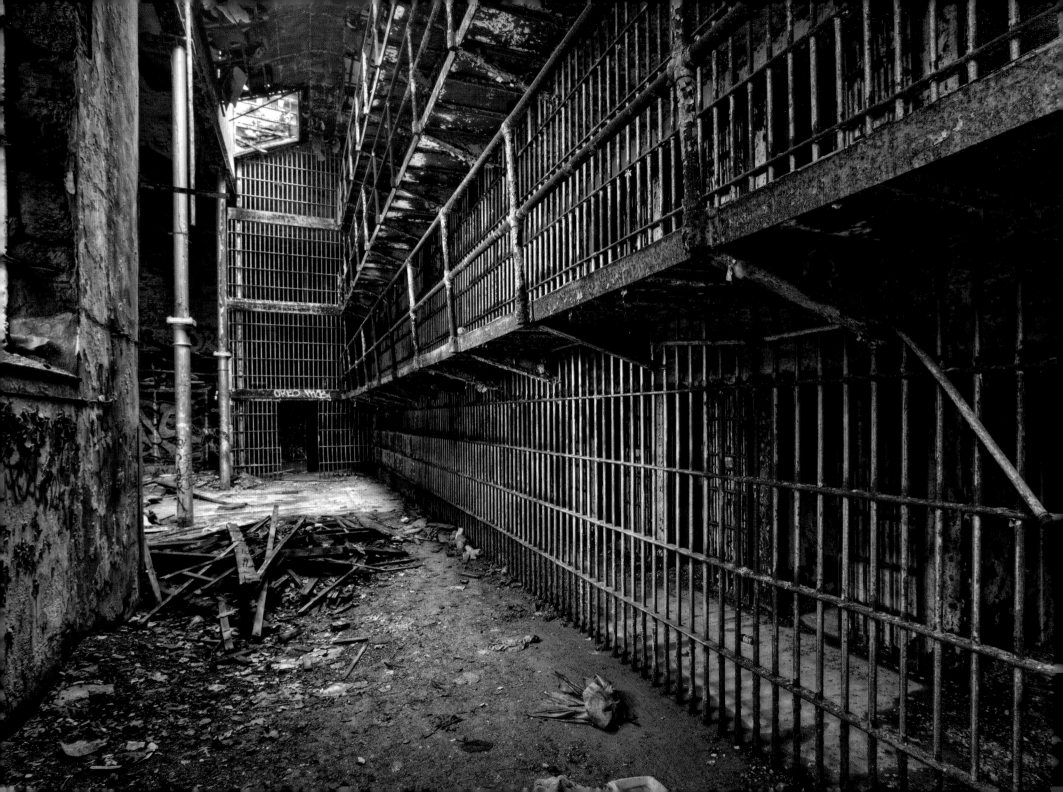

In a somewhat sardonic twist, after it was abandoned the Essex County Prison became a haven for homeless drug addicts, many of whom currently still live in the filthy cells. Garbage and drug paraphernalia litter the cell blocks, and at least two corpses of overdosed drug users have been recovered. Massive floor collapses, caved-in skylights and ceilings, and three-story window frames that have fallen onto the cell blocks are evidence that, despite the sturdy architecture, the building is in dire shape. A fire in 2001 also contributed to the ruinous state of the site. While plans to demolish the prison to build a 50-acre science and technology park were vetoed in 2010 because of the prison's historic status, no real effort is being made to protect the building from the elements, looters, vandals, people illegally dumping trash, or any of the other ravages that are clearly taking such a severe toll on it. There has been some talk of gutting the interior and turning it into a small power-generating station, but currently the Old Essex County Prison continues its decay unabated, populated by heroin and crack addicts sleeping in the rusty cells.

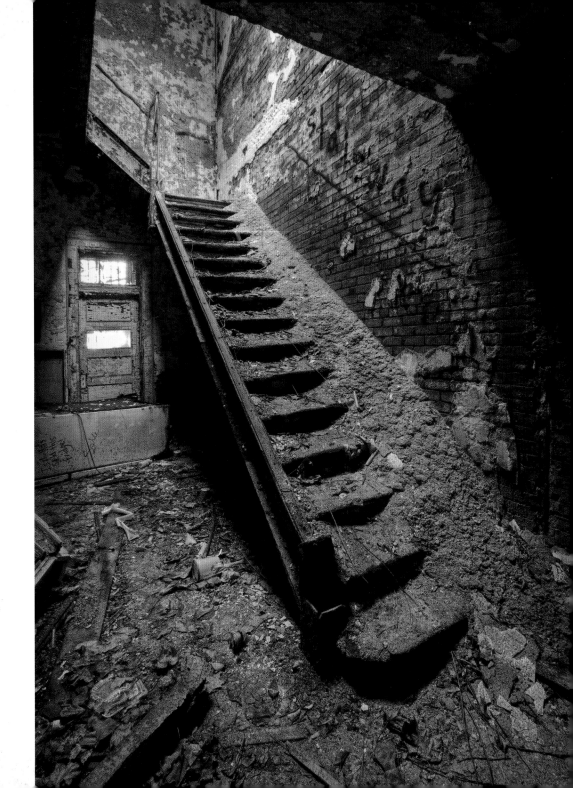

Kohl's Motorcycle Sales & Service

Originally founded in 1969 by motocycle dealer and enthusiast Walter A. Kohl, Kohl's Motorcycle Sales & Service would buy bikes from other dealers who went out of business or take trade-ins. Motorcycles were relatively cheap and for a time the business flourished, to such an extent that in the 1970s Kohl purchased this 1850s stone building to warehouse them. In the late 1990s Kohl sold the business and the new owner became ensnared in a tax battle with the city over the building. The property was in poor repair and they were asking for much more money than the business generated, so he stopped paying and the building was seized and condemned. After suing the city for ownership of the contents, the new owner gained access to the building in October of 2010, selling a tiny percentage of the bikes but scrapping the rest.

On July 30, 2013 the building burned down under suspicious circumstances; three teenagers were witnessed running away as it caught fire. It was demolished shortly after.

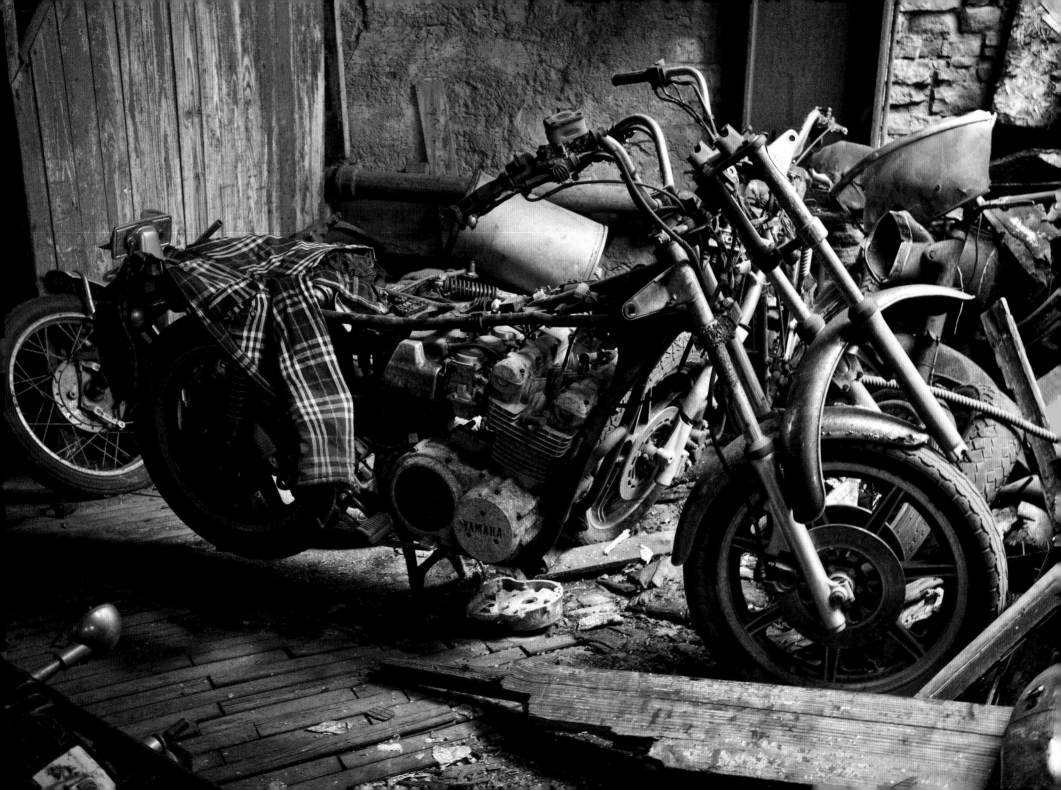

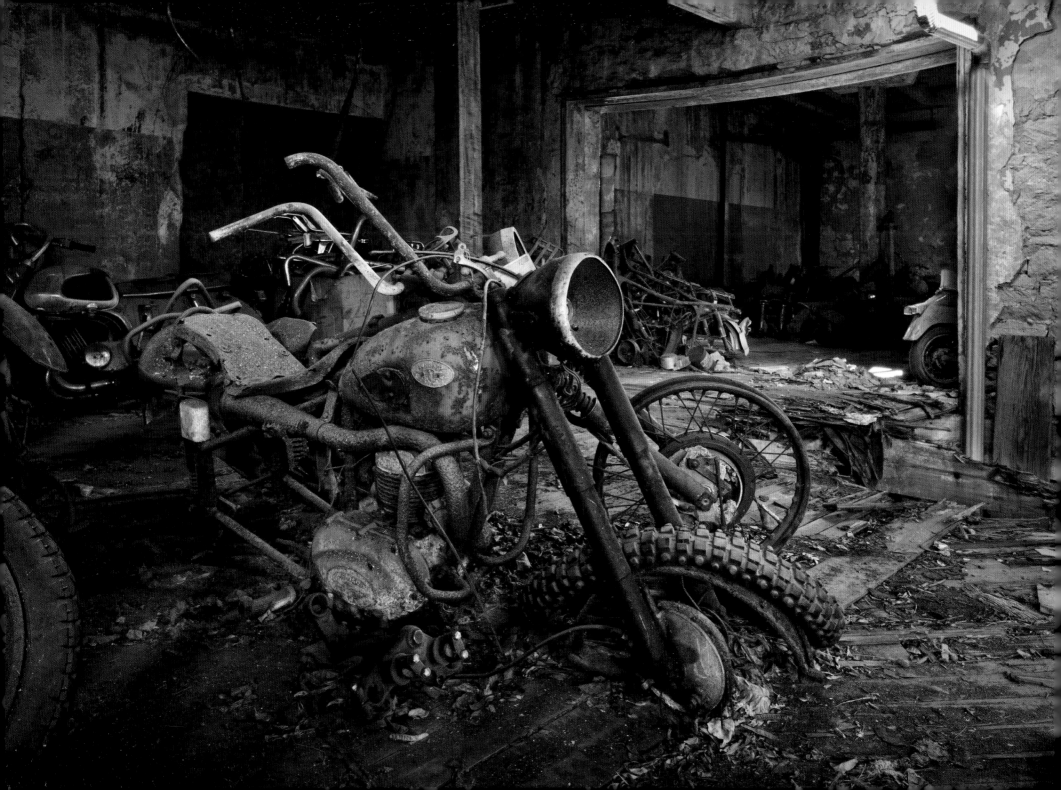

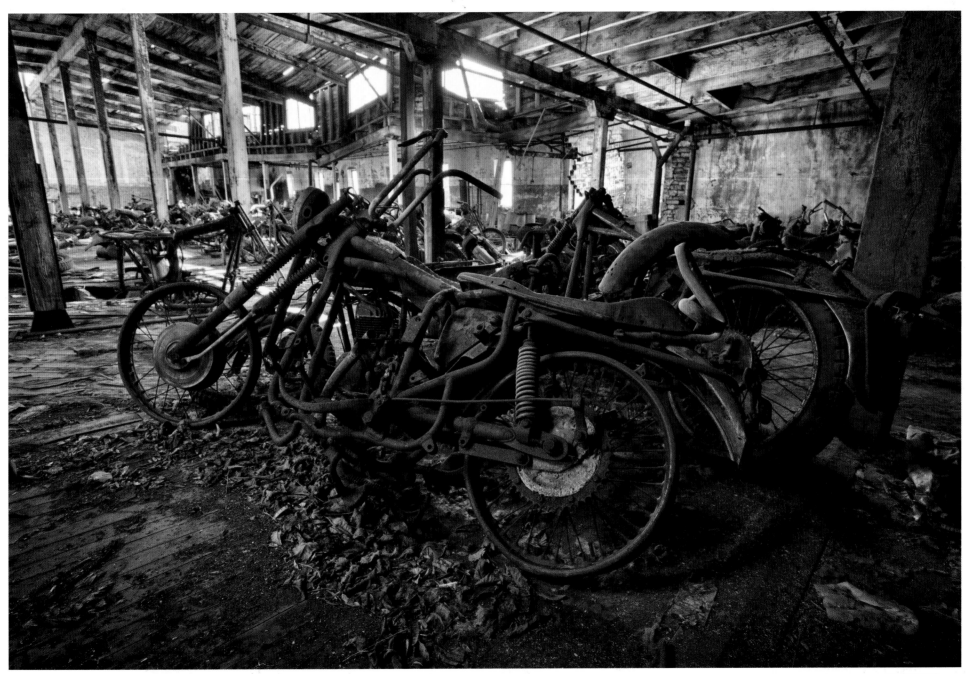

SPRINGDALE PUBLIC LIBRARY
405 S. Pleasant
Springdale, AR 72764

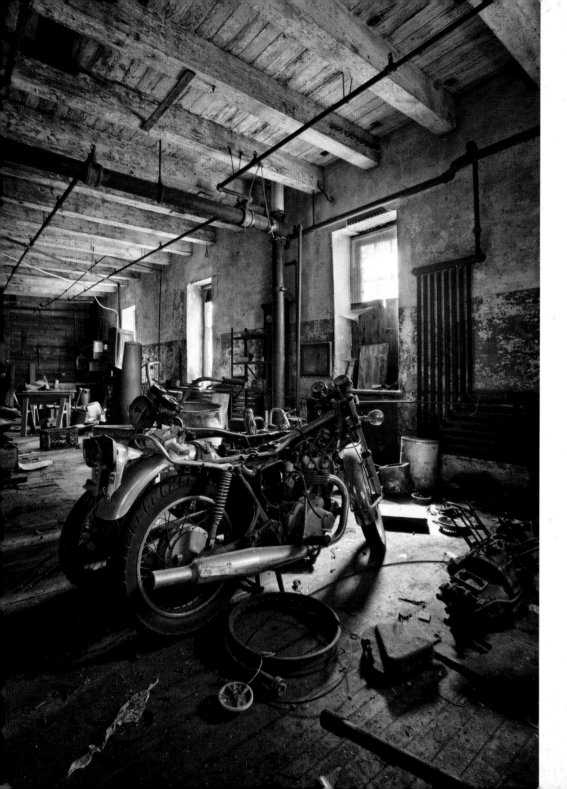

Kohl's Motorcycle Sales & Service was dangerously dilapidated when I photographed it in 2010. The roof had collapsed, the walls were caving in, and huge holes had rotted in the floors. Falling through two stories onto a pile of rusty bikes would have been bad enough, but the very real possibility that the motorcycles on the floor above might fall on top of me also made me uncomfortable. There is no way to measure exactly how much risk is too much or when you are pushing things too far until it is too late, but without the risk the record doesn't exist.

I've spoken with numerous motorcycle enthusiasts since and they are always heartbroken that these vintage, hard-to-find relics were left to rot and ultimately were scrapped. I know very little about motorcycles myself, but it is clear that the collection was a huge labor of love. All dreams have to end eventually, but it's still a shame to see something that mattered so much to someone and could have been enjoyed by so many others lost forever.

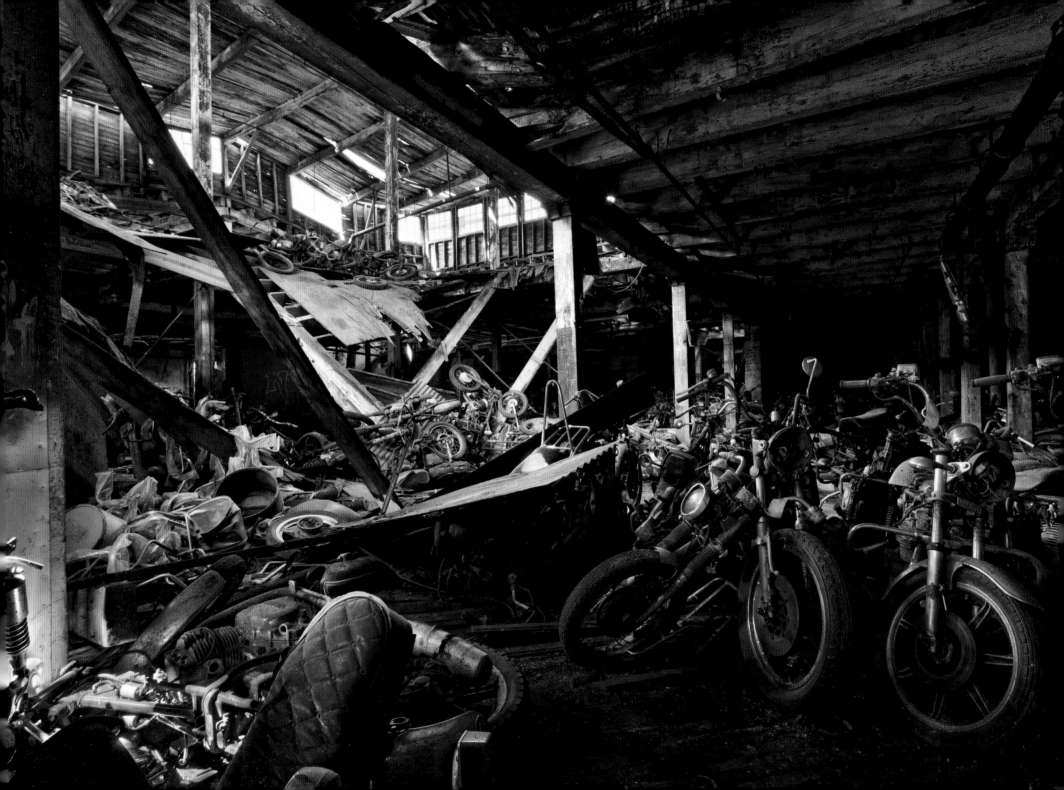

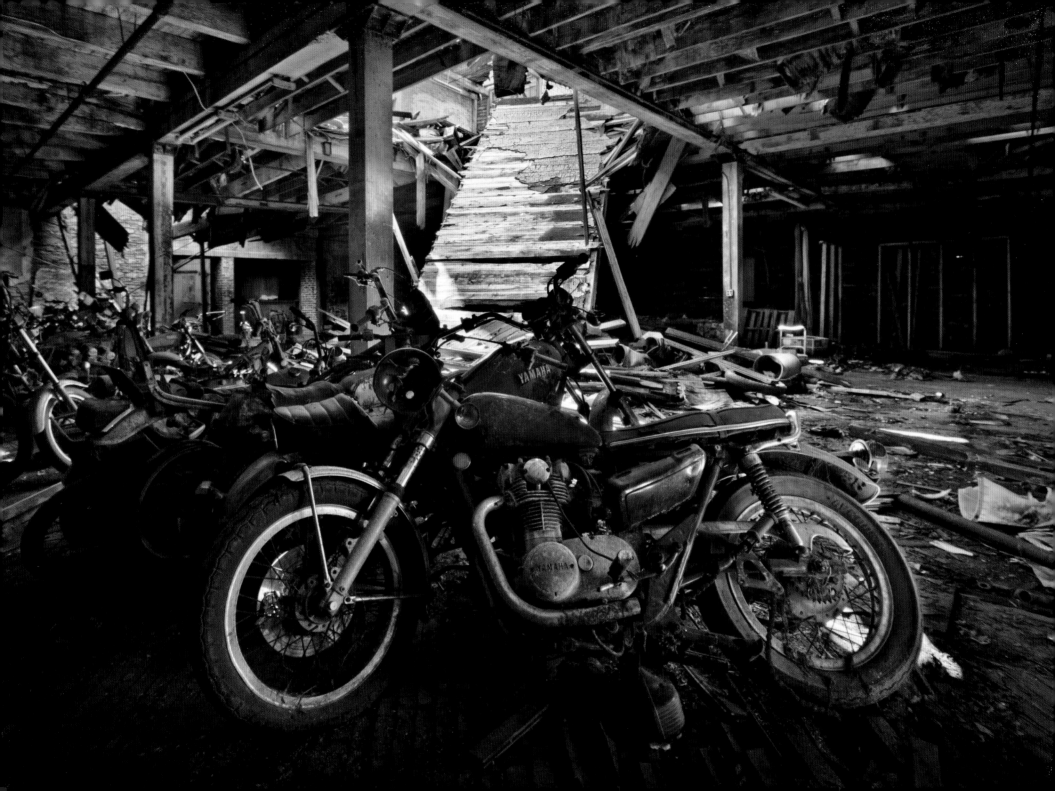

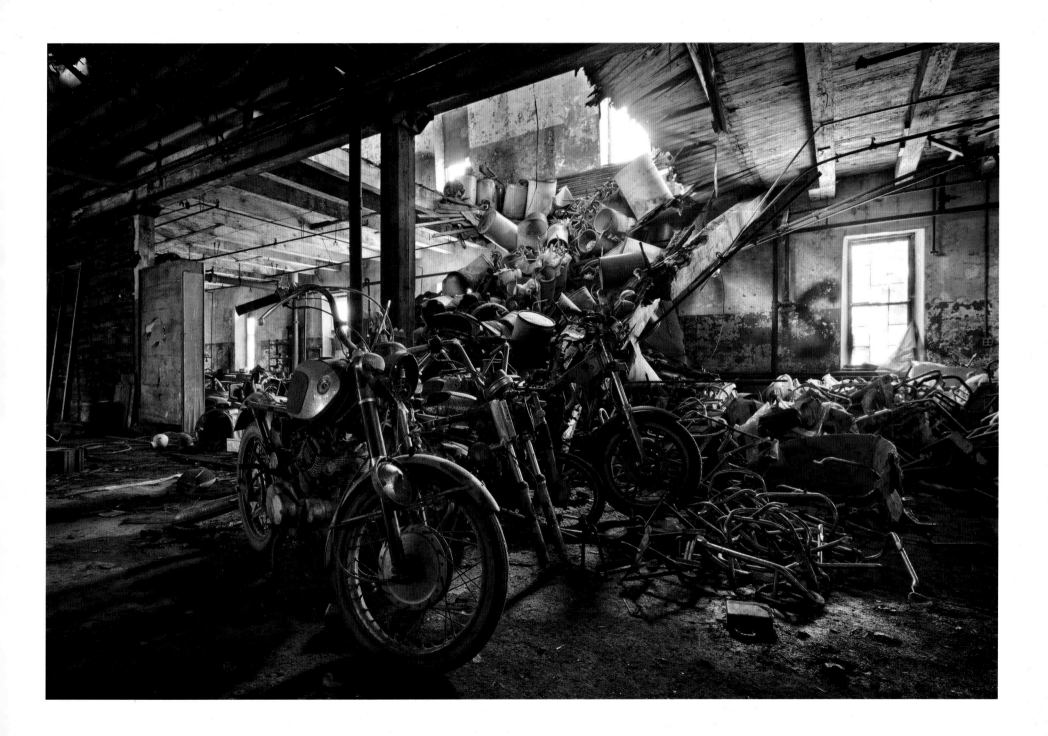

Bell Labs Holmdel Complex

The Bell Labs Holmdel Complex in Holmdel, New Jersey, was created as a new research and development facility for Bell Telephone when they decided to move operations out of Manhattan. Constructed between 1959 and 1962, it was the swan song of architect Eero Saarinen, who also designed the Gateway Arch in St Louis and the TWA Flight Center at John F. Kennedy International Center. Saarinen died a year before Holmdel was completed and six years before the six-story complex was named Laboratory of the Year by *R&D Magazine*. The outside curtain wall of mirrored glass that allowed in 25 percent of the sun's light while blocking 70 percent of its heat led to the Holmdel Complex being christened "The Biggest Mirror Ever" by *Architectural Forum*, and the complex was used in universities as an example of one of the crowning achievements of the modernist architectural style.

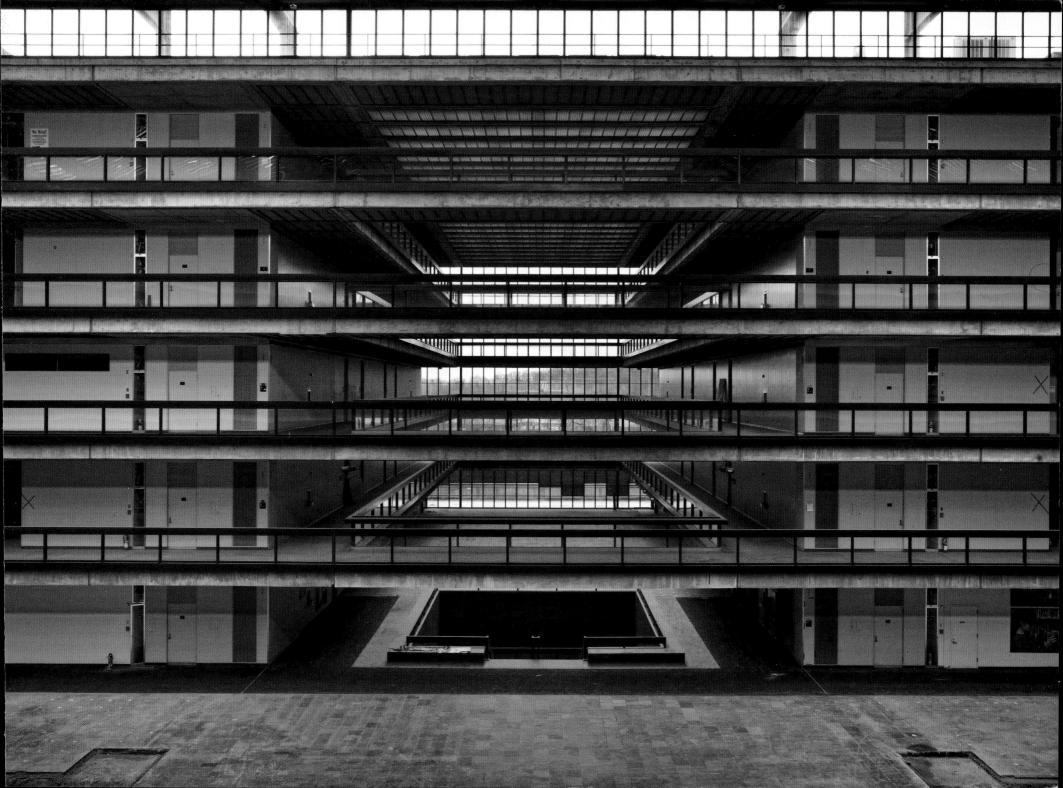

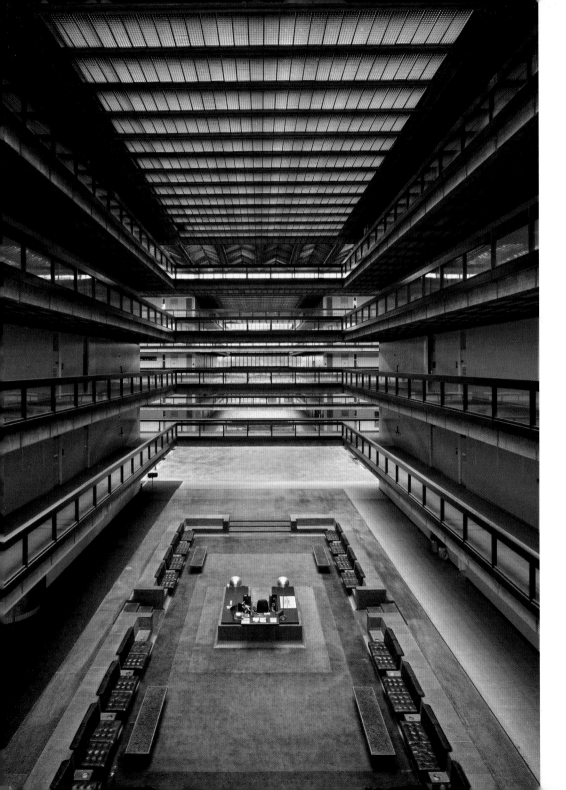

Once inside, a 70-foot-high cross-shaped atrium divides the site into four segments where over 5,600 researchers and engineers worked. One of these researchers, Steven Chu, went on to receive the 1997 Nobel Prize for his work at Holmdel using laser light to trap and cool atoms. Two others, Arno Penzias and Robert Wilson, received their Nobel Prizes for the Holmdel Horn Antenna, credited with proving the Big Bang theory, and Arthur Schawlow and Charles Townes invented the laser at Bell Labs in 1958. Other notable technological advances brought about in Bell Labs include cellular phones, microwaves, modems and the transistor as well as the development of satellite and fiber optic communications.

Two later additions to the facility would bring it to a total size of 2 million square feet. The parent company Bell Telephone subsequently became AT&T, then Lucent, and finally Alcatel-Lucent. Alcatel-Lucent planned to sell the 473-acre property in 2006 to a developer who intended to raze the campus and build an office park. Preferred Real Estate Investments (PREI) CEO Michael O'Neill remarked in a *New York Times* piece, "So many of these lavish old commercial buildings have a great history to them, and then one day their useful life is over."

The backlash from the scientific community was swift and passionate. Petitions were started, preservation groups were contacted, and the media response was highly critical. A year later the deal fell through. In 2013 Somerset Development Company bought the property for $27 million; their plan is to retain "as much as possible of the original design". According to Tom De Poto in *The Star-Ledger*, the building will house "a health and wellness center, skilled nursing facility and assisted living center, a hotel, restaurants and shopping, spa, office spaces and a 20,000-square-foot public library."

Architect Alexander Gorlin allowed me to photograph Bell Labs shortly before the renovation began. Much of the interior had been stripped to the basic elements and the plants in the atrium were gone, but the architecture was still mesmerizing. I had visited the building when it was open many years ago but it was unfamiliar to me now. Many of the rooms were entirely anonymous after everything in them had been removed. Gorlin's plans for the building look amazing, and it is a tremendous victory that the complex will be saved. The first tenants are scheduled to occupy the building in late 2014, and I am excited at the prospect of visiting it when it is reopened.

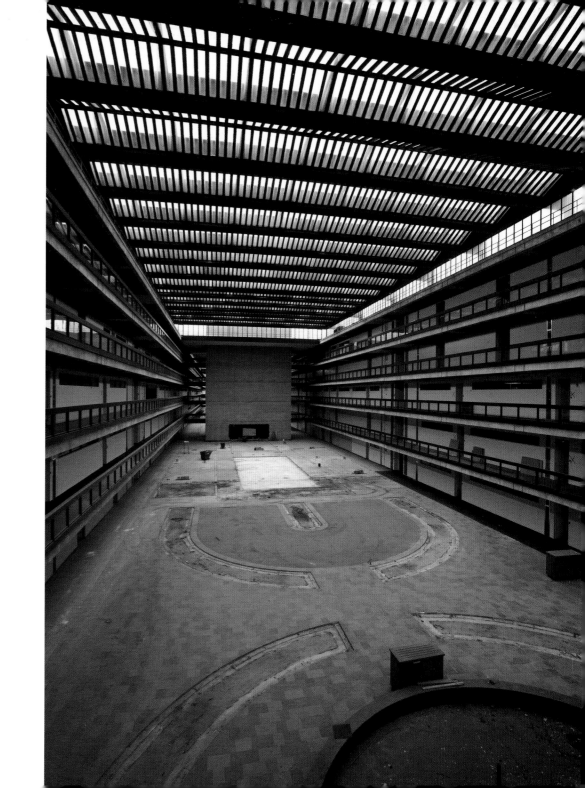

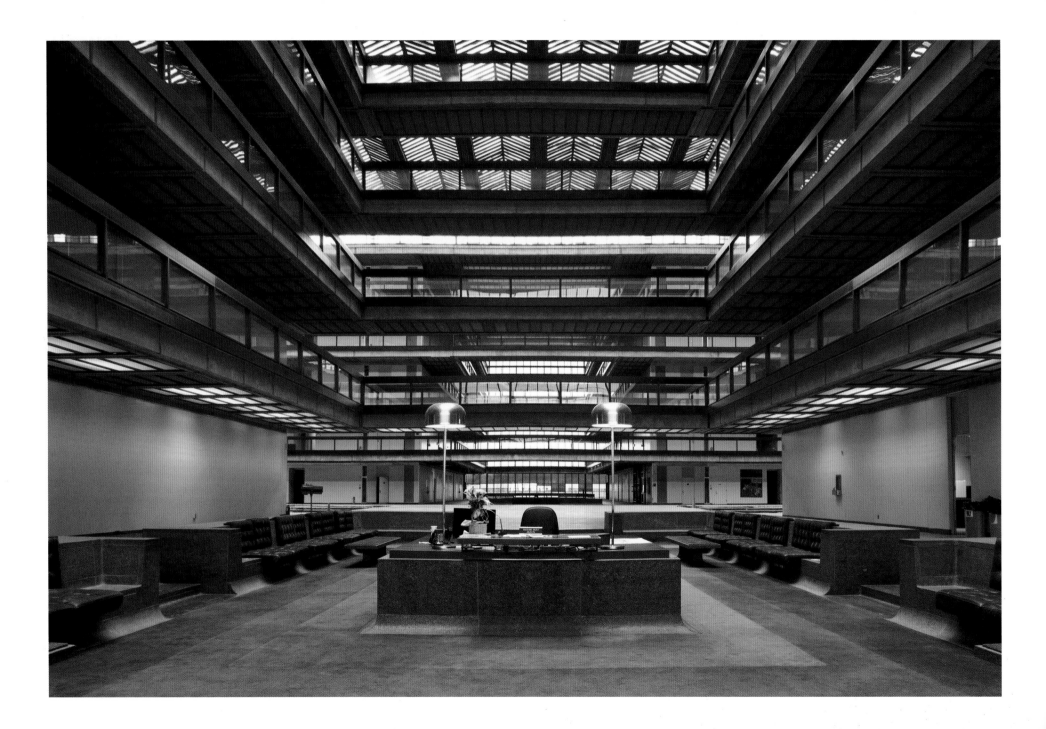

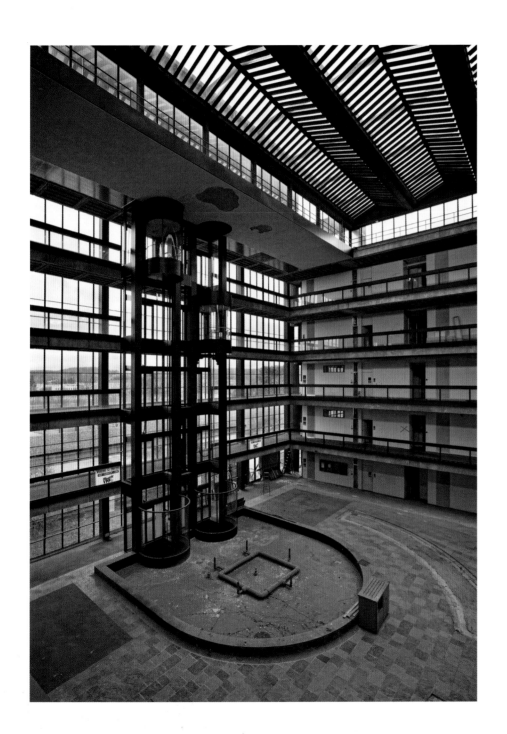

Carrie Furnaces

For quite some time, the Carrie Furnaces in Rankin, Pennsylvania, were open to anyone intrepid enough to hike there. After you had made your way through an overgrown employee parking lot, down an embankment and back up onto an elevated railroad track, the furnaces loomed up above you in the distance like a steampunk mirage. As you neared them, the enormity of their scale seemed impossible; the empty field around them both exaggerated their size and isolated them, as though they were an industrial island, perhaps an odd growth that sprouted from a bolt or gear someone had planted there a century ago.

Built in 1906, the furnaces themselves tower 140 feet above the grassy plains around them, with plants and trees of all kinds weaving their way in and out of the gigantic pipes and ladders like sinews. Several of the buildings still stand, their substantial size dwarfed by the furnaces. On the side facing the waterfront, a segment of the elevated railway remains, no longer connected to anything except a gargantuan gantry crane that has been rusted in place for decades. For all intents and purposes, it seems like the last vestiges of a civilization of giants. Rather than flaking frescoes or cracked religious reliefs adorning the walls, there are indecipherable graffiti tags from over the years. It is hard to imagine that such a place was ever inhabited, or that the furnaces once roared. The silence is nearly absolute, save for the rustle of the wind in the leaves or an occasional deer bounding through the grass.

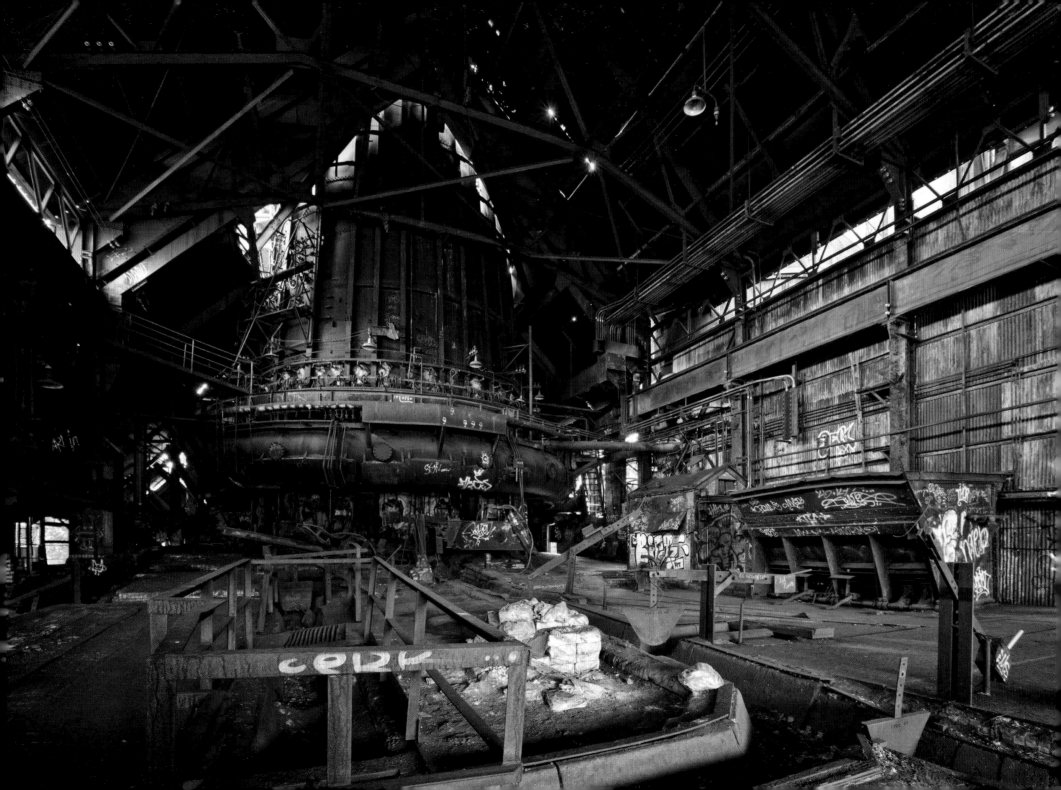

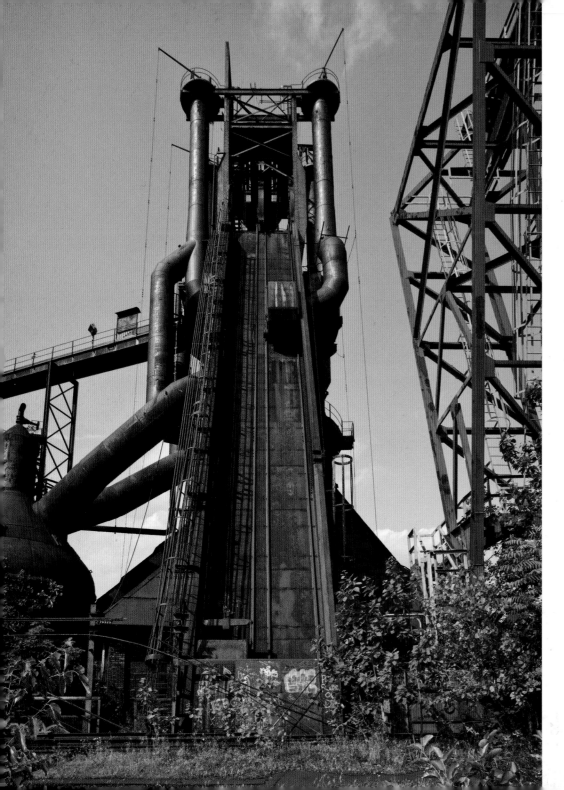

The Homestead Steel Works, once a significant component of Andrew Carnegie's Pittsburgh steel empire and one of the most important parts of the region's history, closed in 1986. Originally purchased by Carnegie in 1888, and integrated into the Carnegie Steel Company, the steel plant was the site of the 1892 Homestead Strike, one of America's bloodiest labor disputes.

While the majority of the complex was razed to make way for a waterfront shopping center that opened in 1999, the Carrie Furnaces on the other side of the river were left untouched, largely due to their inaccessibility. The Hot Metal Bridge, a truss bridge that carried crucibles of steel from the blast furnaces to the rolling mills on the opposite side of the Monongahela River, still stands and will be converted to a bicycle and pedestrian bridge.

The Carrie Furnaces were abandoned to the elements for years, and it seemed inevitable that they would also be torn down to make way for some form of new development. However, in 2005, the furnace property was sold to Allegheny County, and the next year, furnaces 6 and 7 were designated as a National Historic Landmark. Three years later, Rivers of Steel Corporation became caretakers of the property. Rivers of Steel began offering guided and unguided tours of the furnaces, and have been working on raising community support for their stabilization and renovation. This will "allow visitors to climb a series of walkways around these industrial giants and see at close hand the furnaces that set world records in the production of iron." Now fenced off and inaccessible to the curious wanderer (save through these limited tours), the Carrie Furnaces are becoming one of the hottest attractions in Western Pennsylvania.

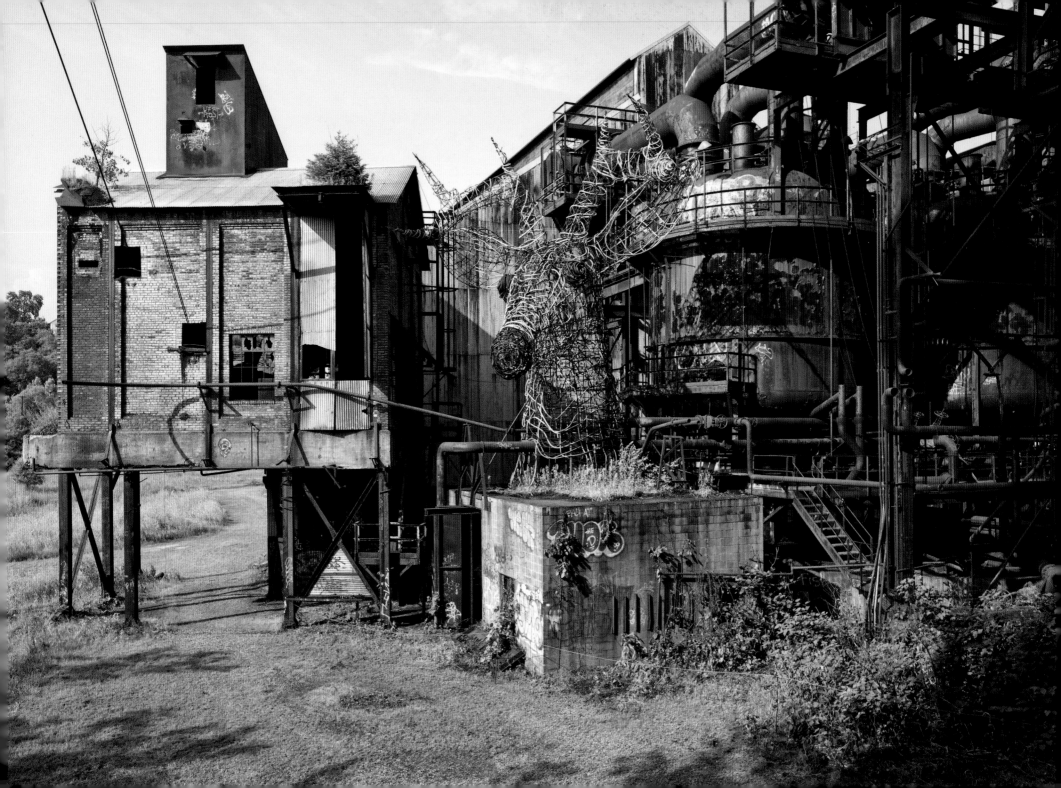

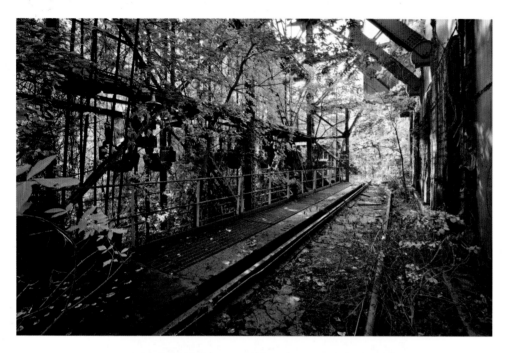

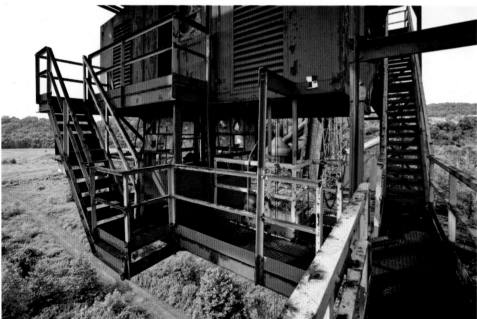

When I originally visited the furnaces in 2008, it was a hot October day, and I remember climbing to the top of the gantry crane and looking out across the bulk of the furnaces, with the car dumper and the ore yard seemingly a million miles beneath me.

It was as though the nightmarish sprawl of housing developments and shopping centers was gone, and I had found a little hidden pocket of magic that remained. The mysterious and inexplicable machinery before me was a part of something greater and more majestic than the normal dingy stretches of chain stores and big-box retailers. Even though I couldn't articulate what the furnaces' purpose was now, I desperately wanted them to survive so that the trembling awe I felt when I looked out at them wouldn't be erased.

The age of American industrial behemoths is nearly passed, for better or for worse, and many of the staggeringly large facilities we used to produce glass, bricks, coal, steel, and the myriad of other resources, which literally built our country, have been bulldozed. What remains in their stead are all too frequently petty franchises which erase the identity of a region in favor of anonymity, where every town is a rough copy of the next.

We *need* places like the Carrie Furnaces, not just to remind us of who we were, but also of who we are and could be. I have visited hundreds of abandoned sites across the country and have documented as many as possible—but the opportunity to experience a place like this firsthand is exceptional because, all too often, sites are simply torn down, with little or no attempt made to preserve the heritage that is lost with them. The Rivers of Steel Corporation's effort to give the furnaces back to the public and educate visitors about their history is both laudable and rare. It is my hope that their example will be duplicated for similar sites in future.

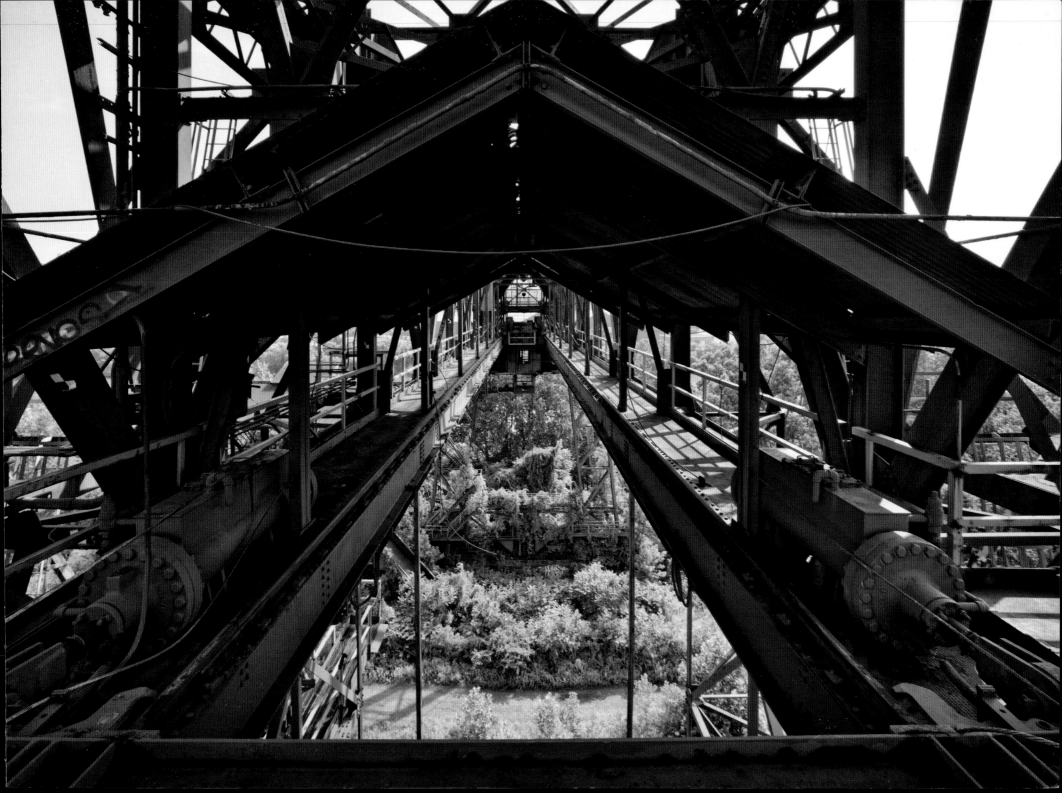

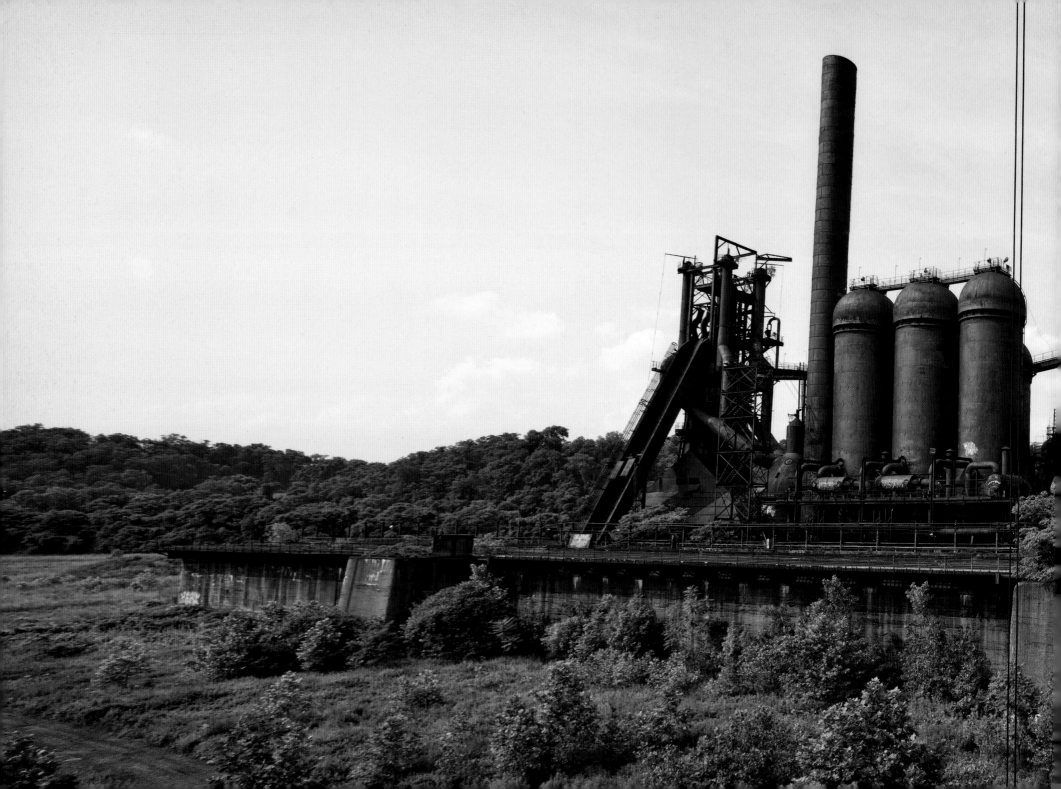

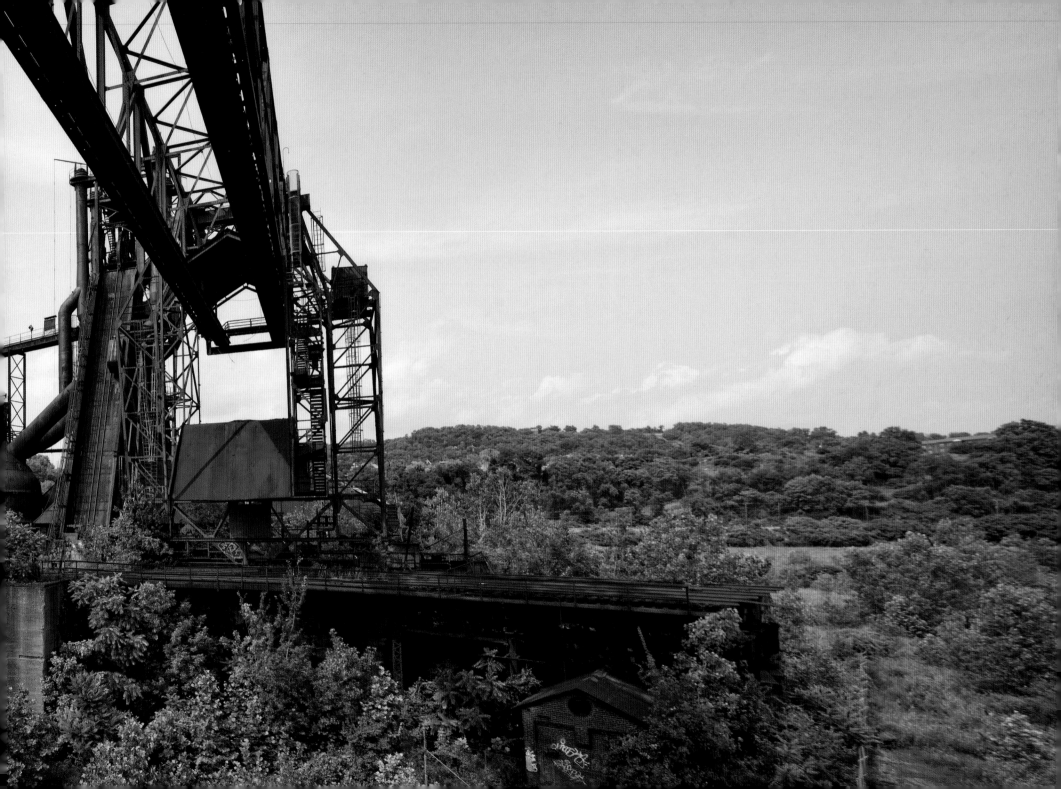

The Church of the Transfiguration

Originally a humble wooden chapel built on a parcel of farmland in 1905, the Church of the Transfiguration's parish flourished to such a degree that a new building was needed. The lower church was built for the parishioners in 1925 and the upper church was finished in 1928. Capable of seating over 2,500 people, it was one of the biggest and most magnificent churches in Philadelphia. But by the 1970s the neighborhood demographics had changed and it was closed in 2000, consolidated into another less impressive church a few blocks away.

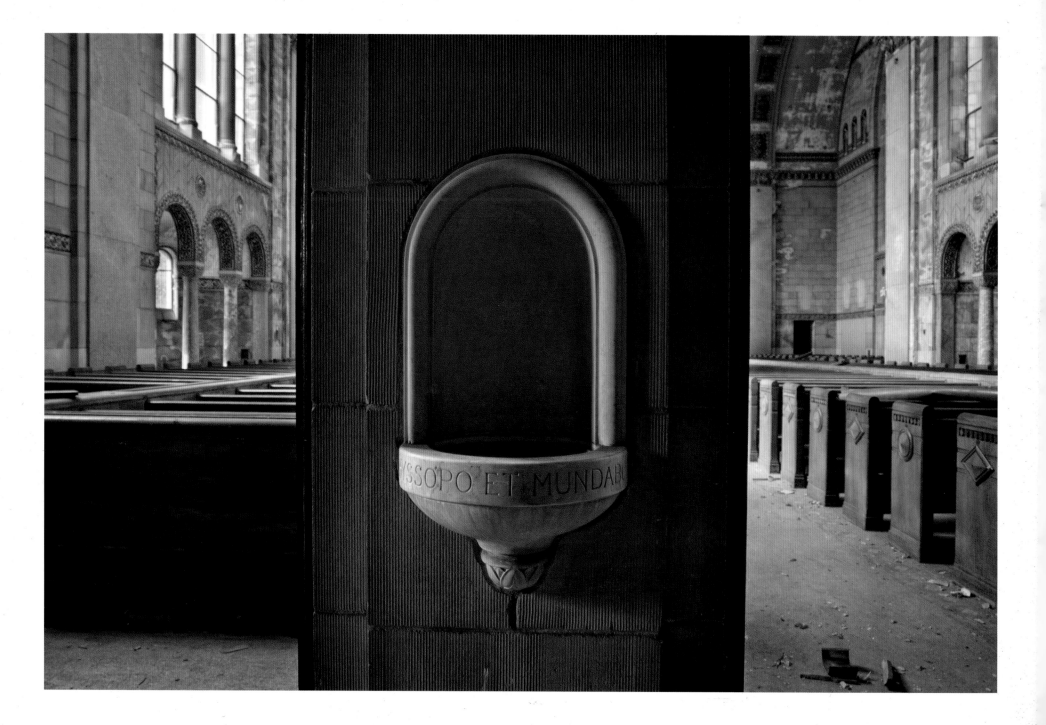

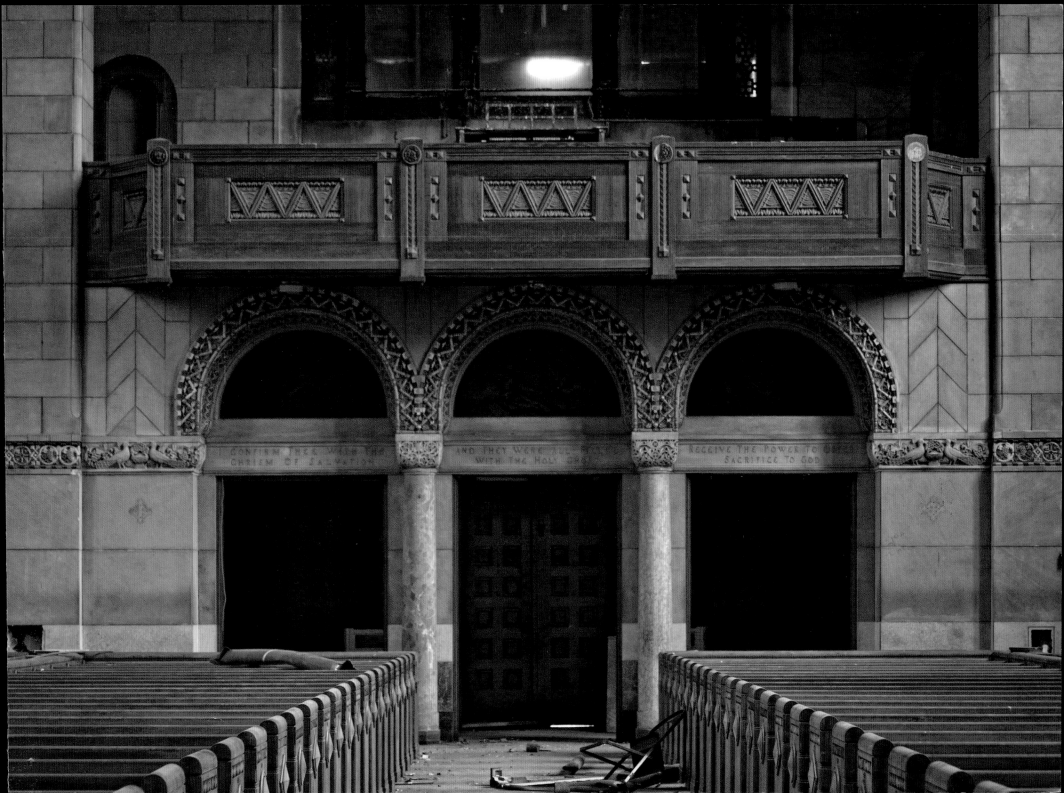

After being closed, Transfiguration was purchased by conman Raffaello Follieri, who was supposedly going to use inside connections to buy churches from the Vatican for low prices and rehabilitate them into community centers. Instead, he used investors' money to live a lavish lifestyle with his girlfriend at the time, actress Anne Hathaway. He had no inside connections and lost bids on all other churches he tried to buy, save for three. Transfiguration was one of them, and sat abandoned for roughly a decade. When it was resold in 2009 after Follieri's imprisonment, the buyers (the Boys' Latin of Philadelphia Charter School) only wanted the school and very quickly demolished the church and rectory before any opposition could be mounted from the community. For swindling investors out of millions of dollars and being convicted on fourteen counts of fraud and money laundering, Follieri spent four years in jail. The spot where Transfiguration once stood is currently an empty, trash-strewn lot and the majority of the building was dumped in a landfill.

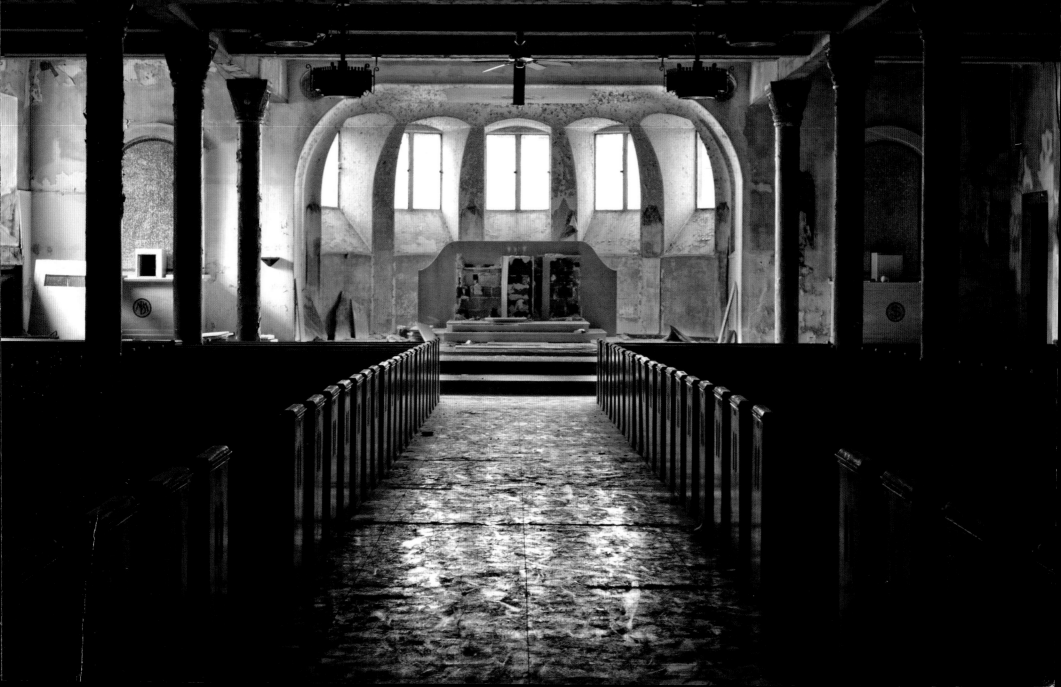

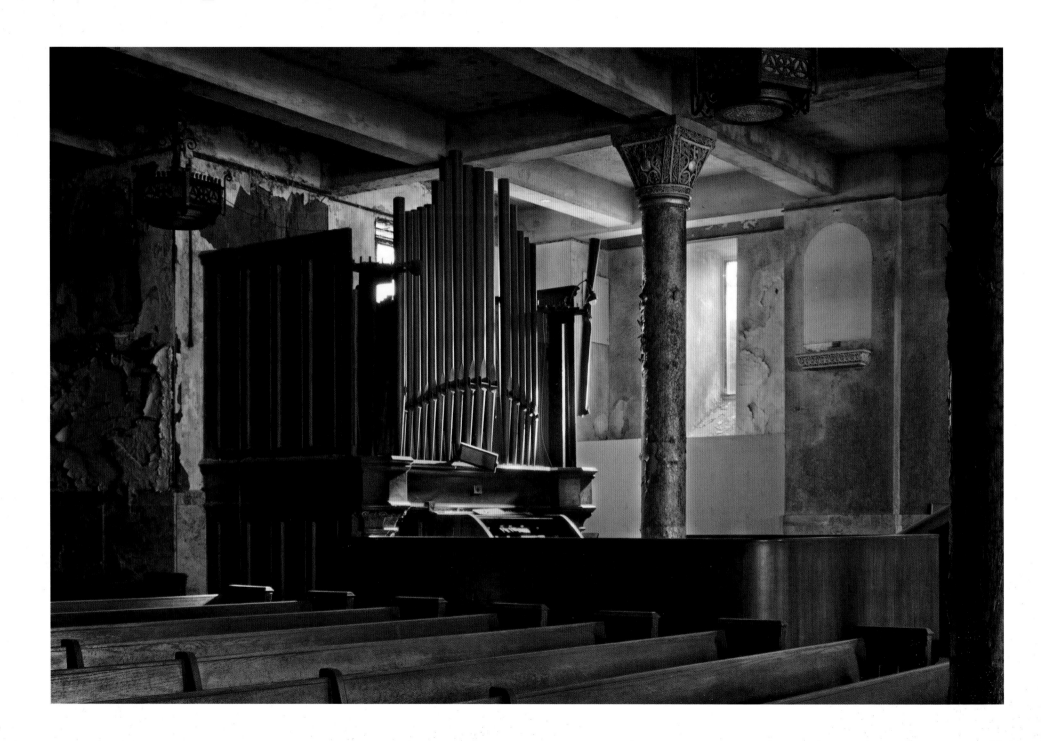

Even after all I've written about the Church of the Transfiguration, it's hard to articulate what it meant to me. There are some places I photograph that I am indifferent to, others that I like for various reasons – but Transfiguration was one that I genuinely loved. Of all the places I have photographed, this is the one about which I've received the most correspondence. Alice E. Mozer Farnsworth wrote to me, "The services were always very emotional to me as well as the hymns that were sung either by the students or the choir. Just to be in the atmosphere to me seemed like Heaven. I feel blessed that I had the opportunity to experience this when I did and am very saddened that the Transfiguration Church was demolished. It seems like such a crime to destroy something that gave so much good and beauty to so many people. It certainly is one of my best God-given memories in my lifetime."

The reason is that Transfiguration wasn't just a building, it was a legacy. It's gone now but on the afternoon that I photographed it, it was radiant. I can't really explain it, but it touched me. Barely a month later the demolition process was underway, but on that day the church seemed to hold its secrets with pride. I believe whatever greater good that people came to worship there was still very much present. It was waiting for someone to look for it there, to be still and listen.

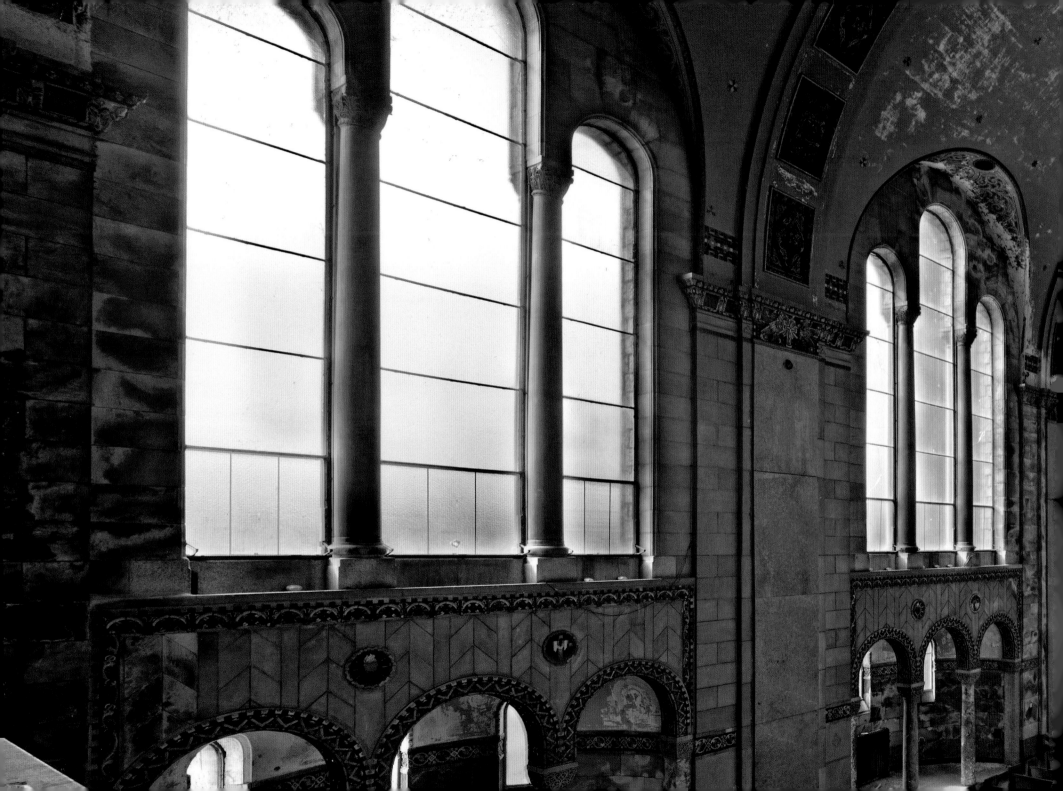

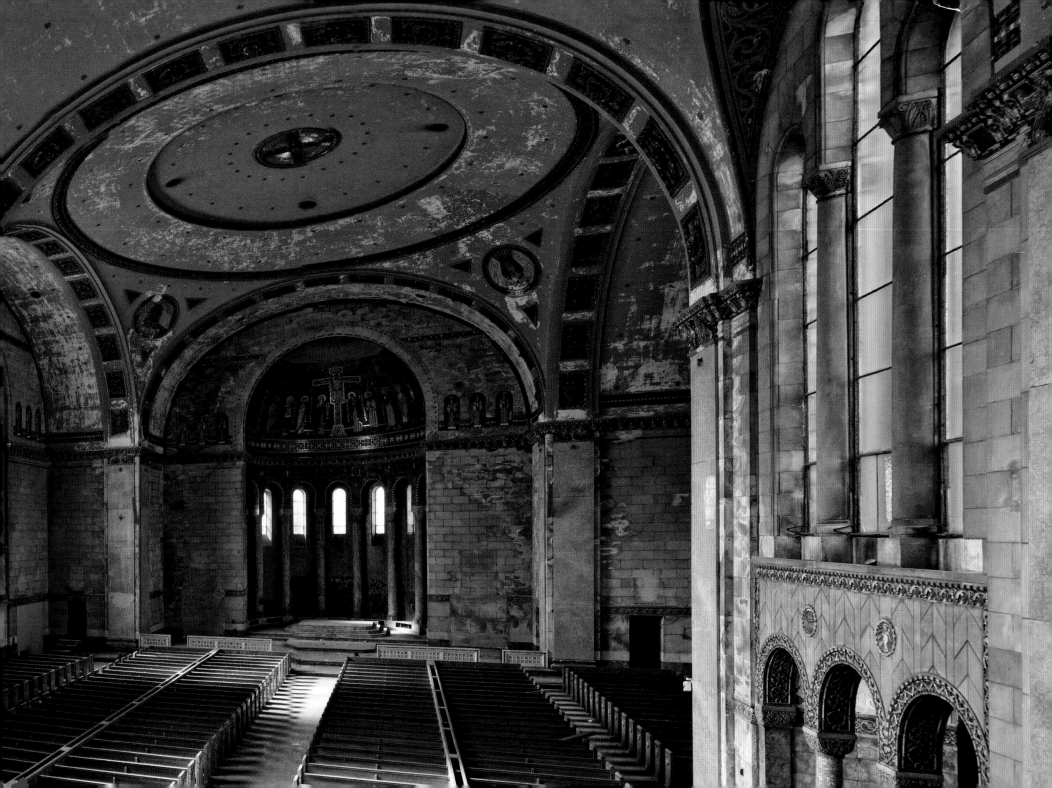

The Garman Opera House and Hotel Do De

The Garman Opera House and the Hotel Do De were adjoining properties in downtown Bellefonte, Pennsylvania. Several smaller businesses also occupied the space, including a restaurant called La Bella Trattoria, a bar, an inn, a hair salon, and several apartments.

The historic Hotel Do De, originally the Garman House, was built by a jeweler named Daniel Garman in 1861. It was rebuilt after a fire in 1887 and again after another fire in 1890, which is when the Opera House was added.

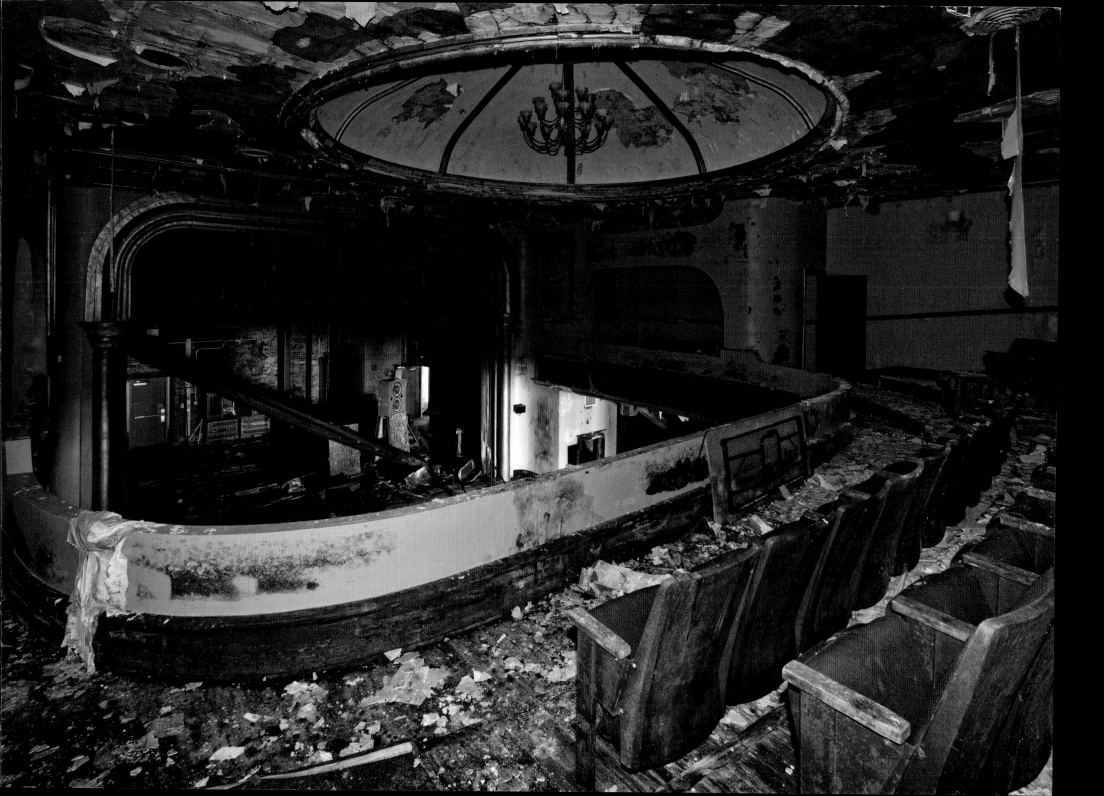

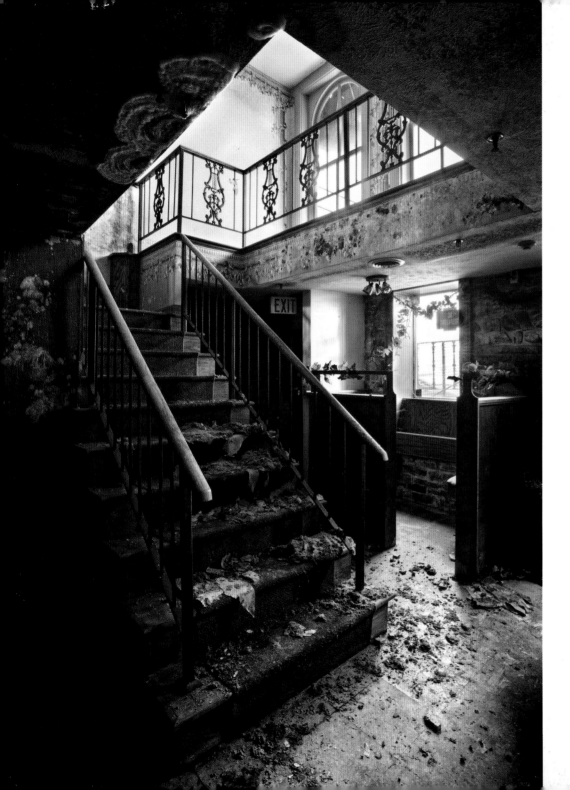

The Garman Opera House opened in 1890, with Daniel's son William Garman as manager. According to the Bellefonte Historical Association, it "was host to the likes of George Burns and Gracie Allen, Houdini, the Flora Dora Girls, and a myriad of Wild West and one-act shows" in addition to being the first place where the song "After the Ball is Over" was performed for the public. The theater had both electric and gas lighting and could seat 950 patrons. With the advent of cinema, the Opera House was also used as a single-screen theater showing silent films and talkies and was renamed the State Theater in 1931. The State Theater had a difficult time competing with multiplexes in the late 1950s and closed in 1961. For around thirty years, it was used as a warehouse for an area furniture business, but a series of local business owners rehabilitated it first as a theater for plays in the late 1990s, and then as a 400-seat movie theater in 2000. The La Bella Trattoria and a ten-room inn were added in 2005-2006, and there were plans to add an IMAX movie theater. Unfortunately, the Garman Opera House was unsustainable as a business and closed again in 2008.

The Hotel Do De remained open, as did the bar on the first floor. On September 9, 2012 a fire that was later ruled to be arson broke out, gutting the building and leaving eighteen families without a home or their possessions as it was too unstable for them to return to retrieve them. Luckily, nobody died in the fire. According to a local newspaper, neither the Garman Opera House nor the Hotel Do De had sprinklers.

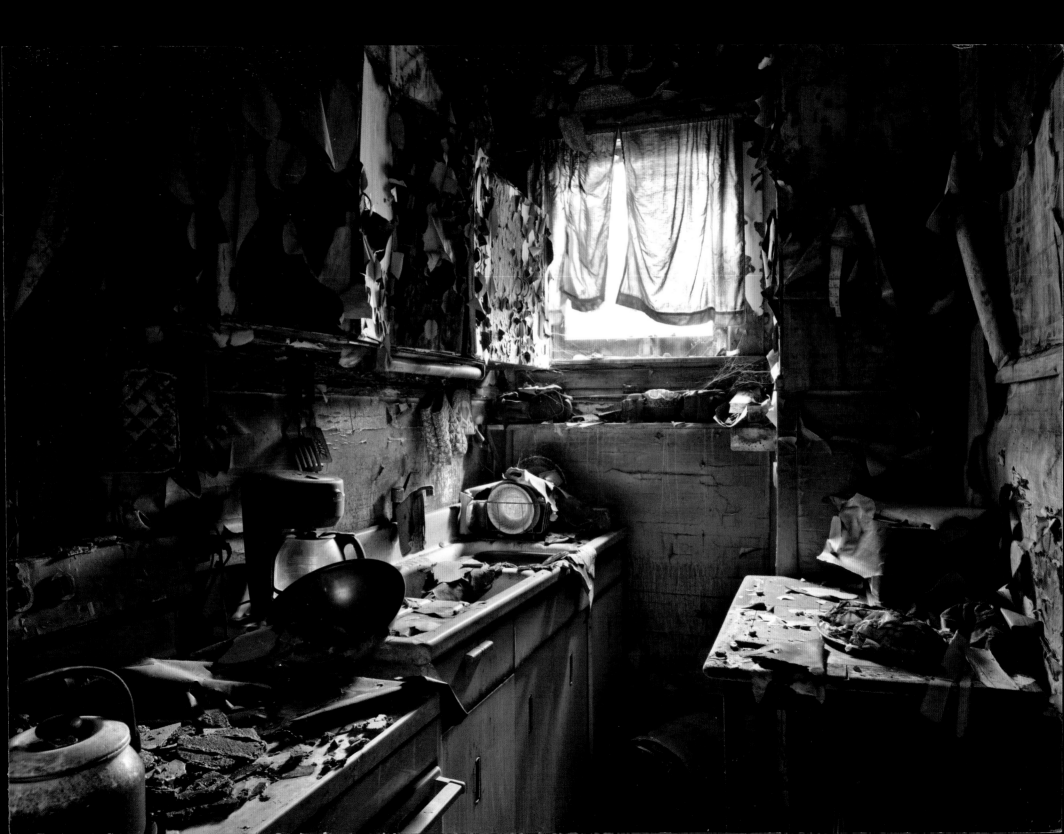

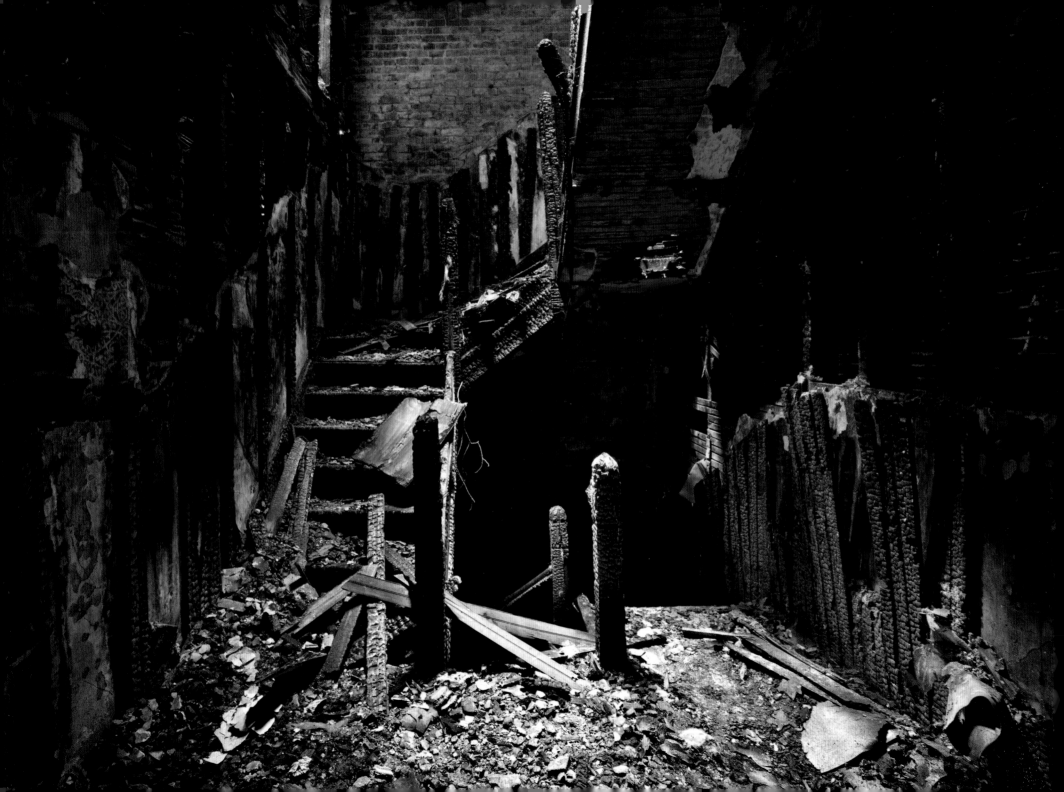

I arranged with Progress Development Group (PDG) to photograph the site before it was torn down in January 2014. Many members of the community were passionate about preserving the Garman Opera House, and PDG had made a fairly unprecedented move for a developer in allowing members inside to see how bad the conditions were. The Garman's interior was cosmetically untouched by the fire, but the roof was letting in significant amounts of water.

When I entered the property, I was unprepared for its disastrous condition. The Garman Opera House, La Bella Trattoria, and the inn/apartments had black and white mold coating literally every surface. The black mold was on walls, doors, mirrors, chairs, lights—but the white mold was *in* everything, blooming out of cracks and corners and rippling across the ceilings in foul upside-down pools. The PDG representative said they had consulted several firms and had been told that "all organic matter with mold on it would have to be removed and replaced."

I didn't see anything that appeared salvageable. If what the PDG representative told me was true, it seemed probable that every surface and beam of the buildings would have to be removed and replaced, a very expensive proposition for a business that had characteristically been unable to sustain itself as a theater to begin with. Even from across the street, the building smelled like death, and going inside the dark, moist cavern of the Opera House felt like entering the mouth of some hostile organism that was just waiting to infect you with its own wretched disease. The Opera House itself was still beautiful, but it was very clear that the year or so without adequate roofing had all but destroyed it.

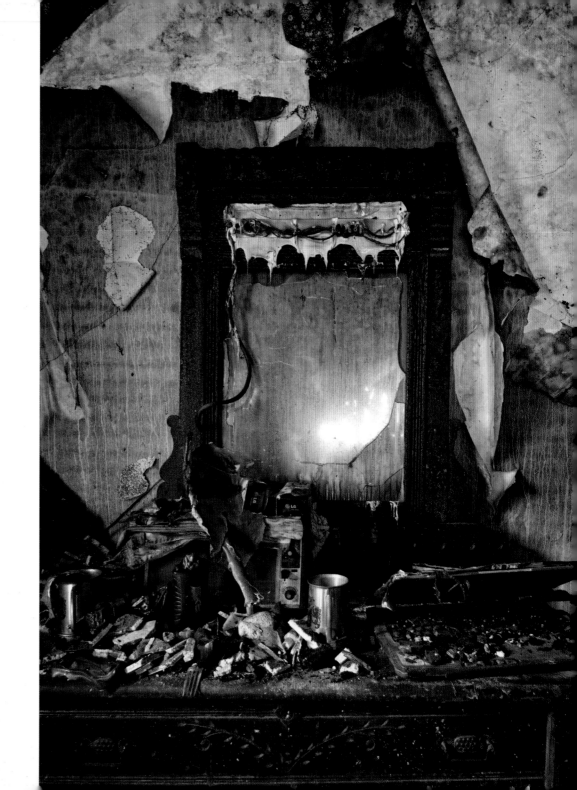

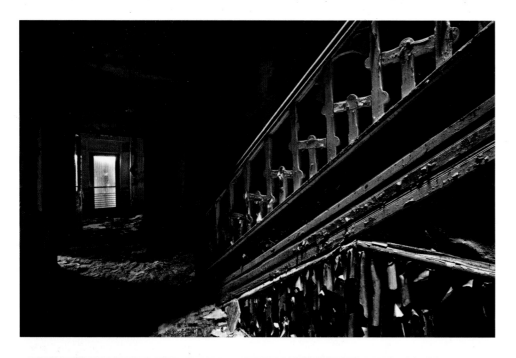

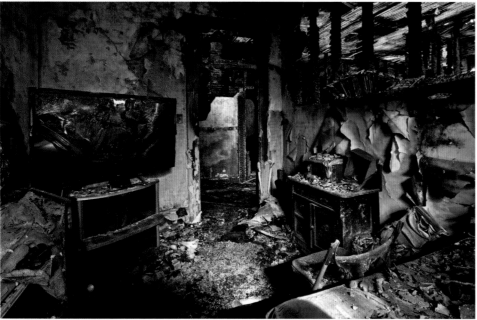

The Hotel Do De had fared much worse. The fire had obliterated the interior, blackening and twisting the residents' rooms and the bar below. The floors and walls were all but non-existent, and the staircase was terrifying as you could feel the carbonized steps crunching under your feet. In a bedroom where two boys lived, a scorched piece of sheet music signed by Kurt Cobain still sat framed on the dresser. In other rooms, stacks of DVDs had fused together and numbers had melted off microwaves. You don't often see places that are truly untouched, but you could tell that nobody had disturbed the items since the fire. It was also clear how much the blaze had cost the families that used to live there.

The community outcry over the demolition of the Garman Opera House, and to a lesser extent the Hotel Do De, were drowned out by the equipment tearing them down. The developer argued that both buildings had been lost to the fire before they purchased them and that the following year of water damage had irreparably damaged the Opera House. I am almost always an advocate of preservation of some sort but in this case I didn't see how it was possible either, physically or economically. From the emails and comments I received later, though, it was clear that both buildings had meant a tremendous amount to the town The bar was a favorite haunt for townspeople and everyone had fond memories of the Opera House and wanted to see it put back to use. Unlike so many towns that are ready to cast off buildings the moment they are no longer functional, these people really cared about them. It was a terrible loss for the community.

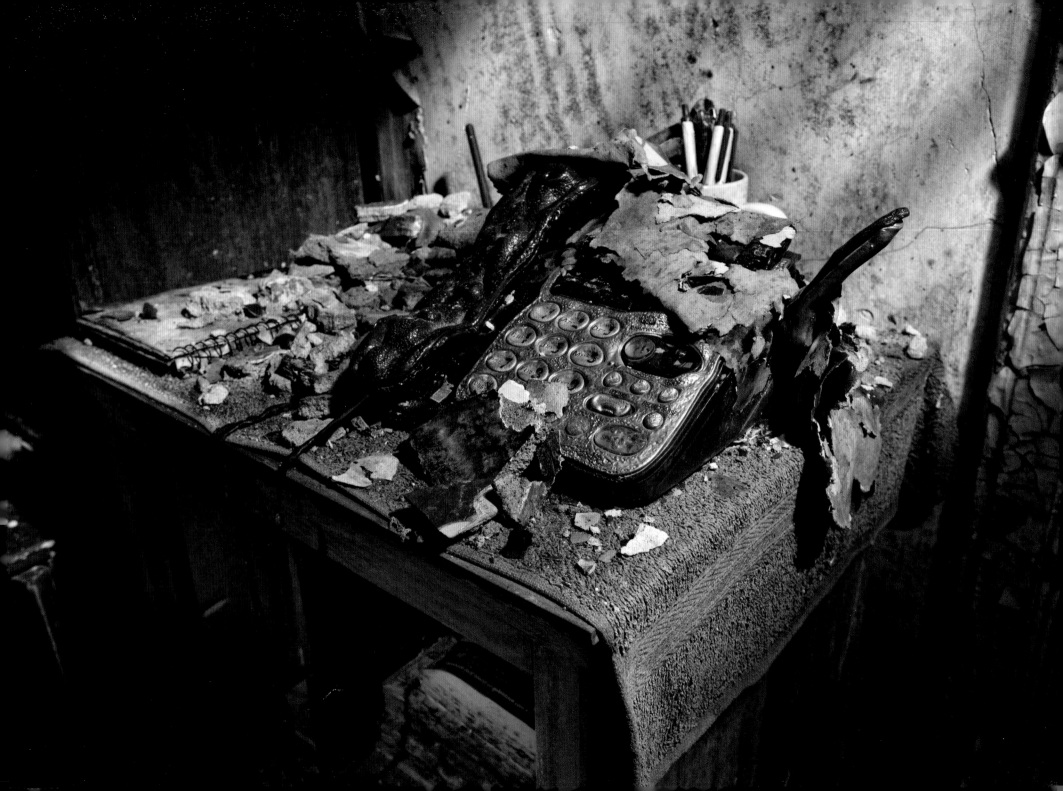

Frank R. Phillips Power Station

The Frank R. Phillips Power Station was built to provide coal-fueled electricity to the Pittsburgh area from South Heights, PA in 1942. At the time of its dedication in 1943, it was capable of providing power to the entire Pittsburgh area on its own and was intended to supplement the heavy demand created by the boom in local industry during World War II. Originally owned by Duquesne Light and Orion Power Midwest and named after its president at the time, the Frank R. Phillips Power Station changed hands several times during the course of its operations, but the decision to idle it was made in the 1990s because of a lack of industries in the area.

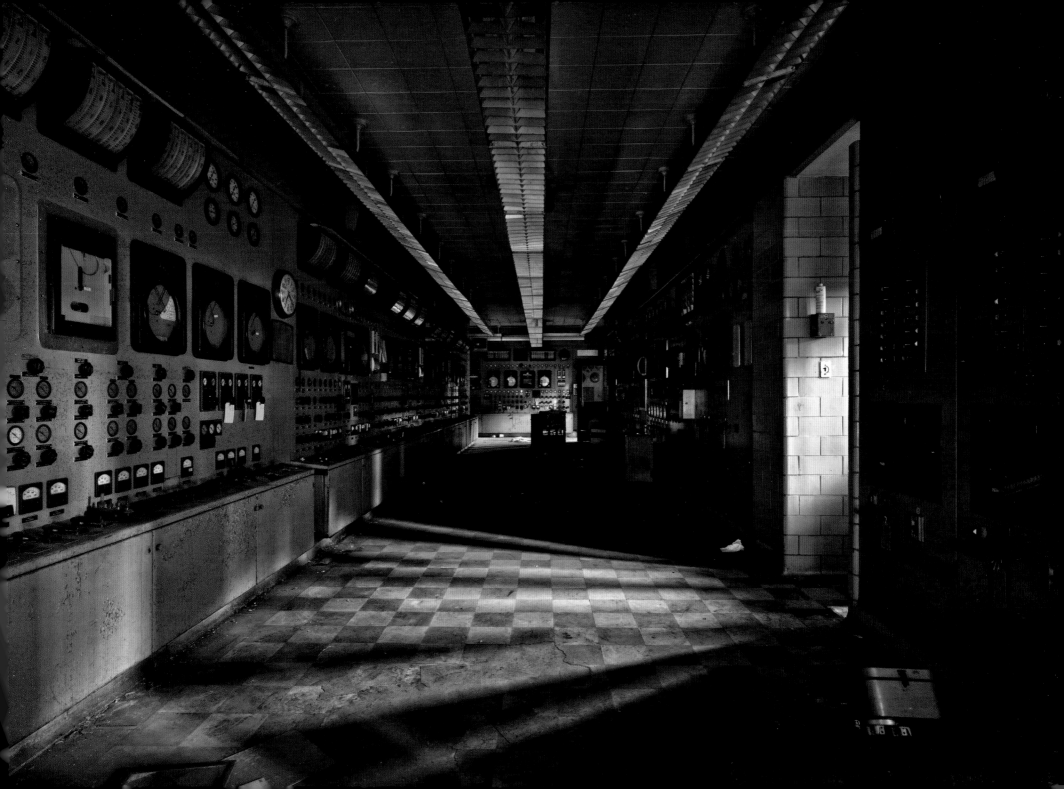

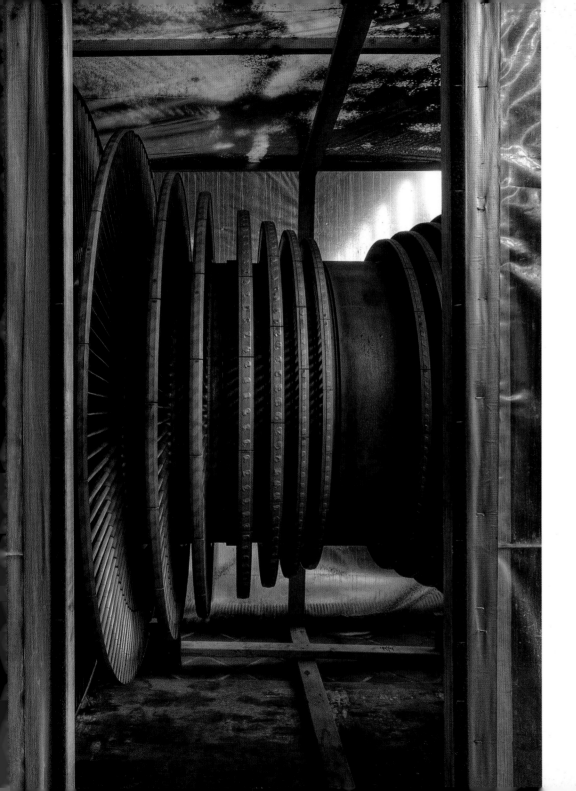

There were several unsuccessful attempts to restart the power station, but ultimately the eleven-story building just sat vacant on a lot spanning 50 acres. Considered an eyesore and a nuisance to the local police because of numerous metal thefts, in 2009 Houston-based owner RRI Energy Inc. decided to start removing equipment and machinery, and by 2010 a full-scale salvage operation was underway. In 2010-2011 Global Demolition tore down the plant. The location is currently being considered for natural gas drilling.

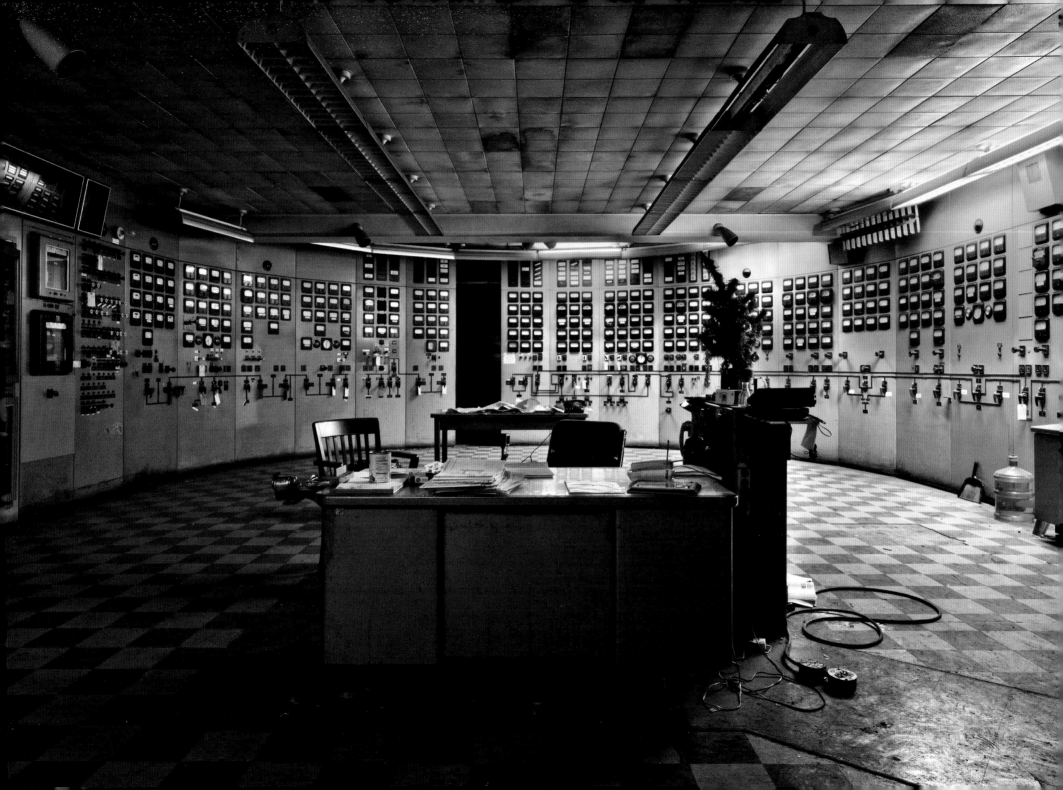

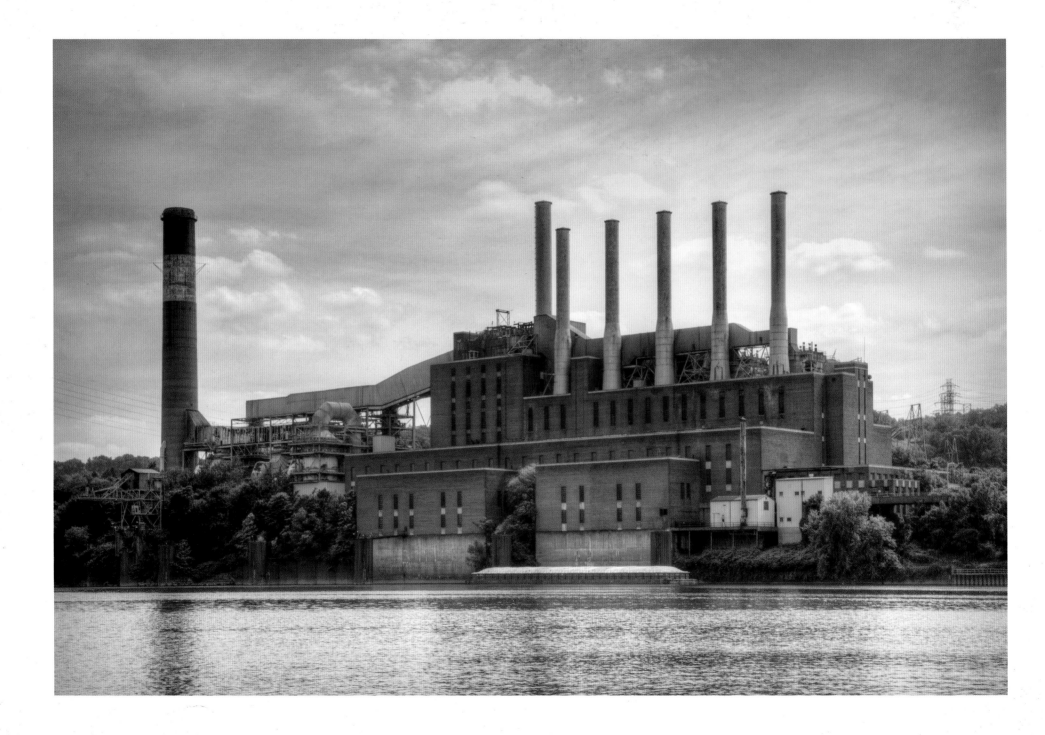

Few places are as overwhelming to work at on a tight schedule as a power plant. The Frank R. Phillips Power Station was much larger than the amount of time I had to document it, which led to a frenzied rush to find, assess, and photograph as much as I could before the day was over. Afterwards, I looked at the images and wondered what was further down in the basement. What if I had pressed along the ground floor rather than climbing the steps to the tops of the furnaces? What if I had had more time to speak with the engineer who led us through about how the plant functioned?

The problem is that when you are racing against the clock, there is never enough time. Compared to many power plants, the Frank R. Phillips facility had a short lifespan. When approaching it along the river, it was hard to fathom that such a gargantuan facility could ever be closed, much less torn down, and yet within a year of my visit it was gone. I've never put much stock in the supernatural, but one thing I am haunted by is missed opportunities, by my own limitations and those imposed by time. A legacy, no matter how seemingly solid and indestructible, can be erased so quickly that things like documentation, reconciliation, or acknowledgement are all but forgotten. As a culture, we feel it's better to push forward, regardless of the cost, even if we don't know what the future has in store.

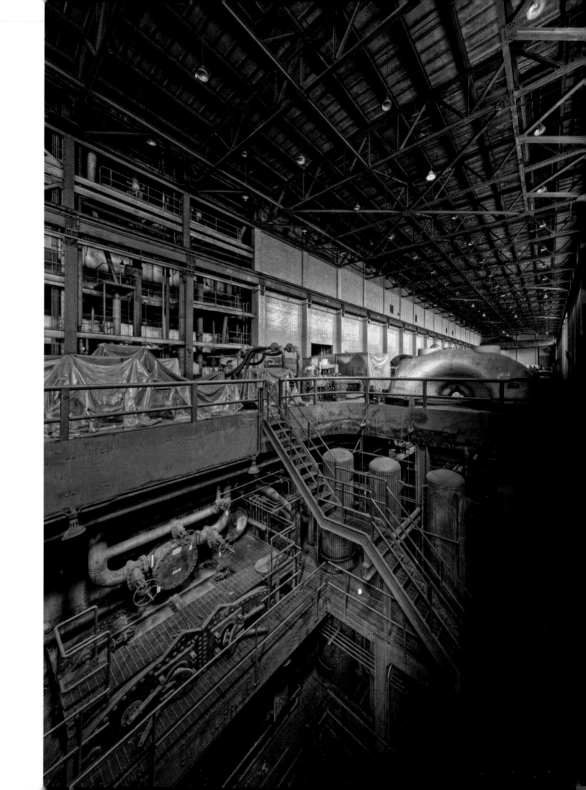

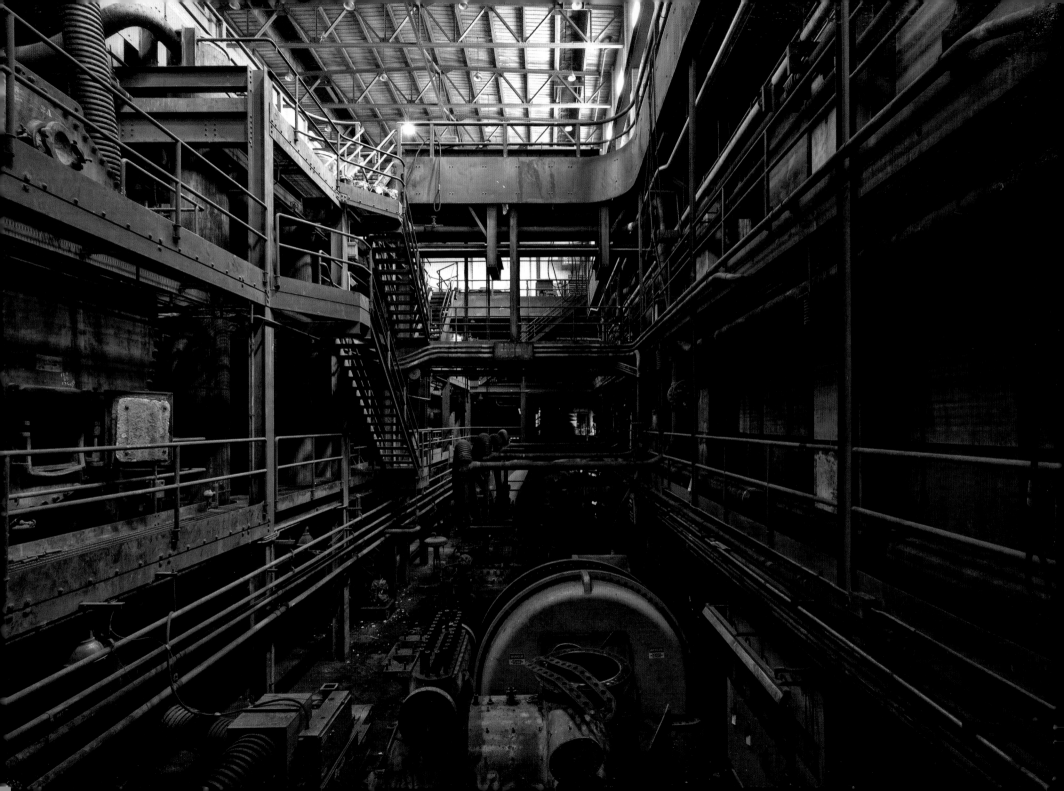

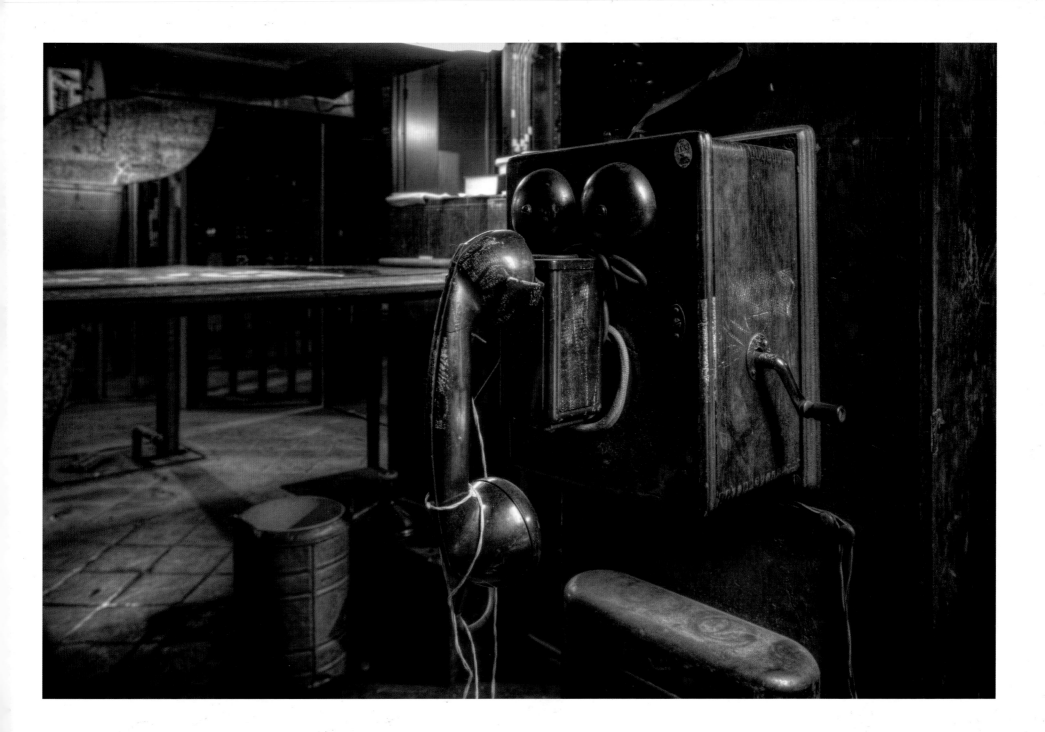

Norwich State Hospital

Built in 1904, Norwich State Hospital originally consisted of one building, but rapidly grew: in a little over a decade there were sixteen buildings, and it continued to expand to over twenty in the 1930s, including laboratories, doctors' and attendants' housing, a greenhouse, a barbershop, recreational facilities, and more. Though it was built for the mentally ill and criminally insane, it also housed the elderly, patients with chemical dependence issues, and tuberculosis patients.

The closure of the buildings began in the 1970s and when the facility was completely shut down in 1996, only two of them were still in use. Since then it has sat abandoned, a popular destination for urban explorers and vandals. Plans to build a theme park, hotel, performing arts school, and movie studio onsite fell through in 2006, and though the property was patrolled by police and security, the deterioration of the buildings and the toll taken on them have been severe.

Though the site is on both the National and State Historic Registers, and despite the fact that as of writing no final plans for its future have been agreed, the Preston Redevelopment Agency started demolishing the buildings in 2011 using state grant funding—a wasteful and ignominious fate for a series of beautifully built and culturally significant structures. Though Preston First Selectman Rob Congdon (R) is quoted as saying, "It's sad to see this incredible architecture come down, but there really is no choice," I saw no evidence that any alternatives other than demolition were ever considered for the site or that any effort whatsoever was being made to preserve it.

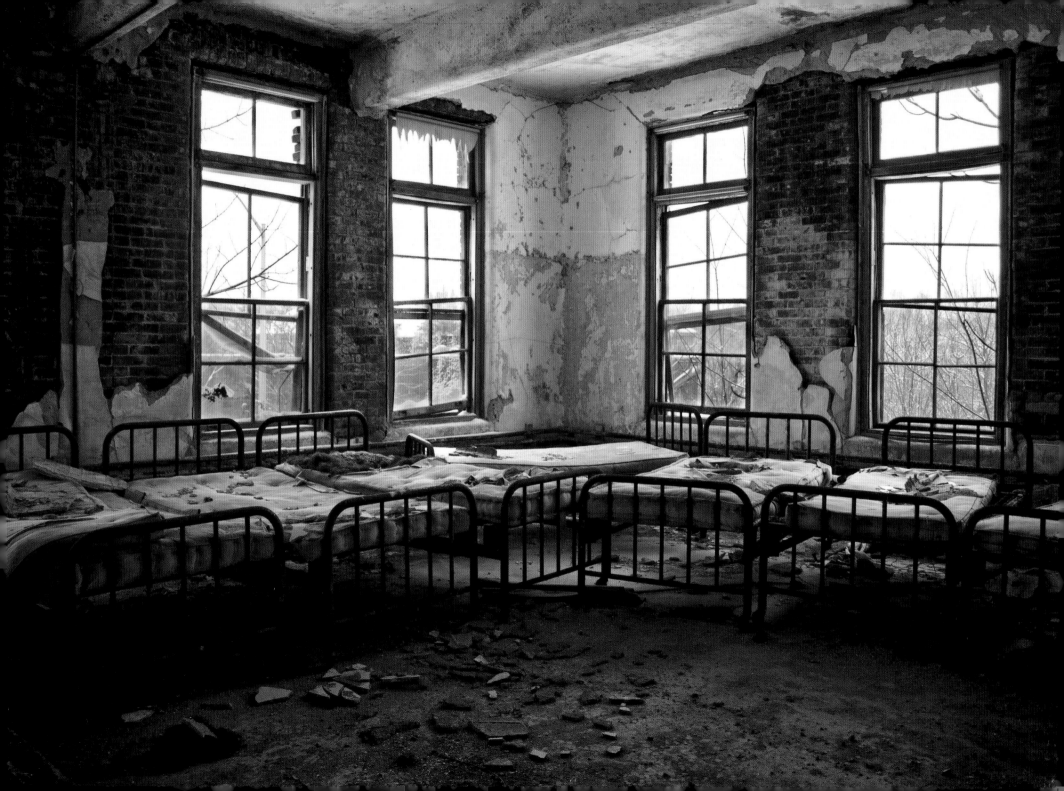

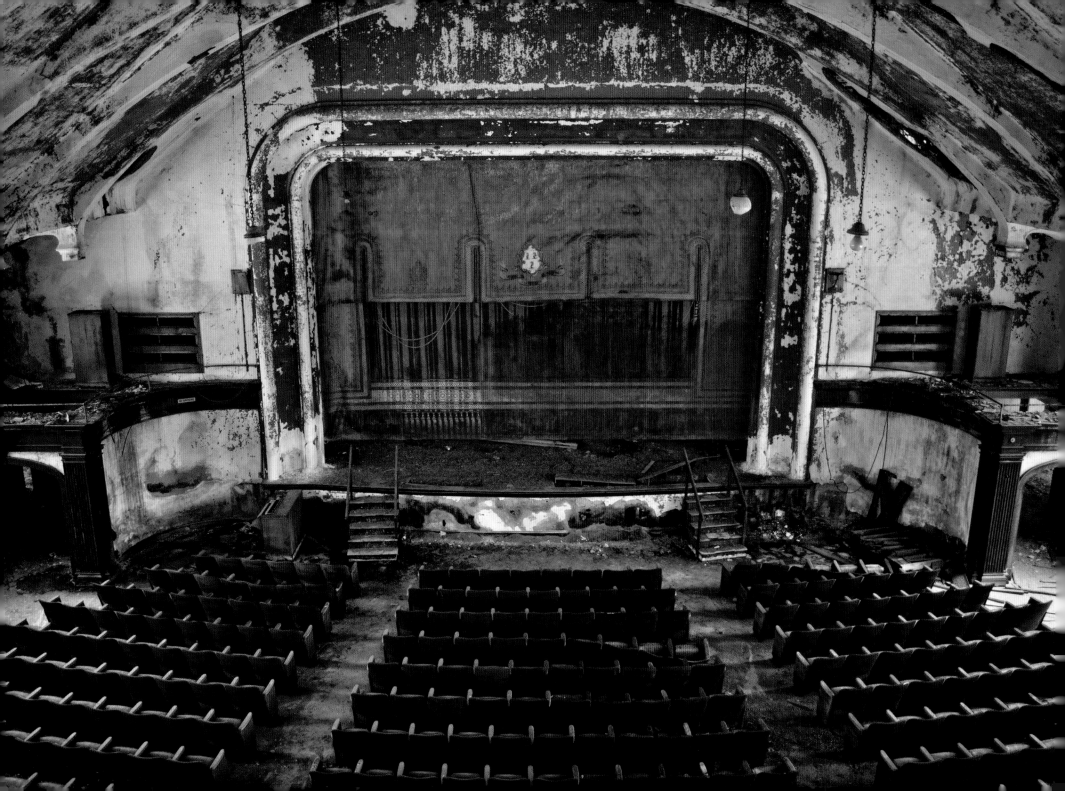

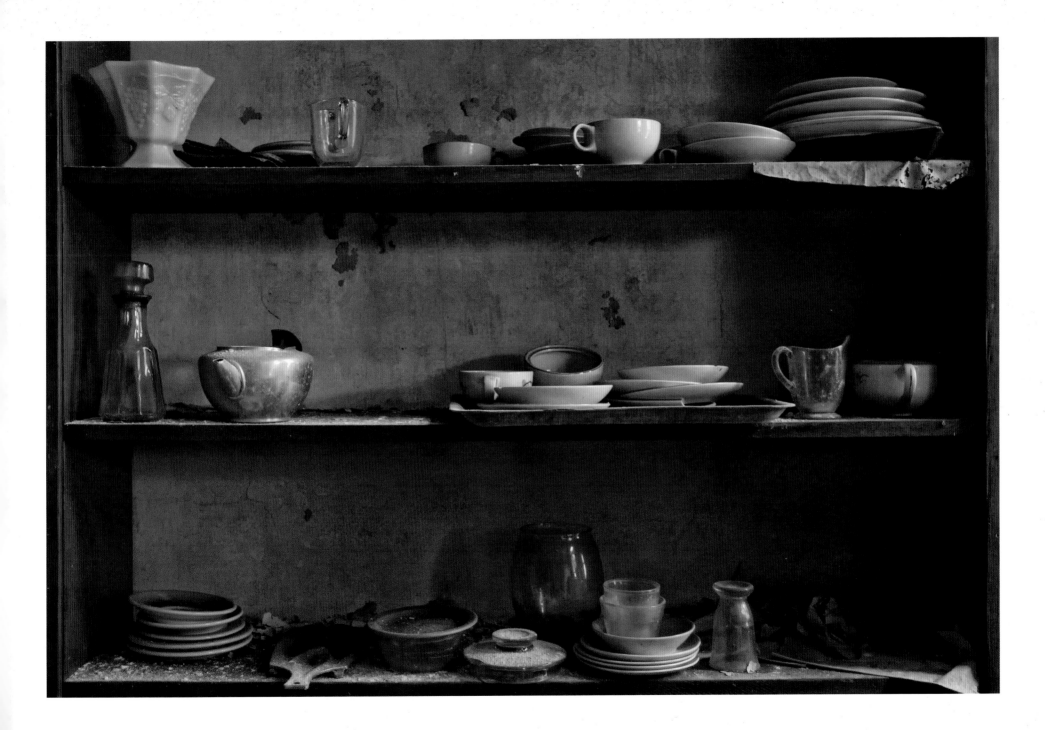

My last visit to Norwich State Hospital was a dreamlike experience. Waking up to find nearly a foot of snowfall outside and more accumulating quickly, the drive was tense due to bad roads and the hike was more arduous than normal. Leaving footprints that the security could follow was a concern. Once inside, we went to the enormous theater and looked out over the campus. It was perfectly silent save for the wind, and snow was drifting in through the windows. Our tracks vanished quickly. It was very cold but I barely noticed.

We covered a lot of ground that day, sticking to the tunnels to go between buildings as much as possible. Years later, areas of the tunnels were collapsed to make it impossible to travel the campus underground, but that day the network was invaluable. There were old gurneys with restraint straps still attached, broken asbestos-covered pipes that became unfastened and jutted off at odd angles. All the while, the snow steadily fell outside, as though it would just keep going until we were buried inside.

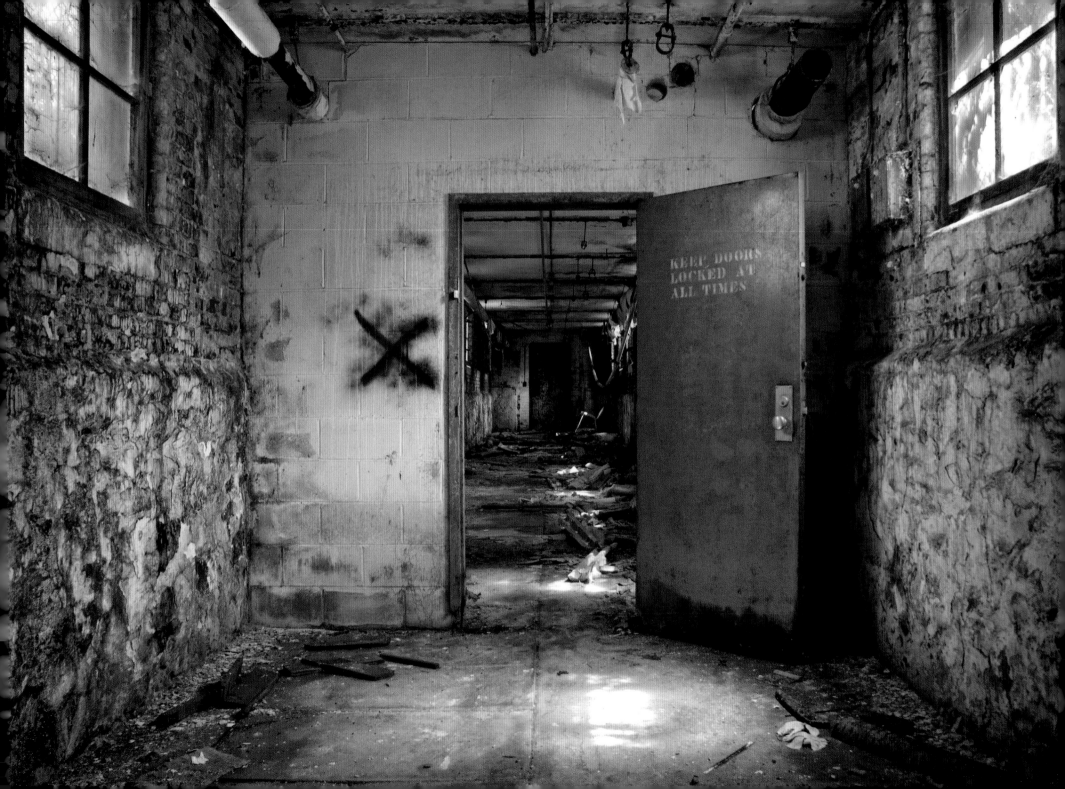

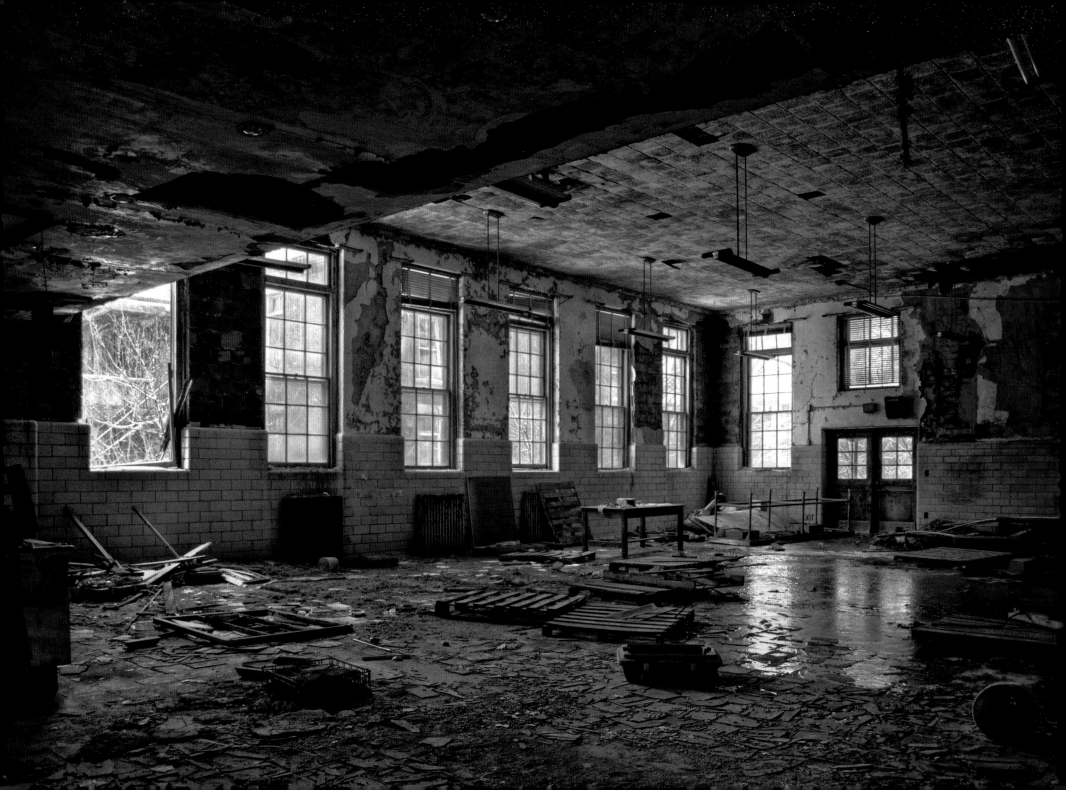

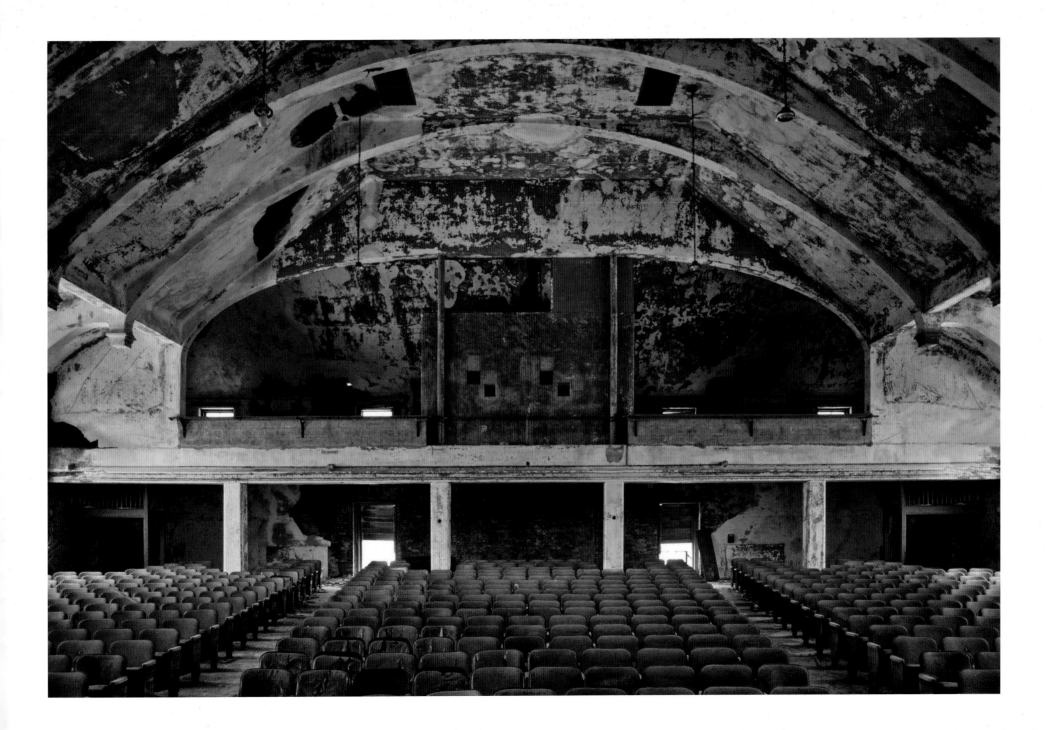

Thomas A. Edison High School

The Northeast High School in Philadelphia (known later as the Julia de Burgos Magnet Middle School and Thomas A. Edison High School) was originally built in 1905 in Fairhill. It was a time when the idea of a publicly funded free school for the working class was progressive and controversial. Structured like a medieval castle, with turrets, stone lions flanking the entrance, and gargoyles encrusting the cornices, Northeast High School was a prestigious institution that taught trades to area students. Albert Einstein, Babe Ruth, Herbert Hoover, and Amelia Earhart were among the dignitaries who visited the school, but as the minority population in the neighborhood increased in the 1950s it was decided to build a new Northeast High School in a more suburban area. The old school was left to deteriorate due to systematic neglect.

During the Vietnam War, the former Northeast High School had the distinction of having the most casualties among its alumni. But by the 1990s it was infested with rats and falling apart; fewer than fifty percent of the math teachers could do basic math themselves, textbooks were outdated or non-existent, and outbursts of violence were commonplace. Named the worst school in Philadelphia, it was taken over by a private contractor (Edison), which was to provide education. Edison built a new building and closed the older one shortly thereafter in 2002, leaving it to vandalism and decay.

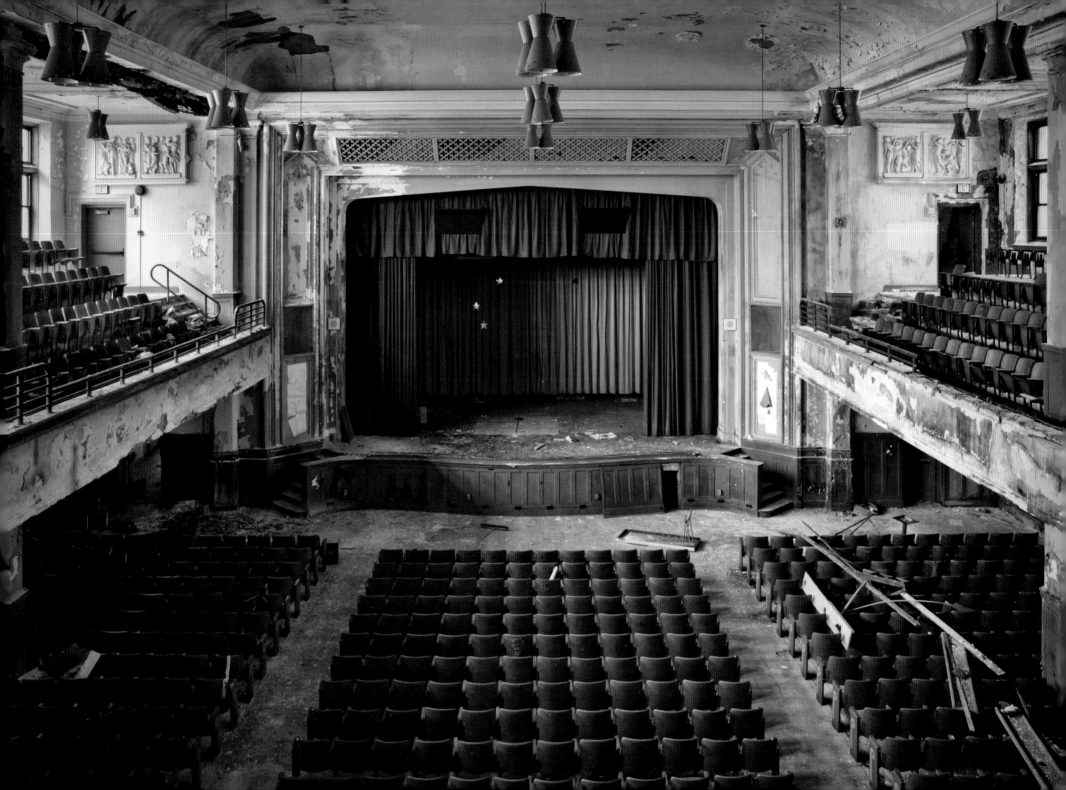

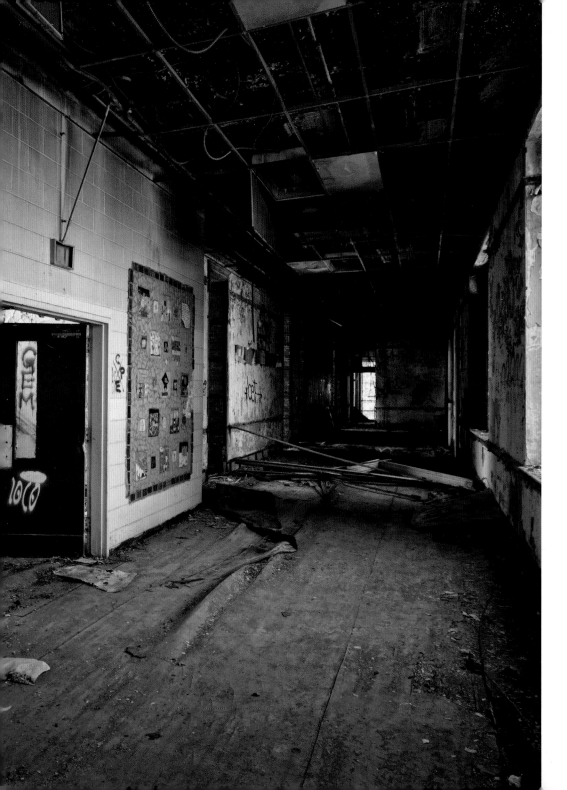

After the school had been abandoned for nearly a decade, a four-alarm blaze broke out in August of 2011, causing heavy damage to the upper floors. While it took eighteen fire engines to control the blaze and much of the roof was destroyed, a large portion of the building was unaffected. Aside from several sections where the floor needed repairs, it appeared to be structurally sound. In 2013 the school was torn down. The distinctive gargoyles on the turrets were saved and the Art Deco rear of the building is slated to be restored to use. Mosaic Development Partners L.L.C. and Orens Bros. Real Estate Inc. plan to bring a Save-A-Lot grocery store to the lot.

Visiting Northeast High School during its demolition was a heart-wrenching experience. Even though the possibility of saving it became increasingly remote as the years went by, particularly after the fire that destroyed much of the roof in the front section of the building, I always hoped that someone might see what a phenomenal facade the building had and at least save that.

During my visit, workers scurried around the site with wheelbarrows full of textbooks still in serviceable condition even after all these years, dumping them in a two-story-high pile in the central courtyard. Mountains of hardwood flooring, wainscoting, cabinetry, and all manner of other things were stacked in a heap that roughly measured a half-block in any direction, and narrow paths had been made through it all. Thankfully, salvage companies were trying to reclaim as much material as possible, but most of it was destined for landfill. Responsibly sifting through the mess to see what could be reused was not the priority: tearing down the site as fast as possible was.

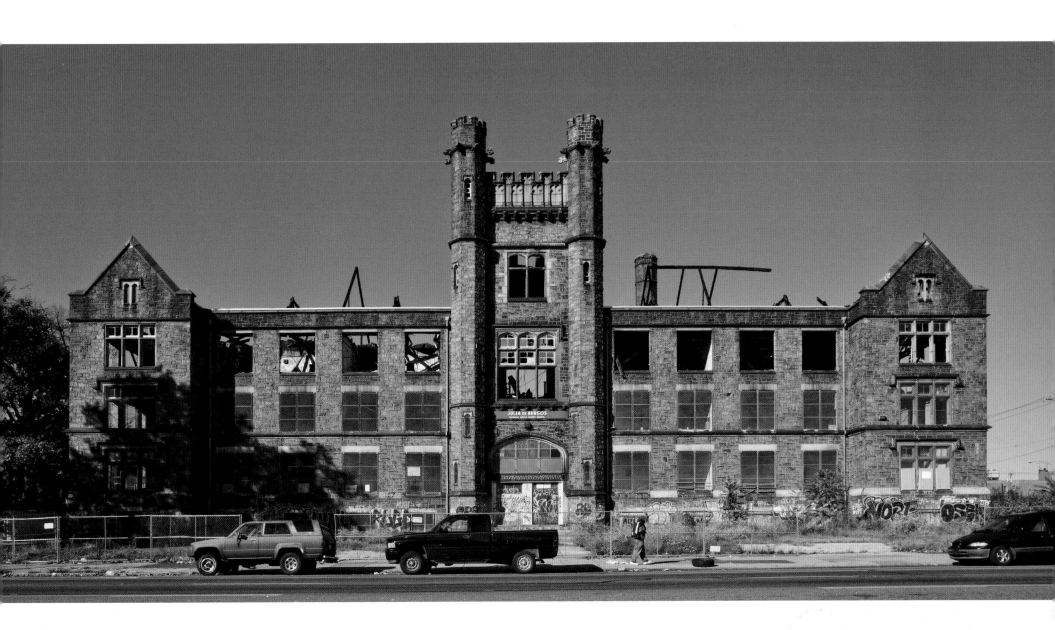

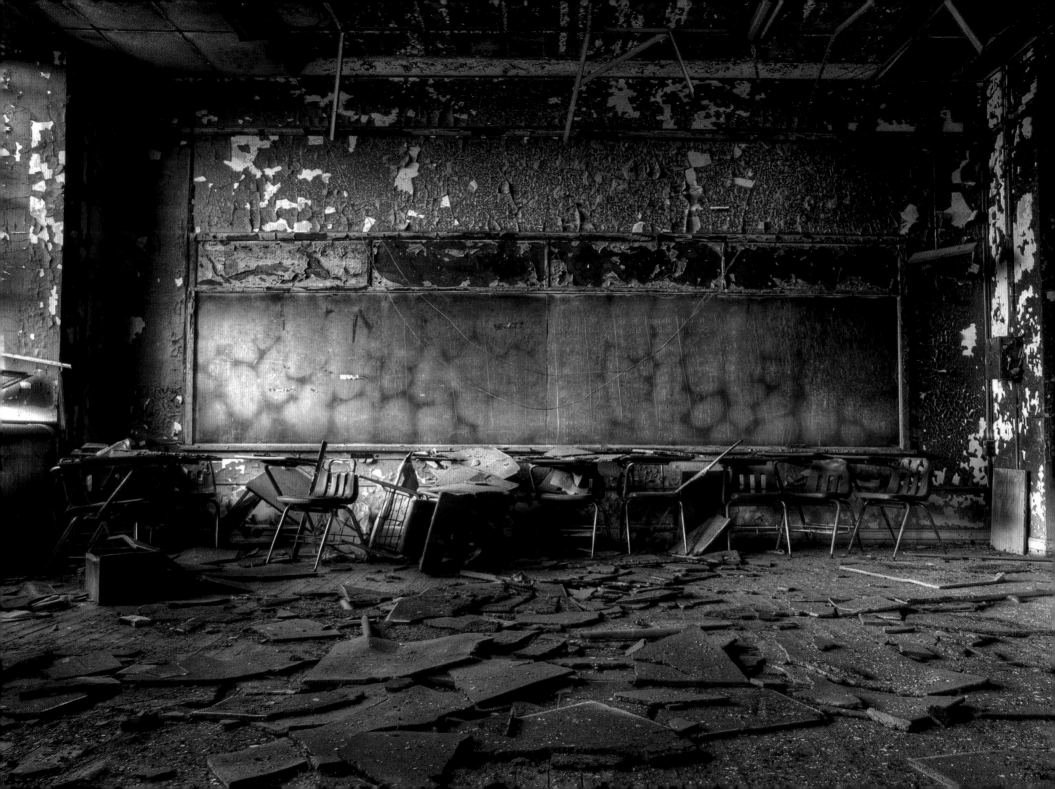

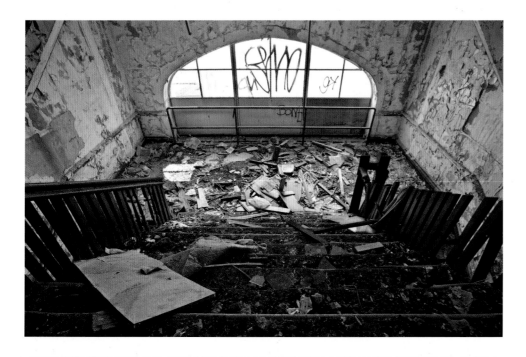

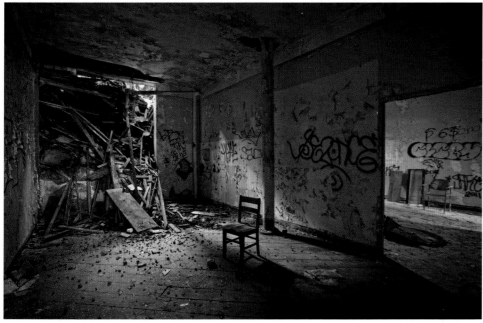

I felt like an ant crawling around on the bones of a mastodon; I was tiny compared to the former Northeast High School's storied history and prestigious beginnings. Trying to fathom how many people had been a part of the place, for better or worse, was humbling. In the end, whatever it had once been amounted to little more than a trash heap for the people tearing it apart. There was no reflection or ceremony about it, just a bunch of guys whacking it apart with hammers and power tools.

It seemed more than anything to be a final crowning moment of stupidity and failure in such a long string of stupidity and failure that tracing its origin wasn't even possible any more, not that anyone was bothering to do so. Where a great beacon of the commitment to public education had once stood, there would be another parking lot and another cheap, trashy store selling goods made in sweat shops in some foreign country without labor laws. Where Northeast had been founded as a trade school to teach people skills to use in the once-thriving industrial landscape of Philadelphia, it would be destroyed only to be replaced by a store that would contribute to the decline of American industry. In a place where joblessness and poverty were the norm, maybe the only work is tearing apart the things that had once made the area grand.

As I photographed the building that last day, a passerby on the street stopped and commented: "I went to that school. It was beautiful. What a shame. They'll never build anything like that again. Never." In my opinion, he is probably correct.

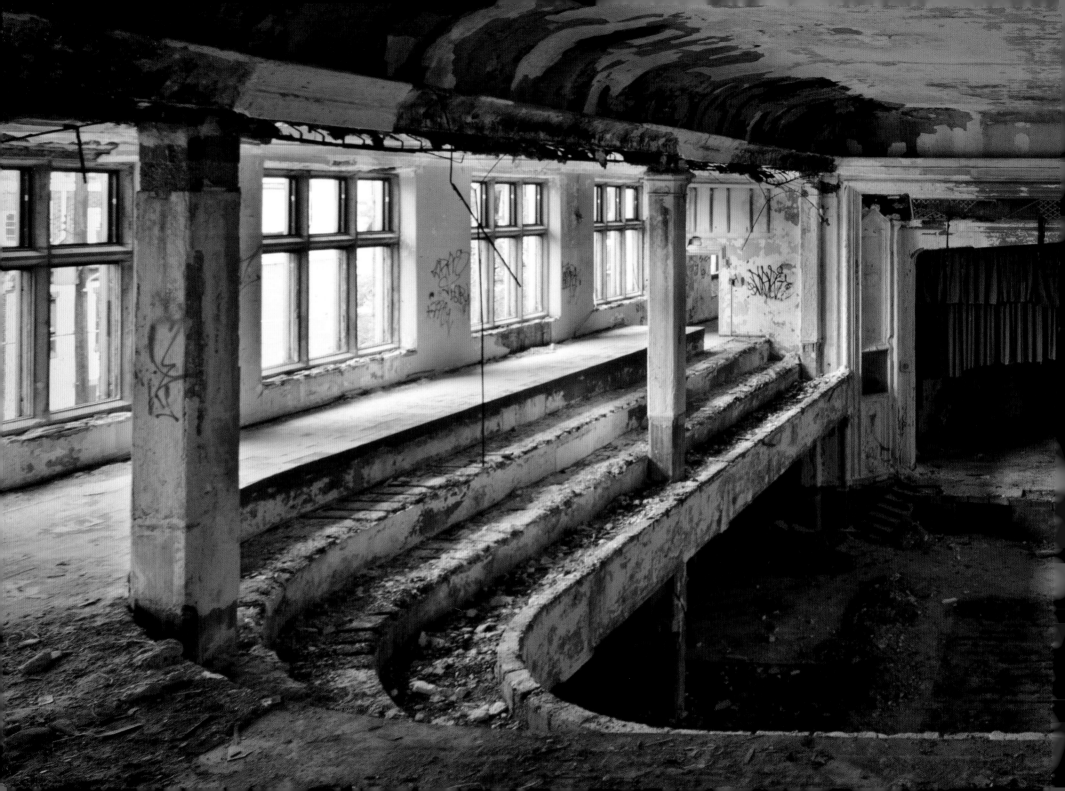

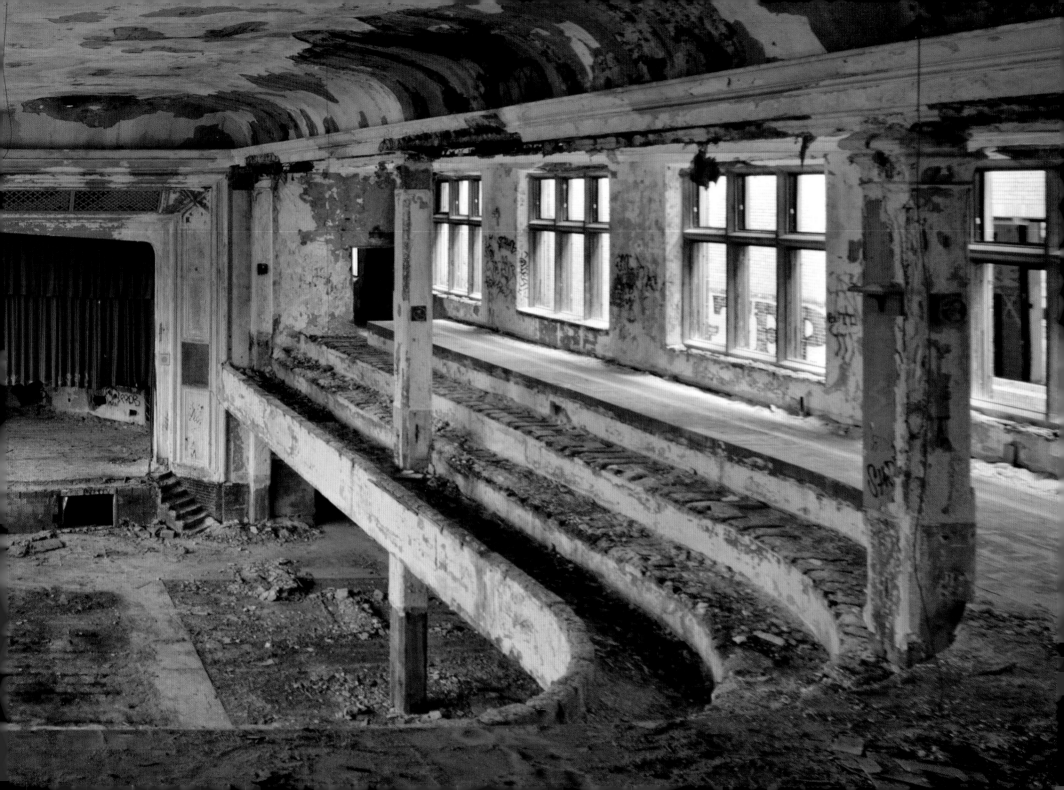

Packard Motor Car Company

When it opened in 1903, Packard's Detroit plant was the most advanced auto factory in the world. Designed by renowned architect Albert Kahn, the plant was located on a staggering 40 acres of land and boasted over 3.5 million square feet of space. It was also the first industrial site in Detroit to use reinforced concrete in its construction. The Packard Motor Car Company built an excellent reputation not only for innovation (introducing the modern steering wheel and the 12-cylinder engine) but also for luxury, attracting some of the wealthiest auto buyers across the world. During World War II, the Packard plant produced engines for P-51 Mustang fighter planes, but afterward its legacy as a status symbol was slowly diluted by the introduction of cars aimed more at the middle class. Losing its upper-class market and not finding a footing as a middle-class manufacturer because of heavy competition from the Big Three, the company's last car model, simply called the "Packard", was produced in 1958 though the Detroit plant had ceased manufacturing in 1956. Several attempts were made to resurrect the brand, but to no avail. The gargantuan plant in Detroit still stands vacant, now a status symbol of a different sort.

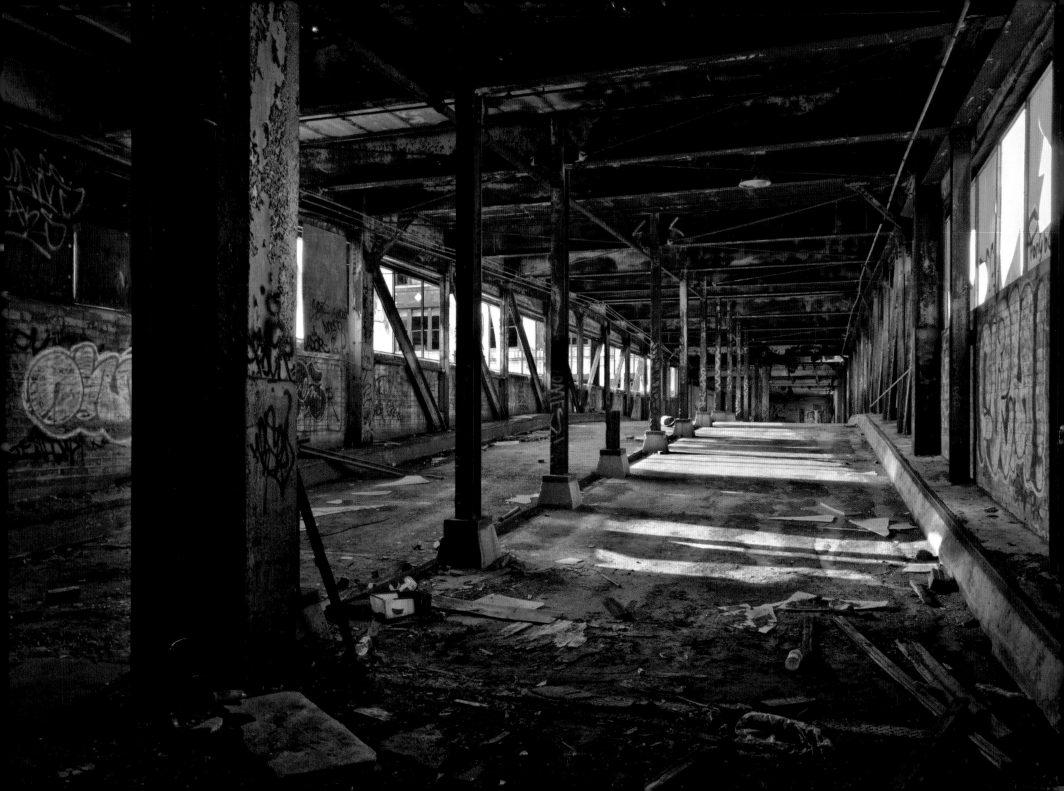

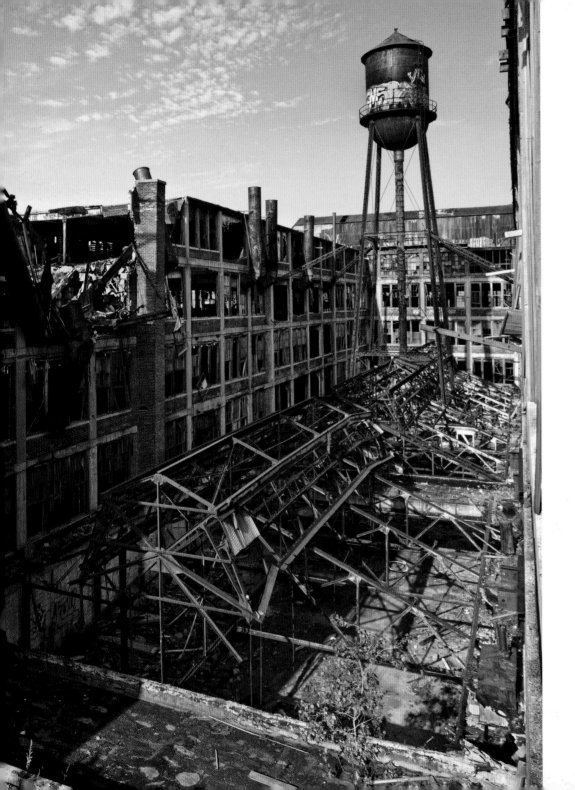

The Packard Motor Car Company is hard to fathom, even when one is inside of it. Stretching for blocks upon blocks, it feels like entering a maze you may never find your way out of. From certain vantage points on the roof, the factory sprawls out over the horizon as though it has swallowed the entire world. Because it has been abandoned for some time and is located in a city that is fairly efficient in stripping its buildings of things of worth, there isn't a lot left to give you an idea of how it was in the past. Mementos are few and far between, and vandalism and graffiti have taken their toll. We did see several other people exploring the factory and they seemed not to be threatening sorts, but there is always the fear of running into someone who will try to murder you to steal your equipment. Reports of packs of thieves who prey on photographers, either robbing their cars or holding them up for their camera gear, have become more prevalent in recent years. I was perhaps never happier for the companionship of others than I was in Detroit, where my four other co-explorers helped provide a (probably unjustified) sense of being buffered from any potential violence.

What Packard lacks in terms of original character, it more than makes up for in scope. We walked down corridor after corridor, through huge rooms, up crumbling stairways, through a paintball-splattered administrative section, and across the elevated walkway. We went up through the substantial parking structure attached to the plant, and gazed out from the roof over the twisted remains of what was once a widely respected luxury automobile manufacturer. Trees are starting to overtake the structure in some places, and I find odd comfort in that. It will be a pile of indistinguishable rubble one day—whether due to the elements and time or because it has been razed. A Peruvian developer has recently purchased it and plans to restore it into lofts, offices, and stores. Today, though, it is still something of a spectacle: a site to be seen, but more importantly, a site to be considered.

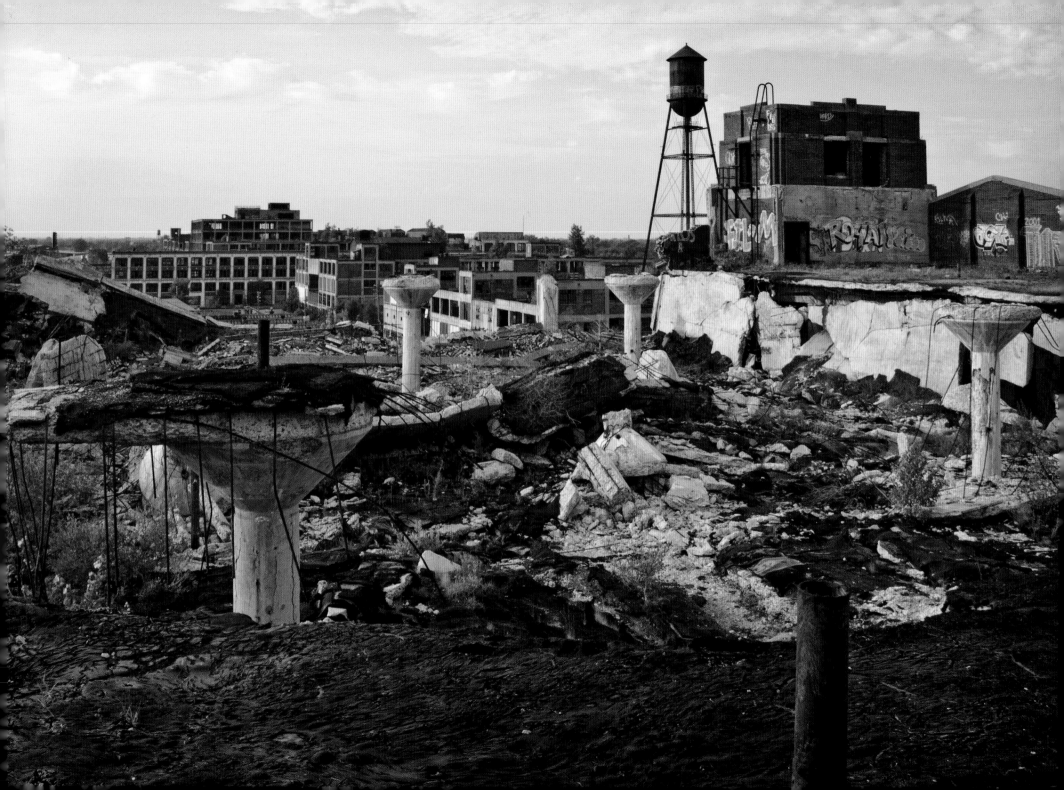

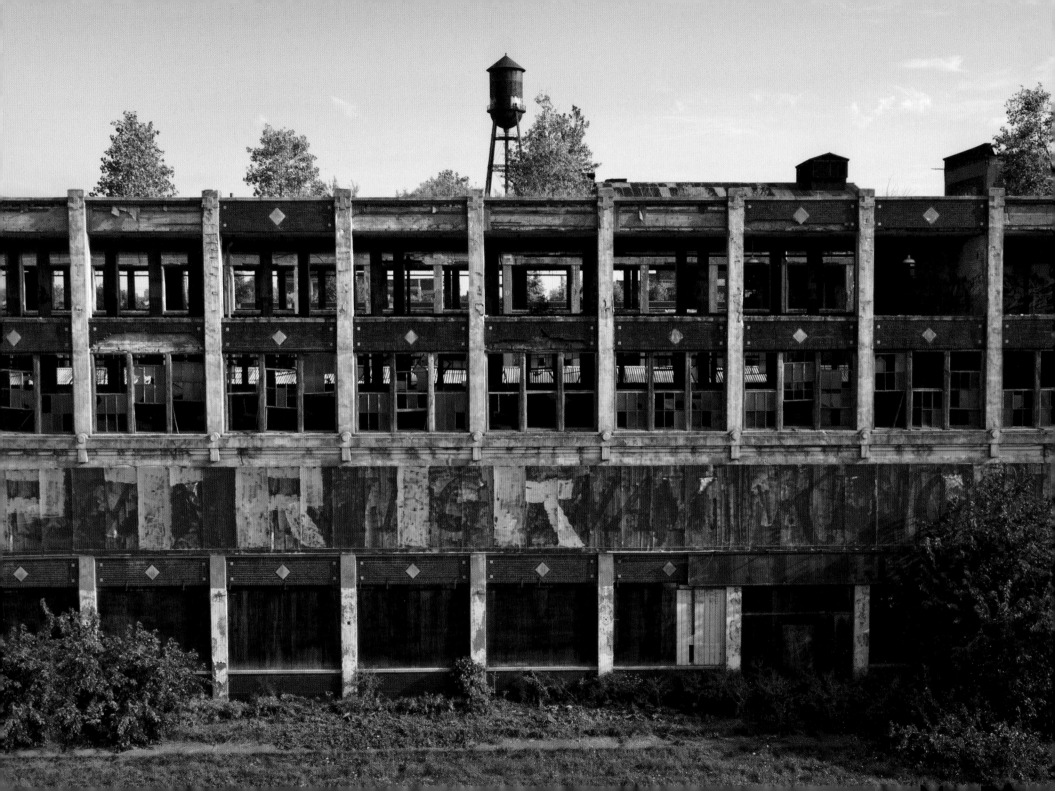

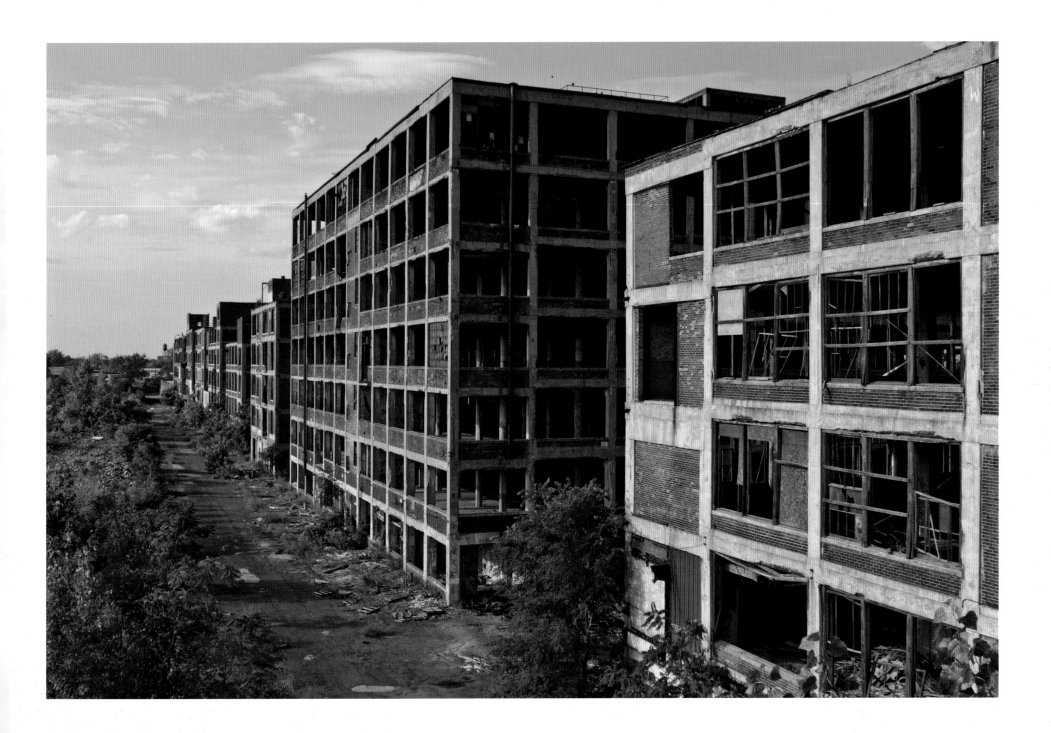

Holmesburg Prison

Holmesburg Prison was opened in 1896 to relieve overcrowding at Philadelphia's Moyamensing Prison and was closed in 1995, though parts of the campus are still sporadically used for prisoner overflow and work programs. While one does not expect prisons to have cheery histories, Holmesburg's past includes some particularly barbarous instances of rioting, rape, torture, corruption, medical experimentation, and murder.

Designed on the same spoke-and-wheel layout as the nearby Eastern State Penitentiary, the original philosophy was "separate penal confinement," where prisoners were isolated and left to contemplate their crimes. A narrow slit in the ceiling allowed light into the cell. Overcrowding quickly became the norm, and as early as 1928 riots broke out, due in part to the ratio of three prisoners to a single cell—this led to an expansion of the prison.

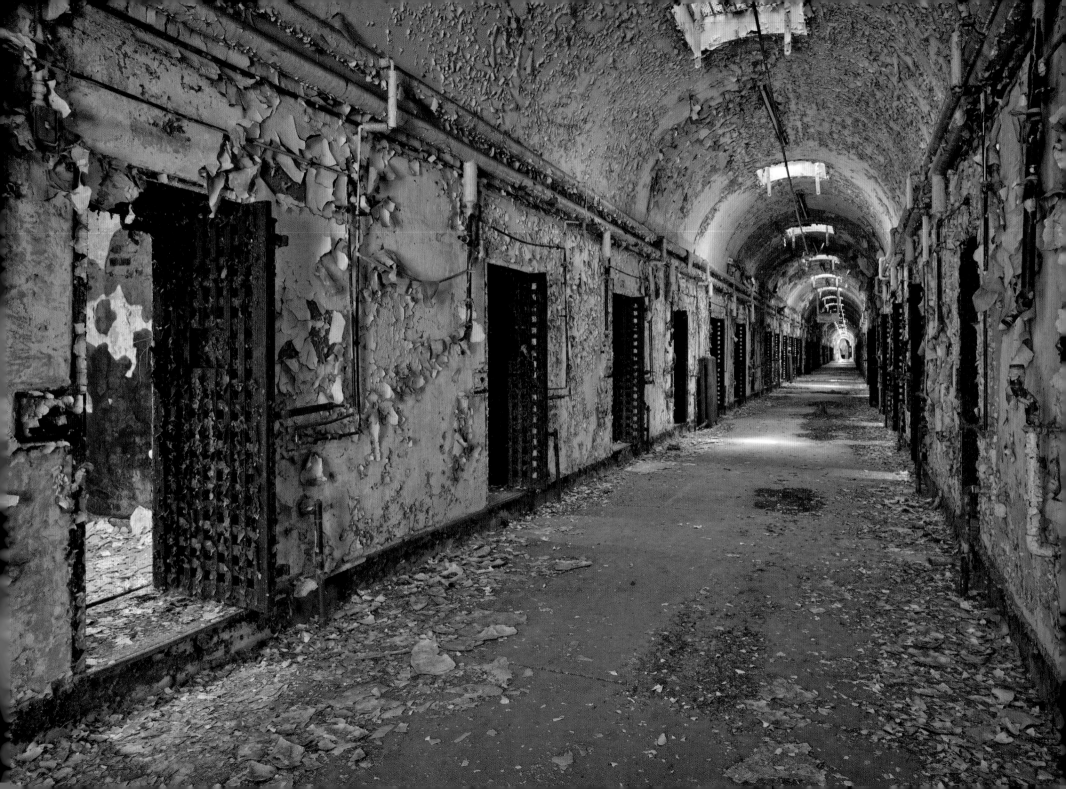

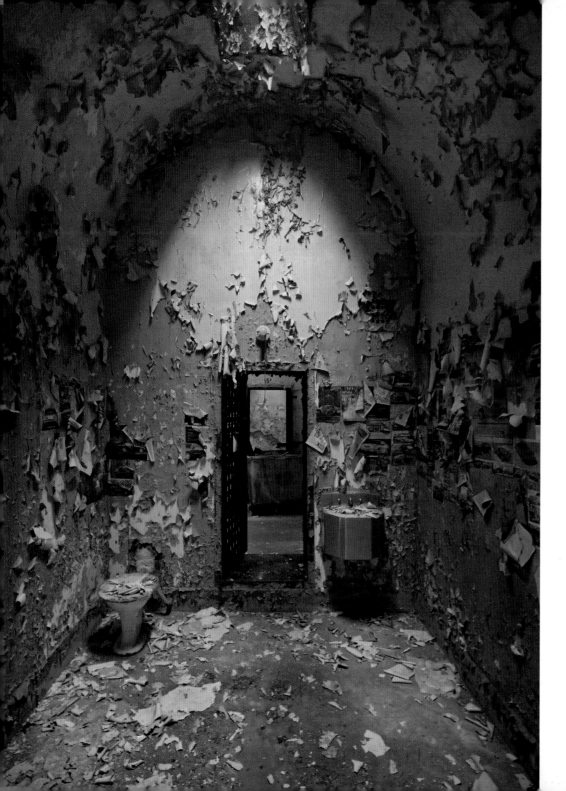

Reactions to the unrest were swift and brutal. One of the prison's most gruesome incidents was in response to a 1938 hunger strike, when half of the prisoners refused to eat because of the extremely poor food. Twenty-five prisoners identified as leaders of the strike were taken to a building called the Klondike, a narrow cell block lined with radiators and steam pipes. The windows and ventilation grills were closed and, in conjunction with an August heat wave, raised temperatures inside to nearly 200 degrees. Four of the men died of horrific injuries consistent with severe beatings and being boiled alive. The governor visited to investigate following a public outcry and was so shaken by what he saw that he reported to the press, "In this case, having gone into the matter, I find the press has, if anything, understated the horror of the death of four men." Of the fourteen prison staff members against whom charges were brought, only two were convicted and given light sentences. The Klondike was torn down in the 1970s.

Other instances of murders and beatings dotted the years, including an incident in 1973, when the warden and his deputy were stabbed to death by inmates. A riot in 1970 was started by some 100 prisoners who were, according to a Bulletin article, "armed with meat cleavers, boning knives, makeshift pitchforks and table legs"; they destroyed the dining hall and butchered other inmates and guards. Nearly 100 people were injured in the incident. The ensuing lawsuit focused public attention on the beatings, filthy conditions, and sexual assaults and led to reforms aimed at addressing the overcrowded conditions.

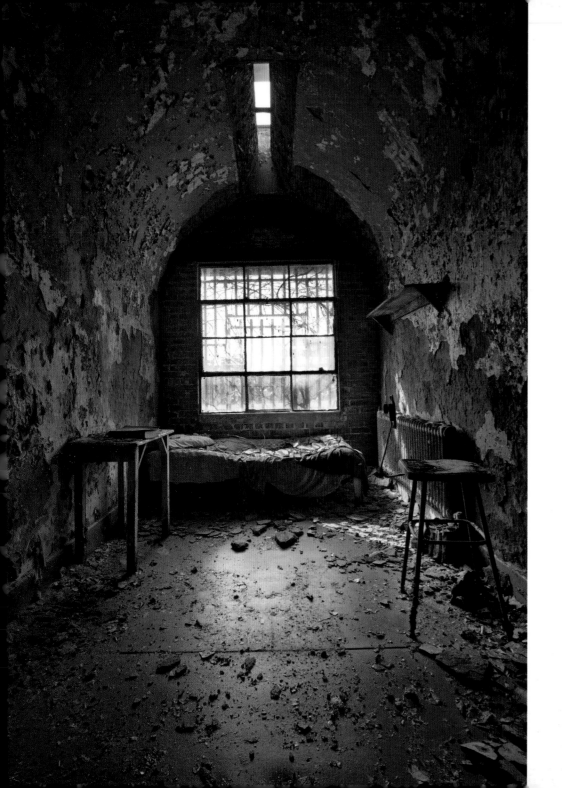

Another dark passage in Holmesburg's history was the twenty-year period when Dr Albert M. Kligman performed a variety of medical experiments on the prisoners, exposing them to herpes, staphylococcus, cosmetics, skin-blistering chemicals, radioactive isotopes, psychoactive drugs, and carcinogenic compounds such as dioxins. The experiments were financed by thirty-three different sponsors, including Johnson & Johnson, Dow Chemicals, and the U.S. Army. Prisoners were paid minimal amounts and were not properly advised of risks or treated for the complications that arose. It is reported that as many as nine-tenths of the prison population underwent these studies during the period they were conducted from 1951 to 1974. The experiments ended in Congressional hearings, public outcry, and lawsuits alleging that the tests were a breach of the Nuremburg Code. Though the records were destroyed and the lawsuits dismissed, they led to strict regulations regarding the use of prisoners in medical studies in the future.

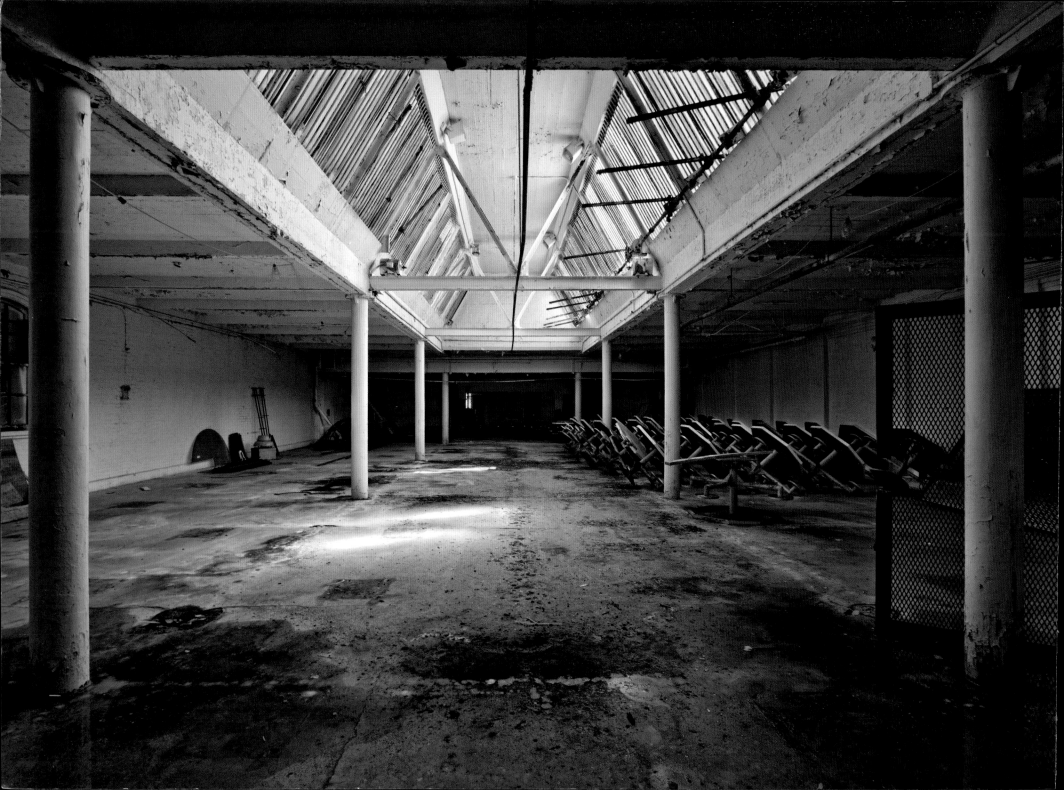

I was able to gain access to photograph Holmesburg fifteen years after it closed. While there, I chatted with one of the correctional officers about his small (cut) role in the movie *Law Abiding Citizen*, which had filmed there two years previously, and about what it was like working in a mostly abandoned prison. The thick walls were badly deteriorated in parts as trees and vines effortlessly pried the bricks apart with their roots, and some cells were flooded with several inches of water. It was hard to believe what Holmesburg had once been although remnants were everywhere. Prison records filled the hallways, barbed wire spiraled around the guards' walkways, and graffiti and collages adorned many of the cell walls. Less than a year later, two artists removed much of the graffiti via a preservation process called *strappo*, where layers of paint are removed with cloth. The result was part of an exhibit at Moore College. I missed the graffiti on my return visits but it had been eroding rapidly.

Objectively speaking, Holmesburg Prison was a terrible place. It was where the worst of the worst prisoners were sent, and its nickname "the Terrordome" was well deserved. If the city of Philadelphia ever gets around to tearing it down, I'll be sad to see it go, though. If nothing else, it serves as an important reminder of who we are, what we are capable of, and how frighteningly close we are to the worst parts of our own past.

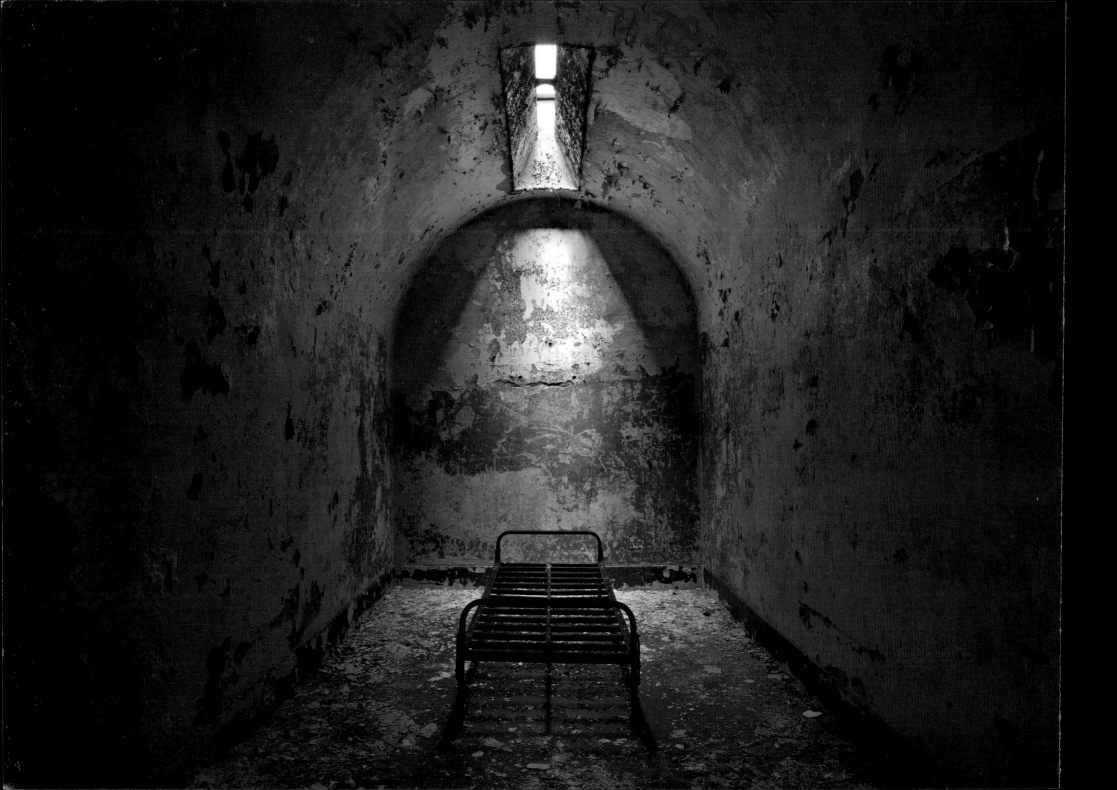

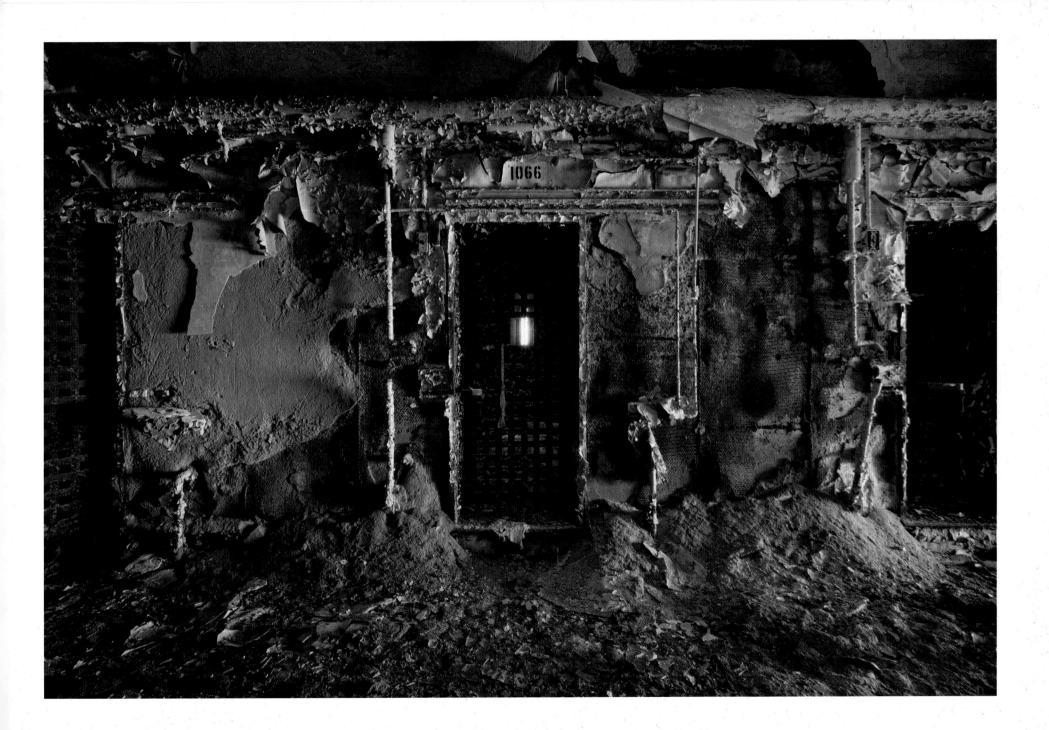

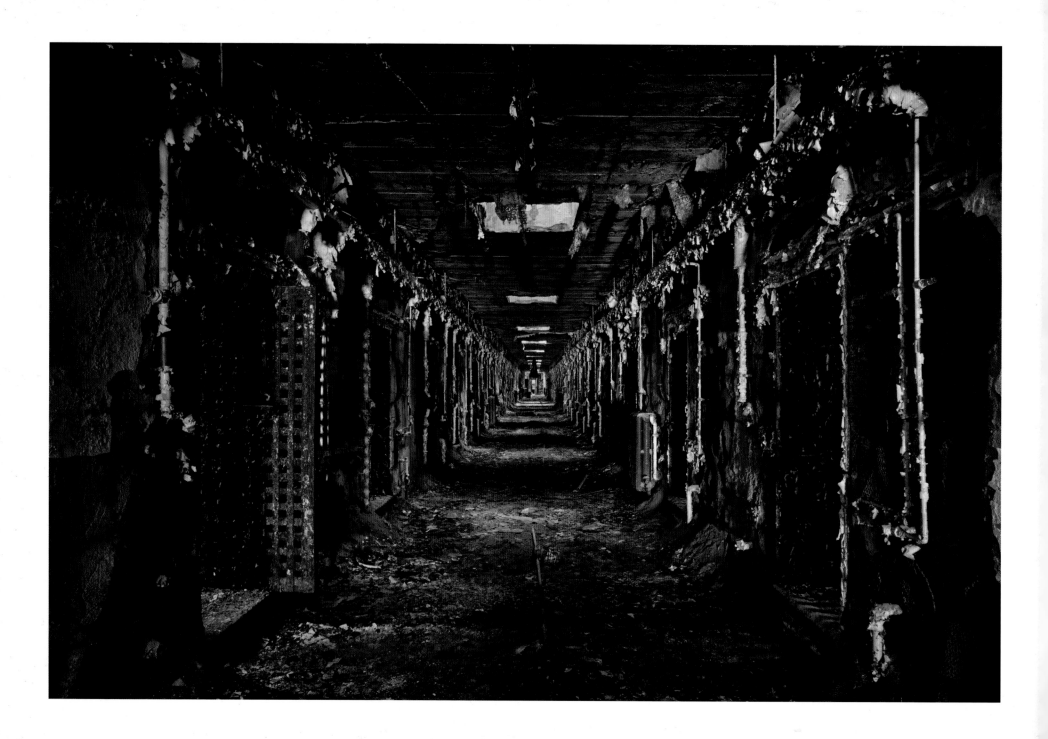

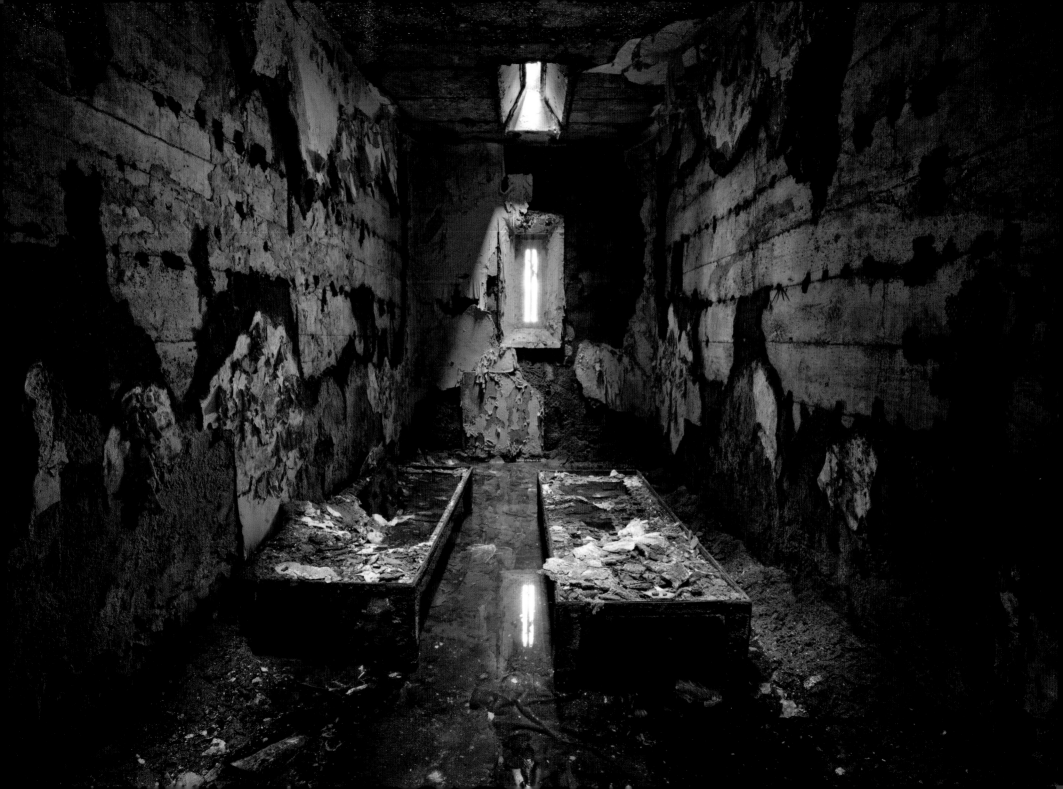

St. Boniface

The history of St. Boniface began with the establishment of St. Peter's Church in 1843 to serve the German Catholics in Philadelphia's West Kensington neighborhood. The parish grew quickly and in 1866 the property on which St. Boniface and an adjoining school would be built was purchased. The cornerstone was laid in 1868 but St. Boniface was not dedicated until 1872 because of lack of funds. The financial troubles continued until the archbishop intervened and wrote a letter on behalf of the church requesting assistance from Rome. Though the ship carrying the letter was wrecked and caught fire, the mailbag carrying it was washed ashore and the singed but still-legible missive was delivered. It was deemed to be the work of God that the letter had survived, and the archbishop's requests were granted. The Redemptorists, a society of missionary priests specializing in preaching to the poor, took over the church. The Sisters who lived in the school vacated the third floor for them and prepared meals for their new guests.

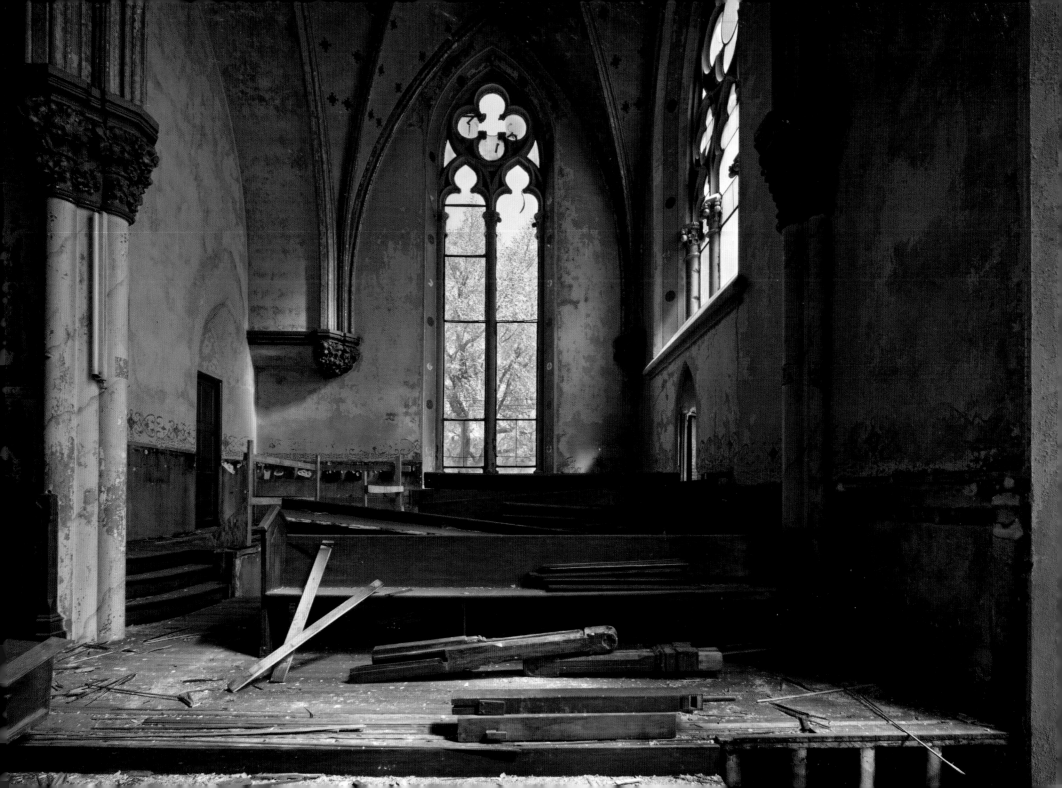

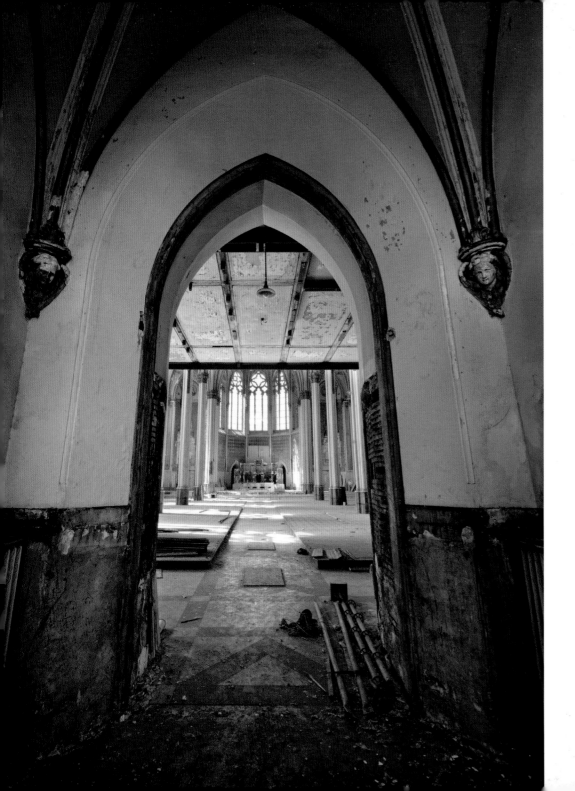

In 1876 all of the city's parishes took collections for St. Boniface and raised $30,000. This funding went in part to a new wooden altar that was purchased from Munich craftsmen at the Centennial Exposition in Philadelphia that year. A member of the parish bought an award-winning reproduction of Michelangelo's *Pietà* at the Exposition for the church as a gift. Church fundraisers helped cover the costs of the new bells and an economical temporary convent/rectory was built in 1877. In 1885 the Redemptorists finally received a permanent rectory, and work was started on enlarging the church: it was eventually lengthened by 30 feet. Over the years parishioners presented the church with many gifts: statues, lamps, crucifixes, volunteer labor, cash, and stained glass windows imported from Munich. A new permanent convent was completed in 1920 and the parish hall was built four years later, complete with a bowling alley and an auditorium.

The first English mass was held in 1894, as younger members of the parish did not understand German. By 1930, the German masses were poorly attended and the majority had switched to English. The parish thrived, with a succession of charity events, picnics, dances, bazaars, and social clubs. Like St. Bonaventure, however, the neighborhood's demographics changed over the years and the church population declined. The dwindling parish was unable to keep up with maintenance on the building. In its final days, scaffolding was erected in front of it to stop people getting hit by falling debris, and the windows were removed because the lead filling had eroded so badly that they were crumbling. Repairs were reportedly estimated at $7 million, and though the church survived longer than many others in the area, the archdiocese closed it in 2006. It was purchased by a developer who demolished it in 2012 to make way for housing.

While researching the history of these churches and photographing them, I am often struck by the optimism of the parishes in constructing them. Over the decades, a remarkable amount of labor and substantial financial contributions were required to complete the myriad of buildings associated with the parish. The prevailing sentiment seemed to be that the churches would serve their communities for hundreds of years to come, much as the cathedrals of Europe had done. I sometimes wonder what the reaction would have been if someone had told the Redemptorists that St. Boniface would only last 140 years. It must have seemed inconceivable at the time that in less than a century and a half, all the hard work and sacrifices would be erased.

I feel my generation is the product of an age where many of the "too big to fail" institutions did just that, where architecture became consciously disposable. In less than ten years, a Borders Bookstore might become a Target, a chain restaurant could go through three different life cycles, and a church might be converted into apartments. We are in essence planning for failure (or transition, if you prefer), whereas only a century ago the mindset was one of continued progress and expansion. We've made too many advances since then to romanticize the entire era, but like many people I'd take a church like St. Boniface over some strip mall tabernacle any day. St. Boniface speaks of a sublime faith in something greater than what lies on this planet, and by its very design lifts our heads to contemplate the nobility toward which we should strive.

The other architectural ethos we are increasingly surrounded by seems to hang its head in defeat without having made any attempt to preserve the past; it sees any project designed to create something everlasting as sheer futility. When architect and artist Augustus Pugin witnessed the decline of the medieval Gothic style in favor of utilitarianism, his documentation of and fiery arguments against the shift helped bring about the very Gothic Revival movement that shaped the architecture of St. Boniface. It is my hope that contemporary tides will shift again one day, and that people will once again look to past triumphs such as St. Boniface for inspiration.

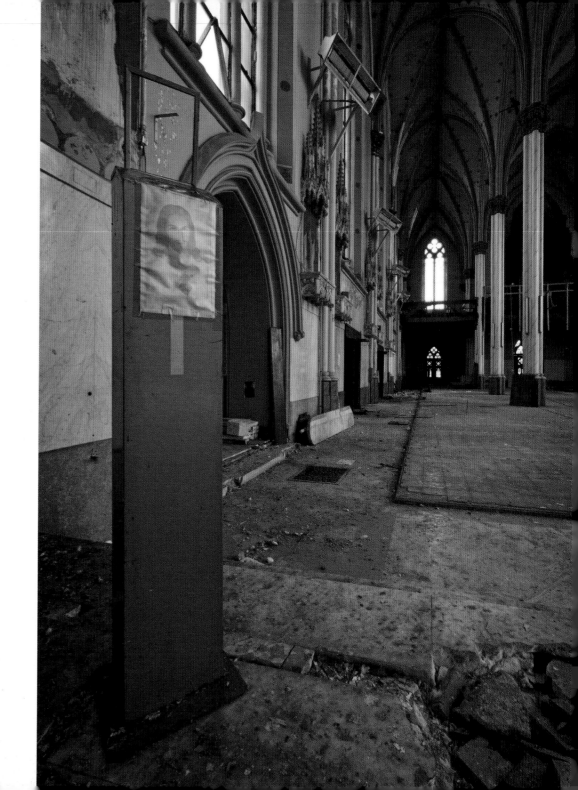

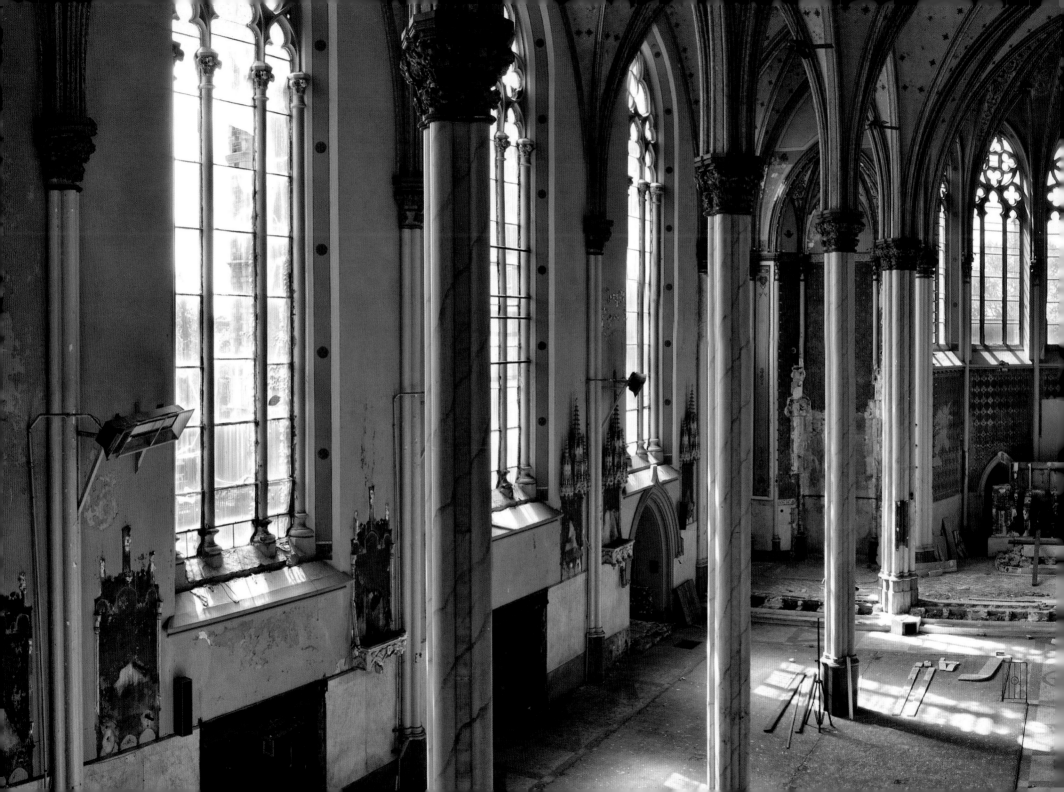

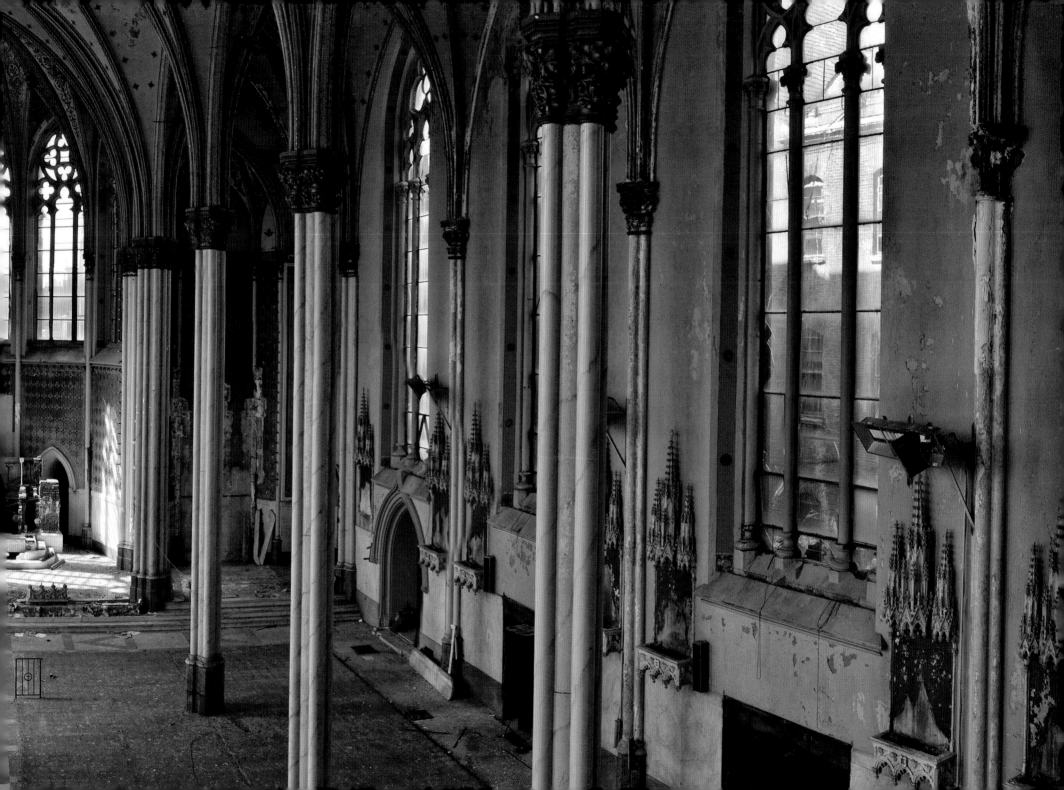

St. Bonaventure Roman Catholic Church

St. Bonaventure Roman Catholic Church in the Fairhill neighborhood of Philadelphia was designed in 1894 by Edwin Forrest Durang, who built over 100 ecclesiastical structures in a typically Roman Baroque style. Fairhill's large population of German Catholic immigrants had been drawn there by the prospect of work at the myriad of industries in the area, which included iron foundries, soap and textile factories, lumber and coal yards, and a coffin factory among others. Some immigrants were also fleeing the persecution of Catholics in Germany at the time. A University of Pennsylvania report stated that one reason for the foundation of St. Bonaventura parish was that a neighborhood inhabitant "had tired of traveling to the German parish of St. Boniface on Norris Square, twelve blocks to the east of his home."

Named after a 13th-century philosopher known as the "Seraphic Doctor," the Gothic church that would serve the parish took twelve years to complete due to limited resources. It was a difficult project that required a tremendous amount of perseverance, sacrifice, and hard work by members of the neighborhood. Many of the church's architectural features were either directly imported from Germany or created by local German craftsmen. The interior was adorned with marble wainscoting, two-story marbleized columns, and gold leaf stenciling, and the Munich Pictorial Style stained glass windows were produced by highly regarded companies in Philadelphia, Dusseldorf, and Austria.

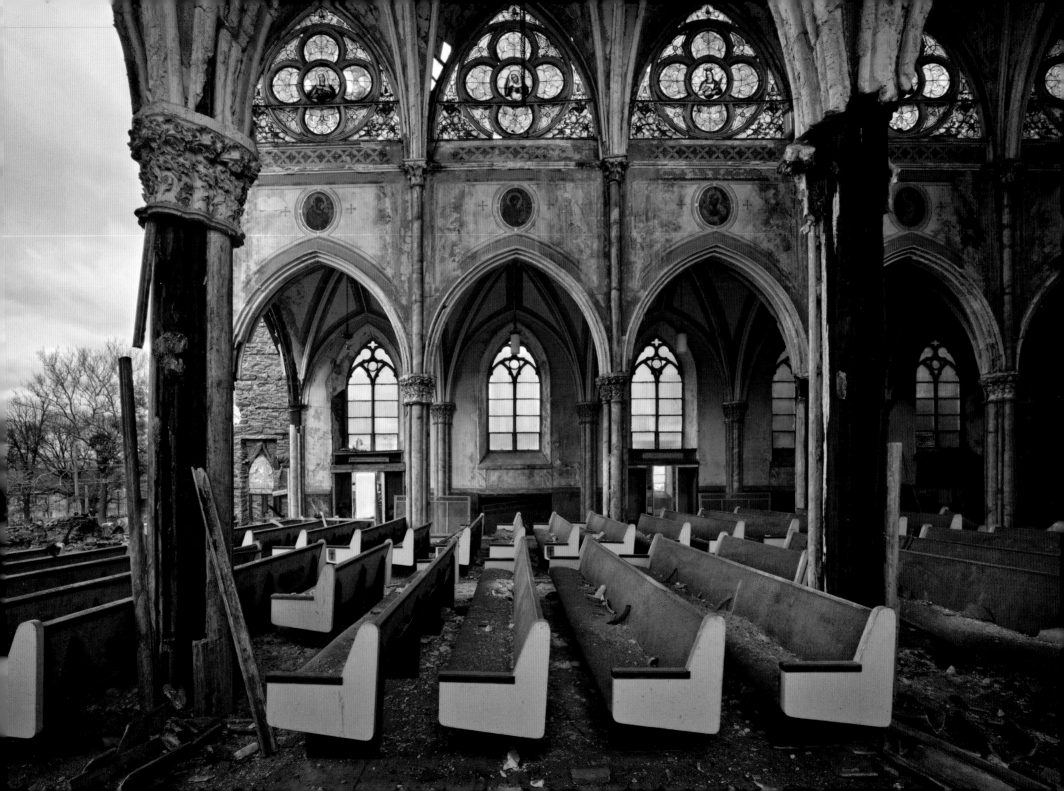

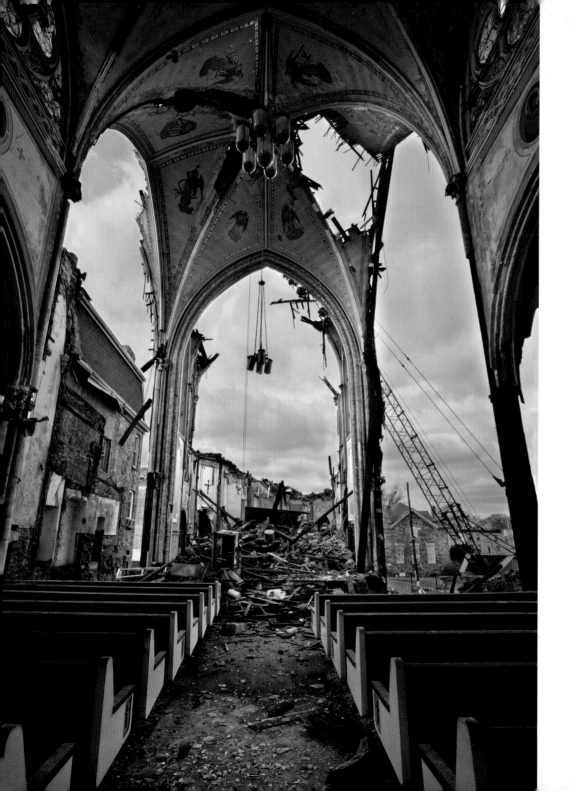

The eighteen-story clock tower topped with a gilded cross was one of the most notable architectural features of the neighborhood, which also boasted the late-17th-century Quaker cemetery half a block away, where Lucretia Mott was buried. Ethnic segregation at the churches operated for many years; the Irish Catholics were directed to St. Edward's parish, and a German mass was held at 7 a.m. every morning.

In the period following World War II many of the European settlers left the area, to be replaced by African Americans brought in partly because of redlining, and a Puerto Rican population who had migrated to find work in the sugar, tobacco, and cigar companies. The area's industrial base eroded significantly, taking a heavy toll on the local economy. Violence and crime were major problems from the 1970s to the 1990s, with Fairhill placed squarely within the area of Philadelphia that came to be known as "The Badlands." The church's first Spanish mass was held in 1975; by the 1990s, the German population had almost entirely moved to other areas.

St. Bonaventure was closed in 1993, along with many other north Philadelphia churches in lower-income neighborhoods. It was later sold to the New Life Evangelistic Church, who left it vacant for years with what appeared to be very little effort to maintain the building. During this period the copper roof was partially stripped and thieves stole windows, water pipes, and other items. In 2013 the Department of Licensing and Inspections (L&I) deemed the steeple in imminent danger of collapse after visiting it following complaints about slate shingles falling from the roof during Hurricane Sandy. While Rev. Carswell Jackson was quoted an estimated $77,000 to stabilize the steeple, L&I opted instead to spend approximately $1 million of taxpayer money to tear down what was widely considered the neighborhood's most significant remaining architectural feature.

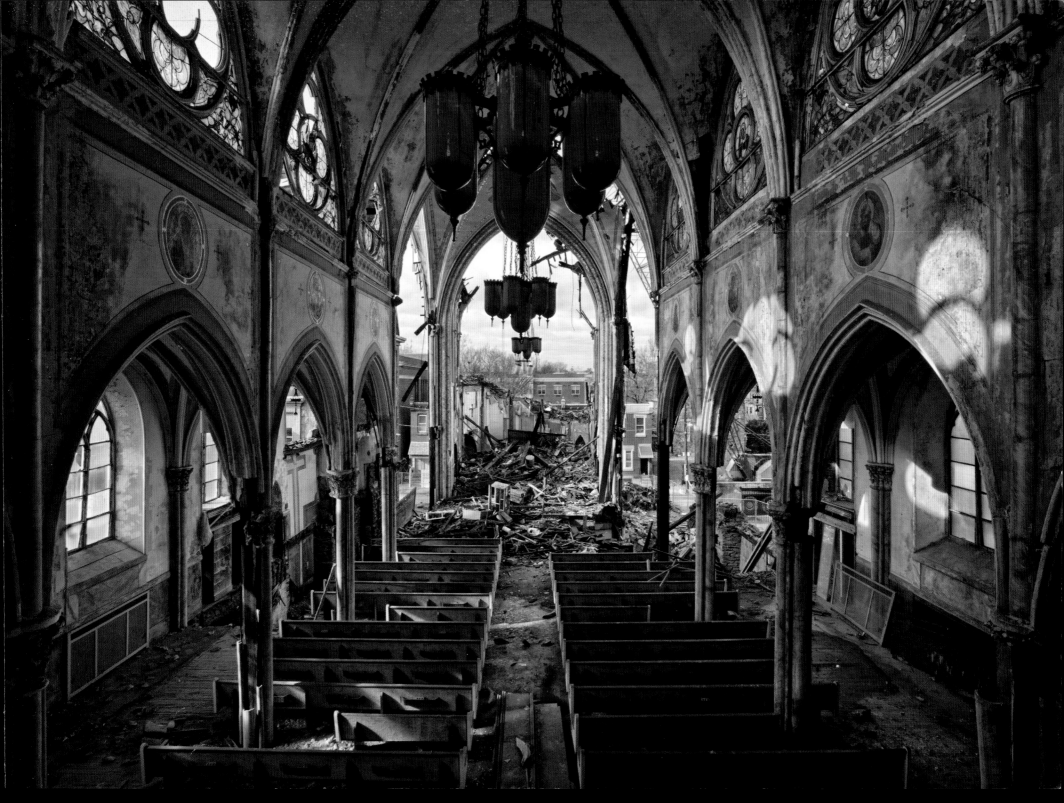

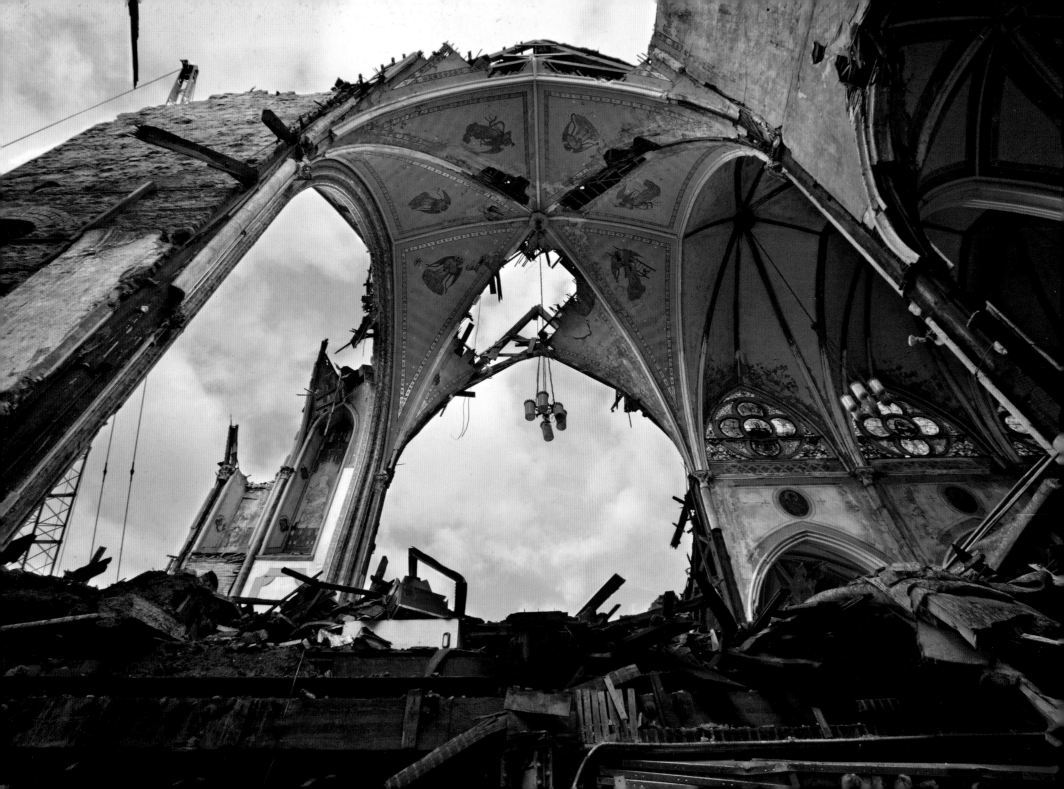

I had tried unsuccessfully for six years to find a way of photographing the church. The owners were impossible to contact and seemingly never at the property. When I finally got there, most of the apse and transept had been shredded by a demolition company. It was a sickening sight. I wish that people would stop viewing cathedrals (and, by extension, all faith-related structures) as symbols of religious doctrine. Regardless of one's beliefs, these buildings must be valued for the effort and artistry involved in their construction, and for the irreplaceable collection of cultural and historical artifacts they frequently contain.

The destruction of a true work of art is never something to be celebrated. The erasure of a beautiful cathedral like St. Bonaventure is a tragedy for us all—something that was of incalculable value has been senselessly destroyed. The city created this situation by allowing the New Life Evangelistic Church to let St. Bonaventure fall into ruin. Rather than rectify their mistake, they tore an enormous hole (both literally and figuratively) in the community, leaving what will probably become a trash-strewn lot like the one that occupies the space where Transfiguration used to stand.

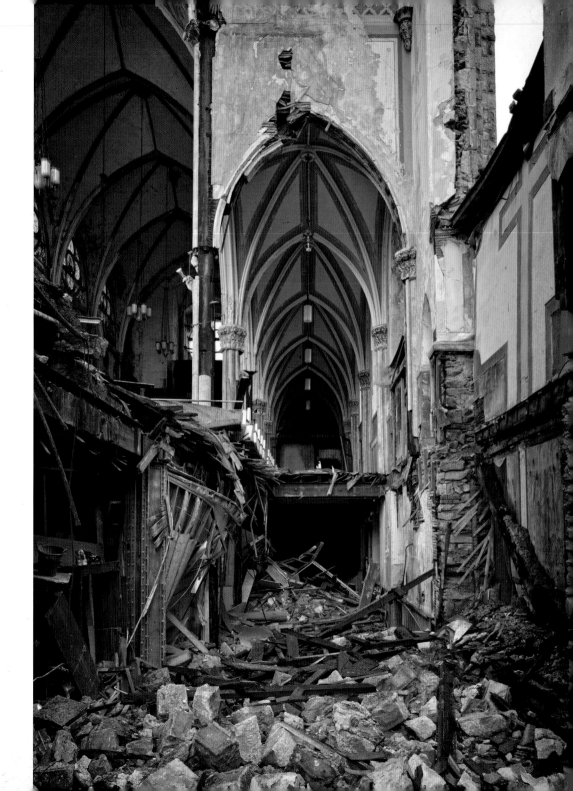

Huber Breaker

The Huber Breaker was built in 1939 by the Glen Alden Coal Company in Ashley, Pennsylvania to replace their Maxwell #20 breaker. Named after Glen Alden Chairman Charles F. Huber, the Huber Breaker produced Glen Alden's famous blue-dyed anthracite coal. Coal was shipped in via train from local mines and onto a conveyor. The conveyor transported the coal to the top of the breaker, where young boys would pick out slate, rock, and bone by hand, sometimes losing fingers in the process.

After the coal was sorted, it began a descent through the eleven-story building's machinery, which would clean and crush it. The Huber Breaker could produce 7,000 pounds of coal per day and at its peak employed 1,700 people. At the height of the coal boom in Pennsylvania, there were 300 breakers of varying sizes in the surrounding two counties; Huber was one of the largest.

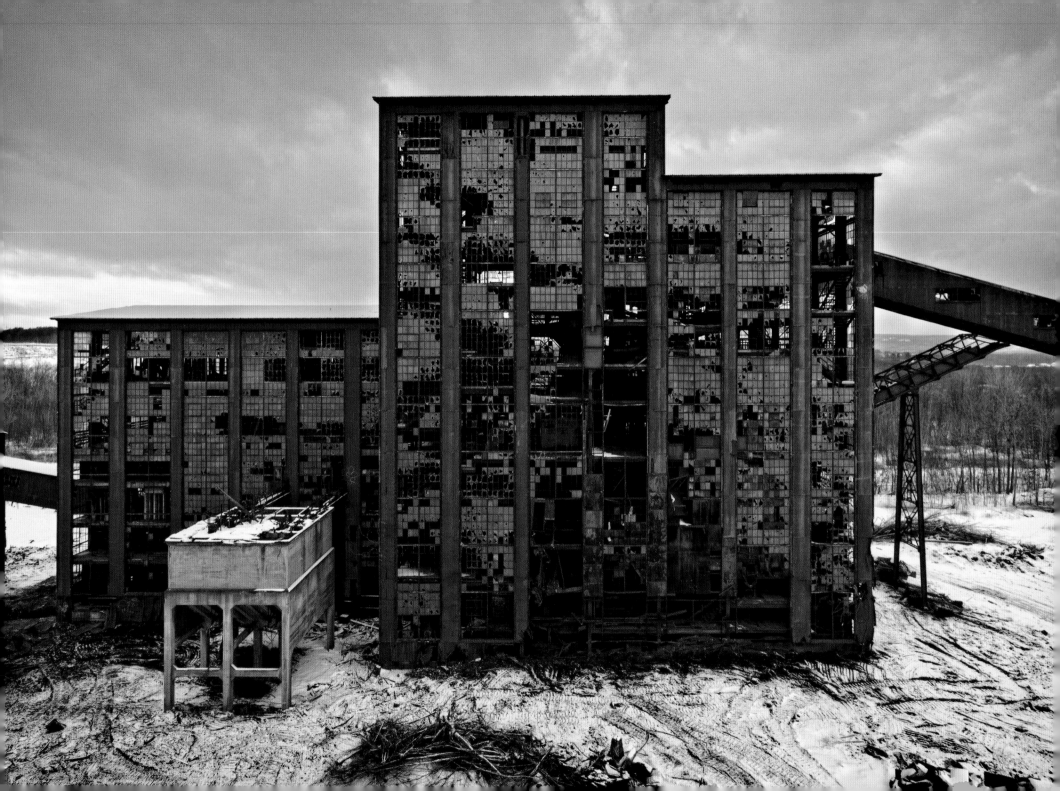

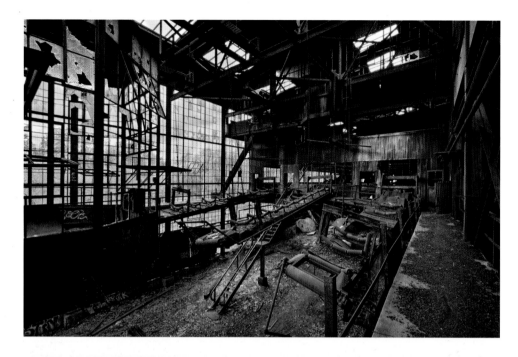

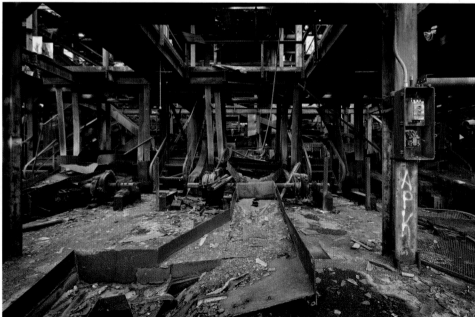

As oil and natural gas replaced coal as fuel sources for heating homes after World War II, many of the collieries struggled and either closed or operated at reduced capacities. Diesel-burning locomotives replaced coal-burning ones, and oil and nuclear power plants replaced ones that used coal to generate electricity. By the early 1970s, the Huber Breaker operated as the Lucky Strike Coal Company. The colliery ceased operations in the late 1970s. Lucky Strike was later fined by the Department of Environmental Resources for illegally discharging wastewater into a nearby stream and went bankrupt in 1991. Documents released during the bankruptcy proceedings have led to speculation that former Teamsters' President Jimmy Hoffa's disappearance may have been related to his association with shady land deals involving the Huber Breaker in the mid-1970s.

After its closure, the Huber Breaker sat abandoned for years and remained Ashley's most visible structure. It became a popular hangout for local youths and a well-known destination for urban explorers despite the fact that some of the interior was badly deteriorated and extremely dangerous. The structure had actually weathered the elements comparatively well due to its tar-coated sheet metal construction. Efforts to preserve the site as part of the region's heritage seemed to be gaining traction, and it was hoped that tourist revenue would prove more beneficial to the area in the long run than the scrap value of the estimated 900 tons of steel in the structure.

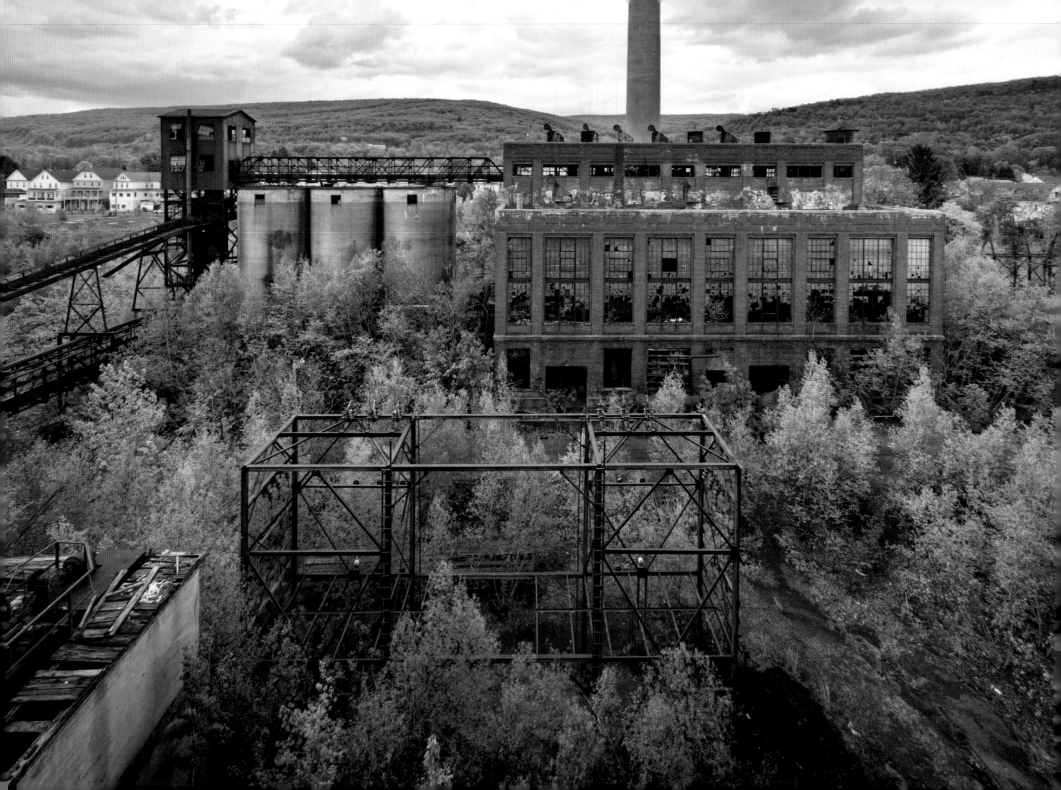

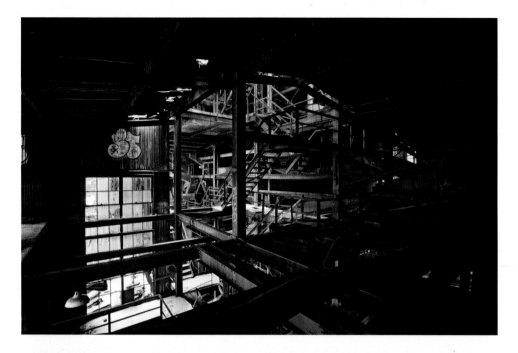

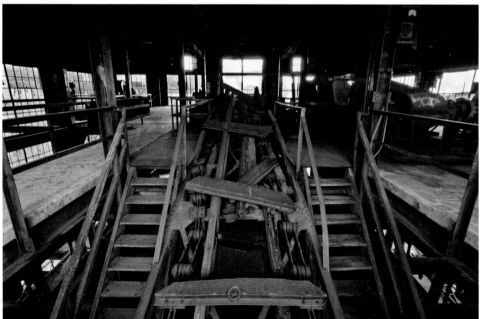

In 2013 the building was sold to Paselo Logistics, LLC, who planned to scrap it. There were concerns about asbestos and other pollutants that would be released when the breaker was torn down and the demolition was briefly halted. When the breaker finally came down in 2014, however, an enormous black cloud of dust billowed hundreds of feet into the air. One woman filming the event unhappily observed that it was moving toward the section of town where her house was.

I photographed the Huber Breaker many times over the years and always marveled at how unique and intricate it was. It is an odd sensation to be inside a tremendous, decaying machine. Watching the video of it collapsing, I felt an unexpected ache. The old colliery had been abandoned for longer than I have been alive and somehow I expected it would always be there, a shadow of Pennsylvania's vanishing coal-mining past. Like a riddle no one knows how to solve, these places show us how foolish we are when it comes to placing value on the things that formed our identities. Beyond the financial motives, beyond the hollow promises of progress and hope and healing, I sometimes wonder if we cannibalize our own past specifically so it can no longer stand defiantly out in the open and challenge us with the daunting prospect that the proudest technological achievements of today will be little more than fodder for the scrap heap of tomorrow.

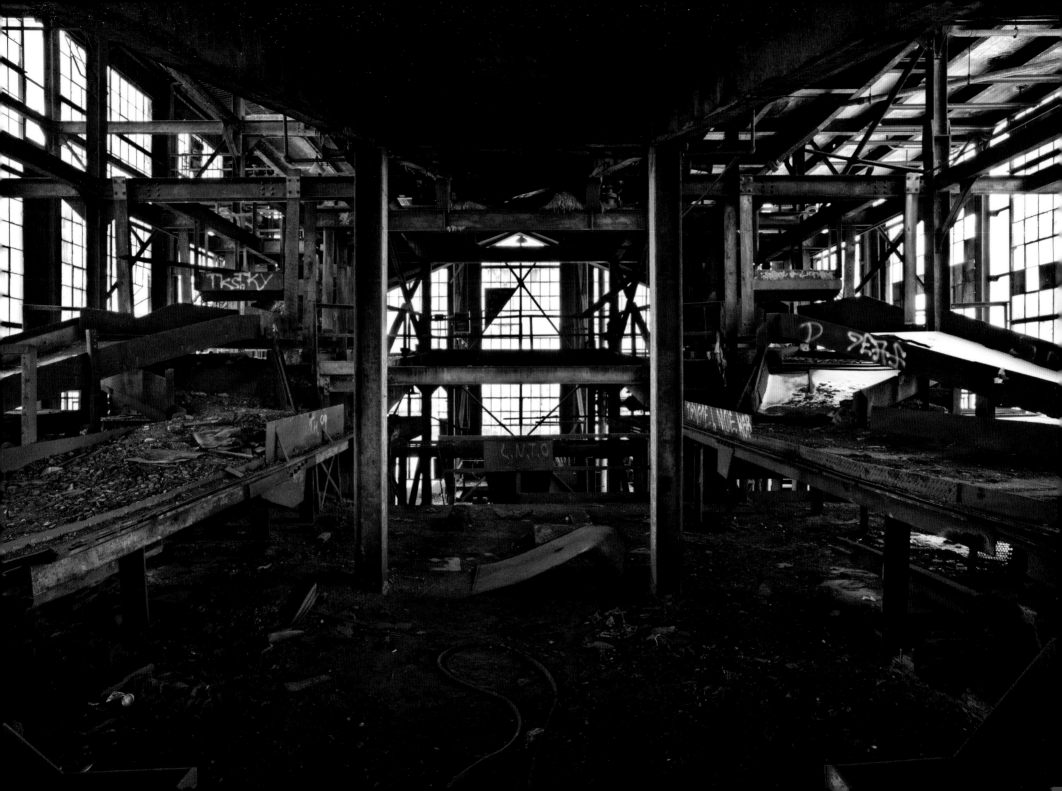

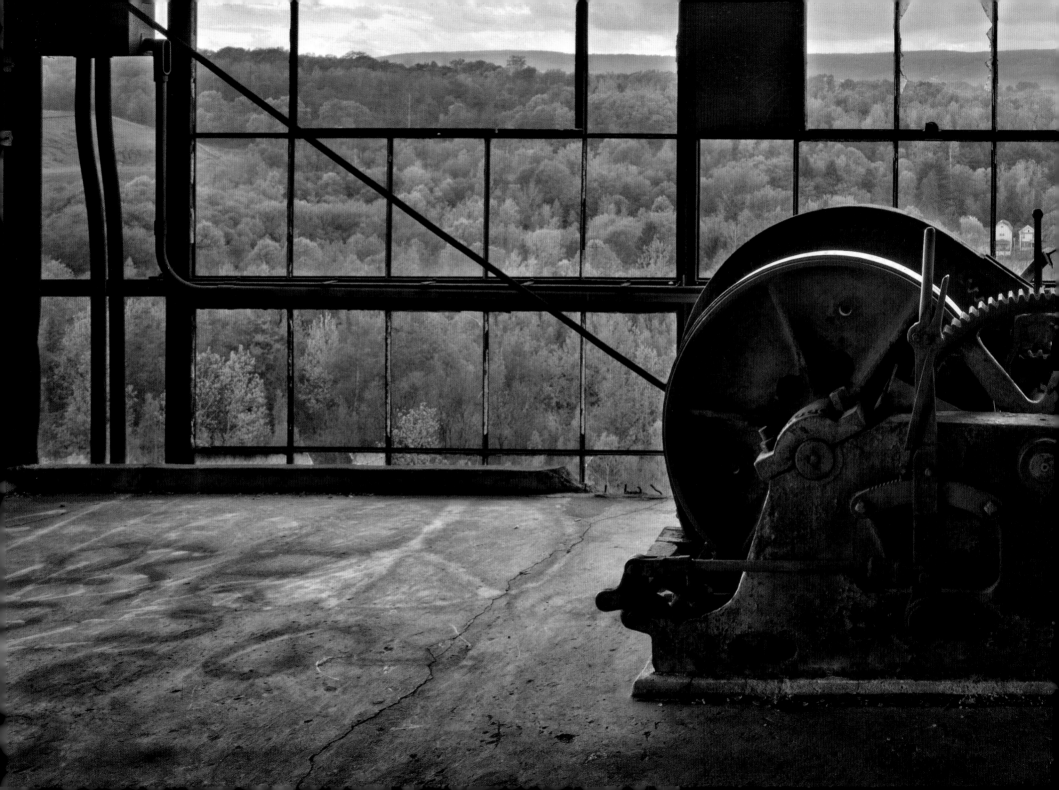

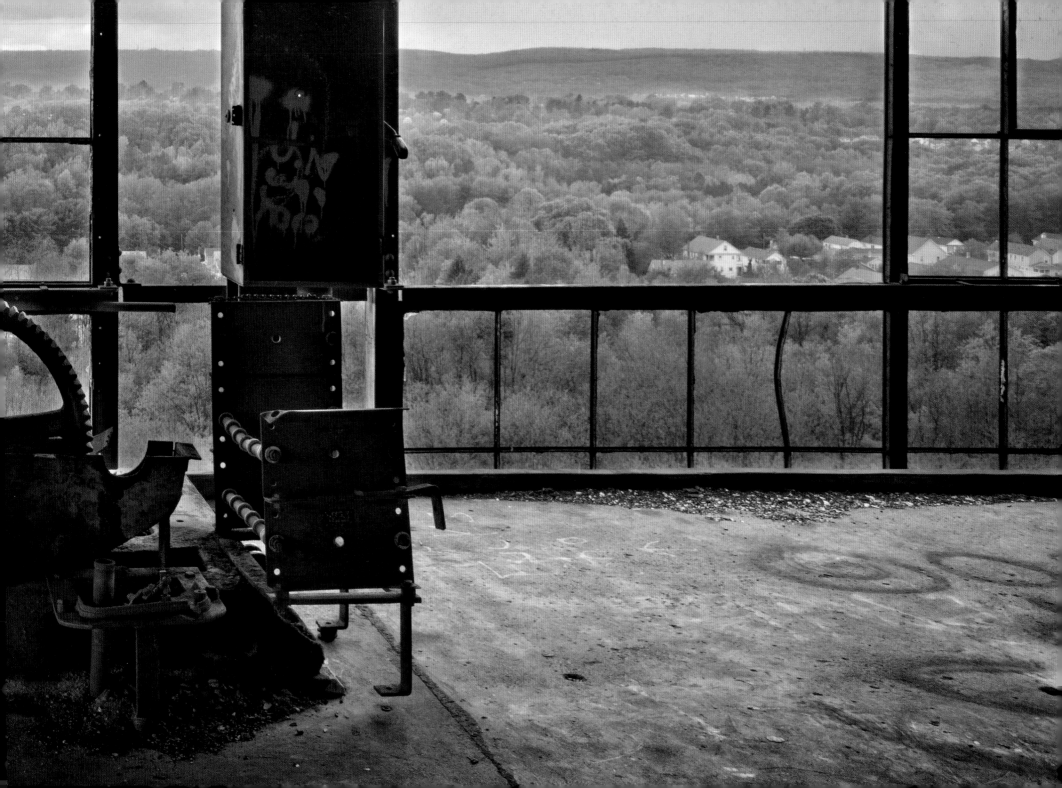

Scranton Lace Company

Established in 1890 and incorporated seven years later, the Scranton Lace Company was one of the premier manufacturers of a variety of textiles ranging from tablecloths, napkins, yarn, and laminates to many others—including Nottingham lace, for which it was famed. During World War II the company produced parachutes, tarpaulins, and mosquito/camouflage netting for the Allies. An enormous factory complex that once employed 1,200 people and boasted its own gym, barbershop, theater, four-lane bowling alley, and an infirmary for its employees, the Scranton Lace Company even owned its own cotton fields and coal mine offsite. Overseas competition and poor investments in television studios led to a slow decline in the textile mill's prominence. In its final days, the staff had dwindled to fifty (given the size of the buildings, one wonders how often they even crossed paths) and had average annual sales of about $6 million. In 2002 the company finally shut its doors mid-shift, telling employees that the factory was closed: "effective immediately".

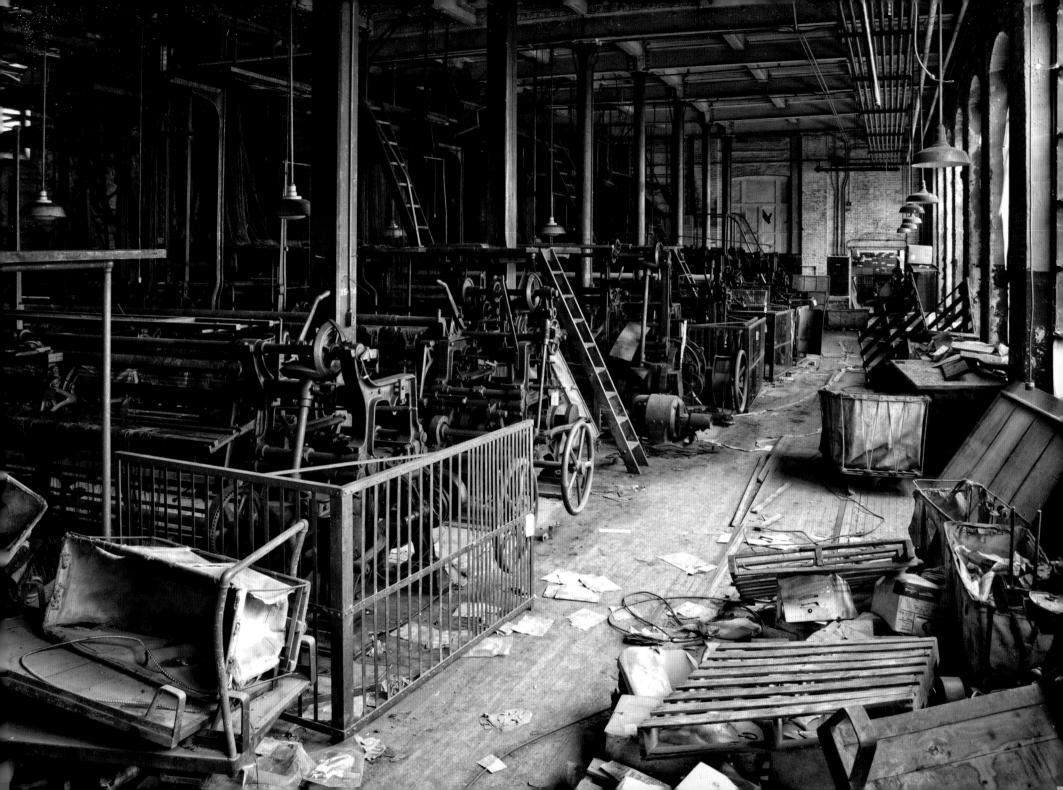

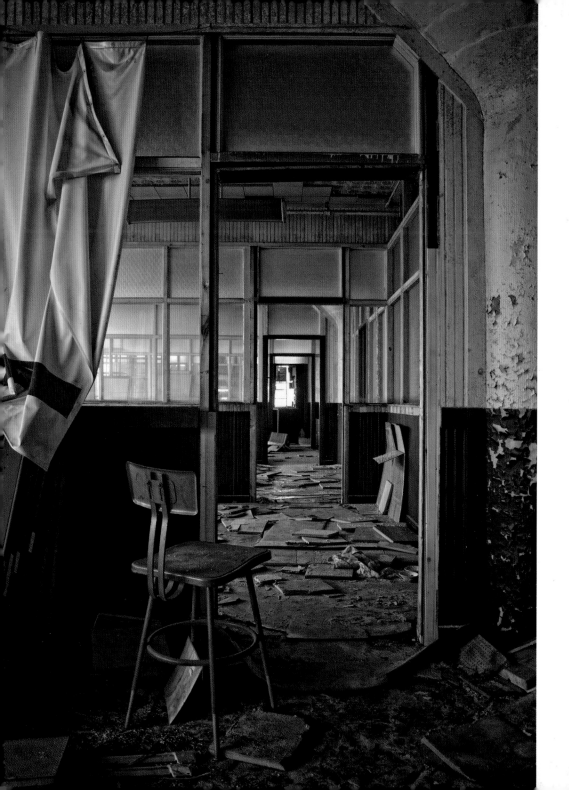

The 8.4-acre site has been purchased by Lace Building Affiliates LP, who were awarded over $5 million in state grants for a redevelopment project intended to turn it into apartments and retail space. Many of the interior artifacts have been stolen, scrapped, or sold. Of the nearly one dozen Nottingham looms—each weighing 20 tons and measuring 50 feet in length—that were imported from England to produce the iconic Scranton lace, only one now remains, unprotected from the elements. I have visited this site many times over the years and watched with dismay as it has disappeared bit by bit.

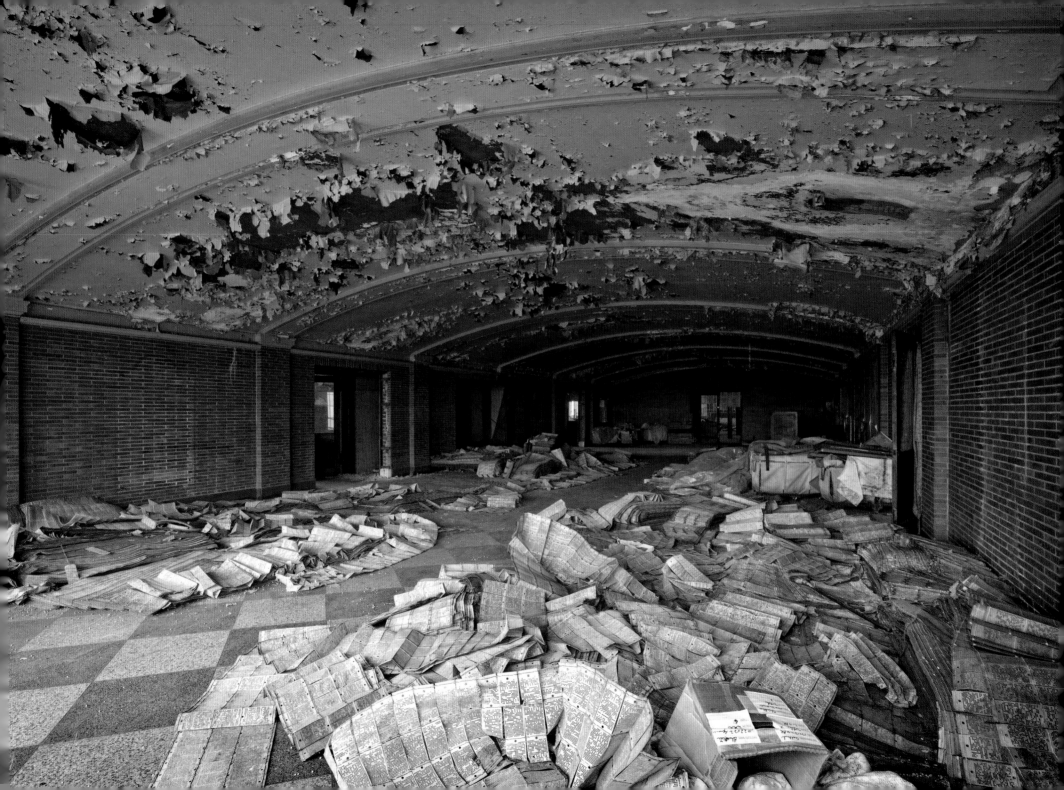

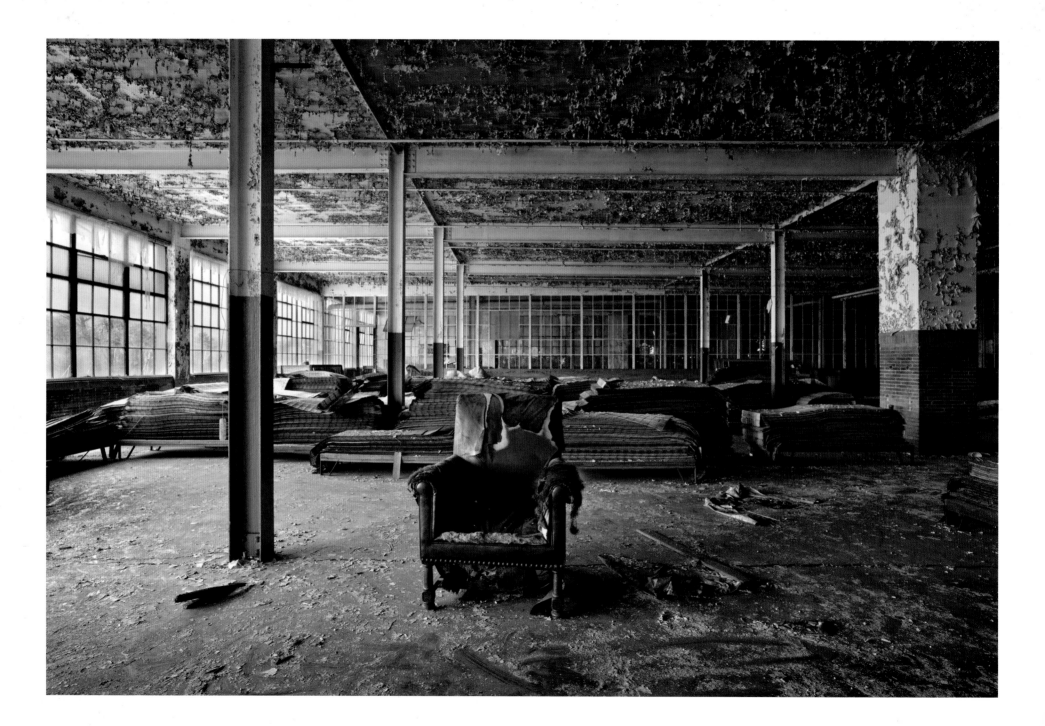

I desperately hope that Scranton Lace, whose clock tower was once a symbol of the city's prosperity, will be restored as a functional part of the community and that something will remain of what it once was. You can still find fleeting glimpses of Scranton's golden years—a handful of scoring sheets in the bowling alley; a pallet with Victory Parachutes stamped on it if you know where to look; a graffiti-covered fireplace in one of the heavily vandalized lounges. The sad, battered Nottingham loom, which I have heard is the last in the United States although I am unable to confirm it, is still threaded with the tatters of the lace being producing when the factory closed, as though waiting for someone to return and put it back to use. Perhaps that's just projecting my own feelings on an inanimate object. I am certainly waiting for it too.

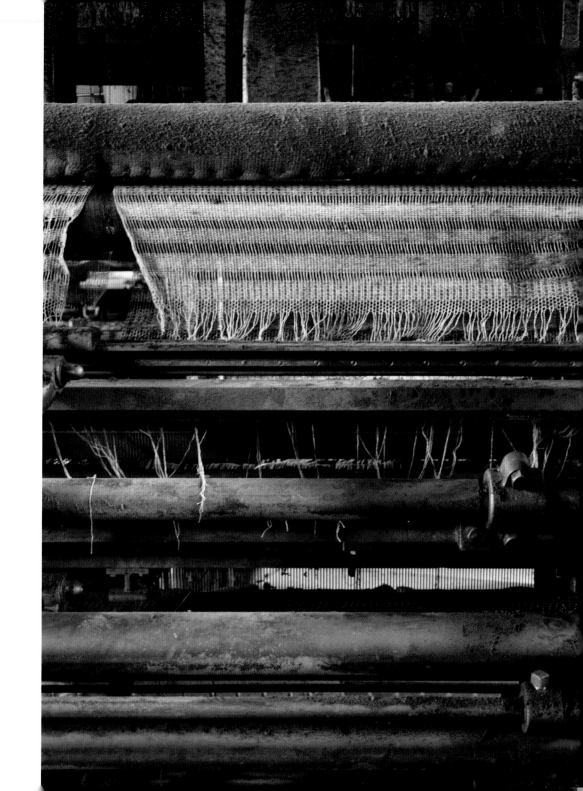

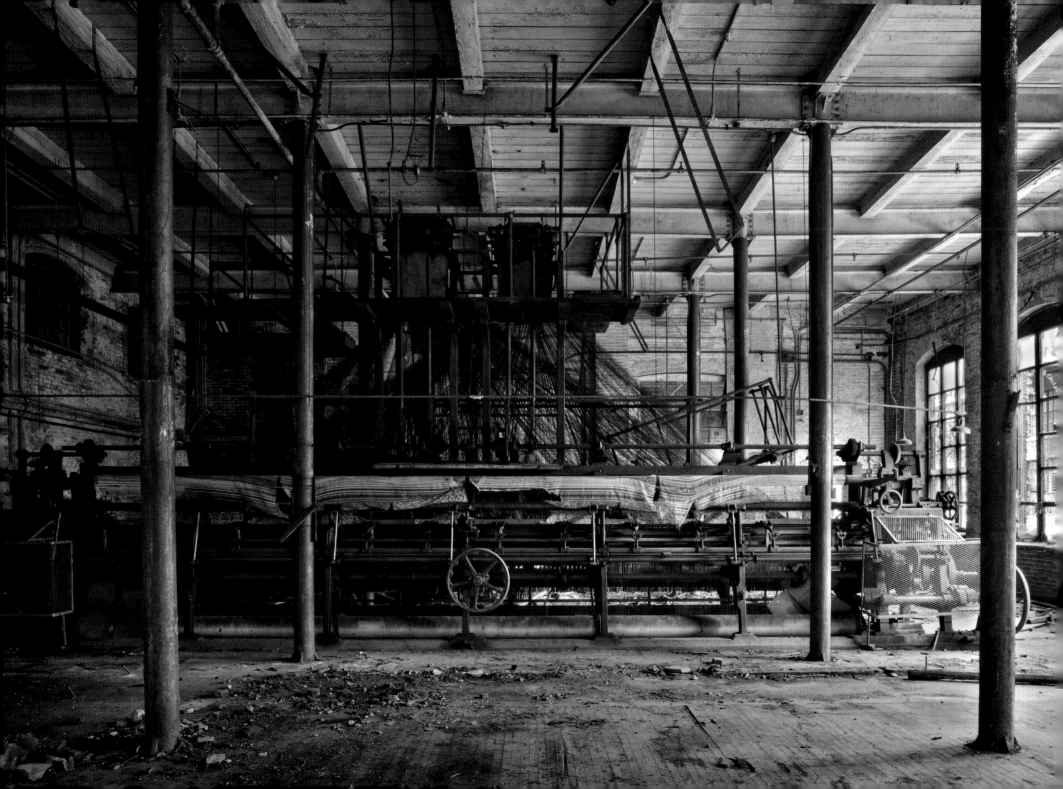

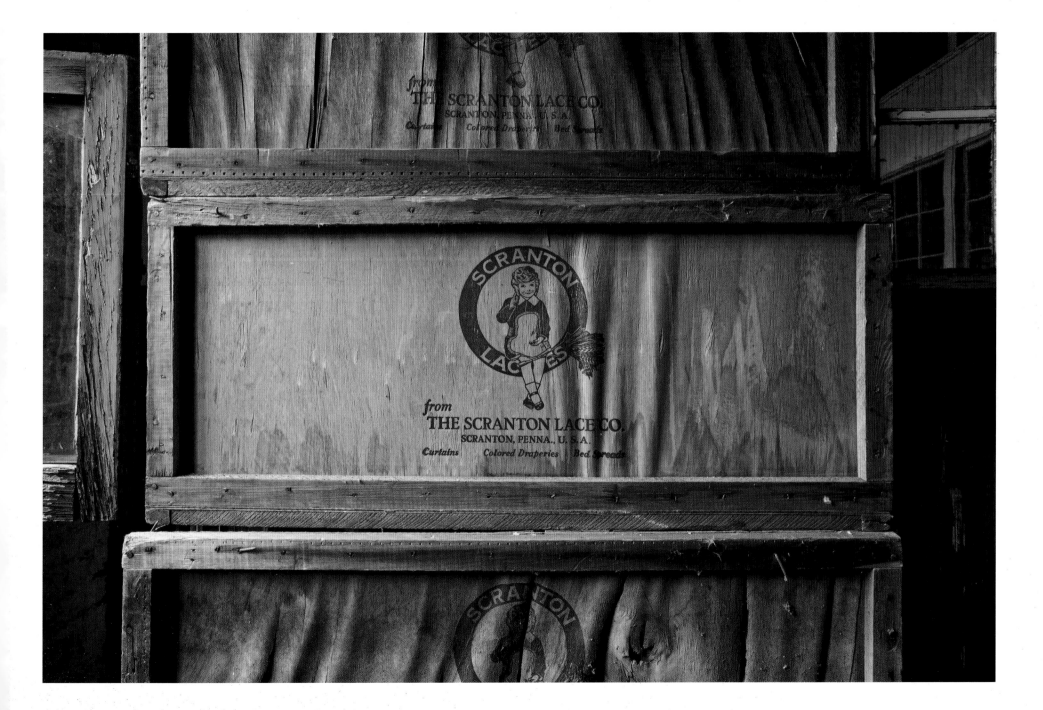

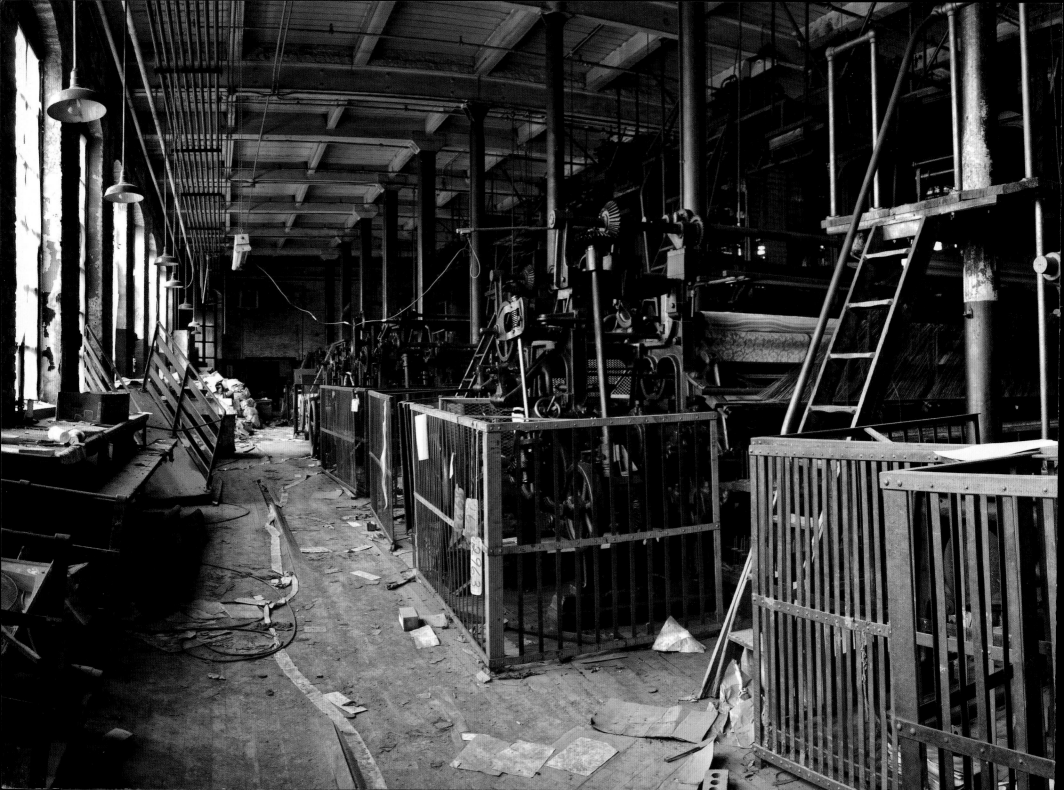

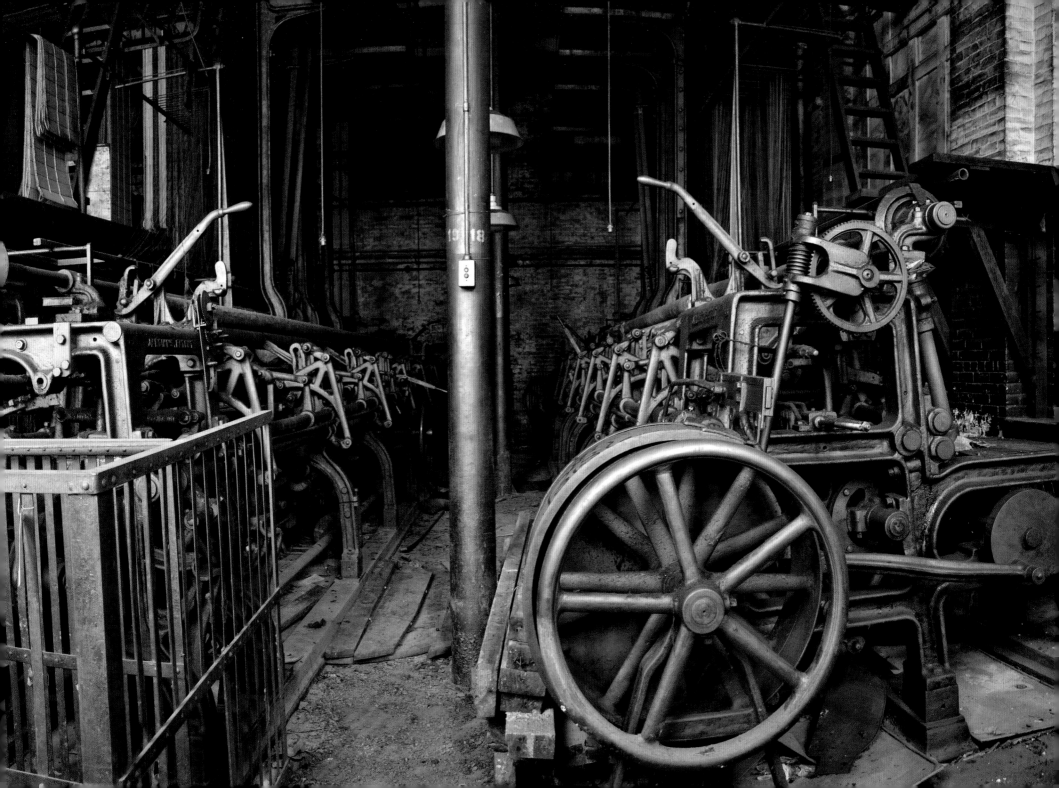

Westport Generating Station

Built to serve the rapidly growing industrial base around it, the Westport Generating Station was opened in 1906 on a 12-acre parcel of land on the bank of the Middle Branch of the Patapsco River in Baltimore. This was the same year that Consolidated Gas Electric Light & Power Company, Baltimore Gas & Electric's predecessor, absorbed all competing electric companies in the city, as it had done with all rival gas companies eighteen years previously. Westport, originally a steam plant, was at the time of its construction reputed to be the largest reinforced concrete building in the world. Using concrete rather than wood made the plant fire-resistant, and when Consolidated decided to merge all the smaller plants it had acquired in 1906 to one location in 1908, Westport was the natural choice.

At the time, Westport boasted the tallest smokestack in Baltimore at 209 feet and its steam and combustion turbines could produce 252 megawatts. Conveyors raised coal to an elevated railway that ran over the top of the plant and delivered it to the furnaces below. The 1940s were a prosperous time for Consolidated. Industrial output during World War II was high, leading the company to increase its generating capacity. In 1948 the Westport facility was expanded and renovated but by the 1950s the production of plastics had taken a toll on the nearby factories, and the community library and theater closed. Westport Generating Station closed in 1993 and the neighborhood's last surviving factory, the Carr Lowry Glass Company, closed a decade later, plunging the area into poverty and blight.

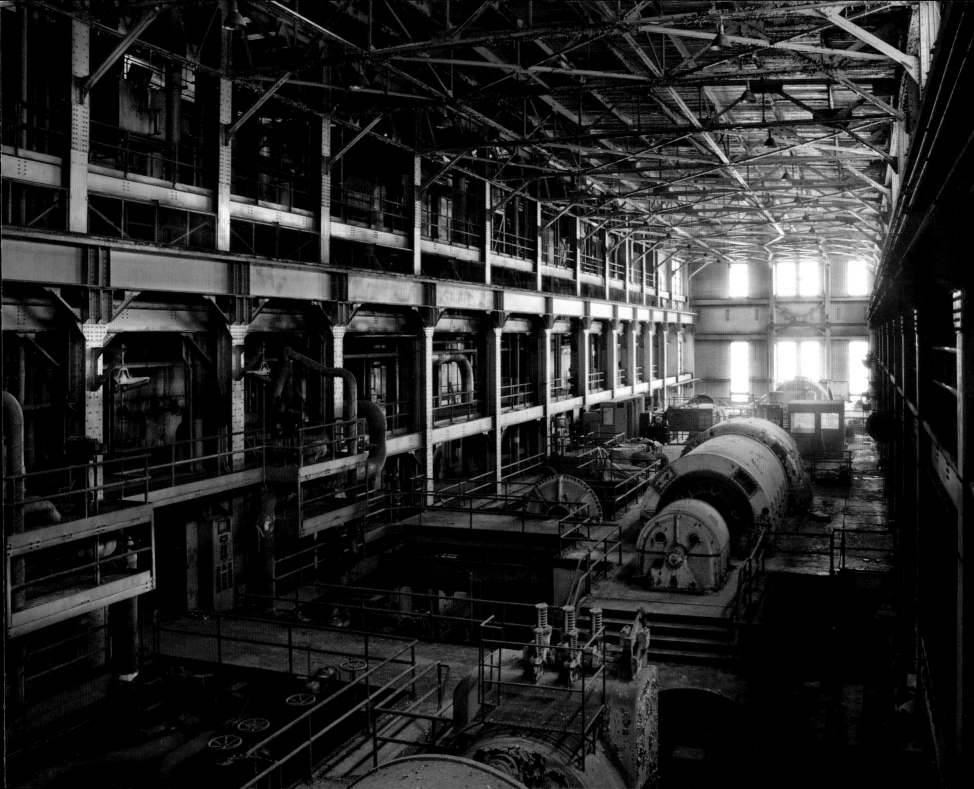

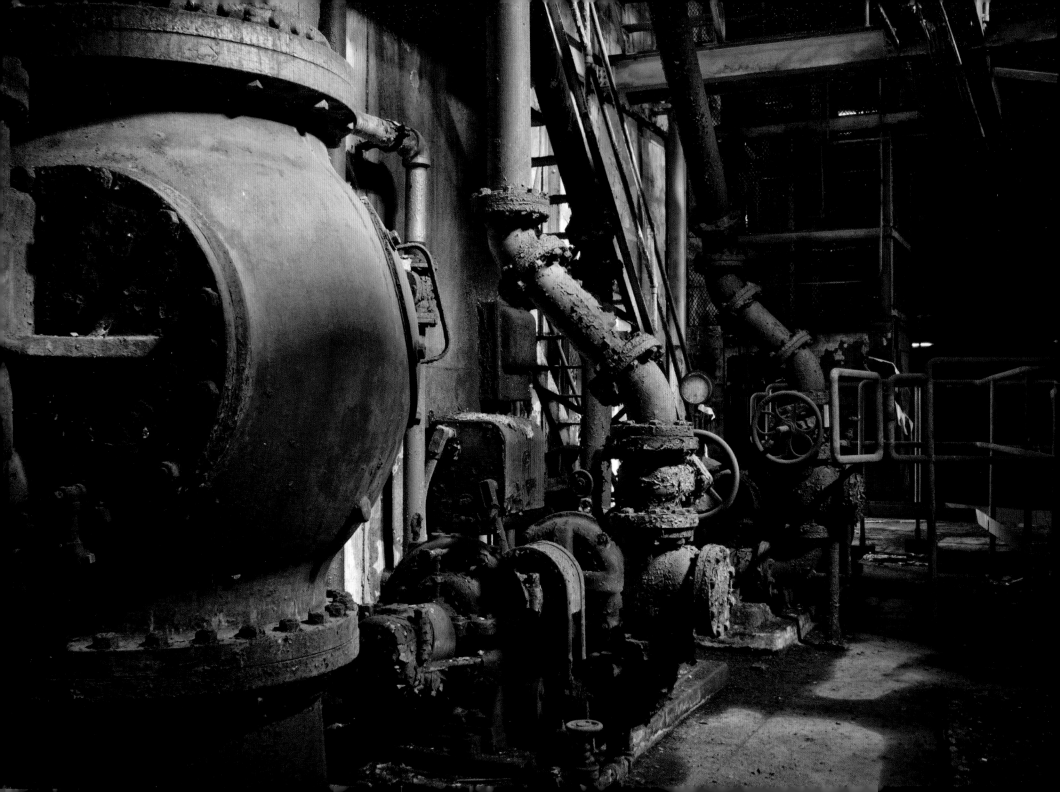

The generating station was razed in 2008 for a waterfront development slated to start construction in 2010 that has yet to materialize. Despite $160 million in funding from the city of Baltimore to return the brownfield site to a functioning part of the community, Westport Generating Station remains a relatively lifeless empty lot.

Of all the places I've visited, Westport remains one of my most favorite. The few people who managed to gain access before it was abruptly demolished still remember it fondly and frequently mention it when talking about spots they would go if they could turn back the clock. My first visit was fairly challenging—entry involved pulling myself up some pipes on the wall, and then wriggling into a hole in a ceiling about 10 feet off the ground, while contorting myself around the maze of pipes inside. When I finally emerged through a hole in the second floor, it was an enormous relief as falling through the pipes onto the concrete below would have been painful.

The plant itself was spectacular. The first turbine hall was gargantuan, but there were two more equally large turbine hallways behind it. The scale of the machinery and the building itself was unbelievable. When I had finished absorbing the grand vistas in the turbine halls, I entered the room at the bottom of the multistory furnaces. Soot-blackened machinery lined the hallways, and in the golden afternoon light shimmering in through the grimy windowpanes, ferns that had taken root in the furnaces glowed an enchanting green and complemented the surreal aura. Next, I made my way up the stairs along the furnaces until I arrived at the massive bins where the coal was dumped into the top. Even though it seemed that the site couldn't possibly be more fascinating, here was an elevated, narrow gauge railway that ran the coal cars around the top floor of the building.

Entering the railroad perched atop the labyrinthian network of turbine halls and furnaces was an abrupt shift between the waking and dreaming world. It seemed it must be an illusion; there was no precedent in my mind for such a thing. In my experience, railroads had always existed outdoors, on the ground. Yet here one was, stories above the turbine hallways where it seemed to have no business to be, softly lit by dusty sunlight. It was as though it had been randomly inserted into my consciousness by a misfiring synapse, as though it had never been built at all but had in fact always been there in the back of my mind waiting for me to find it. For a moment I felt I had seen a ripple across the surface of reality itself and could almost glimpse the murky forms beneath it.

The afternoon swiftly vanished and in what seemed like no time the building too was gone forever. Occasionally it would reappear in my memory but it seemed too odd and improbable to be real. If I told someone about it, surely they would think me a liar, but I had the photographs to prove it. These flickering collections of pixels were not only Westport's witness, but my own.

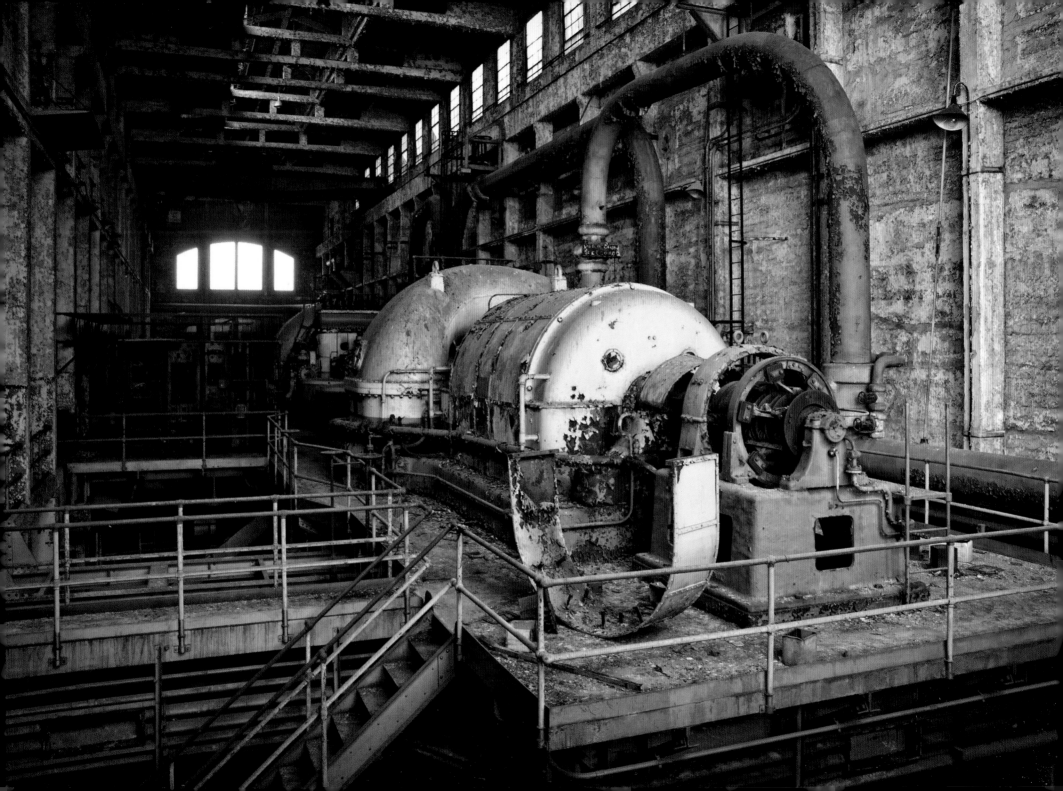

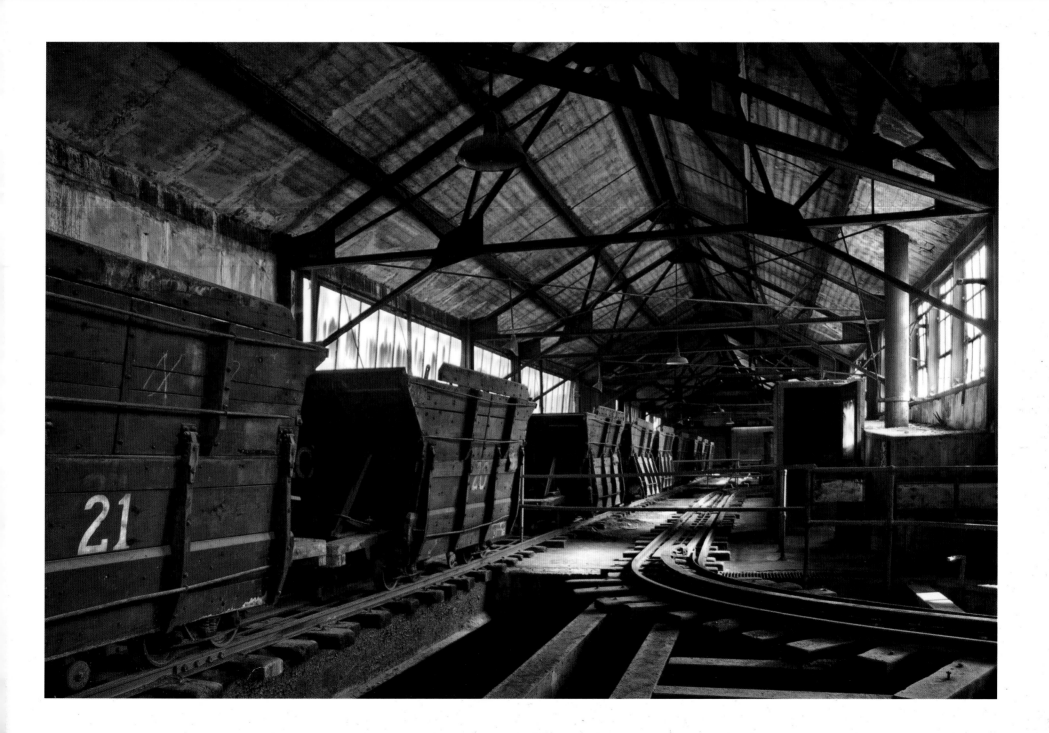

John Wilde & Brother

At the time of its closure in 2012, John Wilde & Brother, Inc. in Manayunk, Pennsylvania had the distinction of being the oldest continually operating yarn mill in the United States. When Thomas and John Wilde founded their carpet yarn business under the name John Wilde & Brother, Inc. (I can find no explanation of why Thomas wasn't named or what he thought about that), Manayunk was home to dozens of dye houses and textile mills. The area had transitioned from cotton production to wool during the Civil War, primarily to manufacture wool blankets for the Union Army, and the Wilde brothers were familiar with textile production from their jobs at an English mill in the 1850s. They began their business in rented space in 1880, and when construction was completed on their first stone mill building in 1884 they moved their operations there. Records show that their endeavor met with success, employing mostly English and Irish immigrants. At the time, there were 800 textile operations in the greater Philadelphia area, over 300 of which were dedicated to carpet yarn; by 1910 it would constitute 35 percent of the city's workforce.

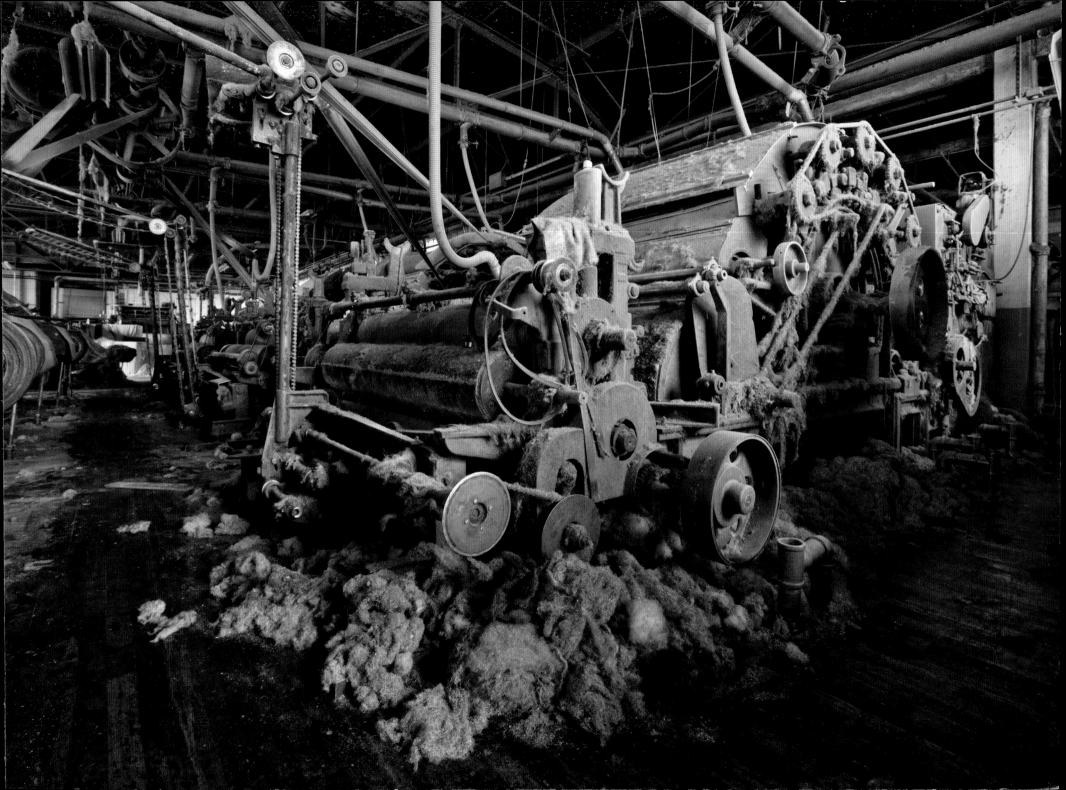

John Wilde & Brother remained family owned and operated, and a second mill building was added in 1932. The company's prosperity was directly at odds with the rest of the area's textile industries, however. Unionization and labor turbulence led to the closure or relocation of many of the textile mills in the 1930s, but Wilde remained small enough to dodge many of these difficulties. Between 1935 and 1940 their workforce tripled but in the 1950s business began slowing down. Synthetic fibers like nylon swiftly overtook wool in carpet production, and competition from imports became more of a factor. While Wilde remained primarily in the business of carpet fiber, they were forced to diversify to niche markets among craftspeople. Stockings, dolls, and handmade Navajo rugs were some of the products created using the specialty wool from Wilde. The factory's production capacity was 750,000 pounds of wool yearly, but demand was waning and actual output to meet demand was much less.

When John Wilde & Brother, Inc. finally closed, it was a quiet affair with little mention despite its significance. The site was quickly snapped up by a developer who planned to turn the old mill buildings into apartments, and much of the ensuing media discussion centered around the impact on local traffic and parking.

The developer was kind enough to allow several photographers, myself included, to document the site before the process of scrapping the machinery within the mill began. I had about a month. The site was astonishing: the machinery in some areas was over a century old, and the sensation of having found a perfectly preserved time capsule was intoxicating. Wilde was not as decayed as other places I have visited, partly because of the relatively short time it had lain unused, but it was in essence a museum of yarn-making technique from the late 1800s through the mid-1900s.

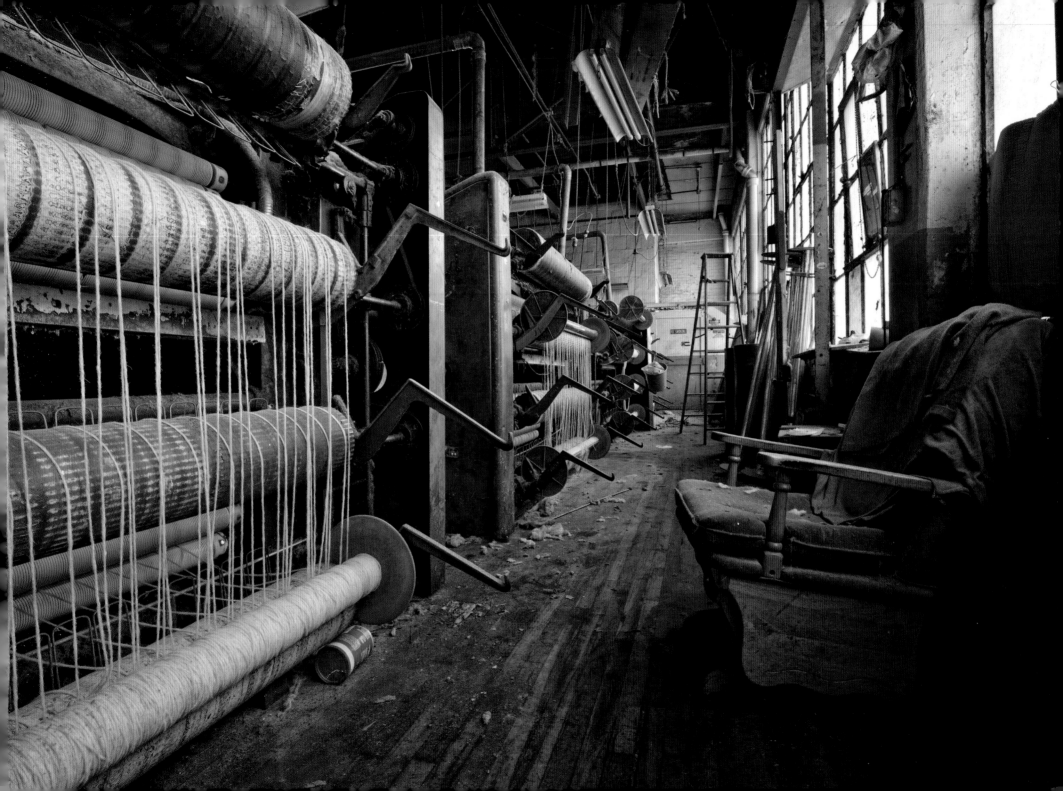

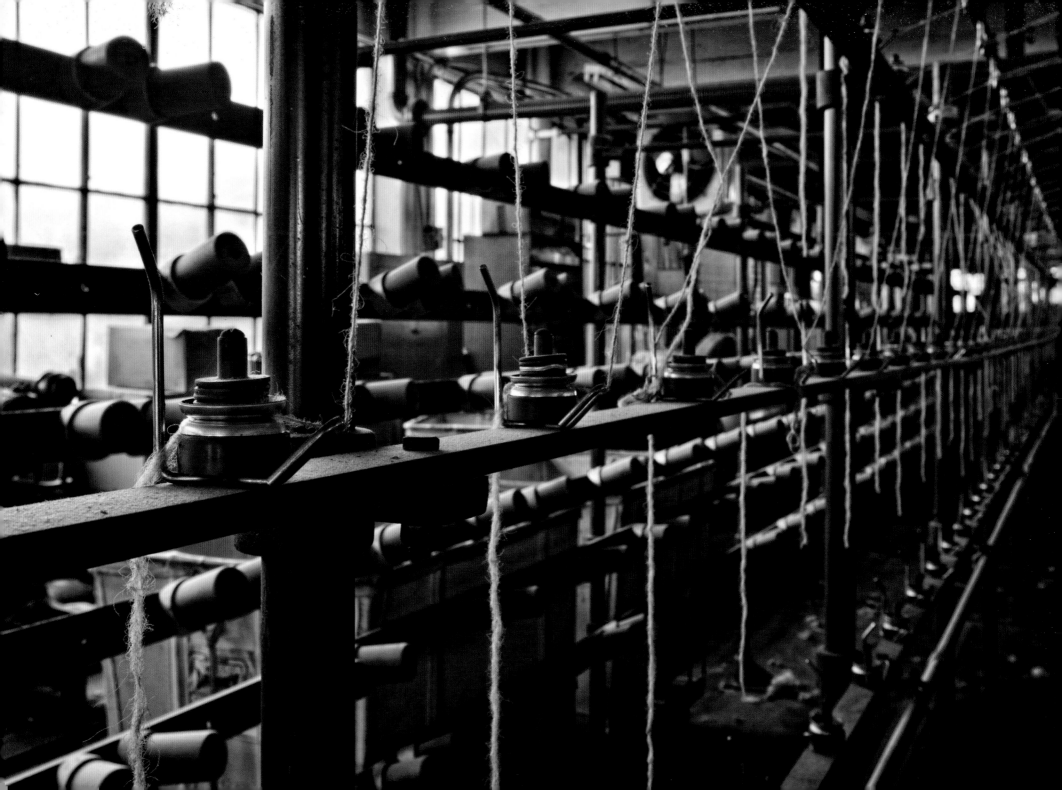

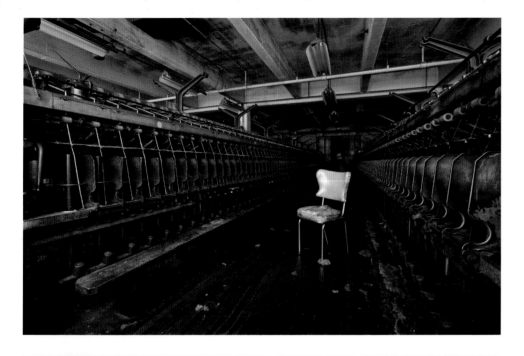

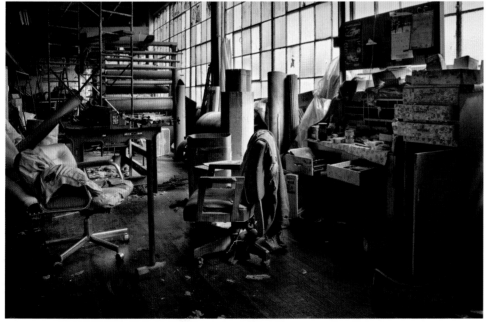

I don't fault the developer for wanting to move swiftly with the property: it's in a prime spot in a very trendy area and I suppose the business had run its course. I do wish that the surrounding community had expressed greater acknowledgement of the importance of John Wilde & Brother, Inc., but maybe I blinked and missed it. I did notice that with the proliferation of images taken by the lucky handful who managed to capture the interior before it was gutted, the conversation shifted in tone somewhat to its historical context. It has always been my hope that photographs can convey the magic and meaning of a place, and maybe in Wilde's case they had.

Time waits for no man, or so I'm frequently told. I'm a sentimental sort in some ways and I would like to have seen Wilde remain untouched, but that's unrealistic. I'm grateful that I had a brief moment alone with it to discover the little secrets it had hidden away over the years before they were gone, and to be able to share them with others who I hope will understand what made it wonderful. That's the power of an image: finding the heart of a moment and laying it bare so that others can see it and love it too, even after the physical point in time has been lost forever.

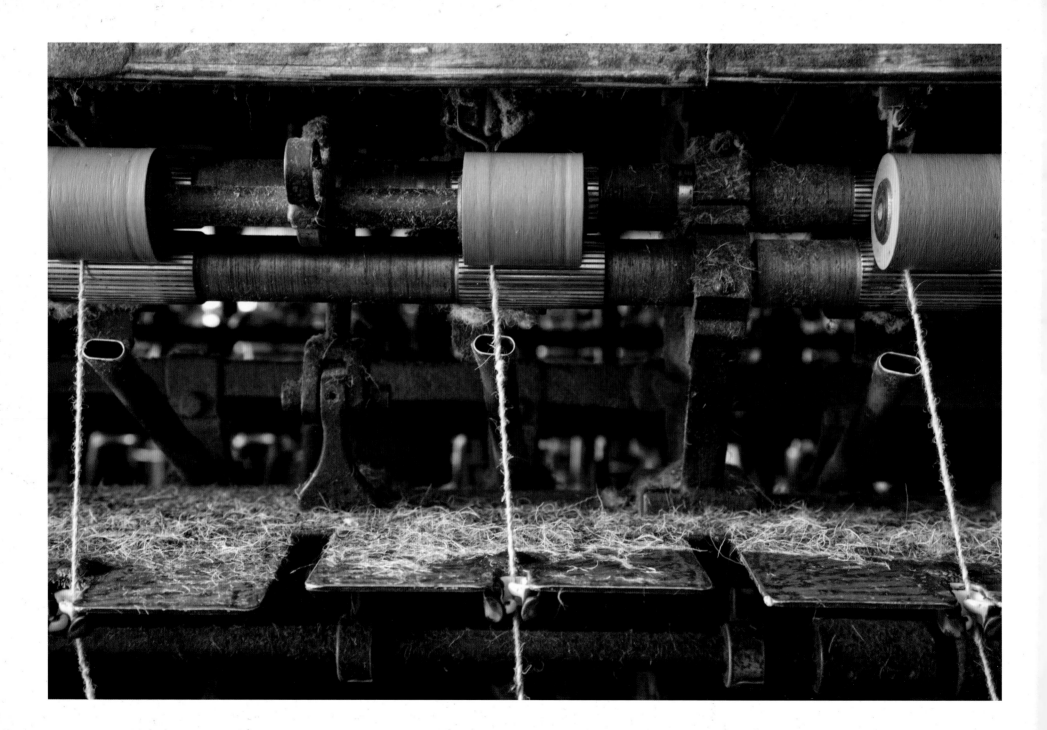

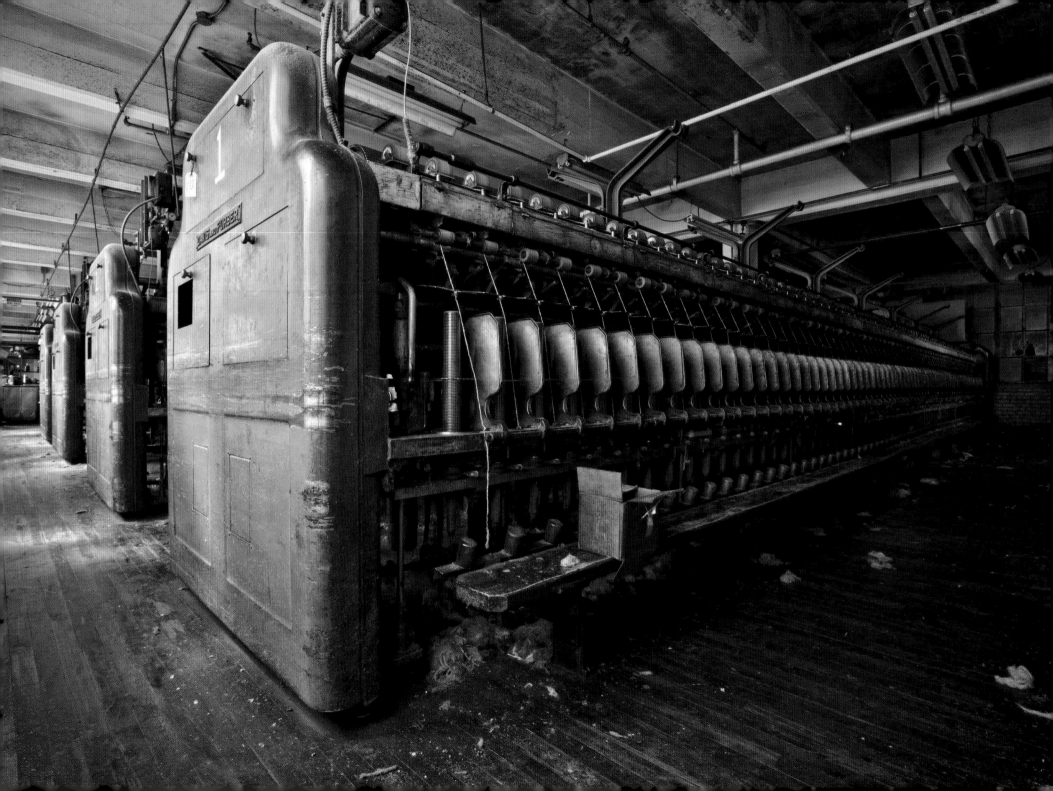

Atlantic Avenue Power Station

There is little information available on the coal-fired power plant I've renamed Atlantic Avenue Power Station to protect its location. Most news sources state it opened in the mid 1900s; some sources state it was in the 1920s but I believe this an error and rather the time when a massive consolidation of all the city's gas and electric companies occurred. For many years, the power station was the sole provider of electricity for the entire city, with well over 100,000 customers. The plant closed in the early 1970s as a result of the shift toward generating electricity via nuclear power. Nearly a decade ago it was sold to a developer but plans to rehabilitate it have been in limbo, mired in bankruptcy proceedings. The 50-acre waterfront property was slated to be repopulated with hotels, shops, restaurants, and an expansion of the nearby convention center, but two of its investors defaulted and litigation was required to remove them from the project. According to a 2013 news article, both the investors who had been removed and the development company that remained had histories of fraud and bribery.

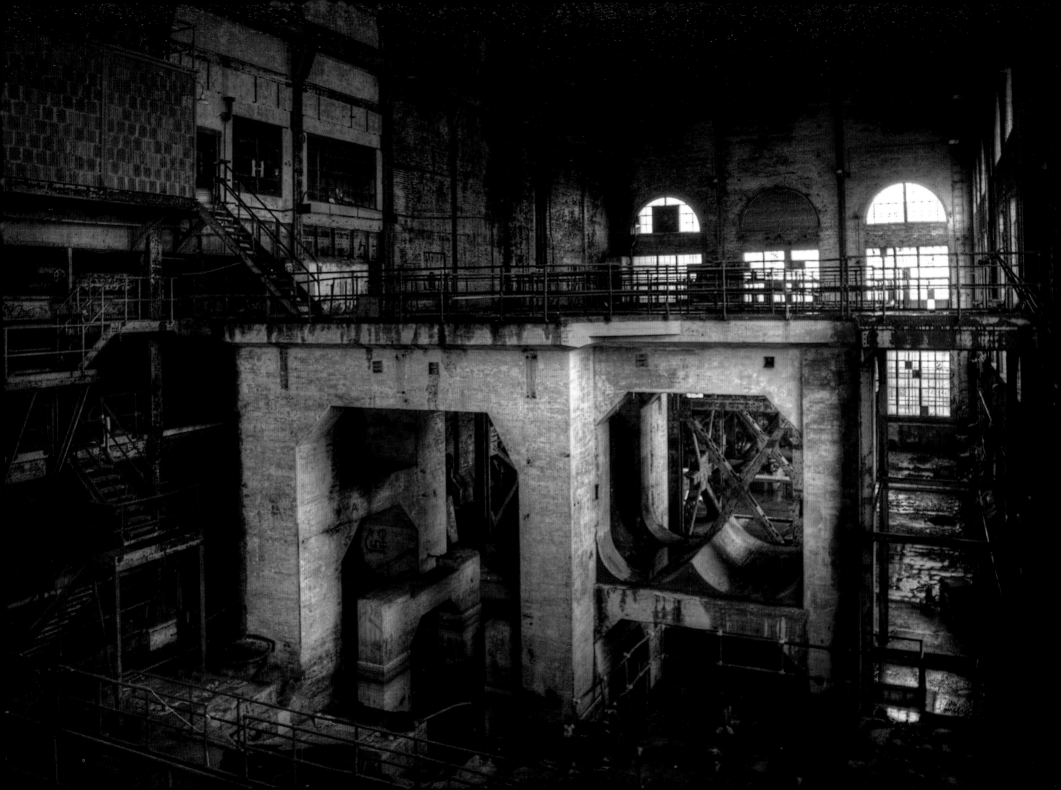

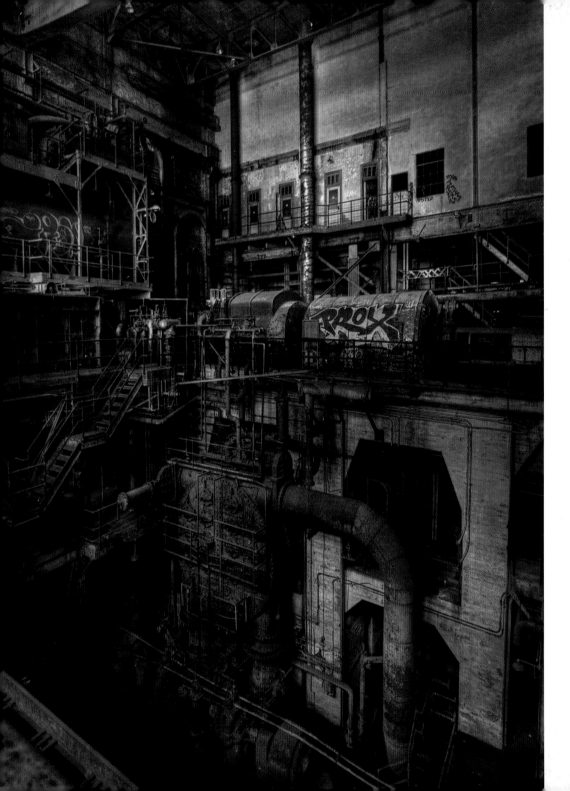

An ongoing corruption trial of the city's mayor includes testimony that the former Atlantic Avenue Power Station investors bribed him in a kickback scheme involving the plant and two other properties. While millions of dollars have been borrowed against the property, no apparent progress has been made at the site. It seems that the redevelopment plan was little more than a massive swindle by all parties. A recent news article indicates that the property may be up for grabs once again.

The five-story building is one of the oldest and most recognizable in the city but vandalism, scrapping, and exposure to the elements continue to follow their inevitable course. Recent photographs show that several areas inside have flooded, and while I am a firm believer in not naming vacant sites that are unprotected, this policy has little effect on the larger factors that shape the fate of places like the Atlantic Avenue Power Station. Quite often I hear people talk about buildings being too old or deteriorated to save, throwing up their hands and in a weird mix of fatalism and blind optimism calling the destruction of historic sites "progress".

I don't see progress, I see such insatiable greed that it consumes all things in its path. I see a project that could have saved a landmark building and revitalized a polluted area but is now derailed by corruption and fraud, another casualty of urban governments that prioritize stuffing their pockets over the well-being of their citizens. I could rattle off a depressingly long list of similar stories that ended with the erasure of important places that could have been vibrant and distinctive destinations for city residents and visitors. More often than not, the cycle just repeats itself over and over, until so many great places are lost that it's hard to even count them all.

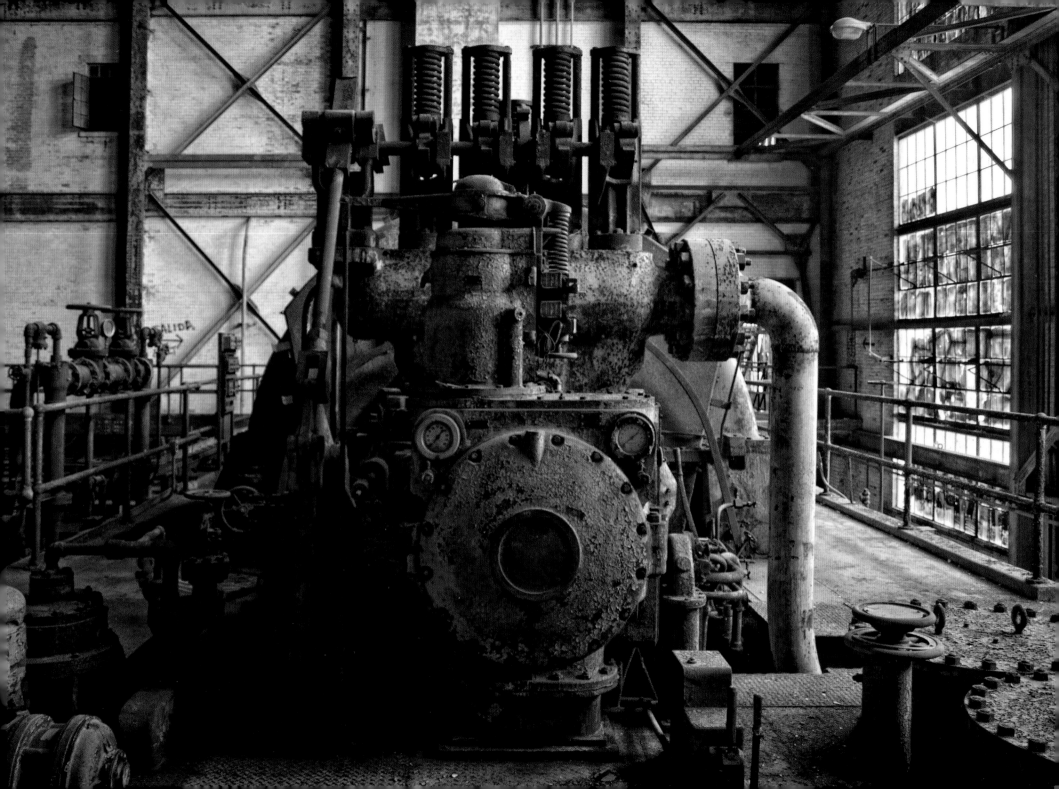

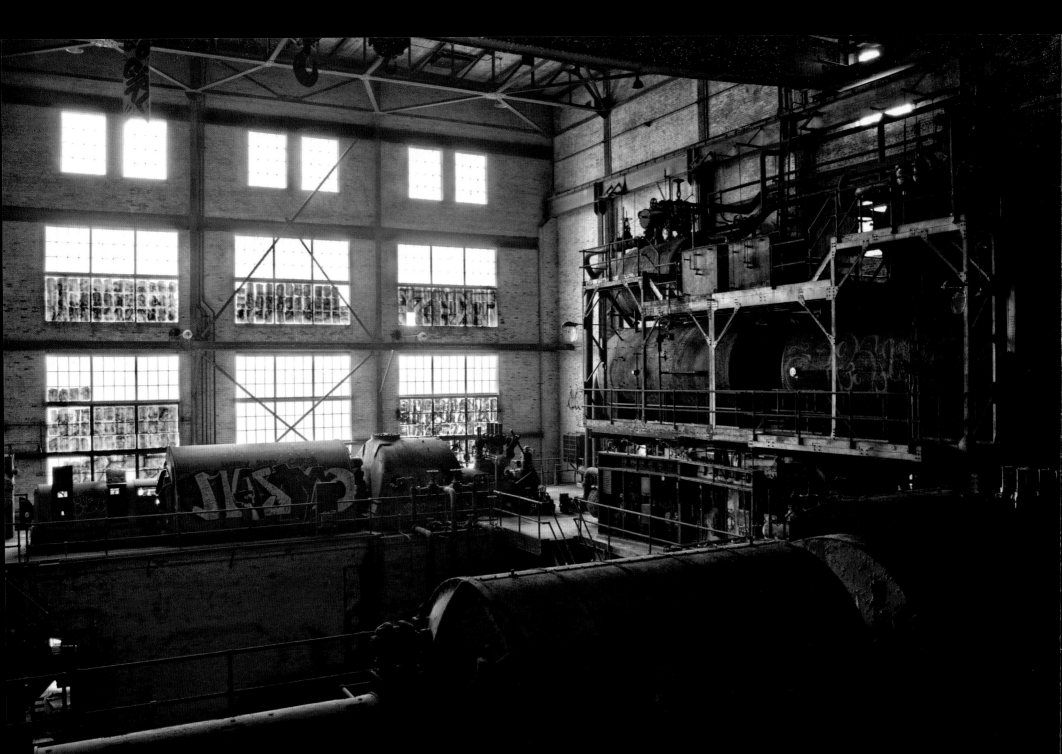

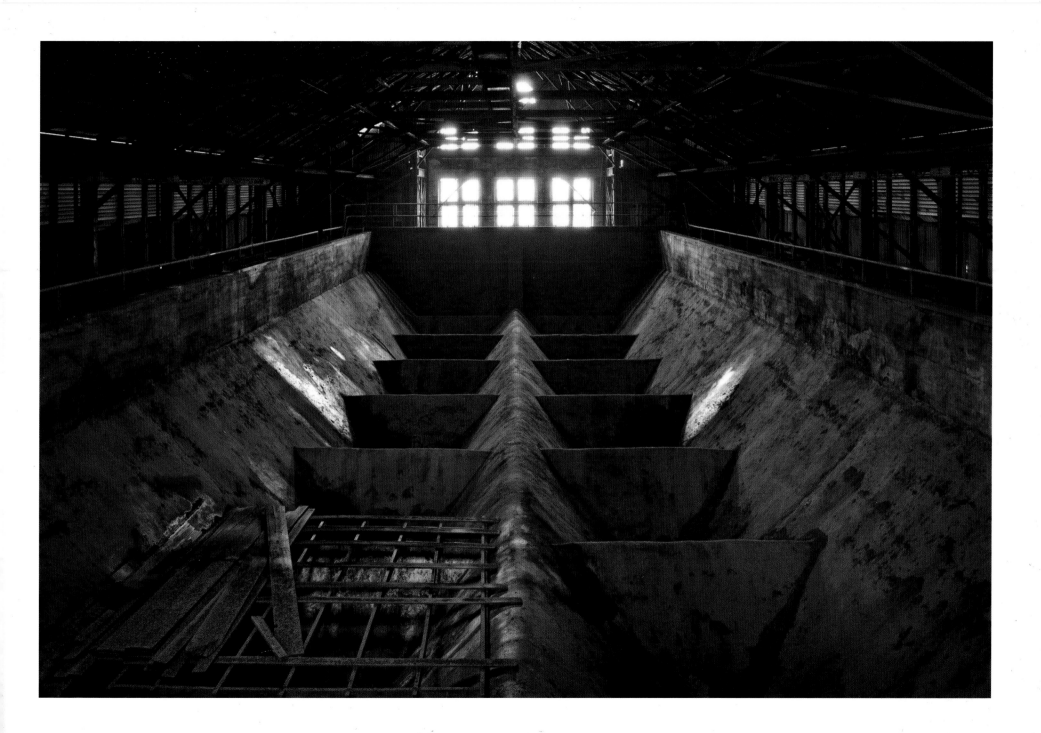

Lansdowne Theater

Located just outside of Philadelphia in Lansdowne, Pennsylvania, the Lansdowne Theater opened in 1927 with a screening of the silent film *Knockout Riley*. The 1,358-seat theater, designed by architect William H. Lee, was best described as being in the Hollywood Moorish style, with elements borrowed from various other architectural styles. The theme is carried out through elaborately decorated ceiling, chandelier, and proscenium. According to Matt Schultz – CEO of the Historic Lansdowne Theater Corporation and one of the greatest champions of the theater's restoration effort – rather than adopting a single style, Lee was attempting to create an atmosphere of timeless opulence that reflected cinema itself. On opening day, a biplane flew over the suburban theater and Miss Lansdowne (an exchange student from Sweden that year) threw roses to the crowd below. The theater showed movies three times a day every day of the week except Sunday. Retail stores and professional offices in front of the property anchored the site as one of the chief attractions on the main street running through Lansdowne.

The theater closed in 1987 following an electrical fire in the basement during a showing of the film *Beverly Hills Cop II*. Attempts were made to reopen it but ultimately it sat unused until the Historic Lansdowne Theater Corporation purchased the property in 2007. Since then, the condition of the building has been stabilized, the marquee completely restored, and retail and office spaces fully leased. The exterior features in the popular film *Silver Linings Playbook*. Another film, *The Dying of the Light*, includes scenes where the projectors are put back into use after more than twenty years.

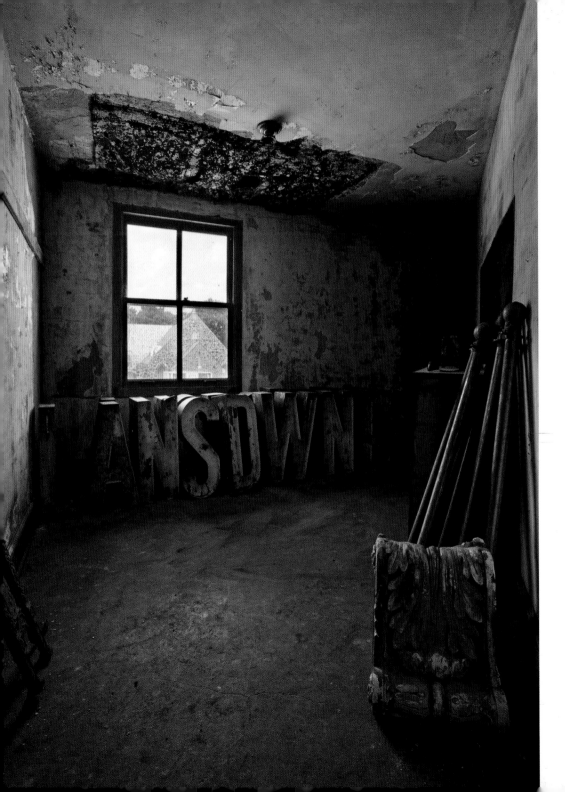

Recognizing the theater's architectural and historical significance and the potential for economic development, the Commonwealth of Pennsylvania has committed $4 million to the campaign to restore it. Additional support has come from the National Endowment for the Arts, National Trust for Historic Preservation, Pennsylvania Historical and Museum Commission, Delaware County Council and hundreds of individual donors. The goal of returning it to use as a concert venue seems closer to becoming a reality than ever. Philadelphia has lost nearly all of its Golden Age theaters, and while not technically within the city limits, saving the Lansdowne would be a step in the right direction.

Matt Schultz clearly believes in the cause, and has devoted an inordinate amount of effort to showing others why the theater is so significant. In my talks with him, he spoke with a quiet passion about the loss of buildings with a unique identity. "Kids today go to theaters that all look alike," he observed. "It's amazing to see their faces when they come into a place like this and realize what they used to be like. "Many of the abandoned places that I've been to and have come to love for their individuality and significance are gutted, looted, and razed as the years go by. It is dispiriting to watch one fall after another. People like Schultz are sorely needed – not just to save specific sites and revitalize their communities, but to serve as proof that it is possible, that those who see these sites as lost causes are sometimes giving up too easily. The Lansdowne Theater was nearly gutted to become an electrical supply storehouse. While that might have served the community by generating taxes and reopening the building, it is my belief that in a landscape increasingly hegemonized by chain stores and restaurants, the sense of place that Schultz talks about will prove to be of much more value in the long run – people will come to realize that iconic sites like the Lansdowne are finite resources, ones that not only contribute to but also celebrate the communities of which they are a part.

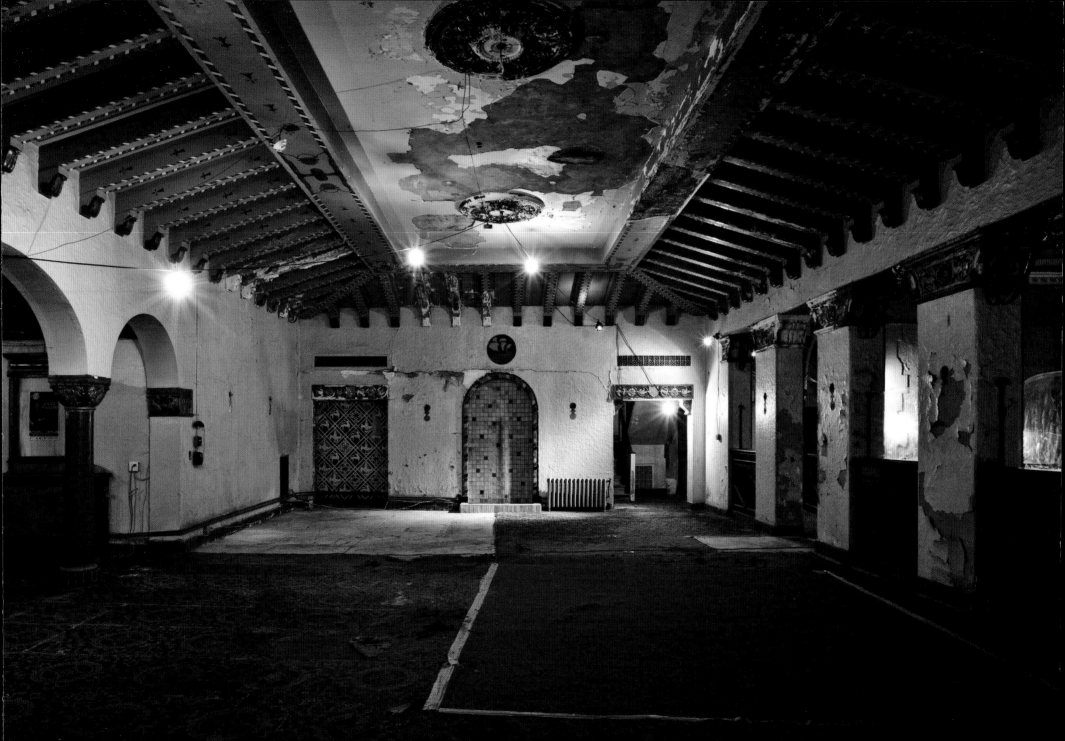

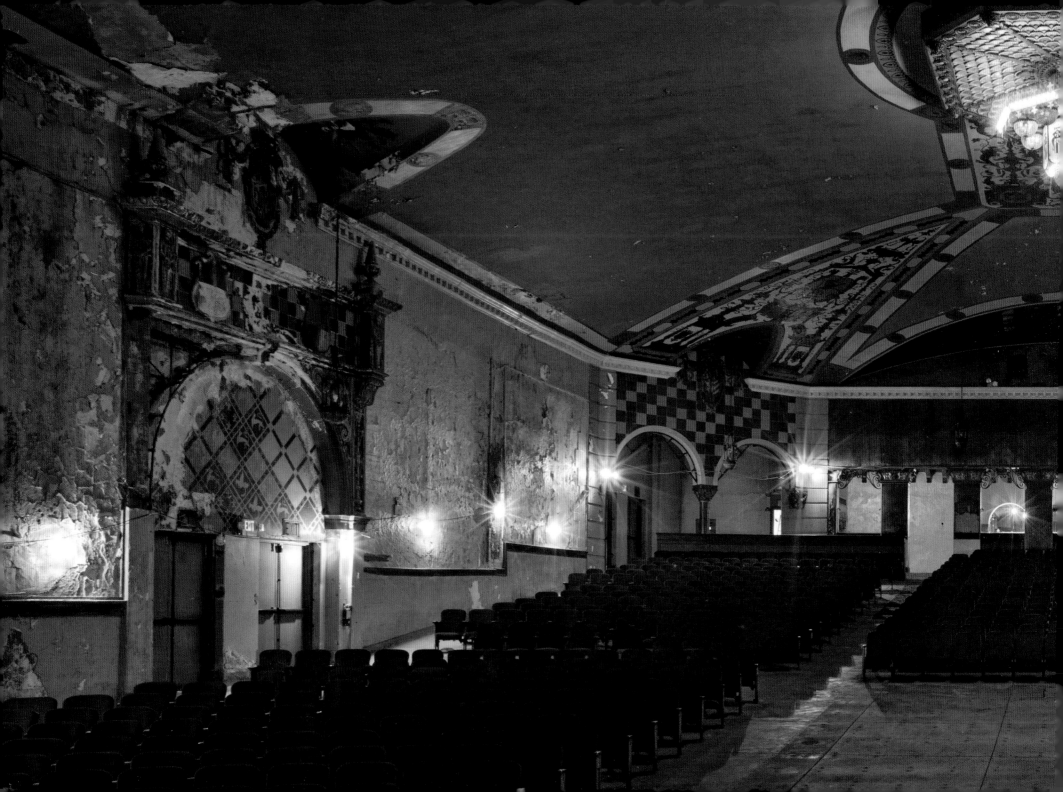

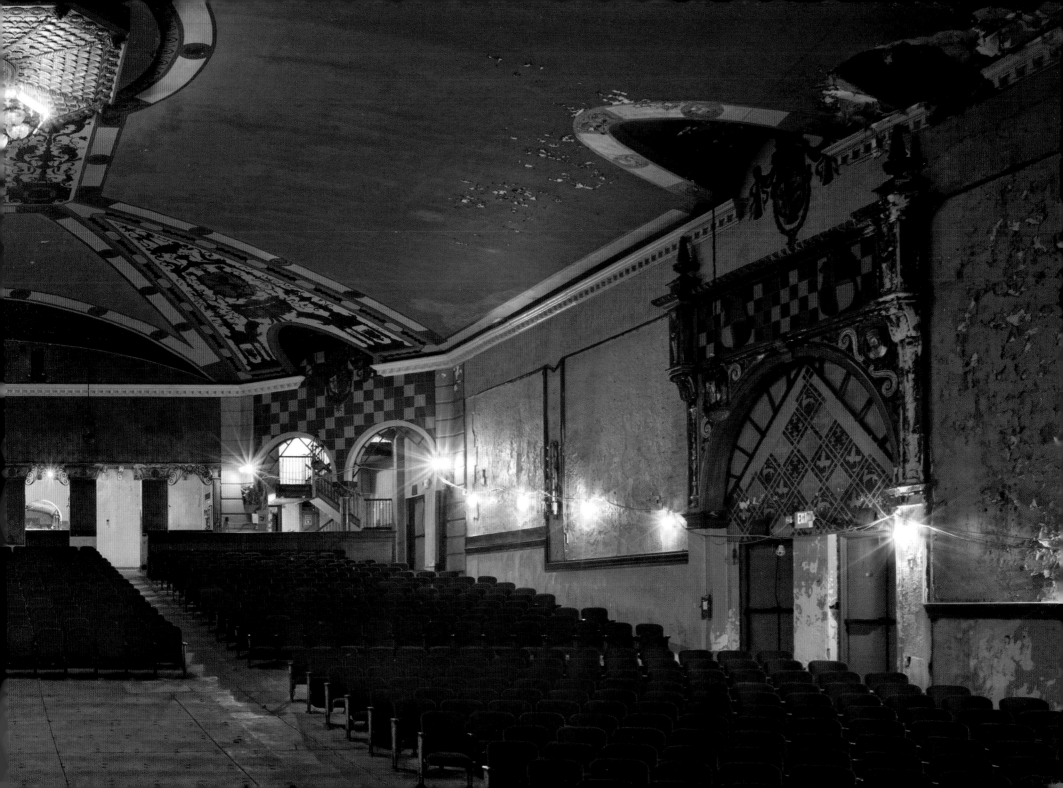

Harmony House

Listed under a pseudonym in this text, Harmony House Resort was built on land seized from Prussian barons during World War I and subsequently sold to a blouse-makers' union in 1919. The union (whose members included survivors of the infamous 1911 Triangle Shirtwaist Company fire) found it difficult to manage the 655-acre resort and make a profit, so they turned it over to the international union several years later. Union members could enjoy dancing, operas, lectures, and performances by popular and classical musicians; they could also canoe and swim in the 80-acre lake. The resort was extremely progressive, not only in terms of labor issues but also women's rights and racial equality. A fire in 1936 destroyed Harmony House; it was rebuilt, only to burn down again in 1969, resulting in the destruction of murals by celebrated Mexican artist Diego Rivera.

Harmony House was a low-cost vacation destination that offered a week's retreat with high-class food and service for half the going rate of other resorts in the area. It attracted famous visitors like Eleanor Roosevelt, Guy Lombardo, and Glenn Miller and periodically played a role in negotiating union contracts. The resort could host 1,200 visitors; as the years passed, it went from being a singles' destination to a resort geared towards families.

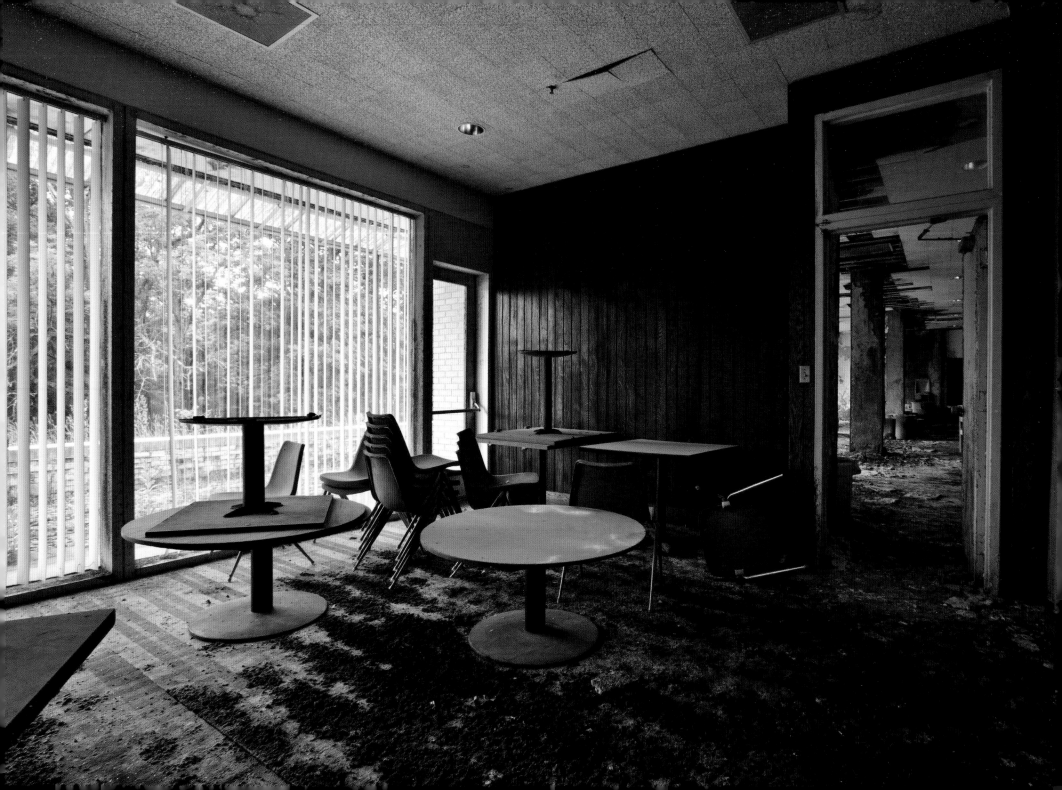

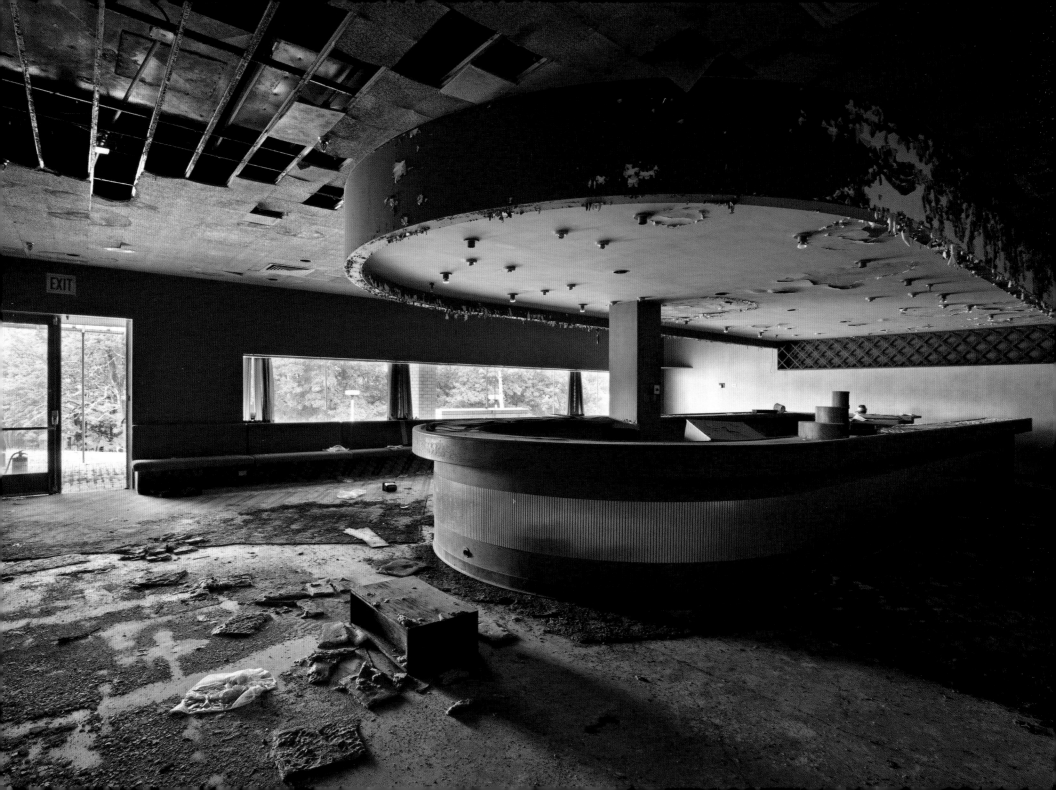

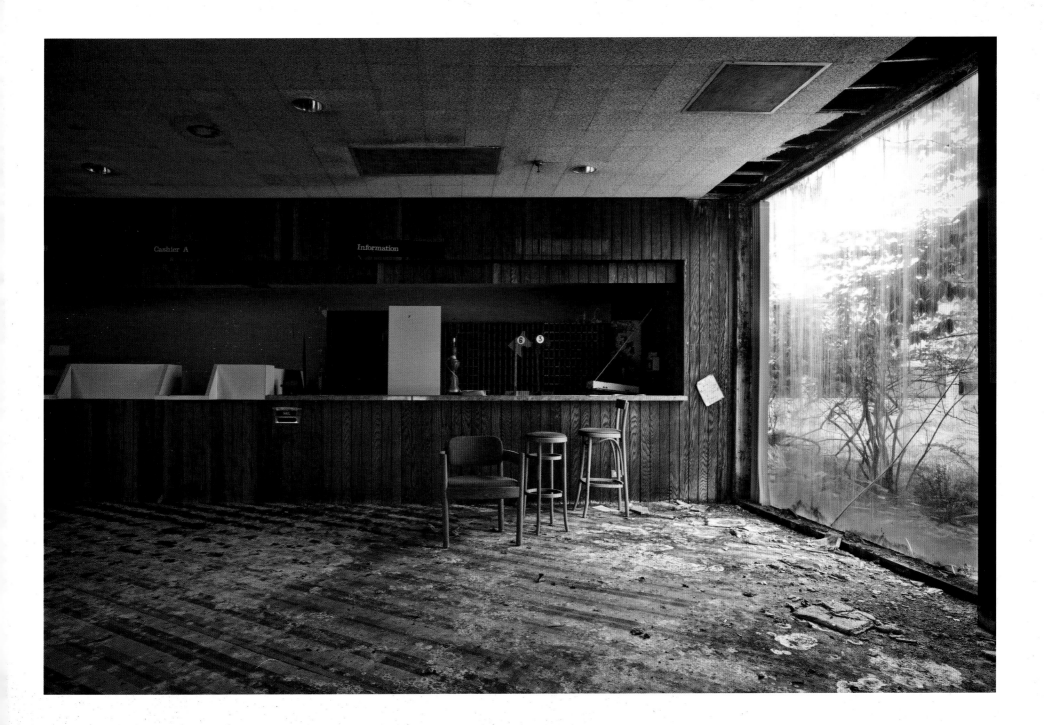

In the 1970s overseas production began gutting the garment unions and younger visitors were less inclined to visit the sedate resort. In its final days, Harmony House was losing a million dollars a year; the number of Philadelphia garment manufacturers had dwindled from 300 to 30. The situation was similar elsewhere and union membership had declined to well under half of what it had been during the peak years.

The resort was closed in 1989 and left to rot for a quarter century. The floors were in a terrible state in many of the buildings and the grounds were overgrown. As I wandered through the buildings, I wished I had been able to visit the resort during its heyday. It must have been a tremendously fun place—Harmony House was the embodiment of the ideal that American workers deserved a place to vacation in a beautiful environment while the onsite entertainment educated and enlightened them. It seems that this party is one that my and successive generations are destined to miss: the working middle-class clientele for whom places like Harmony House were built is vanishing into the pit of minimum-wage service industry jobs that don't offer benefits, let alone vacations. Unions may be a hot topic in present-day politics, but providing members with community gathering spots like Harmony House seems not only a reasonable goal but a noble one.

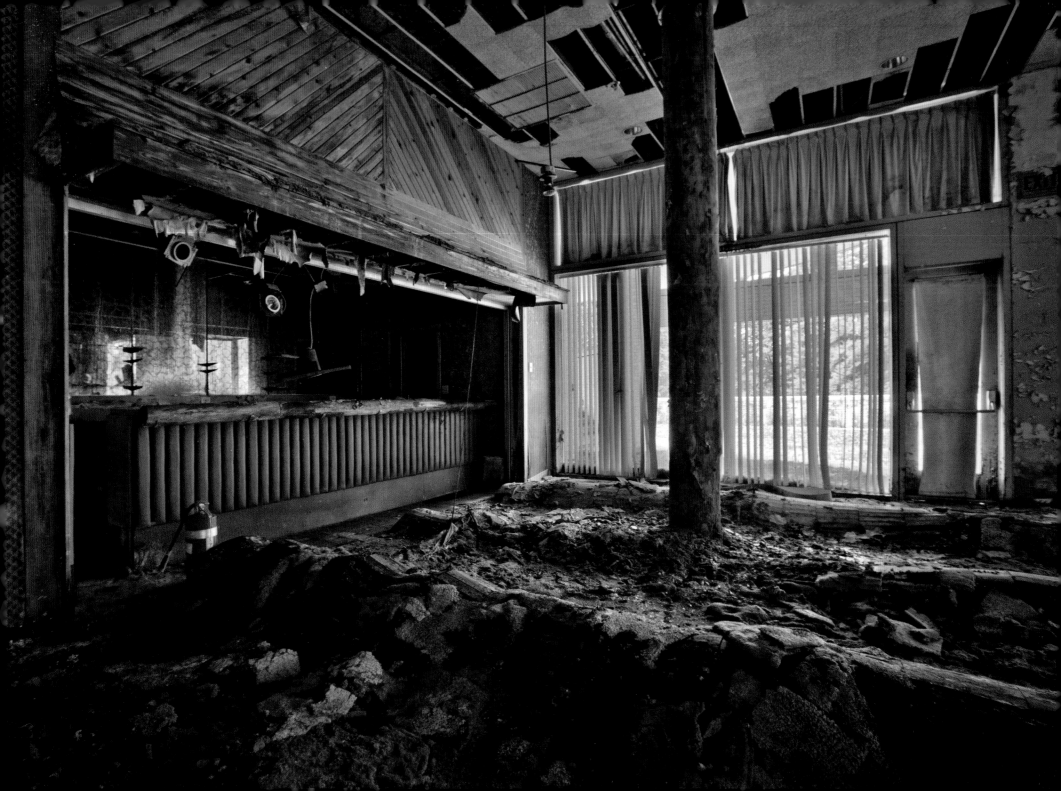

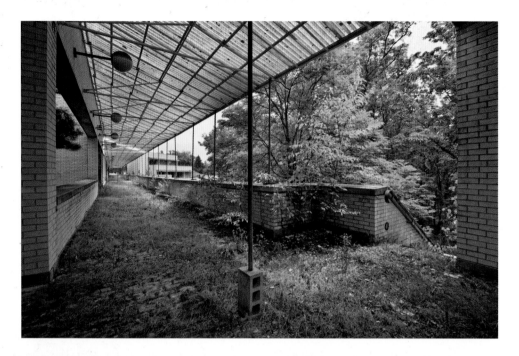

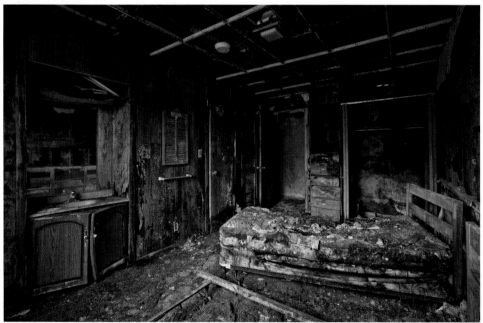

I see many places as literal embodiments of the ethos that led to their creation, and with their closure one often finds a concurrent dismantling of the ideals they represented. When a school or a church closes, it is not necessarily because the community no longer needs it, but rather that there is no systemic support for its existence. Harmony House didn't close because it was no longer wanted. It is true that the resort wasn't attracting younger members like it had in previous years, but most of the union base that had supported it had been eradicated by shifting jobs to areas where unions don't exist. The jobs that remain make it difficult for blue-collar workers to find the time or money to enjoy resorts like these, and it is unlikely that the women and children employed in garment factories in Bangladesh or Pakistan have a place like Harmony House to vacation at either. Its closure isn't just about the loss of one specific place, but of a vision of how good things could be.

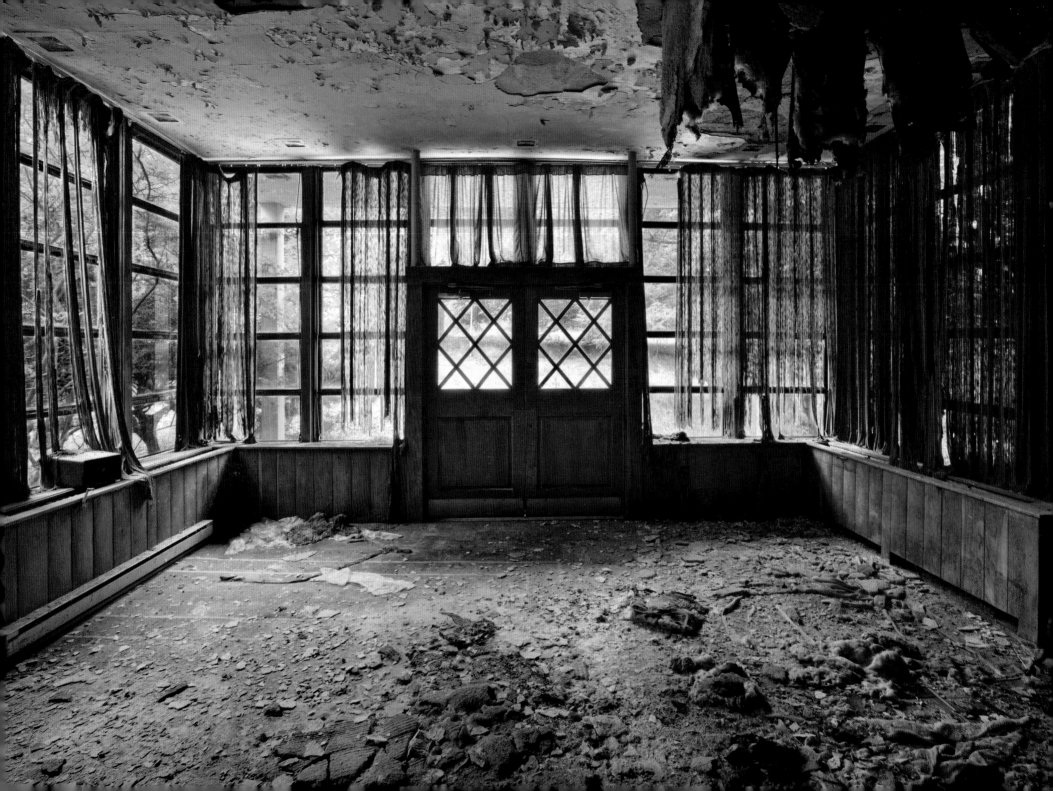

Fox Hotel

The town in which the Fox Hotel (a pseudonym) was built was known for its "healing waters" even before the Revolutionary War. The area's mineral springs drew many visitors over the years and by the late 19th century it had become a fashionable spa that attracted such notables as the Vanderbilts, the Macys, Ulysses S. Grant, Charles Dickens, and Oscar Wilde. Hotels, bath houses, cottages, boarding houses, and pavilions were built in styles including Beaux Arts, Mission Style, Gothic Revival, Colonial Revival, Greek Revival, and Renaissance Revival; Italianate and Queen Anne were the most popular. The town began falling out of favor with its wealthy clientele by the early 1900s, however, partly because another nearby town's racetracks and casinos eclipsed the waning popularity of drinking and bathing in mineral water.

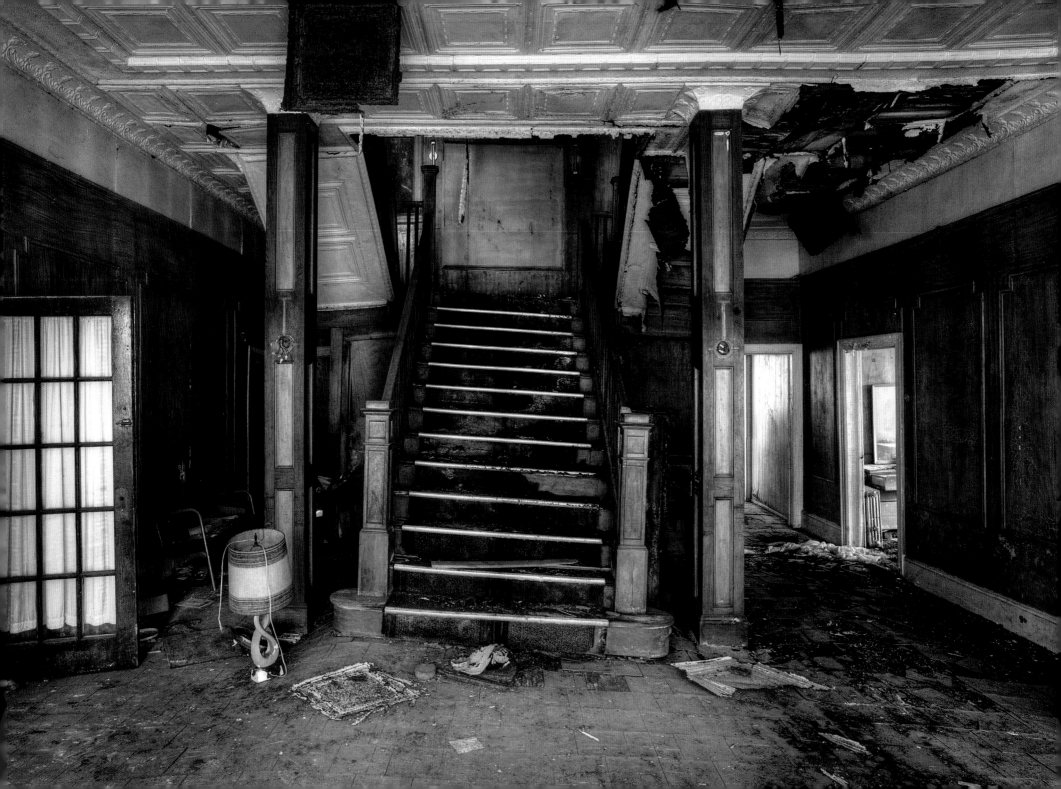

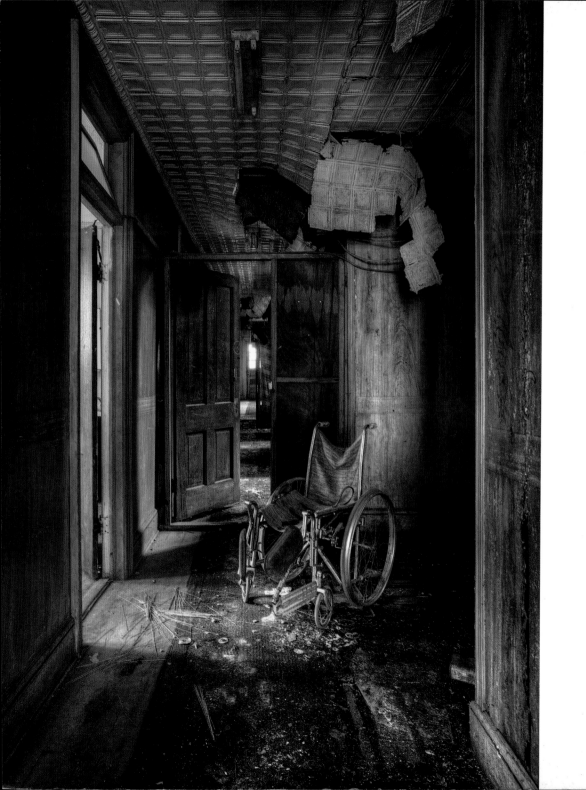

The town found a limited resurgence of popularity with a Jewish clientele, who were barred from many other resorts. A synagogue was built and several kosher hotels were added, including the Fox Hotel. Little historical information on this specific building is available; one source lists it as being erected in the early 1930s; however, I've found an ad for it in a 1923 newspaper. For the town, maintaining the status of a resort destination became increasingly difficult; Prohibition damaged the area's hops industry, and during the depression the town's rail service was discontinued. While the post-World War II years saw a small increase in popularity due to the reparations paid to Holocaust survivors by the German government, the overall decline continued. By the late 1960s the Fox Hotel was being used as a yeshiva for the town's Hasidic visitors.

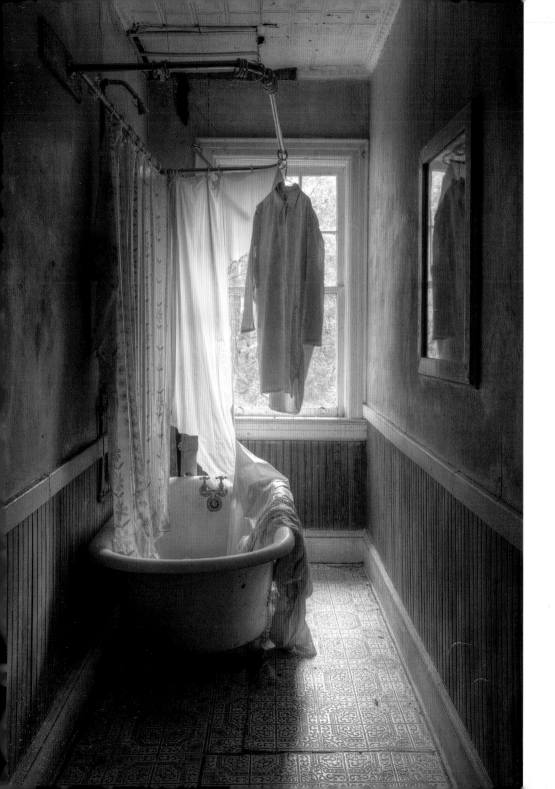

The 1980s saw the closure of many hotels and boardinghouses, and in the years that followed many were demolished or burned. Several attempts were made to resuscitate the town as a resort destination, with mixed success. By the turn of the 21st century many of the hotels were gone or abandoned, but a few remained open. When several large properties were purchased by a development group, it was hoped that their vision for the town would revitalize the area, but none of the plans were enacted and the company's holdings there continued to suffer from neglect and vandalism. By 2013 the developer had received new loans and separated the project from investors he claimed were holding it back, and stated that progress would begin soon. Aside from demolition of one of the former hotels, as of 2014 the projects do not appear to be underway.

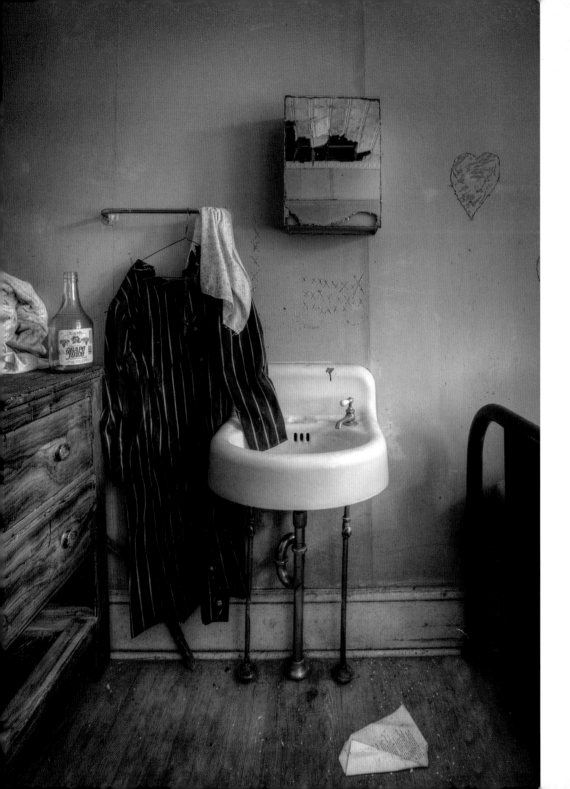

The Fox Hotel—given its pseudonym in honor of the sole remaining resident, a fox who had built a nest in one of the mattresses—was badly deteriorated when I photographed it. The staircase had listed to the right and the slant was noticeable and unsettling when ascending it. The front porch was gone and the property was overgrown with trees and weeds. The lobby floor was rippled and gave a sense that it could collapse at any time, and many of the hallways in the upper floors had begun to sag. The ornamental pressed-tin ceilings hung in tatters and the carpet was threadbare. Nevertheless, many of the vacationers' personal items remained: a wheelchair in the hallway, a book of prayers, a blue dress still hanging on the wall. As with many popular resort destinations, the fall from favor had come at a high cost. Slowly but surely the remaining bits of its identity are being stripped away by demolition and exposure to the elements. Despite grants and investments, much of what gave the area its identity will be lost, and the Fox Hotel will surely be one of the casualties, its past fading into nothingness as those who stayed there take their memories of it to the grave.

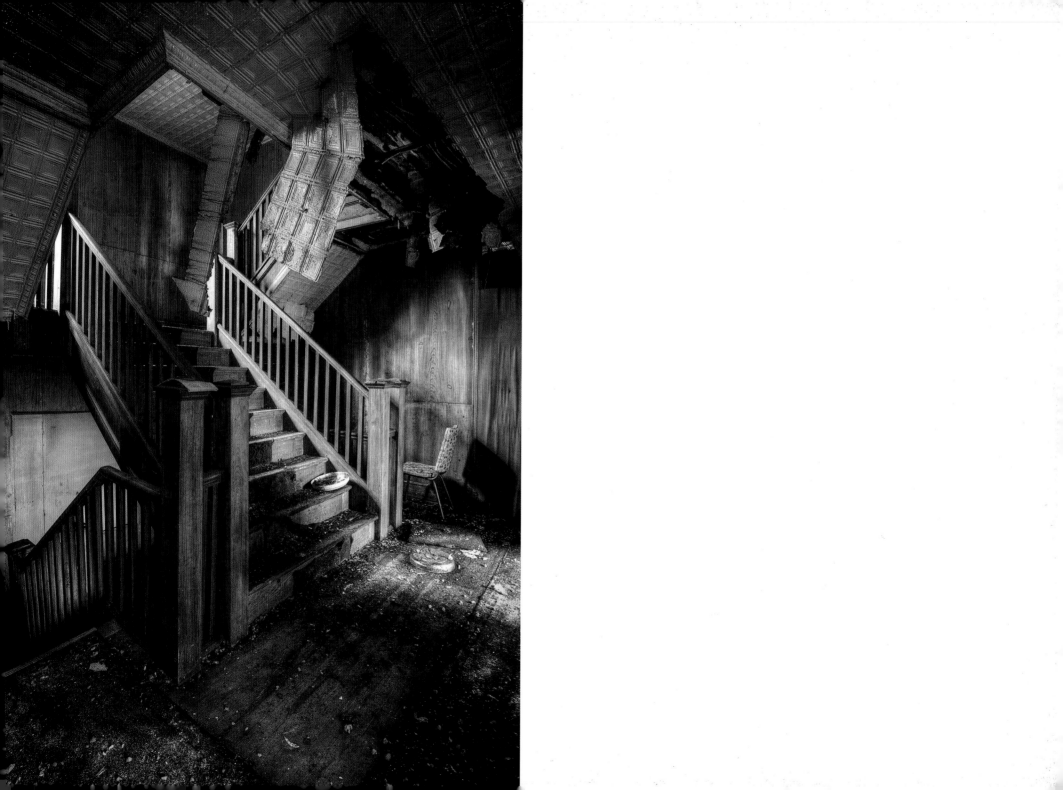

Bethlehem Steel

The Lackawanna, NY branch of Bethlehem Steel was actually started in the mid-19th century as an iron forge by the Scranton brothers in a Pennsylvania town that would come to be named after them. Despite some gruesome incidents with labor strikes due to frequent pay cuts, the company prospered and became the second largest producer of iron in the United States.

Around the turn of the century, the Lackawanna Iron and Steel Company decided to move operations to the suburbs of Buffalo in an attempt to reduce labor costs and to ship materials via the Great Lakes. The mill started construction in 1900. The town and Beaux Arts administration building followed in 1901. In 1902 the company became Lackawanna Steel Company, the largest in the world, although that title was swiftly usurped by U.S. Steel. The mill started operations with 6,000 workers in 1903 and the property in Scranton was sold for scrap.

Union struggles followed Lackawanna Steel to New York, as did financial difficulties. Bethlehem bought out Lackawanna Steel in 1922 and spent $40 million on plant updates over the next decade. At its height, it was the world's largest steel factory and employed over 20,000 workers, producing steel plates for the military and for the beams used in the Empire State Building and the Golden Gate Bridge.

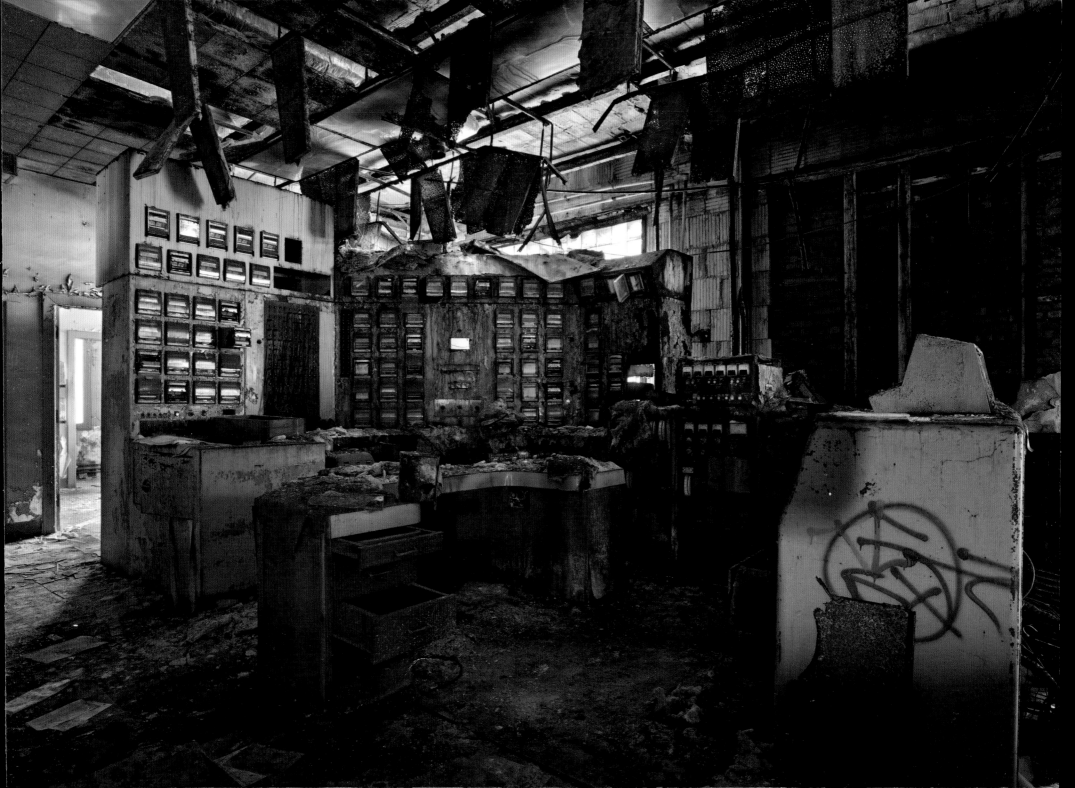

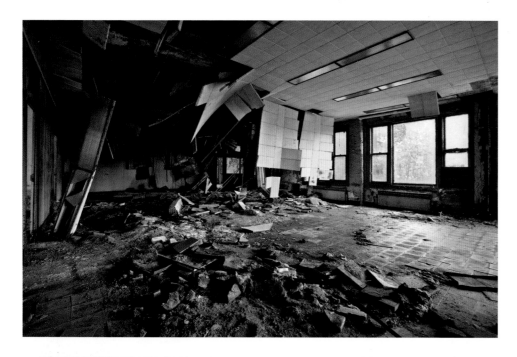

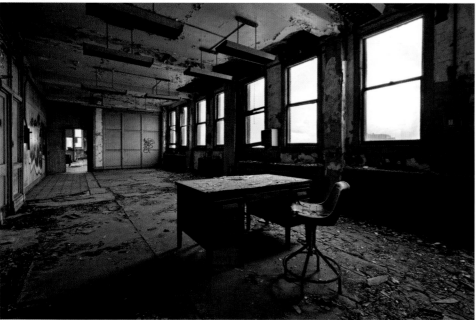

Overseas competition and Bethlehem Steel's dislike for New York taxes and environmental regulations led to Lackawanna Steel's obsolescence. It was replaced by another facility in Indiana and closed in 1982, leaving a polluted 1,000-acre Superfund site in its wake. While some active industries remain, much of the plant was torn down.

The administration building, where these photographs were taken, was designed by Lansing C. Holden and was known for its ornate pediments, copper-trimmed dormers, and columns. It was left to the elements by its owners, Gateway Trade Center Inc., for nearly thirty years with no attempt to maintain or protect it. Despite one of the best preservation campaigns I've seen—with detailed proposals for reuse, a sizeable grant, and the involvement of several experts in the rehabilitation of similar sites—Lackawanna mayor Geoffrey Szymanski and Gateway Trade were determined to tear down one of the last intact remnants of the company that had built their town. As in many cases, the structure itself was blamed and called blight and an eyesore, while the fact that the owners had neglected it and the town had *allowed* it to be neglected were conveniently ignored. In court the Lackawanna Industrial Heritage Group demonstrated that the owners and the city were withholding documents showing that the building was structurally sound, and the Campaign for Buffalo History Architecture & Culture, Inc. delayed demolition by showing that no environmental reviews had been performed. Nonetheless, the building was destroyed in January 2013. The demolition crews deliberately went first for the ornamental architectural features that made the building special, so that if orders were given to halt the demolition there would be nothing left to save.

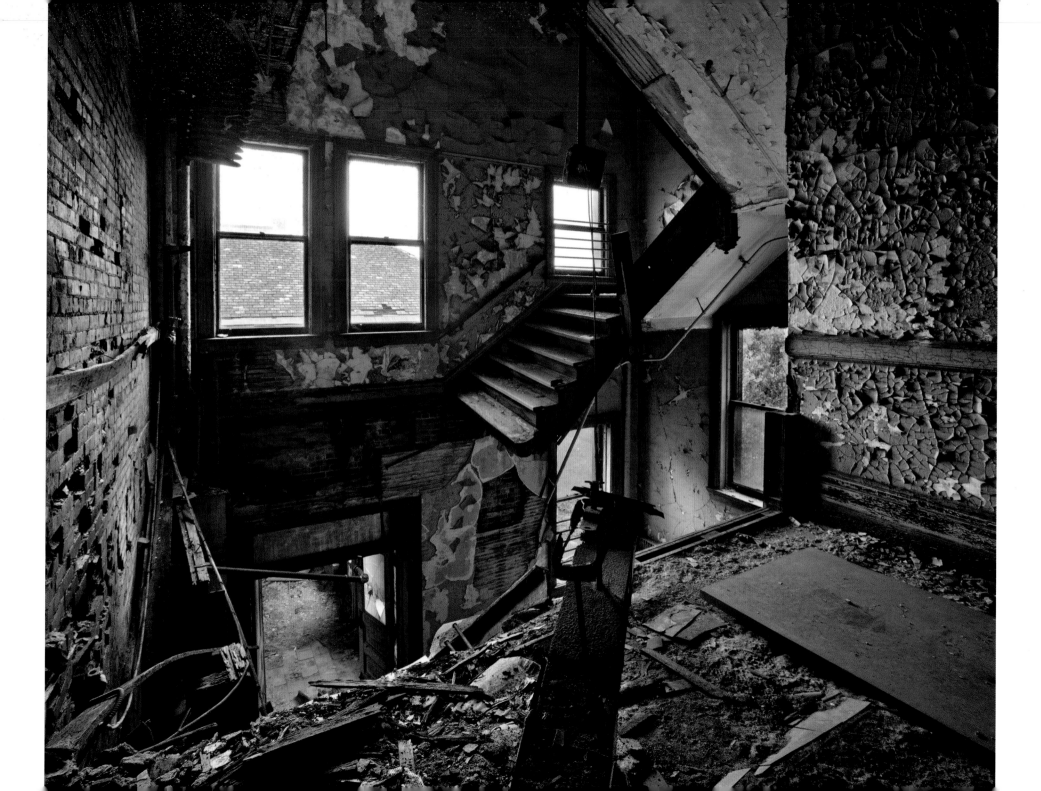

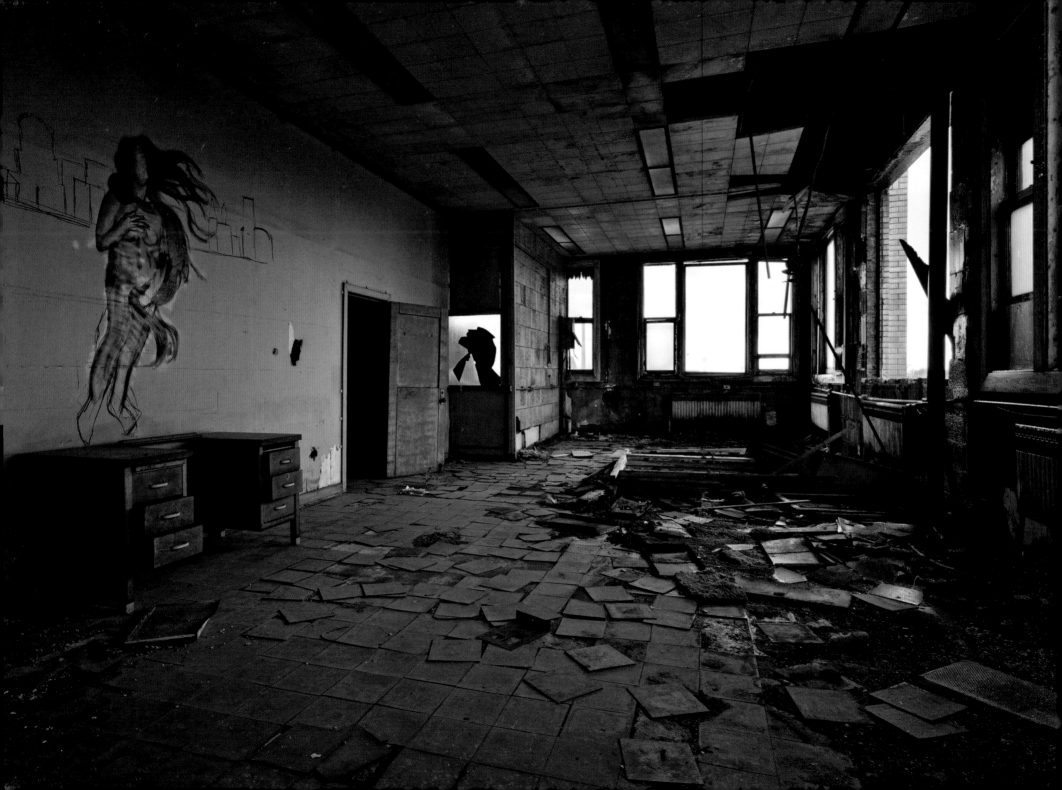

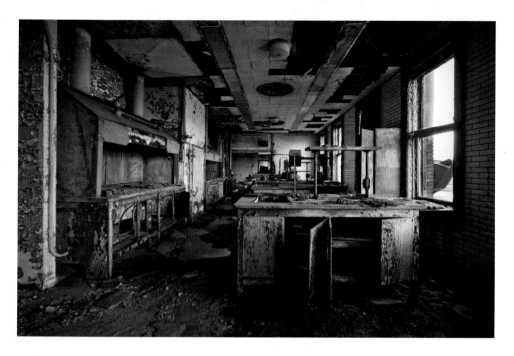

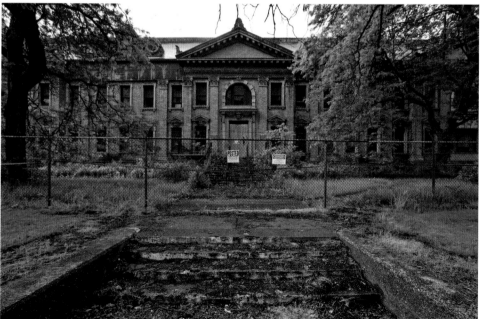

The loss of the administration building was a heartbreaking event. Seeing the grief of the people who had worked so hard to preserve it and wanted so badly to return it to a functioning part of the community was wrenching, as was watching videos of construction equipment ripping apart a place I had loved so much. Some of the interior areas (like the infamous main staircase) made it appear that the building was in much worse condition than it really was. The town of Lackawanna got its name and its foundation from the steel plant. Now when people want to know about the area's heritage, there will be little in terms of tangible objects or places to show them.

Eastalco Alcoa Works

Alcoa Inc.'s plant in Adamstown, Maryland—the Eastalco Alcoa Works—produced 8 percent of the aluminum in the United States (about 1.25 million pounds per day) in the form of 1-ton cylinders known as billets. A report prepared by the Environ Corporation stated, "Eastalco's primary aluminum reduction operations include two center-worked prebake potlines and an electrode manufacturing operation made up of a paste production and anode baking operation." Comprised of over 130 buildings on 400 acres, it operated for 35 years. The Eastalco plant was one of the largest electricity consumers in the state; in one hour the plant required thirty-five times what an average individual would use in a year. After several rounds of bitter negotiations, Eastalco closed major operations on December 19, 2005 when its contract with a regional energy company expired and rates for their electricity would have tripled. Alcoa was unable to find what they deemed to be a cost-efficient source of power. Six hundred jobs were lost in the closure.

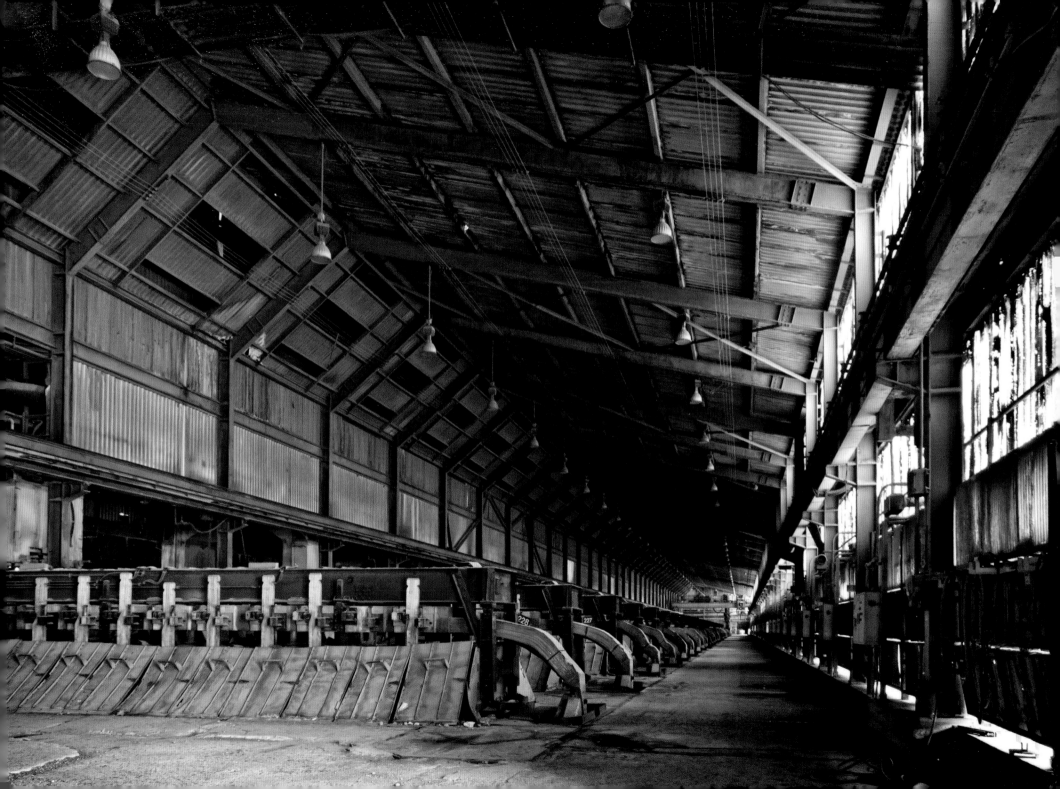

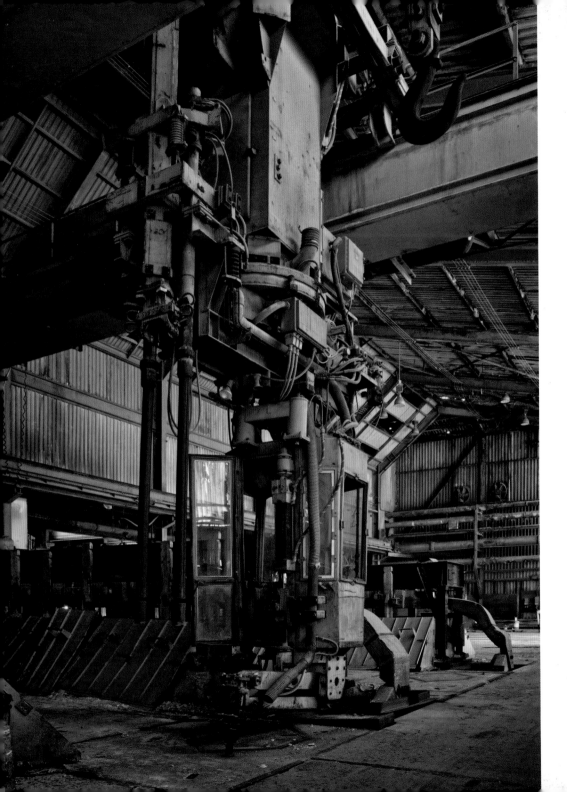

In 2006, the Eastalco Alcoa Works moved to make a gift of 27 acres of the property for a community sports complex, potentially named after the plant as a memorial. Plans stalled when the Maryland Department of the Environment pointed out that the land was a Superfund site being monitored for elevated levels of fluoride.

An attempt to reopen the Eastalco Alcoa Works stalled in 2007 after plans to build a dedicated power plant at the Indian Head Naval Surface Warfare Center in Charles County, MD, fell through. Alan Brody writes, "The approximately $1 billion plant would have created up to 200 permanent jobs, along with [providing] a stable energy supply and additional corporate tax revenues to Charles County." Alcoa decided that the cost was too great.

Between 2011 and 2013 the facility was razed. According to Bethany Rodgers, "Since the 2005 closure of the Eastalco plant, Sempra considered the property for an electric power generation station and the U.S. Bureau of Diplomatic Security weighed it for a training facility. Neither possibility panned out."

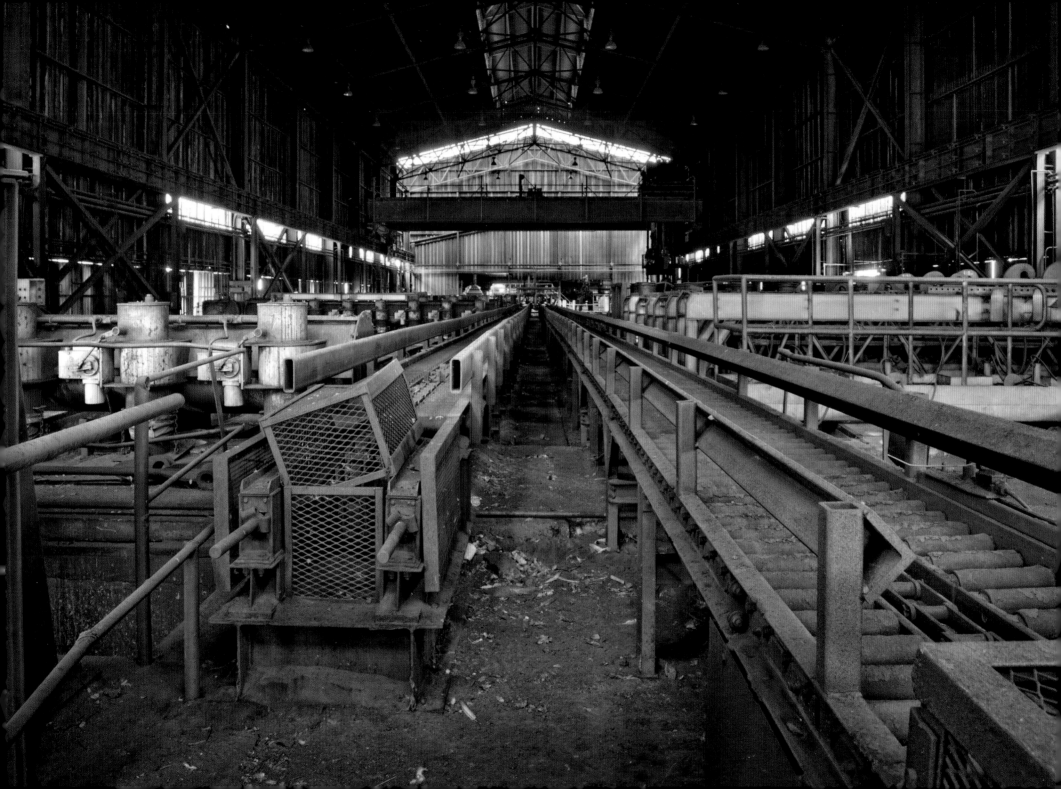

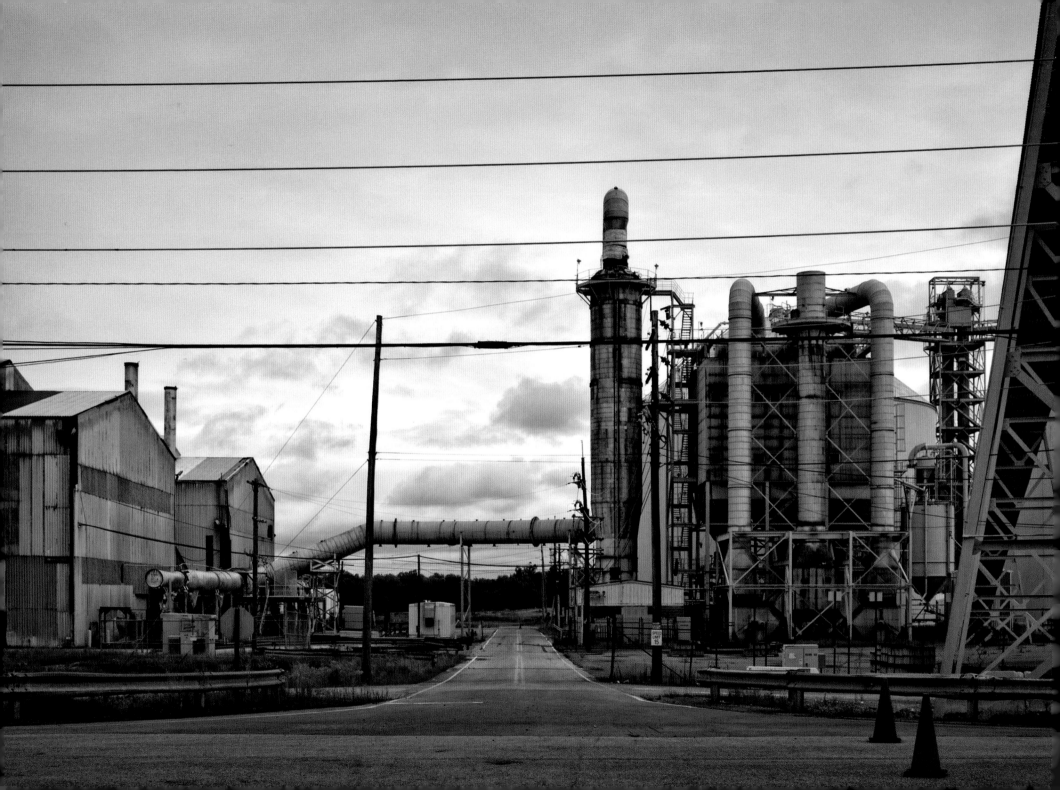

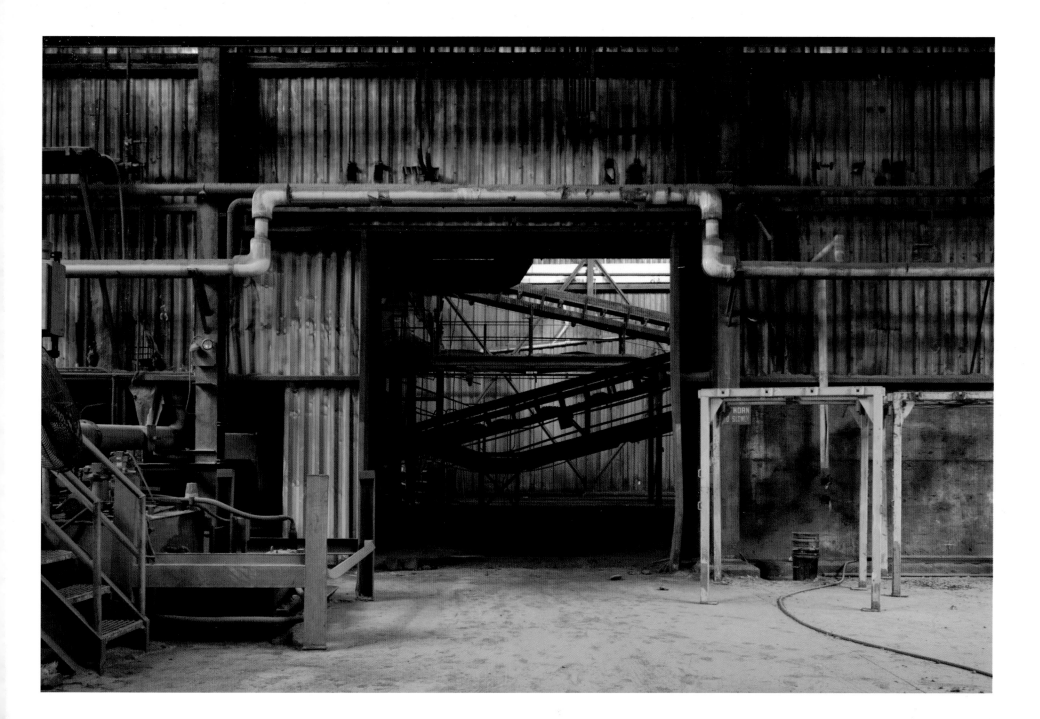

Essex County Jail Annex

Built in 1872/3, the Essex County Jail Annex (ECJA, or Escopen, as it came to be known) was constructed with locally quarried brownstone on the border dividing Caldwell and Verona, New Jersey. The imposing Italianate Victorian structure was perched atop a hill and originally included the jail itself and a farm. Over the years, additions included the Men's Building, the Women's Building, a Power Plant, the Shoe Shop, and the "New" Wing, constructed in 1923. Until the 1980s, the jail housed between 450 and 550 inmates.

In 1983 the New Wing was closed because it had deteriorated past the point of being able to house inmates safely, reducing the capacity of the prison by 200 beds, but the population was steadily rising and by 1986 it had passed 1,000. Despite the fact that no repairs had been carried out, the New Wing was reopened and prisoners were crammed into areas that were not originally intended for them, such as the Shoe Shop, the basement of the Women's Building and visitation areas. The corridors were filled with stretchers and cots with very little room for movement; as a result, prisoners were without day areas or space to keep personal belongings. Roughly half of the population had not yet been convicted of a crime, but were awaiting their dispositions.

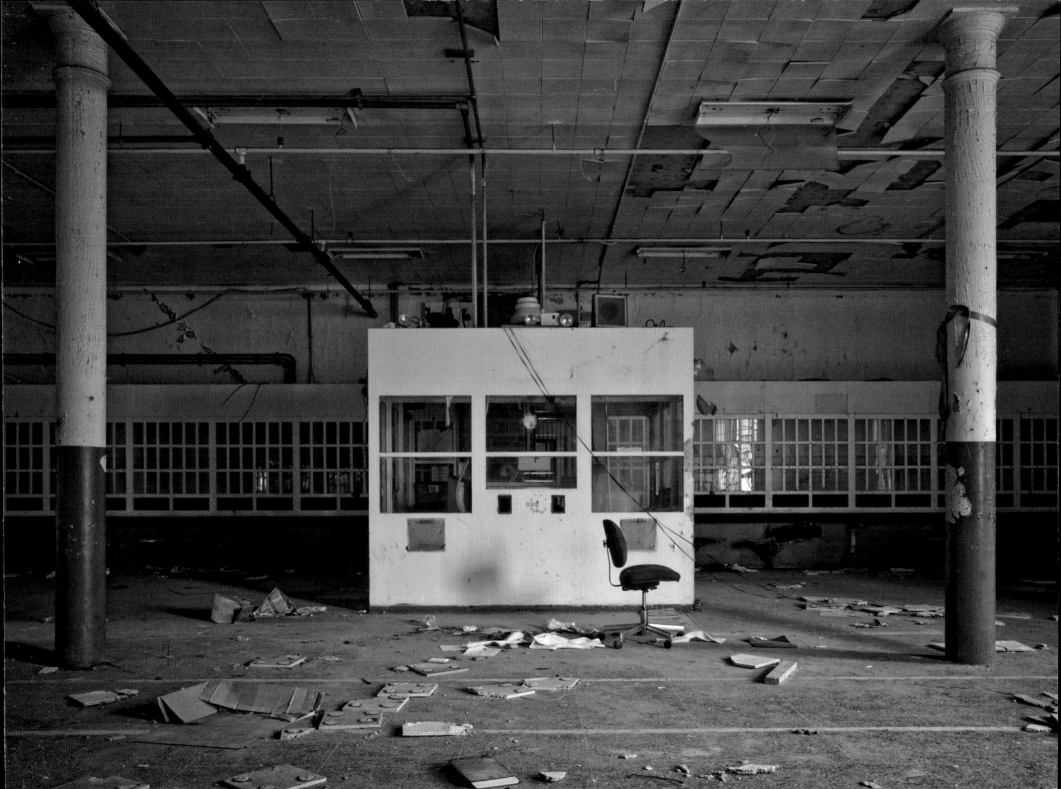

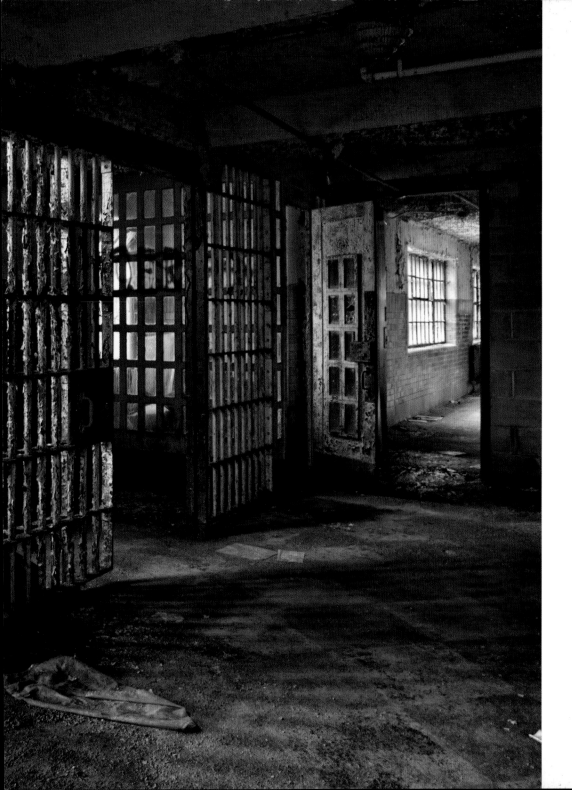

Rodents and insects including ants, fleas, roaches, water bugs, and flies infested cells, toilets, and food-preparation areas. The roofing and ceilings were rotted and crumbling, and windowpanes regularly fell from their frames onto areas where the stretchers and cots were placed, sometimes injuring the inmates. Toilets and sinks didn't flush or sprayed water into the cells, and bedding was placed in areas where water had pooled from radiators. Some areas only had two functioning toilets for thirty inmates. Showers were covered with black and green slime and lacked temperature regulation, so the water varied wildly between extremely hot and extremely cold. In addition, the drainage system didn't work properly, so the showers were flooded with water that reeked of sewage; leaks from the ceiling gave the inmates rashes and sores. Nearly every area of the prison dripped with filthy water, forming stalactites and rusting holes in walls and the floor. Reeking puddles formed in the food-serving areas and when paired with exposed electrical wires presented the threat of electrocution. Dirt, garbage, mold, and mildew were everywhere, and the ventilation system was inadequate, so during the summer months the heat and humidity were intolerable.

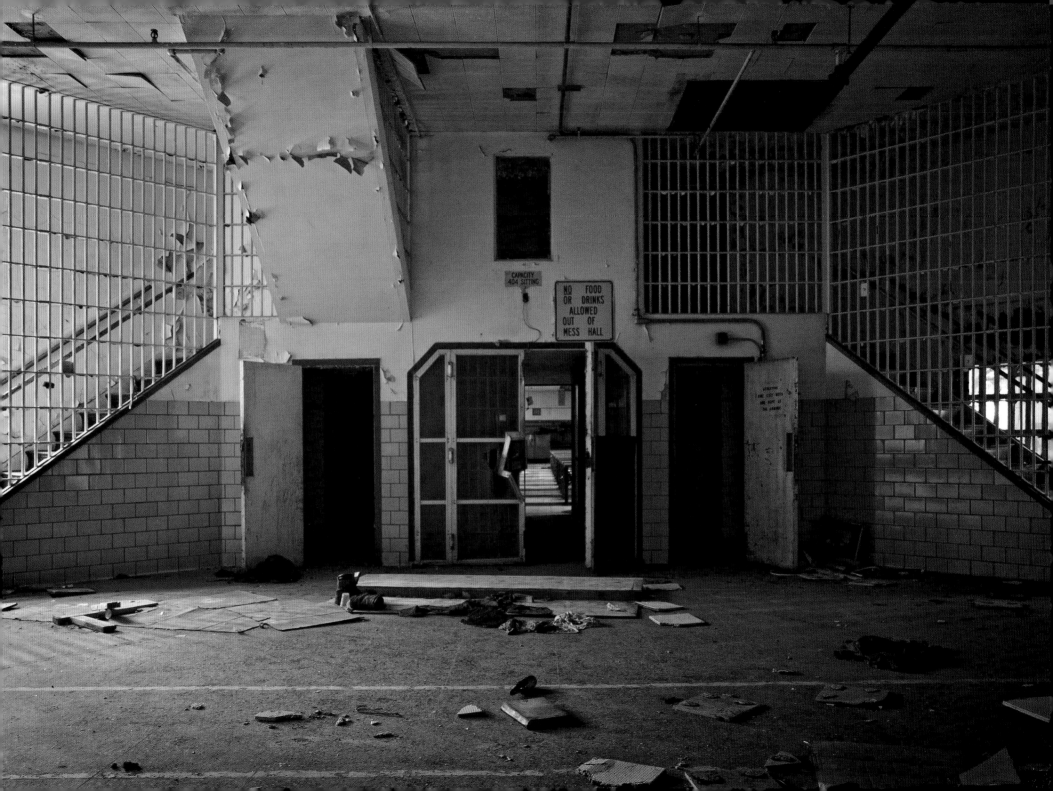

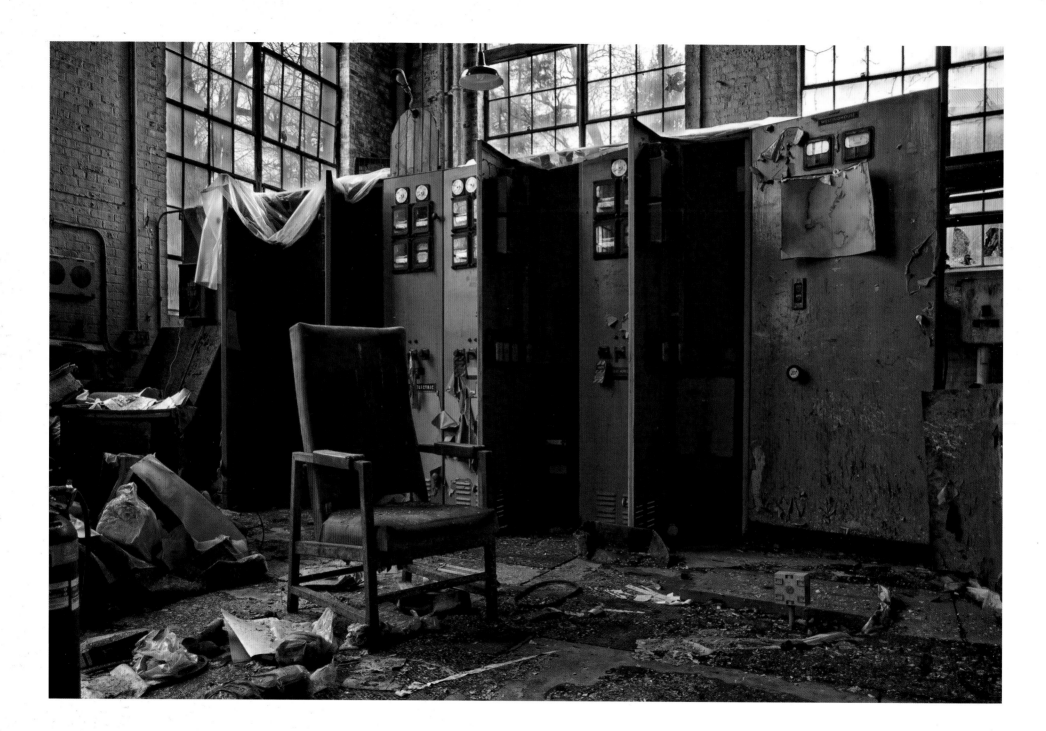

Inmates were not medically screened when they were brought into the prison and lacked access to adequate medical care. The infirmary was frequently not properly staffed, and so could not give the necessary medications to patients, including those with conditions such as asthma. Prisoners lacked access to activity areas, gyms, law libraries, and courtyards. There were no consistent emergency precautions, and many of the guards were considered temporary or probationary and had not received any training.

Unsurprisingly, the inmates' disposition was not improved by the conditions, and the tension led to an atmosphere of constant fear and violence. In one instance in 2003, a 19-year-old named Lamonte Gallemore was arrested and transferred to a unit housing gang members, despite his having no affiliation with any gangs. He was brutally beaten near the shower area and died. He had only been in the prison for a few hours. His family tried to file a complaint and documents related to the incident were subpoenaed, but the prison simply ignored the court orders. Repeated attempts to pursue the matter legally were similarly ignored until 2009, when the county council ruled that too much time had passed and the personnel had changed.

In 2004 ECJA was closed to consolidate it with another Newark prison built on top of a landfill contaminated with lead, petroleum, and arsenic. The site remained vacant until it was torn down in 2010 despite the protests of historians and preservationists; its demise was hastened after a police officer was injured chasing vandals through the complex at night. A housing complex was built on the property and in 2012 the Borough Council elected to build a monument to the prison made of bars and doors on the field where prisoners once worked. It is the only remaining trace of the prison.

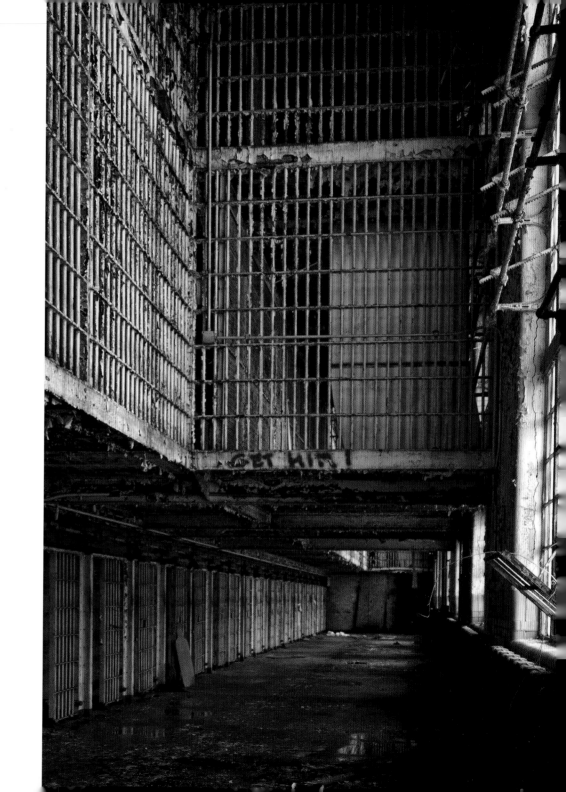

New Jersey Zinc

The New Jersey Zinc plant in Palmerton, Pennsylvania was built in 1898 and was the reason for the founding of the town. Palmerton was ideally located near both the anthracite coal mines and the zinc mines necessary for a large-scale zinc-smelting plant, and in 1917 the world's largest zinc research and technology center was built there. By most accounts, New Jersey Zinc's company town was beautiful and had better-than-average medical care and educational opportunities for the residents. The zinc produced by the plant was found in a myriad of products, including galvanized steel, tires, and brass, and it was used by the military in both World Wars. In 1966 New Zersey Zinc merged with Gulf+Western and operated as a subsidiary; in 1981 it was bought out and renamed Horsehead Industries after New Jersey Zinc's logo. Shortly thereafter it made the list of Superfund sites and a long-drawn-out battle with the Environmental Protection Agency (EPA) began over the terrible toll the plant had taken on the mountains and forests nearby. Conservative estimates reported over 2,000 acres heavily polluted with lead, arsenic, cadmium, copper, manganese, and zinc. The nearby mountainside, located in an area otherwise known for lush forestation, had the blasted, lifeless look of an asteroid because the soil had been rendered sterile and vegetation could no longer grow there. Nearby forested areas had a dead, petrified look because the bacteria that decomposed the wood had also been killed.

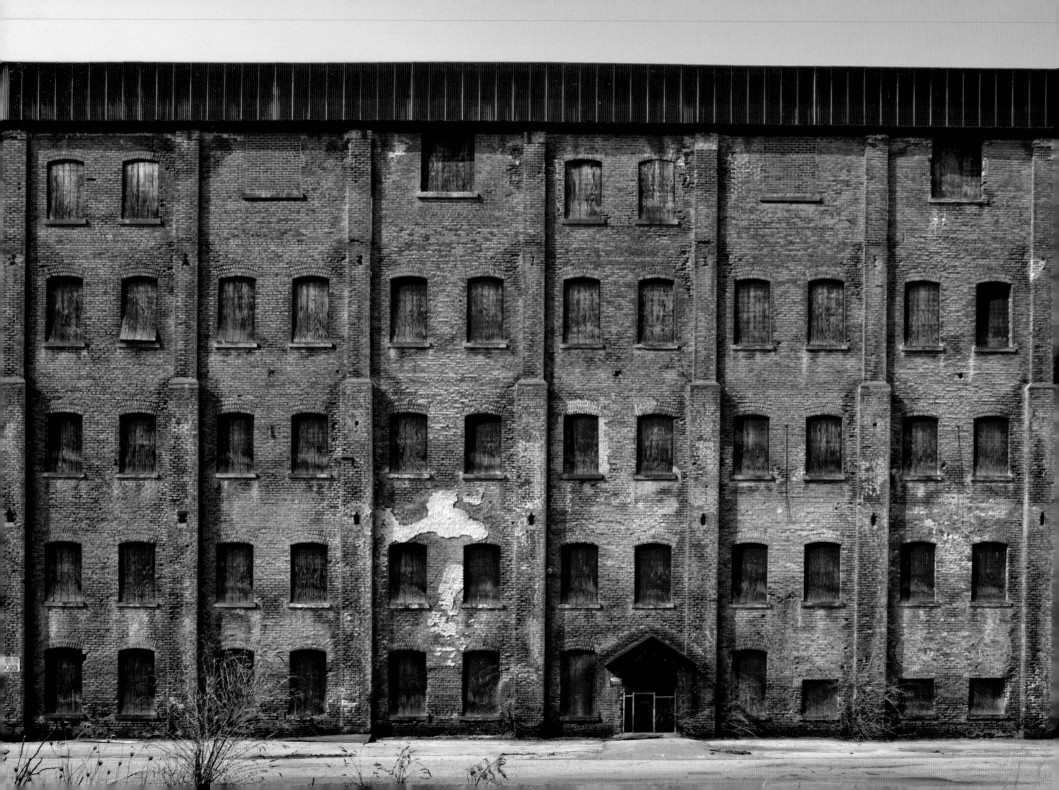

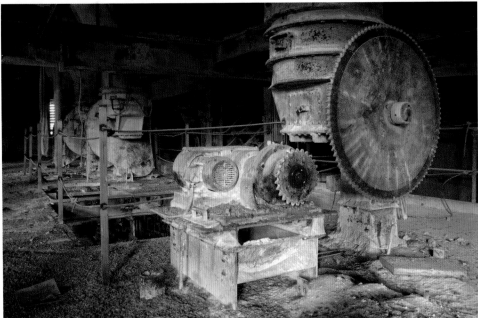

While some studies did lend credence to the possibility that health claims regarding lead and heavy metal exposure had been blown out of proportion, the environmental damage was hard to refute. A waste pile measuring 100 feet high, 500 to 1,000 feet wide, and stretching for almost 2½ miles was leaking contaminants into a nearby creek. Subsurface fires covering 25 acres had burned for years. While several measures were taken to mitigate the destruction, ultimately Horsehead Industries filed for bankruptcy in 2002, citing low prices for zinc. Its assets were scooped up a year later by Sun Capital Partners, who put them under the name of the Horsehead Corporation and continued zinc-smelting operations elsewhere. The Palmerton plant sat abandoned until it was demolished in 2010. After years of hard work, remediation efforts by groups such as the Lehigh Gap Nature Center have had some success; vegetation is now growing in several of the previously barren areas, but there is still work to do.

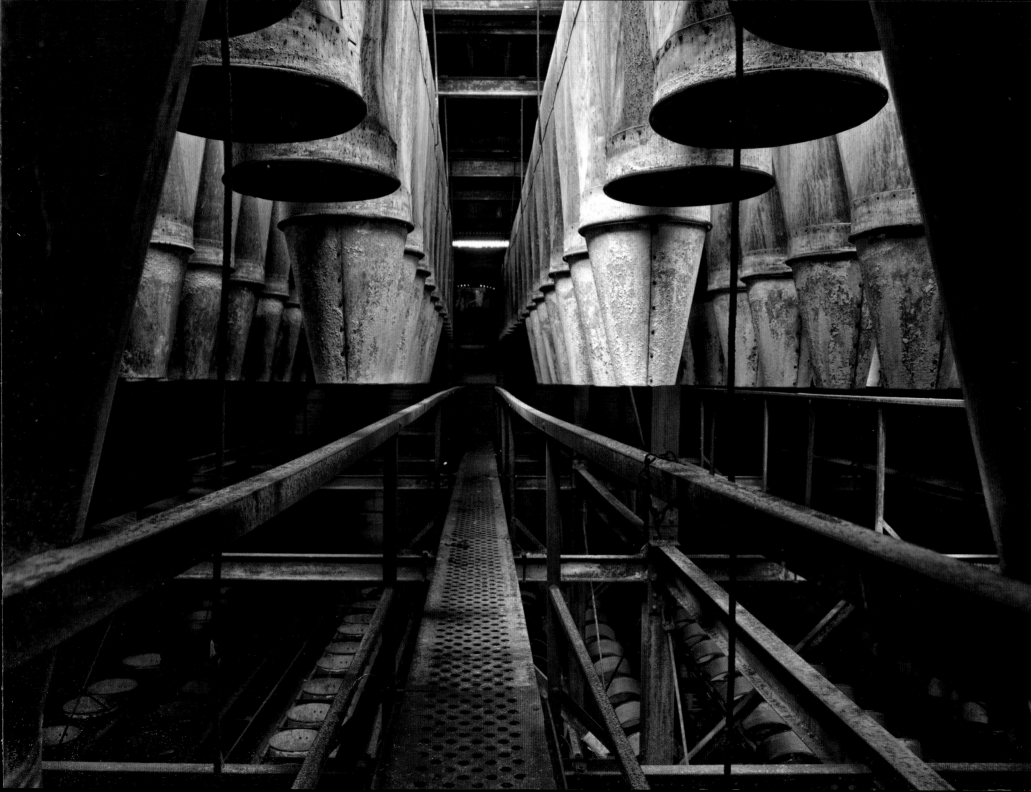

I knew little of the history of New Jersey Zinc when I first visited the plant in 2009, but as I neared it I noticed a sharp difference in the environment. Before I even reached the town, I could see the stark contrast where the verdant hillsides vanished and the areas oddly resembling a desert began. When I arrived onsite I found it eerily quiet and devoid of birds, insects, or other signs of life. The zinc buildings with their boarded-up windows and doors looked like huge mausoleums. Plants that had clearly not been alive for quite some time, yet had not decayed, peppered the property; and many of the interiors of the smelting operations were still coated with white dust. It was a surreal, eerie place, and even without a background on the site, one could easily tell that something was wrong. It was a feeling that was difficult to shake off during my time there.

I visited twice before the plant was demolished. When I returned shortly after the first trip and was walking around, I noticed two police officers wandering over the site. I went up and introduced myself—they said I would have to leave, but were glad that I hadn't tried to run away from them. They turned out to be two of the nicest police officers I've met, and they told me about the scrappers and teens they frequently had to chase away. One of the scrappers had hit a live wire, and if I recall correctly it had killed him. The officer told me that nobody would claim to own the site now "unless someone wants to buy it," and after a friendly chat he offered to drive me back to my car. In researching my article, I noticed that another scrapper had suffered the same fate in 2013.

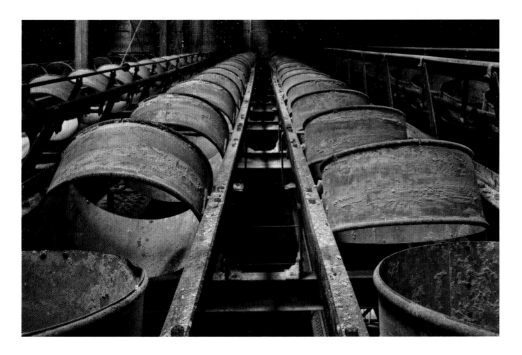

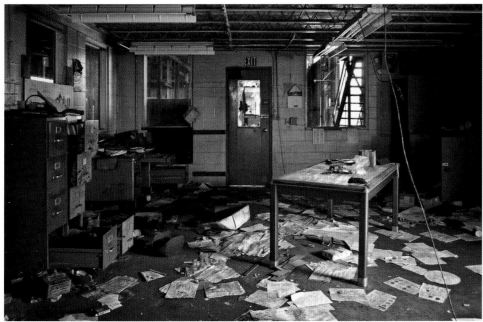

Since posting the photographs taken here, I've seen that the controversy is still raging, with the town itself sharply divided. Some people have mentioned the health consequences suffered by relatives and the frighteningly blighted appearance of the plant and the nearby mountain. However, many residents were very loyal to the company and felt that the health and environmental concerns were exaggerated by the EPA. Horsehead Industries was one of the area's largest taxpayers and donated to local parks and libraries, and many people felt that the zinc plant had built the town. People have told stories of their time working at the plant and lamented the loss of an economic tentpole, a benefactor for the town, and center of their community's identity. The debate continues, often with an angry insistence that outsiders can't understand the significance of the plant and the good it did for the area, and that those who focus on the damage are badmouthing the community. Maybe someone who isn't from the town truly can't understand what it meant, and it's easy to forget that the people who worked there lived in the very town that the plant was polluting. Obviously, they were just trying to make a living, not poison their own homes.

Shortly after my visits, the site was torn down. Efforts have been underway to mitigate the damage done to the area, including dumping sewage sludge and fly ash (which is itself industrial pollution), and to deal with the cadmium, zinc, and other heavy metals. When I was last there, the mountains were still barren but hopefully someday the area can recover. Perhaps it is indicative of the era we live in, one when we attempt to atone for the mistakes we made decades ago even as we perpetuate them elsewhere.

Ocean Vista Hospital

Once known as consumption, or the white plague, pulmonary tuberculosis has been one of the most devastating diseases known to mankind. The oldest conclusive identification of the *Mycobacterium tuberculosis* bacillus dates from 17,000 years ago, and evidence of its deadly presence has been found in nearly every society, from that of prehistoric man to the present day. By the 1800s tuberculosis was thriving in urban areas, causing roughly one out of every four deaths in Europe. Despite massive health campaigns to educate the urban poor and quarantine the sick in sanatoria that maximized their exposure to light and fresh air, the disease was barely slowed and half of those treated still died within five years.

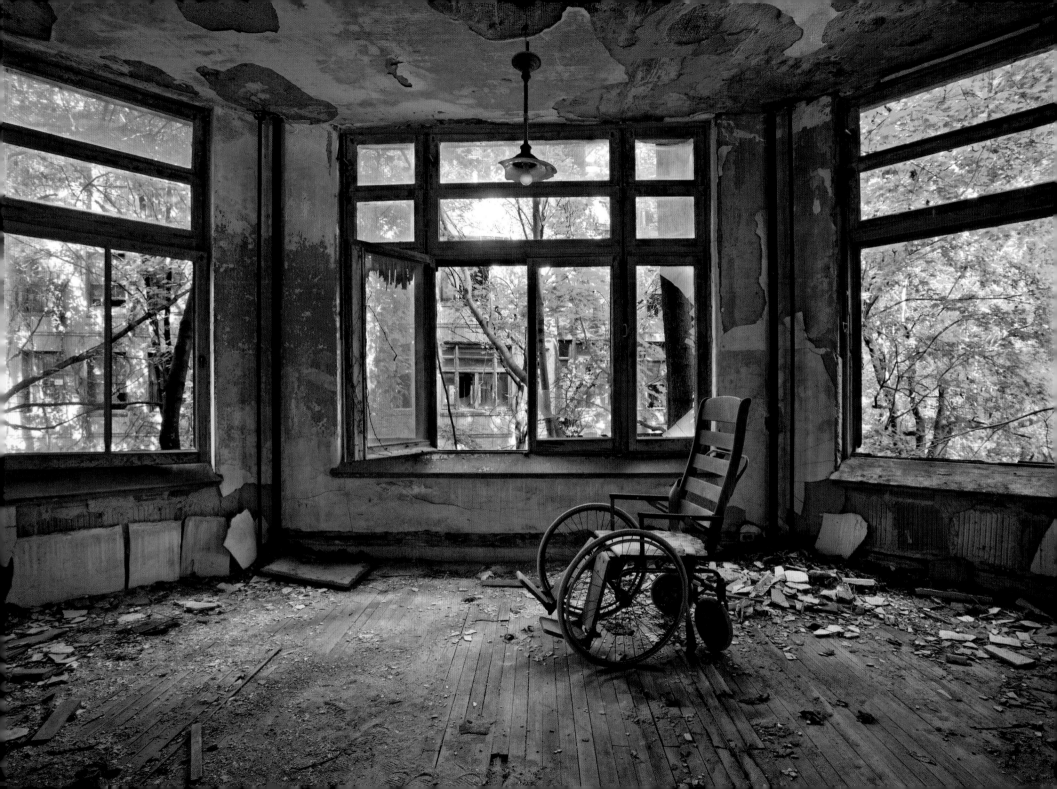

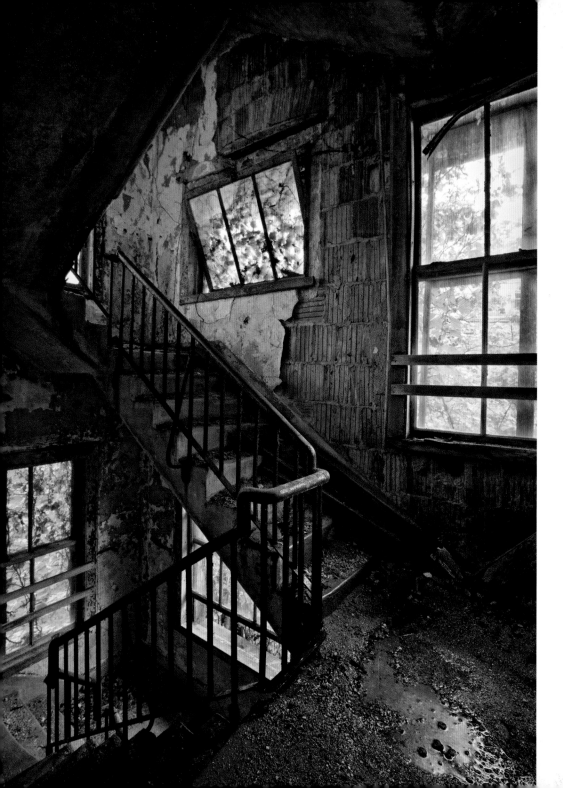

Ocean Vista Hospital (given a pseudonym in this publication) was opened in 1913 to treat cases from New York City, where tuberculosis was claiming more lives than any other disease. The *New York Times* heralded Ocean Vista as "the largest and finest hospital ever built for the care and treatment of those who suffer from tuberculosis in any form. It is a magnificent institution that is vast, ingenious, practical, convenient, sanitary and beautiful. [It is] the greatest hospital planned in the worldwide fight now being waged against the 'white plague.' The opening of this hospital is the most important event of this decade in the effort to save 10,000 lives each year, that being the number in the past that have been lost to New York through the ravages of tuberculosis. This splendid hospital, erected by the City of New York at great cost, will serve a most humane purpose in the comfortable care of those who would otherwise be sufferers from neglect and privation."

Eight four-story pavilions were built, with porches lining each floor, in addition to French doors and large windows that encouraged the circulation of air. There were also several supporting structures, including a surgical pavilion, residences for the doctors and nurses, an administration building, dining and laundry facilities, and a power house. Like the Maryland Tuberculosis Sanatorium for African Americans, Ocean Vista was perched on a hill to maximize exposure to the wind. Though the first successful immunization occurred in 1906, this treatment did not catch on outside of France until after World War II. In the interim, fresh air, rest, sunlight, and periodic operations that collapsed one of the patient's lungs so it could rest or injected air into patients' chests were some of the only treatments available. Ocean Vista's capacity was quickly expanded from 1,100 to 2,000 four years after the facility opened.

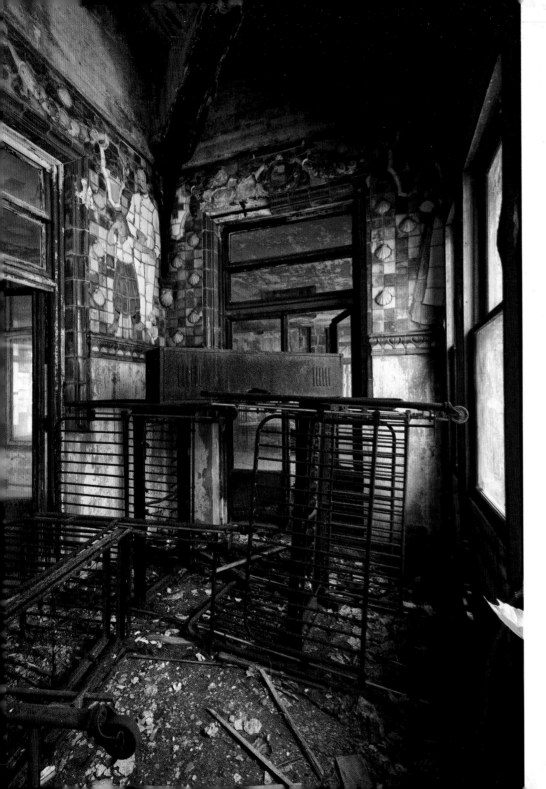

Ocean Vista's crowning moment came in 1952, when a cure for tuberculosis was found there. There had been successes with other treatments, including fresh air and Streptomycin, introduced in 1947, but treating the disease with Isoniazid was a pivotal moment in the battle against the disease. Experiments on some of the most desperate cases at Ocean Vista produced miraculous results, and eventually the drug's success led to the elimination of the need for sanatoria altogether. The last patients were discharged from Ocean Vista in 1961 and much of the 365-acre campus sank into disrepair. Four pavilions were demolished when a nursing home was built and a few other buildings were repurposed, but despite its designation as part of a historic district in 1985, large parts of the campus remain neglected.

These photographs were taken in the women's pavilions, built between 1909 and 1911. While they are in extremely poor condition, many items used in the treatments remain. Perhaps one of the most heartbreaking losses is from the porches, which were enclosed in the 1930s. Beautiful terracotta murals, imported from Holland, show scenes of doctors and nurses treating patients amid colorful designs featuring flowers and seashells. Pieces of the murals have become a favorite souvenir for trespassers at the site and are swiftly vanishing. Over the coming years, without a plan to restore the pavilions, demolition by neglect will probably lead to their erasure too.

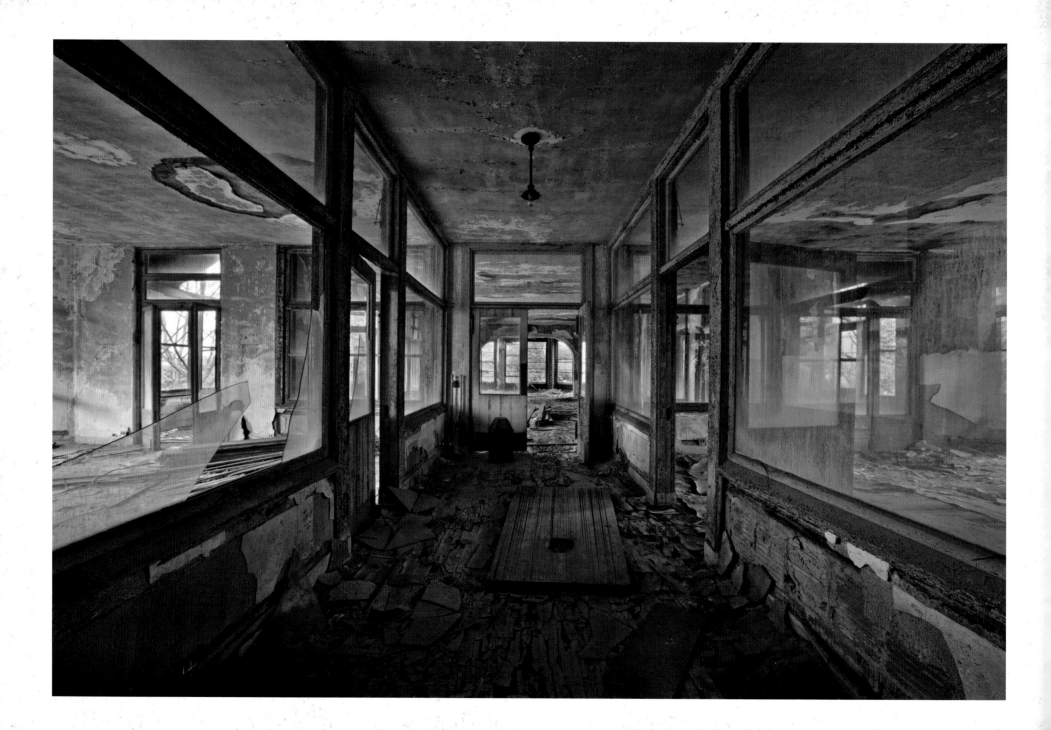

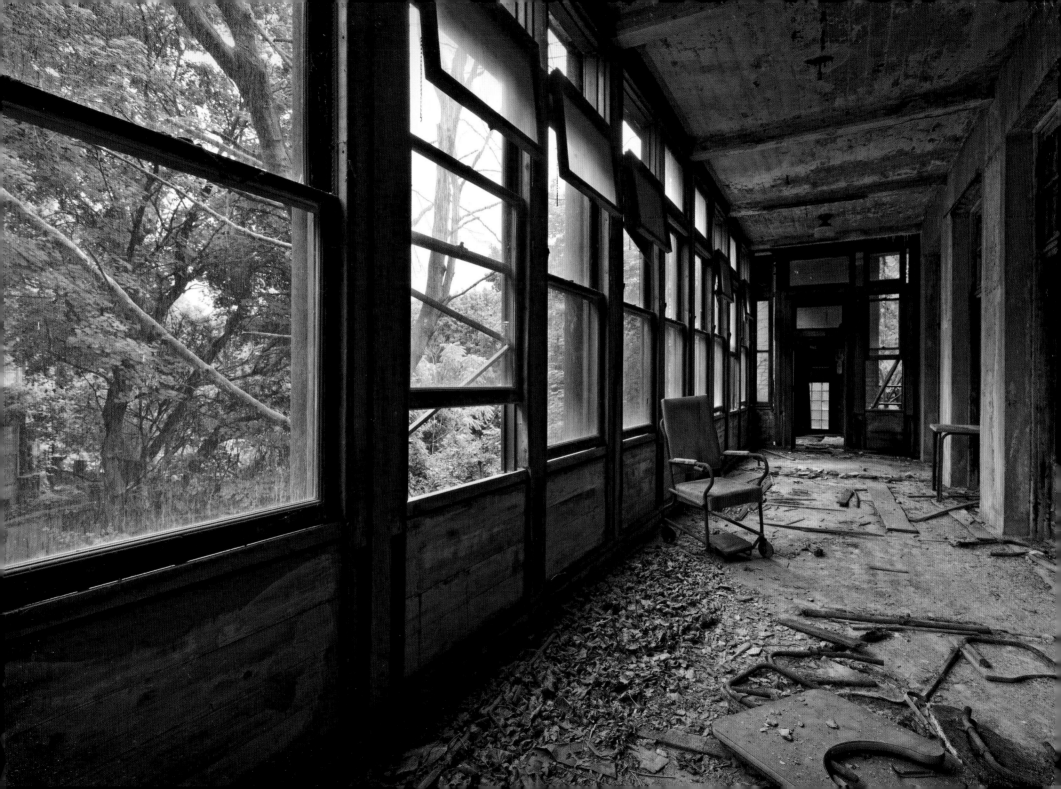

Bibliography

"12 West Main Street, Lockport, NY." J. Fitzgerald Group. Accessed July 20, 2014. http://www.jfitzgeraldgroup.com/downloads/12_WEST_HISTORY.pdf

"A Community on Company Time." Independent NEPA. December 08, 2012. Accessed July 21, 2014. http://independentnepa.com/culture/history/1309-a-community-on-company-time

"Alcoa to Curtail Eastalco Smelter on December 19 Because of High Power Costs; Company Will Continue to Explore Competitively-Priced, Long-Term Power." November 23, 2005. Accessed June 06, 2014. https://www.alcoa.com/global/en/news/news_detail.asp?pageID=20051123005210en&newsYear=2005

Allen, Lindsey, Elvan Cobb, Libbie Hawes, Yaritza Hernandez, Helen Johnson, Patrick Kidd, Charles Lawrence, Katie Milgrim, Tiffani Simple, Natalie Weinberger, and Jacqueline Wiese. "Leveraging a Community's Historic Assets to Meet Its Contemporary Needs: A Preservation Plan for Fairhill." 1st ser., 2009. http://www.design.upenn.edu/files/Pages_from_2009_Fairhill_Studio_Final_Report_Part_1.pdf

Anderson, Nicole. "Eero Saarinen's Bell Labs, Reimagined." *The Architect's Newspaper*. September 16, 2013. Accessed July 19, 2014. http://archrecord.construction.com/news/2013/10/131017-Eero-Saarinens-Bell-Labs-Reimagined.asp

Asquith, Christina. *The Emergency Teacher: The Inspirational Story of a New Teacher in an Inner-city School*. New York: Skyhorse Pub., 2007.

Avery, Ron. "Nothing but a Factory of Crime." Philly.com. July 05, 1995. http://articles.philly.com/1995-07-05/news/25677845_1_holmesburg-prison-inmates-gun-tower

"A Virtual Walking Tour of Bellefonte, Pennsylvania: Garman Opera House." Bellefonte Historical and Cultural Association. Accessed July 21, 2014. http://www.bellefontearts.org/Virtual_walk/Garman_Opera.htm

Bales, Jeff. "Benevolent and Protective Order of Elks (BPOE) Lodge – New Castle PA." Lawrence County Memoirs. Accessed July 20, 2014. http://www.lawrencecountymemoirs.com/lcmpages/186/old-elks-lodge-new-castle-pa

Balkan, Evan. *Walking Baltimore: An Insider's Guide to 33 Historic Neighborhoods, Waterfront Districts, and Hidden Treasures in Charm City*. Birmingham: Wilderness Press, 2013.

Bart Determination for Eastalco Aluminum Company Frederick, Maryland. Report. Emeryville: Environ Corporation, CA.

Bauder, Bob. "Power Station Owner Developing Crescent Site for Commercial Use." TribLIVE.com. February 03, 2011. Accessed June 12, 2014. http://triblive.com/x/pittsburghtrib/business/s_721066.html

Bejgrowicz, Tom. "Scranton Lace, I." Tom B. Photography. Accessed July 21, 2014. http://tombphotography.blogspot.com/2010/01/scranton-lace-i.html

Bergmann Associates, PC, Camoin Associates, J. Fitzgerald Group, and Herron Consulting. "City of Lockport Tourism Focus Area Draft Nomination Study 2013." July 2013, 39. Accessed July 20, 2014. http://www.discoverlockport.com/wp-content/uploads/2013/12/Draft_Nomination_Study_Report_July2013_Bergmann_LR.pdf

Bessette, Claire. "Demolition Moves into View in Preston." The Day. March 22, 2012. http://www.theday.com/article/20120322/NWS01/120329852

Bessette, Claire. "Memories Flow About Old Norwich Hospital." The Day. May 16, 2013.
http://www.theday.com/article/20130516/NWS01/305169985/-1/zip06/town/Preston/template/zip06art

Block, Ryan. "Developer to Raze Bell Labs Holmdel Facility, Birthplace of the Cellphone." Engadget. Accessed July 19, 2014.
http://www.engadget.com/2006/07/05/developer-to-raze-bell-labs-holmdel-facility-birthplace-of-the/

Boyd, William. "A Chekhov Lexicon." The Guardian. July 03, 2004. http://www.theguardian.com/books/2004/jul/03/classics

Brady, Shaun. "Two Spanish Artists Remove & Preserve Inmates' Graffiti from Holmesburg Prison." Philly.com. January 25, 2012.
http://articles.philly.com/2012-01-25/entertainment/30663338_1_walls-artists-philagrafika

Brey, Jared. "St. Bonaventure Condemned, but Who Will Salvage its Soul?" Hidden City Philadelphia. March 13, 2014. Accessed July 20, 2014.
http://hiddencityphila.org/2014/03/st-bonaventure-condemned-but-who-will-salvage-its-soul/

"Brief History of Sharon Springs." Sharon Springs Chamber of Commerce Inc. Accessed July 20, 2014. http://sharonspringschamber.com/ourhistory.html

Brody, Alan. "Alcoa Pulls the Plug on Indian Head Plant Project." Gazette.net. December 14, 2007. http://ww2.gazette.net/stories/121407/businew51024_32369.shtml

Burd, Joshua. "Former Bell Labs Site Is Seeking Tenants." NJBIZ. July 16, 2014. http://www.njbiz.com/article/20140716/NJBIZ01/140719777/Former-Bell-Labs-site-is-seeking-tenants

Calafati, Michael. "Saarinen's Bell Labs Waits to be Unshackled." American Institute of Architects. Accessed July 19, 2014. http://www.aia.org/practicing/groups/kc/AIAB081143

"Carrie Furnaces." Rivers of Steel. Accessed July 20, 2014. http://www.riversofsteel.com/preservation/heritage-sites/carrie-furnaces/

Caruso, Michael. "2,098 Pipes (in Area Organ) Will Be 'Smoking' Sunday – Chestnut Hill Local Philadelphia PA." Philly.com. September 07, 2012.
http://chestnuthilllocal.com/blog/2012/09/07/2098-pipes-area-organ-will-smoking-sunday/

Church of the Transfiguration of Our Lord Jesus Christ: Fiftieth Anniversary. Philadelphia, 1955.

Clark, Laurie Beth. "Never Again and its Discontents." Performance Research 16, no. 1, 2011: 68-79. doi:10.1080/13528165.2011.561677

Collins, Glenn. "Signs of Life in a Ghost Town; New Admirers Rebuild a Mineral-Spring Retreat." The New York Times. August 25, 2000. Accessed July 20, 2014.
http://www.nytimes.com/2000/08/26/nyregion/signs-of-life-in-a-ghost-town-new-admirers-rebuild-a-mineral-spring-retreat.html

Conley, Alia. "Four-alarm Fire Roars Through Former Edison High." Philly.com. August 03, 2011.
http://articles.philly.com/2011-08-03/news/29846800_1_fire-officials-fire-engines-school-building

Christopher, Matthew. "Abandoned America – The Carrie Furnaces." Dial Urban Milwaukee TCD Traveler. April 21, 2013.
http://urbanmilwaukeedial.com/2013/04/tcd-traveler-abandoned-america-the-carrie-furnaces/

Christopher, Matthew. "In Lansdowne, Bringing a Moorish Movie Palace Back to Life." Hidden City Philadelphia. April 25, 2014. Accessed July 20, 2014.
http://hiddencityphila.org/2014/04/in-lansdowne-bringing-back-a-moorish-movie-palace/

Corbett, Nic. "After Officer Hurt Chasing Vandals, North Caldwell Asks for Jail Annex Demolition to Hurry Up." NJ.com. August 31, 2010. Accessed June 09, 2014.
http://www.nj.com/news/local/index.ssf/2010/08/after_officer_hurt_chasing_van.html

Corsaro, Louis A. "Plans Heat Up to Preserve, Revive Carrie Furnace Site." *Pittsburgh Business Times*. April 26, 2013.
http://www.bizjournals.com/pittsburgh/print-edition/2013/04/26/plans-preserve-revivify-carrie-furnace.html?page=all

Curcio, Diane. "Essex Jail Comes Under Scrutiny of State." *The Sunday Star-Ledger*, September 13, 1987, sec. 1.

Danielson, Stentor. "Environmental Justice at the Palmerton Zinc Superfund Site, Palmerton, PA." Accessed June 11, 2014. http://debitage.net/academic/Palmerton.pdf

Davis, Christopher. "Court OKs Horsehead Sale to Sun Capital." *Pittsburgh Business Times*. December 11, 2003. Accessed June 11, 2014.
http://www.bizjournals.com/pittsburgh/stories/2003/12/08/daily33.html?page=all

Dawson, Mike. "Bellefonte Hotel Do De Fire Ruled Arson." *The Centre Daily Times*. October 01, 2012.
http://www.centredaily.com/2012/10/01/3355694/bellefonte-hotel-do-de-fire-ruled.html

Decker Keator, Alfred, ed. *Encyclopedia of Pennsylvania Biography*. New York: Lewis Historical Publishing Company Inc., 1948.

Devlin, Ron. "Blue-collar 'Hilton' For Sale." *The Morning Call*. August 26, 1990. http://articles.mcall.com/1990-08-26/news/2756138_1_unity-house-garment-workers-poconos

Dixon, Stuart Paul. *Maryland Inventory of Historical Properties Form*. Report. Washington DC: Lewis Berger Group, 2000.

"Eero Saarinen." Wikipedia. July 18, 2014. Accessed July 19, 2014. http://en.wikipedia.org/wiki/Eero_Saarinen

"Eero Saarinen's Bell Labs, Reimagined." *Architectural Record*. October 17, 2013. Accessed July 19, 2014.
http://archrecord.construction.com/news/2013/10/131017-Eero-Saarinens-Bell-Labs-Reimagined.asp

Eisenstein, Paul A. "Detroit's Iconic Packard Plant Could Soon Be Back in Business." NBC News. October 29, 2013.
http://www.nbcnews.com/business/autos/detroits-iconic-packard-plant-could-soon-be-back-business-f8C11487943

Ellis, Lisa. "A Working-Class Resort No More Union's Hideaway in Poconos Is For Sale." Philly.com. August 12, 1990.
http://articles.philly.com/1990-08-12/news/25933830_1_unity-house-ilgwu-arthur-s-bolger

Elk, Sarah Jane. "Workshop of the World." Wilde Yarn Mill. Accessed July 19, 2014. http://www.workshopoftheworld.com/manayunk/wilde.html

Fontaine, Tom. "South Heights, Crescent Residents Wary of Impact of Drilling." Triblive News. February 11, 2012. Accessed June 12, 2014.
http://triblive.com/x/pittsburghtrib/s_781145.html

"Fraud, Greed and Development of New Orleans Commercial Real Estate." Louisiana Commercial Realty. June 14, 2014.
http://www.louisianacommercialrealty.com/2014/06/market-street-power-plant-development/

Ganapati, Priya. "Once Mighty Bell Labs Leaves Behind Transistor, Laser, 6 Nobels." Wired.com. August 28, 2008. http://archive.today/HaK1P

"Garman Theater Has Storied Past." Progress Development Group LLC. September 11, 2012. http://www.pdg-llc.com/#!garman-theatre-has-storied-past/c11td

Goldwyn, Ron, and Gar Joseph. "A Riot at Holmesburg Changed the Prison System Forever." Philly.com. June 10, 1988.
http://articles.philly.com/1988-06-10/news/26267533_1_prison-system-prison-conditions-holmesburg-prison

Golias, Paul. "Blue Coal's Checkered past Revealed in Bankruptcy." *Citizen's Voice*. January 28, 2013.
http://citizensvoice.com/news/blue-coal-s-checkered-past-revealed-in-bankruptcy-1.1435711

Golias, Paul. "Preservation Society Continues Mission After Losing Huber Breaker." *Citizen's Voice*. September 24, 2013.
http://citizensvoice.com/news/preservation-society-continunes-mission-after-losing-huber-breaker-1.1557176

Goodman, Howard. "Studying Prison Experiments Research: For 20 Years, a Dermatologist Used the Inmates of a Philadelphia Prison as the Willing Subjects of Tests on Shampoo, Foot Powder, Deodorant, and Later, Mind-Altering Drugs and Dioxin." *Baltimore Sun*. July 21, 1998. Accessed July 06, 2014.
http://articles.baltimoresun.com/1998-07-21/news/1998202099_1_holmesburg-prison-kligman-philadelphia

Grady, Matt. "Despite Project Delays, Waldorf School Breaks Ground in Germantown." *Newsworks*, October 21, 2013.
http://www.newsworks.org/index.php/local/nw-philadelphia/61041-despite-project-delays-waldorf-school-breaks-ground-in-germantown

Gray, Christopher. "Streetscapes: Seaview Hospital; a TB Patients' Haven Now Afflicted With Neglect." *The New York Times*. July 15, 1989.
http://www.nytimes.com/1989/07/16/realestate/streetscapes-seaview-hospital-a-tb-patients-haven-now-afflicted-with-neglect.html

Greenle, Michael. "Future Darkening for St. Bonaventure." Hidden City Philadelphia. February 01, 2013. Accessed July 20, 2014.
http://hiddencityphila.org/2013/02/future-darkening-for-st-bonaventure/

Hammer, David. "Former Power Plant Involved in Nagin Investigation Now Out of Bankruptcy." WWLTV.com. October 16, 2012. Accessed July 20, 2014.
http://www.wwltv.com/news/eyewitness/davidhammer/Power-plant-involved-in-Nagin-corruption-investigation-174501751.html

Hammer, David. "New Developers of Major Riverfront Project Have Troubled past." WWLTV.com. January 09, 2013. Accessed July 20, 2014.
http://www.wwltv.com/news/eyewitness/davidhammer/Swickle-and-Mannone-186248072.html

Hasan, Lama, and Katie Hinman. "Anne Hathaway's Ex Raffaello Follieri 'Happy' for Actress, Ready to 'Live My Life' After Prison." ABC News. June 27, 2012.
http://abcnews.go.com/Entertainment/anne-hathaways-raffaello-follieri-happy-actress-ready-live/story?id=16656717

Haughney, Christine. "Vatican Ties Go Just So Far for Follieri Group." Pittsburgh Post-Gazette. August 02, 2006.
http://www.post-gazette.com/business/businessnews/2006/08/02/Vatican-ties-go-just-so-far-for-Follieri-Group/stories/200608020154

Hernandez, Nelson. "Rising Energy Costs May Leave Eastalco Plant in Dark." *Washington Post*, June 12, 2005. Accessed June 06, 2014.
http://www.washingtonpost.com/wp-dyn/content/article/2005/06/11/AR2005061100612.html

Herszenhorn, David M. "Confidential Police Records Left Strewn About Ruined Jail." *The New York Times*. October 24, 1998.
http://www.nytimes.com/1998/10/25/nyregion/confidential-police-records-left-strewn-about-ruined-jail.html

Hildebrandt, Patrick. "St. Boniface." Philadelphia Church Project. Accessed July 06, 2014. http://www.phillychurchproject.com/st-boniface/

"Historic Lansdowne Theater Corporation History." Lansdowne Theater. Accessed July 20, 2014. http://www.lansdownetheater.org/history/history.html

"History of Huber Breaker." Huber Breaker Preservation Society. Accessed June 10, 2014. http://huberbreaker.org/home/history/history-of-huber-breaker/

Hoffman, Elise. "Baltimore Design School." Explore Baltimore Heritage. Accessed July 20, 2014. http://explore.baltimoreheritage.org/items/show/53

"Homestead Strike." Wikipedia. July 14, 2014. http://en.wikipedia.org/wiki/Homestead_Strike

Hornblum, Allen M. *Acres of Skin: Human Experiments at Holmesburg Prison: A Story of Abuse and Exploitation in the Name of Medical Science.* New York: Routledge, 1998.

Hornblum, Allen. "The Klondike Steam Kettle." *Philadelphia Weekly.* August 23, 1995.

Kamal, Sameea. "Connecticut Lawmakers OK Sale of Remaining Norwich State Hospital Land; Prospective Buyer's Plans Are for 'Family Entertainment'." *Hartford Courant.* June 27, 2013. Accessed July 20, 2014.
http://articles.courant.com/2013-06-27/news/hc-norwich-state-hospital-proposed-sale-0628-20130627_1_hospital-property-estate-firm-state-lawmakers

Kelly, Jacques. "Lebow Bros. Building Transforming into Design School." *Baltimore Sun.* March 30, 2012.
http://articles.baltimoresun.com/2012-03-30/news/bs-md-kelly-column-lebow-20120330_1_sewing-machines-baltimore-design-school-crown-cork

Khavkine, Richard. "Historians Lament Destruction of Former Penitentiary in North Caldwell." NJ.com. June 12, 2011. Accessed June 09, 2014.
http://www.nj.com/news/index.ssf/2011/06/historians_lament_destruction.html

Kirsch, Tom. "Old Essex County Jail." Opacity.us. Accessed July 21, 2014. http://opacity.us/site18_old_essex_county_jail.htm

Kirsch, Tom. "Westport Generating Station." Opacity.us. Accessed July 06, 2014. http://opacity.us/site214_westport_generating_station.htm

Koch, Keith. "For Sale: A Part of Bellefonte's History." Edited by Lora Gauss. *Bellefonte Secrets* 4, no. 3, June 2011: 2-3.

Laylo, Bob. "Epa Wants Court Ruling Reversed Says Residents in Superfund Cleanup May Face Harassment if Identified." *The Morning Call.* December 28, 1995. Accessed June 11, 2014.
http://articles.mcall.com/1995-12-28/news/3056912_1_epa-representative-palmerton-superfund-harassed

Lerner, Barron H. "Once Upon a Time, a Plague Was Vanquished." *The New York Times.* October 13, 2003.
http://www.nytimes.com/2003/10/14/health/once-upon-a-time-a-plague-was-vanquished.html

Libby, Sam. "Who Will Win State Property?" *The New York Times.* March 09, 1996. http://www.nytimes.com/1996/03/10/nyregion/who-will-win-state-property.html

Lockwood, Jim. "Scranton City Council Accepts $555K Gaming Grant for Scranton Lace Redevelopment." *The Times Tribune.* October 26, 2012. Accessed July 21, 2014.
http://thetimes-tribune.com/news/scranton-city-council-accepts-555k-gaming-grant-for-scranton-lace-redevelopment-1.1394220

Lowe, Delbert B. *History of the Consolidated Gas Electric Light and Power Company of Baltimore.* Baltimore, 1928.

Mahoney, Edmund H. "Norwich State Hospital Complex Crumbles Despite State's Millions." *Hartford Courant.* June 26, 2010.

Mahoney, Joe. "Sharon Springs Plan Back on Track, Korean Investor Says." The Daily Star. April 13, 2013.
http://www.thedailystar.com/localnews/x266749150/Sharon-Springs-plan-back-on-track-Korean-investor-says/print

Mayo, D. "Some Surprising Facts About (the Problem of) Surprising Facts." *Studies in History and Philosophy of Science Part A,* December 2007. Accessed June 16, 2014.
doi:10.1016/j.shpsa.2013.10.005

Mcauliffe, Josh. "Photographer Captures Pathos of Abandoned Scranton Lace Works in North Scranton." *The Times Tribune.* October 28, 2011. Accessed July 21, 2014.
http://thetimes-tribune.com/lifestyles/photographer-captures-pathos-of-abandoned-scranton-lace-works-in-north-scranton-1.1224218

Miles, Joyce M. "Kohl Cycle Demo Job Under Way." Lockport Union-Sun & Journal. July 31, 2013. Accessed July 20, 2014.
http://www.lockportjournal.com/local/x389846017/Kohl-Cycle-demo-job-under-way

Morgan, Matt. "Bellefonte Resident Wants Garman Theatre Preserved." *The Centre Daily Times*. May 02, 2012.
http://www.centredaily.com/2013/05/02/3601147/bellefonte-resident-wants-garman.html

Morgan, Matt. "One Year Later, Hotel Do De Fire Still Stings Bellefonte." *The Centre Daily Times*. September 09, 2013.
http://www.centredaily.com/2013/09/09/3778427/one-year-later-hotel-do-de-fire.html

Morrison, Blake. "Sally Mann: the Naked and the Dead." *The Guardian*. May 28, 2010.

Mote, Christopher. "Demolition Imminent at North Philadelphia Landmark St. Bonaventure (Updated)." Hidden City Philadelphia. November 06, 2013. Accessed July 03, 2014.
http://hiddencityphila.org/2013/11/demolition-imminent-at-north-philadelphia-landmark-st-bonaventure/

Mote, Christopher. "Final Curtain for the Former Edison High." Hidden City Philadelphia. February 28, 2013.
http://hiddencityphila.org/2013/02/final-curtain-for-the-former-edison-high/

Moutzalias, Tanya. "New Packard Plant Owner Fernando Palazuelo Says He Can Surprise Detroit's Doubters." MLive.com. March 20, 2014.
http://www.mlive.com/entertainment/detroit/index.ssf/2014/03/detroit_free_press_unveils_pac.html

Mrozinski, John. "Council Gives Nod to Scranton Lace Project." Virgin Islands Daily News. January 26, 2011.
http://virginislandsdailynews.com/news/council-gives-nod-to-scranton-lace-project-1.1095501

"New Orleans Public Service Inc. (NOPSI)." Department of Natural Resources. Accessed July 20, 2014.
http://dnr.louisiana.gov/sec/execdiv/techasmt/electricity/electric_vol1_1994/003e.htm

"Norwich State Hospital." Wikipedia. July 20, 2014. Accessed July 20, 2014. http://en.wikipedia.org/wiki/Norwich_State_Hospital

O'Neill, Daniel J. *A History of the Church of the Transfiguration 1905 to 1972*. Report. Philadelphia, 1972.

"Packard Automotive Plant." Wikipedia. July 17, 2014. http://en.wikipedia.org/wiki/Packard_Automotive_Plant

"Packard." Wikipedia. July 19, 2014. http://en.wikipedia.org/wiki/Packard

Palmerton Natural Resource Trustee Council. *Palmerton Zinc Pile Superfund Site Natural Resource Damage Assessment Plan*. Report. Accessed June 11, 2014.
http://www.fws.gov/contaminants/restorationplans/palmerton/palmertonassessmentplanfeb06.pdf

"Palmerton, PA Borough & Police Dept." Palmerton, PA Borough & Police Dept. Accessed June 11, 2014. http://www.palmertonborough.com/history.html

"Palmerton Zinc." EPA. March 24, 2014. Accessed June 11, 2014. http://www.epa.gov/reg3hscd/npl/PAD002395887.htm

Pegher, Kelcie. "Demolition Begins at Former Henryton State Hospital." *Carroll County Times*. June 25, 2013.
http://www.carrollcountytimes.com/news/local/demolition-begins-at-former-henryton-state-hospital/article_1da2938d-38c9-52b4-b846-9dd1eefd712e.html

"Pennsylvania Riot Leaves 103 Persons Injured." *The Bulletin* (Bend, Oregon). July 06, 1970.

"Peruvian Developer Readies to Make the Rundown Packard Car Plant in Detroit Home." Fox News Latino. June 29, 2014.
http://latino.foxnews.com/latino/money/2014/06/29/peruvian-developer-readies-to-make-rundown-packard-car-plant-in-detroit-home/

Prohaska, Thomas. "Historic Lockport Building to Be Demolished in Wake of Fire." *The Buffalo News.* July 30, 2013.
http://www.buffalonews.com/city-region/lockport/firefighters-battling-lockport-blaze-20130730

"Public to Inspect New Elks Home." *New Castle News.* July 10, 1916.

Read, Philip. "Newark Landmarks Commission Seeks to Preserve Historic Essex County Jail." NJ.com. July 22, 2010.
http://www.nj.com/news/index.ssf/2010/07/newark_landmarks_commission_se.html

Rigaux, Pamela. "State Testing Land for Fluoride before Eastalco Donates It." *The Frederick News-Post.* February 23, 2006. Accessed June 06, 2014.
http://www.fredericknewspost.com/archives/state-testing-land-for-fluoride-before-eastalco-donates-it/article_9c27ecd8-e369-57b5-9373-96e01d49a131.html

Rodgers, Bethany. "Eastalco Property a Candidate for Manufacturing Operation." *The Frederick News-Post.* July 28, 2012.
http://www.fredericknewspost.com/archive/article_273a6373-2498-5c5f-86ea-71b9a9e65fb2.html

Rosenberg, Joshua. "North Caldwell Plans Monument to Mark Site of Former Jail." New Jersey Hills Media Group. July 13, 2012. Accessed June 10, 2014.
http://newjerseyhills.com/the_progress/news/north-caldwell-plans-monument-to-mark-site-of-former-jail/article_90b99d16-ccb1-11e1-a3b9-0019bb2963f4.html

Rosenblum, Martin J.. *National Register of Historic Places Registration Form.* Report. Accessed July 04, 2014. http://www.nps.gov/history/nr/feature/places/pdfs/13000258.pdf

Roxanne Gallemore Administratrix Ad Prosequendum for Lamonte Gallemore V. Essex County Corrections Facility Annex County of Essex Director of Public Safety Director of the Essex County Jail Annex Warden of the Essex County Jail Annex Essex County Police Academy (Superior Court of New Jersey, Appellate Division March 08, 2011).

Rujumba, Karamagi. "Redevelopment of Carrie Furnace Site to Begin This Year." Pittsburgh Post-Gazette. May 18, 2009.
http://www.post-gazette.com/business/businessnews/2009/05/18/Redevelopment-of-Carrie-Furnace-site-to-begin-this-year/stories/200905180171

Salisbury, Stephan. "Episcopal Church Closes, the Legacy of Charles Bennison." *Philadelphia Inquirer.* August 04, 2005.

"Scranton Lace Company." Wikipedia. July 17, 2014. Accessed July 21, 2014. http://en.wikipedia.org/wiki/Scranton_Lace_Company

"Sea View Hospital for Consumptives Is Dedicated." *The New York Times.* November 13, 1913.

Seder, Andrew. "New Jobs Coming to Old Coal Site." *Times Leader.* September 07, 2013. Accessed June 10, 2014.
http://www.timesleader.com/news/local-news/840103/New-jobs-coming-to-old-coal-site

"Sharon Springs Historic District." Living Places. Accessed July 20, 2014.
http://www.livingplaces.com/NY/Schoharie_County/Sharon_Springs_Village/Sharon_Springs_Historic_District.html

"Sharon Springs, New York." Wikipedia. July 18, 2014. Accessed July 20, 2014. http://en.wikipedia.org/wiki/Sharon_Springs%2C_New_York

Shearn, Ian T. "Abandoned Bell Labs Could Make History Again." NJ.com. August 03, 2008. Accessed July 19, 2014.
http://www.nj.com/news/index.ssf/2008/08/abandoned_bell_labs_could_make.html

Slade, David. "Epa: Horsehead Industries Must Restore Blue Mountain * Other Companies Also Named In Order to Repair Palmerton Superfund Site." *The Morning Call*. December 21, 1999. Accessed June 11, 2014. http://articles.mcall.com/1999-12-21/news/3271227_1_epa-order-blue-mountain-ruth-podems

Slade, David. "Superfund Plan Elicits Little Comment Cleanup Would Affect 4 in 10 Palmerton Area Homes, but Very Few Voice Opinions." *The Morning Call*. July 20, 2000. Accessed June 11, 2014. http://articles.mcall.com/2000-07-20/news/3323820_1_soil-contaminated-epa

Slade, David. "Horsehead Files under Chapter 11." *The Morning Call*. August 21, 2002. Accessed June 11, 2014. http://articles.mcall.com/2002-08-21/news/3419277_1_zinc-palmerton-superfund-bankruptcy-process

Slade, David. "Satisfied With Palmerton Cleanup, EPA Says." *The Morning Call*. September 26, 2002. Accessed June 11, 2014. http://articles.mcall.com/2002-09-26/news/3414237_1_epa-decision-waste-pile-sewage-sludge

Soliwon, Diane. "Del. Krebs: Funds Available to Deal With Henryton Hospital." Eldersburg Patch. May 02, 2012. http://eldersburg.patch.com/groups/politics-and-elections/p/del-krebs-funds-available-to-deal-with-henryton-hospital

St. Boniface Centennial Book. Philadelphia: St. Boniface Parish, 1966.

Stein, Sam. "Clinton Firm's Deal Left Pennsylvania Churches in Shambles." The Huffington Post. April 10, 2008. http://www.huffingtonpost.com/2008/04/10/clinton-firms-deal-with-i_n_96032.html

Stranahan, Susan Q. "The Yarn Continues in Manayunk John Wilde & Brother Has Been Making Carpet Fiber for More Than a Century." Philly.com. December 06, 1993. http://articles.philly.com/1993-12-06/business/25943060_1_rug-market-wool-manayunk

United States District Court for the District of New Jersey Essex County Jail Annex Inmates, Corey Webb, Thomas Armour, Frederick W. Booker, James Simon, Ronald Mcclendon, Rosetta Drake, Candace Johnson, Rosalind Robinson, on behalf of themselves and all other persons similarly situated v. NICHOLAS AMATO, Essex County Executive, Thomas Thompson, Acting Administrator, Thomas Giblin, President, Essex County Board Of Chosen Freeholders, Joseph Parlavecchio, Vice President, Essex County Board Of Chosen Freeholders, Cardell Cooper, Adrianne Davis, John Alati, James Cavanaugh, Pearl Beatty, Arthur Clay and Monroe, Jay Lustbader, Members Essex County Board Of Chosen Freeholders, Emily Weber, Acting Director, Department Of Public Safety, and Their Successors in Office, Individually and in Their Official Capacities, and William H. Fauver, Commissioner, New Jersey Department of Corrections, and His Successor in Office, Individually and in His Official Capacity (United States District Court for the District of New Jersey March 09, 1987).

Westport Community Partnerships. Accessed July 06, 2014. http://www.westportpartnerships.org/www/docs/118/westport_waterfront_development_community_partnerships/

"Westport Waterfront: Green Harbor." Turner Development. Accessed July 06, 2014. http://www.turnerdevelopment.com/press/waterfrontgreen.php

Wheeler, Timothy. "Abandoned Henryton Hospital near Marriottsville Slated for Demolition." *Baltimore Sun*. March 31, 2013.

Wilkerson, James E. "Companies Will Pay Millions to Settle Palmerton Pollution Case * Epa Is Still Suing Companies for Cleanup of Area Polluted During Zinc Smelting Operations." *The Morning Call*. June 25, 1999.
Accessed June 11, 2014. http://articles.mcall.com/1999-06-25/news/3245538_1_epa-superfund-armco-steel

Wilkerson, James E. "Horsehead Will Pay Settlement Between Epa, 200 Companies * It Doesn't Want Customers to be Held Liable for Cleanup at Palmerton Superfund Site." *The Morning Call*. June 28, 1999. Accessed June 11, 2014. http://articles.mcall.com/1999-06-28/news/3245154_1_superfund-process-epa-superfund-list

York, Michelle. "Like the Water, Grand Plans Buoy Spirits at a Vacation Spot from a Bygone Era." *The New York Times*. June 04, 2008. http://www.nytimes.com/2008/06/05/nyregion/05sharon.html?_r=2&pagewanted=print&oref=slogin&

Acknowledgments

Putting this book together has been an intense and at times very stressful process as it is the culmination of many years of work. I am very grateful to all those who have helped me along the way and feel tremendously fortunate to have so many wonderful people in my life to come back to when I've gazed into the abyss for too long. I would like to thank the following people, and many more I am probably neglecting to name, for their contributions:

My family, for always being there for me and supporting my creative work, no matter how crazy it seemed at the time. I would never have made it to this point without you.

My girlfriend Olivia, for loving me, staying by my side even when the path has seemed unclear or when I am difficult, always inspiring me to try to do better, and for being my best friend.

My friends, for reminding me that there is life outside of work and to step back and enjoy it sometimes.

The faculty and students who helped me improve my work during my studies in the MFA program at the Rochester Institute of Technology, particularly Bill DuBois, the mentor without whom I would never have made it through the program; Ken White, for his stability and great advice; Jessica Lieberman, who pushed my conceptual understanding of what I was doing; Eric Kunsman, for his expertise in technically perfecting images and printing; Carla Williams, for her kindness and assistance in completing the program; and Willie Osterman, for challenging me to do better.

My publisher, Thomas Jonglez, for offering me the opportunity to put this book together and patiently working with me on it even when my perfectionism made doing so challenging.

James Howard Kunstler, for his brilliant and important work and for kindly writing the foreword.

Those who have purchased prints, donated to the website, and attended my photography workshops, for making it possible to visit these places and take the time to engage in this project.

The fans and supporters of my website for their kind comments and emails that give me a reason to keep pushing forward with my photography even when I am unsure where I am going or how to get there.

The property owners who have trusted me to photograph their sites and made this book possible, and those who have helped me find great locations to photograph.

The many others who have been kind to me, helped me along, and taught or comforted me along the way.

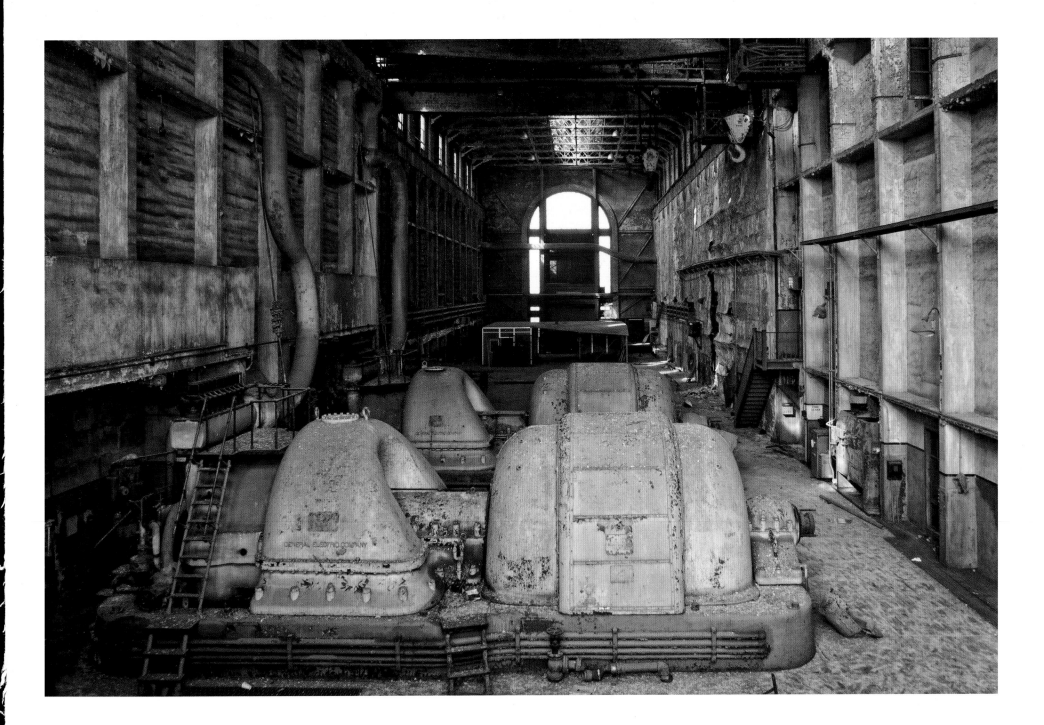

All photographs by Mathew Christopher

Photo copyrights: Mathew Christopher Abandonedamerica.us
Design: Stéphanie Benoit
Editing: Jana Gough
Proof-reading: Kimberly Bess

In accordance with jurisprudence (Toulouse 14-0a1-1887), the publisher is not to be held responsible for any involuntary errors or omissions that may appear in the guide despite the care taken by the editorial staff.

Any reproduction of this book in any format is prohibited without the express agreement of the publisher.

© JONGLEZ 2014
Registration of copyright: November 2014 – Edition: 01
ISBN: 978-2-36195-094-1
Printed in China by Leo Press